Ancient
Indian Art
and the West

Ancient Indian Art and the West

*A Study of Parallels, Continuity and Symbolism
from Proto-historic to Early Buddhist Times*

by Irene N. Gajjar, Ph. D.

Preface by **William H. McNeill**
Professor of History, University of Chicago

D. B. TARAPOREVALA SONS & CO. PRIVATE LTD.
210, DR. D. NAOROJI ROAD — — — — — BOMBAY

PRINTED IN INDIA

Published by Russi J. Taraporevala, for D. B. Taraporevala Sons & Co. Private Ltd., Bombay, and Printed by D. D. Karkaria, at Leaders Press Private Limited, Mazagaon, Bombay-10.

This book is dedicated to
my father
ALEXANDER LUNCAN
and to
my father-in-law
BHADRABHAI G. GAJJAR

Preface

Both the method and the conclusions of this book command attention. The author has chosen to concentrate attention on a number of relatively simple, easily recognizable motifs as they appear in the ancient art of India and the Middle East. This is analogous to the fashion in which anthropologists in studying cultural diffusion fixed attention on culture traits, each simple in itself and easily recognizable even in different contexts. Such a procedure gives a kind of precision to the study of relationships across time and space which cannot be achieved when arguments rest upon vague stylistic affinities or cultural configurations taken as a whole. Similarities are more exact, quantification becomes possible when the focus of attention becomes smaller and more definite.

At the same time, one is bound to ask what even the most carefully measured distribution of culture traits or of art motifs means. Mrs. Gajjar is unambiguous in stating her belief that decorative motifs, whether found on humble pottery or on monumental structures, carried constant symbolic meanings for those who used them. Such a view becomes plausible if one believes, as she does, that ancient cultures both in India and in the Middle East were closely integrated and changed only slowly. Traits originally associated, on such a view, tended to travel together and retained their original associations as they moved from one region to another or endured across hundreds and even thousands of years.

Yet one must admit that the circumstances under which people of one society pick up art motifs or any other culture trait from others, as well as the conditions under which peoples living in close contact with one another for centuries still retain divergent ways of doing things, are not well understood. But before any satisfactory theory can be devised, the facts must become better known. Here a work such as this serves a very useful purpose. The author has painstakingly gathered detailed data from a wide variety of sources, and plotted her results in time and space in such a way as to demonstrate the temporal continuities and wide geographical distributions of the motifs with which she deals.

Her basic thesis, that ancient India and the ancient Middle East shared a common, presumably mainly neolithic cultural background, seems very plausible on the basis of the data she has assembled. The relative importance of this common background as against subsequent encounters, like the Mauryan contact with Persia and Hellenistic Asia, must remain a matter of judgment upon which experts may be expected to disagree. Mrs. Gajjar's arguments for parallel evolution in India and the Middle East on the basis of a common background certainly deserve respectful attention. By looking hard at motifs instead of relying upon overall appraisal of stylistic affinities and differences, she has been able to give a new kind of precision to the debate.

This work raises a larger question in my mind. What would a similar study of art motifs in other parts of the earth produce? Did ancient China, for instance, also share some or all of the ceramic decorative motifs that are found in India and the Middle East? What of southern India itself and south east Asia generally? In other words, can art provinces be defined by tracing the distribution and diffusion of motifs like those studied in this book? German ethnologists have tried to define *Kulturkreise* on the basis of distribution of a few types of stone tools or similarly simple, abundantly surviving artifacts. But a really meticulous survey of the motifs of decorative art, extending across the whole of Eurasia or even embracing the globe, has never been carried through. The task would be enormous, but Mrs. Gajjar has demonstrated in this book how it might be attempted, and how fruitful the results might be.

WILLIAM H. McNEILL
Professor of History
University of Chicago

18 November 1970

Acknowledgements

This study was evolved over a period of more than six years and submitted as a doctoral thesis to Bombay University at the end of 1966. Its revision and publication has also been a lengthy process. In its present form it emerges as an evaluation of motifs and symbols in Indian art in the light of the many parallels these motifs and symbols have in West Asian traditions. Essentially this is a study of Indian traditions and not a comparative study, although comparisons provided the point of departure.

This work has been made possible by the guidance, inspiration, and assistance of many persons. My first indebtedness is to my guide, Dr. L. B. Keny, Head of the Department of Ancient Indian Culture, St. Xavier's College, Bombay. Dr. Keny's experienced criticisms have been of great value. I am also indebted to Dr. Nihar Ranjan Ray of Calcutta University whose recommendation led ultimately to the publication of this book.

Much inspiration has been provided by the works of earlier scholars, especially those of Dr. A. Coomaraswamy, Professor E. Herzfeld, and Dr. Stella Kramrisch. The earliest part of this book owes much of its orientation to Starr's *Indus Valley Painted Pottery* and to Professor Herzfeld's *Iran in the Ancient East,* both of which although now about 30 years old are still invaluable in an analysis of relationships between Indian and Occidental ceramic and glyptic traditions. However, much new material of significance has come to light following the work of the above scholars. This material, noted in the bibliography, has been utilized and assessed.

The chapters on Maurya and Sunga art interpret decorative and symbolic motifs in the light of protohistoric antecedents as well as earlier or contemporary Occidental forms. The works of many scholars have been taken into consideration in the evaluation of these early historic traditions in Indian Art.

Material from a large number of works, consulted and acknowledged in the bibliography, has not been incorporated in the text. Although not always specifically relevant, such material has been of great value in the formulation of this book as a whole.

I am grateful, in addition, to many persons who have been of specific help in the course of my research. Mr. D. N. Marshall, Librarian of the University of Bombay, has provided every possible assistance and facility over a number of years. I have also received much co-operation from other people at the University of Bombay Library and at the Heras Institute of Indian History and Culture, St. Xavier's College, Bombay.

Much assistance has also been provided by the authorities of the Indian Museum, Calcutta and the National Museum, New Delhi. Mr. T. R. Gairola of the National Museum has been especially helpful in providing essential material. Material from the Patna Museum, Patna, has also been of value.

In preparing the photographs I am grateful to Mr. Chandubhai Khata for his assistance, and for the line drawings which form an integral portion of this book. I am thankful to Mr. Kanubhai G. Shah, Mr. Natubhai J. Parikh, and Mr. Sharad V. Patel of Ahmedabad.

For her steady help in proof reading I thank Miss Martha Howell.

I am indebted to Dr. Rustam J. Mehta of D. B. Taraporevala Sons & Co. Private Ltd., for his competent and painstaking work and his many invaluable suggestions in connection with the publication of the book.

I wish to give special thanks to Professor William H. McNeill of Chicago University for writing the Preface. I consider the interest he has taken in this work a great honor.

To the members of my family, especially my husband, and to friends I am deeply grateful for their continued encouragement and cooperation. Without this I would not have had the impetus to undertake this book nor the time to devote to its completion.

<div align="right">IRENE N. GAJJAR</div>

Contents

PREFACE
ACKNOWLEDGEMENTS
THE ILLUSTRATIONS
INTRODUCTION

1 *The Art and Affinities of Early Chalcolithic Cultures of North-West India and Baluchistan* 1

 1. Amri-Nal Ceramics, 1
 2. Quetta Pottery, 4
 3. Kulli, 7
 4. Culture of the Zhob Valley, 10
 5. Cultural Diffusion, 12

2 *The Indus Valley Civilization* 15

 1. Origins, 15
 2. Pottery, 16
 3. Seals, 27
 4. Terracotta and Sculpture, 41
 5. The Balance of Evidence, 48

3 *Post-Harappan and New Chalcolithic Traditions,*
Extensions of Harappan Culture, and the Dawn of a Historic Age 53

 1. Generalities, 53
 2. New Communities with Ancient Affinities, 54
 3. Harappan Outposts, 61
 4. Londo Ware, 64
 5. Painted Grey Ware, 65
 6. Central Indian Traditions, 68
 7. The Early Historic Age, 73

4 *Maurya Sculpture—a Cosmopolitan Art with Ancient Roots* 78

 1. Introduction, 78
 2. Pataliputra and Rock-Cut Caves, 79
 3. Asokan Monoliths, 82
 4. Further Aspects of Maurya Art, 91
 5. An Appraisal of Criticism, 99

5 *Post-Maurya Art, An Affirmation of Popular Traditions* 109

 1. Origins of the Sunga Repertoire, 109
 2. Bharhut and the Meaning of the Stupa, 111
 3. Sanchi, 124
 4. Expansion of the Bharhut-Sanchi Style, 132
 Bodhgaya, 132
 Amaravati and Jaggayapeta, 135
 Cave Temples, 138

CONCLUSION 144
APPENDICES

 A. Chronological Notes for India, 147
 B. Chronological Chart for Iran, 157
 C. Chronological Chart for Mesopotamia, 159
 D. Chronological Chart for Crete and Greece, 161

BIBLIOGRAPHY 167
INDEX 177

Illustrations

PLATES
(*between pages* 80 *and* 81)

1. Persepolis Pinnacle. From Frankfort, *Art and Architecture of the Ancient Orient*, pl. 183.
2. Coping of the Bharut Stupa. Indian Museum, Calcutta.
3. Painted Jar, Mohenjo-daro. The National Museum, Karachi.
4. Lomasa Rishi Cave Façade. Copyright, Archaeological Survey of India.
5. Sarnath Lion Capital. Indian Museum, Calcutta. Copyright, Archaeological Survey of India.
6. Sanchi Lion Capital. From Ray, *Maurya and Sunga Art*, fig. 5.
7. Sankissa Capital. Copyright, Archaeological Survey of India.
8. Rampurva Lion Capital. Indian Museum, Calcutta.
9. Rampurva Bull Capital. Indian Museum, Calcutta. Copyright, Archaeological Survey of India.
10. Campaniform Base, Persepolis. From Herzfeld, *Iran in the Ancient East*, pl. LVI.
11. Campaniform Capital Persepolis. From Herzfeld, ibid., pl. LVII.
12. Lycian Sarcophagus, c. 420-400 B.C. From Richter, *Handbook of Greek Art*, fig. 170.
13. The Dhauli Elephant. From Ray, op. cit., pl. 3.
14. Naga Canopy. Indian Museum, Calcutta.
15. Ringstone, Taxila. From Marshall, *Mohendo-daro and the Indus Valley Civilization*, pl. CLIX-9.
16. Disc, Murtaziganj. From Shere, "Stone Discs found at Murtaziganj," *Journal of the Bihar Research Society* XXXVII, 1951, pl. V, fig. 1.
17. Disc, Murtaziganj. From Shere, ibid., pl. V, fig. 5.
18. Amulet, Mohenjo-daro. From Marshall, op. cit., pl. XII-18.
19. Yakshi, Bharhut. Indian Museum, Calcutta. Photo copyright, Archaeological Survey of India.
20. Medallion, Bharhut. From Cunningham, *Stupa of Bharhut*, pl. XI.
21. Medallion, Bharhut. Indian Museum, Calcutta.
22. Medallion, Bharhut. Indian Museum, Calcutta.
23. Medallion, Bharhut. Indian Museum, Calcutta.
24. Medallion, Bharhut. Indian Museum, Calcutta.
25. Achaemenian Dish. From Ghirshman, *Persia from the Origins to Alexander*, pl. 310.
26. Achaemenian Dish. From Ghirshman, ibid., pl. 311.
27. Ringstone. From Shere, op. cit., pl. VI-4.
28. Medallion, Bharhut. From Cunningham, op. cit., pl. LVIII.
29. Medallion, Bharhut. Indian Museum, Calcutta.
30. Torana, Bharhut. From Cunningham, op. cit., pl. VI.
31. Torana Pillars, Bharhut. From Cunningham, ibid., pl. VIII.
32. Torana Block Bharhut. From Cunningham, ibid., pl. IX.
33. Ground Balustrade, Stupa II, Sanchi. From Marshall and Foucher, *The Monuments of Sanchi*, Vol. 3, pl. LXXVIII, 23 a.
34. Ground Balustrade, Stupa II, Sanchi. From Marshall and Foucher, ibid., pl. LXXXIII, 49 b.

35. Medallion, Bharhut. Indian Museum, Calcutta.
36. West Gate, Stupa I, Sanchi. From Marshall and Foucher, op. cit., Vol. 2, pl. LXVI, fig. c.
37. Ground Balustrade, Stupa II, Sanchi. From Marshall and Foucher, ibid., Vol. 3, pl. LXXXIII, 49 a.
38. Ground Balustrade, Stupa II, Sanchi. From Marshall and Foucher, ibid., Vol. 3, pl. LXXXIII, 44 c.
39. Assyrian Wall Painting. From Frankfort, op. cit., p. 74a.
40. Relief, Nimrud. From Frankfort, ibid., pl. 90.
41. Coping, Bharhut. Indian Museum, Calcutta.
42. Medallion, Bharhut. Indian Museum, Calcutta.
43. East Gate, Stupa I, Sanchi. From Marshall and Foucher, op. cit., Vol. 2, pl. XLI.
44. East Gate, Stupa I, Sanchi. From Marshall and Foucher, ibid., Vol. 2, pl. XLVI.
45. East Gate, Stupa I, Sanchi. From Marshall and Foucher, ibid., Vol. 2, pl. XLVI.
46. West Gate, Stupa I, Sanchi. From Marshall and Foucher, ibid., Vol. 2, pl. LVI.
47. Relief, Khorsabad. From Frankfort, op. cit., pl. 77.
48. Middle Assyrian Seal Impression. From Frankfort, ibid., pl. 75A.
49. Lion Griffin, Susa. From Ghirshman, op. cit., fig. 191.
50. Stupa II, Sanchi. Photo, A. L. Syed.
51. Relief, Persepolis. From Porada, *Ancient Iran*, pl. 44.
52. Coping, Bodhgaya. Indian Museum, Calcutta.
53. Early Coping, Amaravati. From Burgess, *Buddhist Stupas of Amaravati and Jaggayapeta*, pl. XXIX-2.
54. Early Coping Amaravati. From Burgess, ibid., pl. XXIX-3.
55. Outer Rail Amaravati. From Burgess, ibid., pl. XXVI-4.
56. Pillar Slab, Amaravati. From Burgess, ibid., pl. LIV-1.
57. Early Coping. Amaravati. From Burgess, ibid., pl. XXIX-1.
58. Outer Rail, Amaravati. From Burgess, ibid., pl. XXV-1.
59. Early Coping Amaravati. From Burgess, ibid., pl. XXXI-4.
60. Inner Rail, Amaravati. From Burgess, ibid., pl. XL-2.
61. Vihara, Pithalkhora. From Fergusson and Burgess, *Cave Temples of India*, pl. XVI-1.
62. Cave 3, Nasik. From Fergusson and Burgess, ibid., pl. XXII.
63. Chaitya, Bedsa. From Fergusson and Burgess, ibid., p. 229-45.
64. Chaitya, Karla. From Fergusson and Burgess, ibid., pl. XII-4.
65. Pillar, Palace of Knossos. From Hutchinson, *Prehistoric Crete*, pl. 28.
66. Relief, Persepolis. From Herzfeld, op. cit., pl. LXVIII.
67. Gudimallam Lingam. From Coomaraswamy, *History of Indian and Indonesian Art*, pl. XVIII, fig. 66.

<div align="center">TEXT FIGURES</div>

1. Ceramic Design, Amri. After Starr, *Indus Valley Painted Pottery*, fig. 12. 3
2. Ceramic Design, Samarra. After Starr, ibid., fig. 3. 3
3. Ceramic Design, Tell Halaf. After Starr, ibid., fig. 23. 3
4. Ceramic Design, Indus Valley. After Starr, ibid., fig. 11. 3
5. Ceramic Design, Amri. After Casal, *Fouilles d'Amri*, fig. 56-159. 3
6. Ceramic Design, Ur. After Perkins, *Comparative Archaeology of Early Mesopotamia*, fig. 11-21. 4
7. Amri Ceramic Design from Dam Buthi. After Starr, op. cit., fig. 11. 4
8. Amri Ceramic Design from Pandi Wahi. After Starr, ibid., fig. 42. 4
9. Amri Ceramic Design from Susa I. After Starr, ibid., fig. 44. 4
10. Ceramic Design, Nal. After Starr, ibid., fig. 46. 4
11. Seal, Mohenjo-daro. After Marshall, *Mohenjo-daro and the Indus Valley Civilization*, pl. CXIV-521. 5
12. Shell Inlay, Mohenjo-daro. After Marshall, ibid., pl. CLV-33. 5
13. Elamite Seal. After Garbini, "The Stepped Pinnacle in the Ancient Near East," *East and West*, IX, 1958, p. 89, fig. 9. 5
14. Assyrian Seal. After Frankfort, *Art and Architecture of the Ancient Orient*, fig. 24-A. 5
15. Ceramic Design, Quetta. After Fairservis, *Excavations in the Quetta Valley, West Pakistan*, fig. 371. 5
16. Ceramic Design, Quetta. After Piggott, *Prehistoric India*, fig. 3. 6
17. Ceramic Design, Quetta. After Fairservis, op. cit., fig. 375. 6
18. Ceramic Design, Jamdat Nasr Period. After Perkins, op. cit., fig. 13-35. 6
19. Ceramic Design, Jamdat Nasr Period. After Perkins, op. cit., fig. 13-47. 6
20. Ceramic Design, Crete, Early Minoan-III. After Hutchinson, *Prehistoric Crete*, fig. 27. 7
21. Ceramic Design, Crete, Early Minoan-III. After Hutchinson, ibid., fig. 27. 7
22. Ceramic Design, Crete, Middle Minoan-Ib. After Hutchinson, ibid., pl. 4a. 7
23. Ceramic Design, Honan, China. After Herzfeld, *Iran in the Ancient East*, fig. 62. 7
24. Ceramic Design, Mohenjo-daro. After Marshall, op. cit., pl. XCII-15. 7
25. Ceramic Design, Sialk. After Ghirshman, *Iran*, fig. 7. 7
26. Ceramic Design, Quetta. After Fairservis, op. cit., fig. 415. 8

27. Ceramic Design, Quetta. After Fairservis, ibid., fig. 422. — 8
28. Ceramic Design, Jamdat Nasr Pottery. After Perkins. op. cit., fig. 13-49. — 9
29. Ceramic Design, Jamdat Nasr Pottery. After Perkins, op. cit., fig. 10-52. — 9
30. Ceramic Design, Kulli. After Piggott, op. cit., fig. 7. — 9
31. Ceramic Design, Kulli. After Piggott, op. cit, fig. 6. — 9
32. Scarlet Ware Ceramic Design. After Piggott, op. cit., fig. 12. — 9
33. Scarlet Ware Ceramic Design. After Piggott, op. cit., fig. 12. — 9
34. Scarlet Ware Ceramic Design. After Piggott, op. cit., fig. 12. — 9
35. Ceramic Design, Mundigak. After Casal, *Fouilles de Mundigak*, figs. 63-156. — 10
36. Figurine, Kulli. After Piggott, op. cit., fig. 9. — 10
37. Ceramic Design, Rana Ghundai II. After Piggott, op. cit., fig. 13. — 11
38. Ceramic Design, Rana Ghundai II. After Piggott, op. cit., fig. 13. — 11
39. Ceramic Design, Sialk III. After Ghirshman, op. cit., fig. 9. — 11
40. Ceramic Design, Ninevite V Pottery. After Perkins, op. cit., figs. 19-53. — 11
41. Ceramic Design, Mohenjo-daro. After Marshall, op. cit., pl. XCII-20. — 11
42. Ceramic Design, Zhob. After Fairservis, *Archaeological Survey in the Zhob and Lorelai District, West Pakistan*, fig. 54. — 12
43. Ceramic Design, Zhob. After Fairservis, ibid., fig. 90. — 12
44. Ceramic Design, Zhob. After Ross and McCown, "A Chalcolithic Site in Northern Baluchistan," *Journal of Near Eastern Studies,* V, 1946, p. IX-4. — 12
45. Ceramic Design, Rana Ghundai. After Starr, op. cit., fig. 24. — 12
46. Ceramic Design, Samarra. After Starr, ibid., fig. 25. — 13
47. Ceramic Design, Rana Ghundai III. After Piggott, op. cit., fig. 14. — 13
48. Ceramic Design, Rana Ghundai III C. After Piggott, ibid., fig. 15. — 13
49. Ceramic Design, Tell Halaf. After Herzfeld, op. cit., fig. 106. — 13
50. Ceramic Design, Persepolis. After Herzfeld, ibid., fig. 110. — 13
51. Zhob Figurine. After Piggott, op. cit., fig. 16. — 14
52. Figurine, Ur. After Woolley, *Mesopotamia and the Middle East*, fig. 5. — 14
53. Ceramic Design, Harappa. After Vats, *Excavations at Harappa*, pl. LXIX-3. — 18
54. Ceramic Design, Tell Halaf. After Herzfeld, op. cit., fig. 156. — 19
55. Ceramic Design, Tepe Gawra. After Herzfeld, ibid., fig. 156. — 19
56. Ceramic Design, Giyan IV. After Ghirshman, op. cit., fig. 24. — 19
57. Ceramic Design, Sialk. After Starr, op. cit., fig. 88. — 19
58. Ceramic Design, Harappa. After Khan, *Fresh Sidelights on the Indus Valley and the Bronze Age Orient*, fig. I-I. — 20
59. Ceramic Design, Mohenjo-daro. After Marshall, op. cit., pl. XCI-13. — 20
60. Ceramic Design, Mohenjo-daro. After Marshall, ibid., pl. XC-22. — 20
61. Ceramic Design, Mohenjo-daro. After Marshall, ibid., pl. XC-24. — 21
62. Ceramic Design, Mohenjo-daro. After Marshall, ibid., pl. XC-23. — 21
63. Ceramic Design, Crete, Early Minoan III. After Hutchinson, op. cit., fig. 27. — 21
64. Ceramic Design, Crete, Late Minoan II. After Hutchinson, ibid., fig. 60. — 21
65. Ceramic Design, Mohenjo-daro. After Marshall, op. cit., pl. XCI-32. — 22
66. Ceramic Design, Tell Halaf. After Perkins, op. cit., fig. 2-22. — 22
66A. Ceramic Design, Ur. Ubaid I. After Perkins, ibid., fig. 11-2. — 22
67. Painted Jar, Harappa. After Piggott, op. cit., pl. 6. — 22
67A. Ceramic Design, Mohenjo-daro. After Marshall, op. cit., pl. XC-18. — 23
68. Ceramic Design, Mohenjo-daro. Mackay, *Further Excavations at Mohenjo-daro*, pl. LXIX-22. — 23
69. Ceramic Design, Mohenjo-daro. After Marshall, op. cit., pl. XCI-8. — 23
70. Ceramic Design, Mohenjo-daro. After Marshall, op. cit., pl. XC-21. — 23
71. Ceramic Design, Chanhu-daro. After Mackay, *Chanhu-daro Excavations*, pl. XXXVII-27. — 23
72. Painted Pot, Nal. Herzfeld, op. cit., fig. 54b. — 24
73. Painted Jar, Susa I. After Herzfeld, ibid., fig. 53b. — 24
74. Painted Pot, Persepolis. After Herzfeld, ibid., fig. 55. — 24
75. Painted Pot, Persepolis. After Herzfeld, ibid., fig. 52. — 24
76. Ceramic Design, Persepolis. After Herzfeld, ibid., fig. 45. — 24
77. Ceramic Design, Fars. After Herzfeld, ibid., fig. 46. — 25
78. Ceramic Design, Samarra. After Herzfeld, ibid., fig. 46. — 25
79. Ceramic Design, Samarra. After Herzfeld., ibid., fig. 46. — 25
80. Ceramic Design, Kansu, China. After Herzfeld, ibid., fig. 47. — 25
81. Ceramic Design, Halaf. After Perkins, op. cit., fig. 2-21. — 25
82. Ceramic Design, Northern Ubaid. After Perkins, ibid., fig. 5-2. — 25
83. Ceramic Design, Northern Ubaid. After Perkins, ibid., fig. 5-4. — 25
84. Ceramic Design, Ur, Ubaid I. After Perkins, ibid., fig. 11-63. — 26

85. Ceramic Design, Ninevite 5. After Perkins, ibid., fig. 19-44. 26
86. Ceramic Design, Ninevite 5. After Perkins, ibid., fig. 19-44. 26
87. Ceramic Design, Crete, Late Minoan II. After Hutchinson, op. cit., fig. 60. 26
88. Ceramic Design, Crete, Late Minoan II. After Hutchinson, ibid., fig. 60. 26
89. Ceramic Design, Mohenjo-daro. After Marshall, op. cit., pl. XCI-24. 26
90. Ceramic Design, Mohenjo-daro. After Marshall, ibid., pl. XVII-8. 27
91. Ceramic Design, Amri. After Casal. *Fouilles d'Amri*, fig. 57-162. 27
92. Ceramic Design, Mohenjo-daro. After Marshall, op. cit., pl. XCII-21. 27
93. Ceramic Design, Mohenjo-daro. After Mackay, *Further Excavations at Mohenjo-daro*, pl. LXIX-12. 27
94. Ceramic Design, Chanhu-daro. After Mackay, *Chanhu-daro Excavations*, pl. XXXII-2. 28
95. Ceramic Design, Harappa. Vats, op. cit., pl. LXIX-16. 28
96. Seal, Mohenjo-daro. After Marshall, op. cit., pl. CXIV-500. 28
97. Seal, Mohenjo-daro. After Marshall, ibid., pl. CXIV-514. 28
98. Seal. Harappa. After Vats, op. cit., pl. XCV-389. 29
99. Seal, Mohenjo-daro. After Marshall, op. cit., pl. CXIV-516. 29
100. Seal, Mohenjo-daro. After Marshall, ibid., pl. CXIV-528b. 29
101. Seal, Harappa. After Vats, op. cit., pl. XCV-388. 29
102. Seal, Harappa. After Vats, ibid., pl. XCV-391. 30
103. Seal, Harappa. After Vats, ibid., pl. XCV-393. 30
104. Button, Tepe Hissar. After Herzfeld, op. cit., fig. 5. 30
105. Button, North Syria. After Herzfeld, ibid., fig. 7. 30
106. Button, Chagar Bazar. After Herzfeld, ibid., fig. 6. 30
107. Seal, Mohenjo-daro. After Mackay, *Further Excavations at Mohenjo-daro*, pl. LXXXVI-156. 31
108. Seal, Quetta. After Fairservis, *Excavations in the Quetta Valley, West Pakistan*, fig. 23 a. 31
109. Seal, Quetta. After Fairservis, ibid., fig. 23b. 31
110. Seal, Harappa. After Vats, op. cit., pl. XCI-255. 31
111. Seal, Harappa. After Vats, ibid., pl. XCI-255. 32
112. Sealing, Mohenjo-daro. After Marshall, op. cit., pl. CXVI-5. 32
113. Sealing, Mohenjo-daro. After Marshall, ibid., pl. CXVIII-11. 32
114. Sealing, Harappa. After Vats, op. cit., pl. XCIII-303. 32
115. Sealing, Mohenjo-daro. After Marshall, op. cit., pl. XII-12. 32
116. Sealing, Mohenjo-daro. After Marshall, ibid., pl. XII-12. 32
117. Seal, Mohenjo-daro. National Museum, New Delhi. 33
118. Sealing, Harappa. After Vats, op. cit., pl. XCIII-325. 33
119. Sealing, Harappa. After Vats, ibid., pl. XCIV-332. 33
120. Copper Tablet, Mohenjo-daro. After Marshall, op. cit., pl. CXVIII-5. 33
121. Amulet, Mohenjo-daro. After Marshall, ibid., pl. CXVIII-10. 34
122. Terracotta, Harappa. After Vats, op. cit., pl. LXIX-88. 34
123. Copper Tablet, Mohenjo-daro. After Marshall, op. cit., pl. CXVII-3. 34
124. Seal Impressions, Iran. After Pope, *A Survey of Persian Art*, fig. 70B. 34
125. Seal, Mesopotamia, Sargonid Period. After Frankfort, *Cylinder Seals*, pl. XIC. 35
126. Seal, Mohenjo-daro. National Museum, New Delhi. 35
127. Seal, Mohenjo-daro. After Marshall, op. cit., pl. CXI-357. 35
128. Copper Tablet, Mohenjo-daro. After Marshall, op. cit., pl. CXVII-16. 35
129. Seal, Harappa. After Vats, op. cit., pl. XCI-249. 36
130. Seal, Mohenjo-daro. After Mackay, *Further Excavations at Mohenjo-daro*, pl. XCVIII-606. 36
131. Seal, Susa, 2nd Early Dynastic Period. After Frankfort, *Cylinder Seals*, pl. XII-b. 36
132. Seal, Mohenjo-daro. After Marshall, op. cit., pl. CXII-383. 36
133. Seal, Mohenjo-daro. After Marshall, ibid., pl. XIII-25. 37
134. Seal, Mohenjo-daro. After Marshall, ibid., pl. CXII-386. 37
135. Seal, Mohenjo-daro. After Marshall, ibid., pl. CXII-382. 37
136. Seal, Mohenjo-daro. National Museum, New Delhi. 38
137. Seal, Mesopotamia, 3rd Early Dynastic Period. After Frankfort, *Cylinder Seals*, pl. XIVe. 38
138. Seal, Mohenjo-daro. After Marshall, op. cit., pl. CXIV-527. 38
139. Seal, Mohenjo-daro. After Marshall, ibid., pl. CIII-16. 38
140. Seal, Mohenjo-daro. After Marshall, ibid., pl. CIV-38. 39
141. Seal, Mohenjo-daro. After Marshall, ibid., pl. CXI-337. 39
142. Seal, Mohenjo-daro. After Marshall, ibid., pl. CXII-373. 39
143. Indian Seal from Tell Asmar. After Frankfort, *Cylinder Seals*, fig. 108. 40
144. Terracotta Figurine, Mohenjo-daro. After Marshall, op. cit., pl. XCIV-14. 42
145. Terracotta Figurine, Harappa. After Vats, op. cit., pl. LXXVII-39. 43

146. Figure, Tello. After Van Buren, *Clay Figurines of Babylon and Assyria*, fig. 110. 43
147. Terracotta Figurine, Mohenjo-daro. After Mackay, *Further Excavations at Mohenjo-daro*, pl. LXXII-7. 44
148. Terracotta Figurine, Mohenjo-daro. After Mackay, ibid., pl. LXXII-4. 44
149. Terracotta Figurine, Mohenjo-daro. National Museum, New Delhi. 44
150. Terracotta Figurine, Mohenjo-daro. After Marshall, op. cit., pl. XCV-26. 45
151. Terracotta Figurine, Mohenjo-daro. After Mackay, *Further Excavations at Mohenjo-daro*, pl. LXXV-13. 45
152. Terracotta, Mohenjo-daro. After Mackay, ibid., pl. LXXVII-8. 45
153. Terracotta, Mohenjo-daro. After Mackay, ibid., pl. LXXI-28. 45
154. Statuette, Mohenjo-daro. National Museum, New Delhi. 46
155. Pedestal, Mohenjo-daro. After Mackay, *Further Excavations at Mohenjo-daro*, pl. CLV-26. 47
156. Statuette, Harappa. National Museum, New Delhi. 47
157. Statuette, Harappa. National Museum, New Delhi. 47
158. Fragmentary Figurine, Quetta. After Fairservis, *Excavations in the Quetta Valley, West Pakistan*, fig. 17b. 48
159. Fragmentary Figurine, Quetta. After Fairservis, ibid., fig. 17c. 48
160. Bronze Figurine, Mohenjo-daro. National Museum, New Delhi. 48
161. Painted Pottery, Cemetery H Style, Harappa. After Vats, op. cit., pl. LXIX-18. 55
162. Painted Pottery, Samarra. After Herzfeld, op. cit., fig. 36. 55
163. Painted Pottery, Chashma Ali, Tepe Hissar Culture. After Herzfeld, ibid., fig. 195. 55
164. Painted Bowl, Persepolis. After Herzfeld, ibid., pl. VIII. 55
165. Painted Pottery, Cemetery, H, Harappa. After Vats, op. cit., pl. LXII-2. 56
166. Painted Jar, Tepe Giyan. After Herzfeld, op. cit., pl. XX. 56
167. Ceramic Design, Cemetery H, Harappa. After Vats, op. cit., pl. LXIII-18. 56
168. Ceramic Design, Cemetery H, Harappa. After Vats, ibid., pl. LXIV-17. 57
169. Ceramic Design, Cemetery H, Harappa. After Vats, ibid., pl. LXII-11. 57
170. Design on Assyrian Royal Tunic. After Frankfort, *Art and Architecture of the Ancient Orient*, fig. 41. 57
171. Ceramic Design, Cemetery H, Harappa. After Vats, op. cit., pl. LXII-4. 57
172. Painted Pottery, Cemetery H, Harappa. After Vats, ibid., pl. LXII-1b. 57
173. Button Seal, Persepolis. After Herzfeld, op. cit., pl. 1. 58
174. Button Seal, Chagar Bazar. After Herzfeld, ibid., fig. 6. 58
175. Seal, Harappa. After Vats, op. cit., pl. XCV-377. 58
176. Seal, Harappa. After Vats, ibid., pl. XCI-257. 58
177. Seal, Jhukar Level, Chanhu-daro. After Herzfeld, op. cit., fig. 134. 58
178. Seal, Jhukar Level. Chanhu-daro. After Mackay, *Chanhu-daro Excavations*, pl. XLIX-2. 59
179. Button Seal, Tepe Giyan. After Herzfeld, op. cit., fig. 129. 59
180. Button Seal, Sialk. After Ghirshman, *Iran*, fig. 14. 59
181. Seal, Jhukar Level, Chanhu-daro. After Mackay, *Chanhu-daro Excavations*, pl. L-4. 59
182. Seal, Jhukar Level, Chanhu-daro. After Mackay, ibid., pl. L-1a. 60
183. Seal, Jhukar Level, Chanhu-daro. After Mackay, ibid., pl. L-1. 60
184. Seal, Tell Asmar. After Herzfeld, op. cit., fig. 133. 60
185. Painted Bowl, Rana Ghundai IV. After Ross and McCown, op. cit., fig. 5. 60
186. Ceramic Design, Susa 1. After Herzfeld, op. cit., fig. 23. 61
187. Ceramic Design, Susa 1. After Herzfeld, op. cit. ibid., fig. 23. 61
188. Ceramic Design, Persepolis. After Herzfeld, ibid., fig. 21. 61
189. Ceramic Design, Tell-i-Regi. After Herzfeld, ibid., fig. 24. 61
190. Ceramic Design, Shahi Tump. After Herzfeld, ibid., fig. 92. 62
191. Bowl Design, Shahi Tump. National Museum, New Delhi. 62
192. Seal, Shahi Tump. National Museum, New Delhi, fig. 26. 62
193. Seal, Shahi Tump. National Museum, New Delhi, fig. 26. 62
194. Painted Pottery, Lothal. After Rao, "Further Excavations at Lothal," *Lalit Kala*, XI, 1962, p. 26, fig. 1. 63
195. Painted Pottery, Lothal. After Rao, ibid., pl. XII, fig. 36. 63
196. Painted Pottery, Lothal. After Rao, ibid., p. 26, fig. 4. 63
197. Painted Pottery Susa II. After Herzfeld, op. cit., fig. 151. 63
198. Seals, Bahrein. After Bibby, "The Ancient Indian Style Seals from Bahrein," *Antiquity*, XXXII, 1958, pl. XXVII-f & j. 64
199. Londo Ware. After de Cardi, "A New Prehistoric Ware from Baluchistan," *Iraq*, XIII, 1951, p. 68, figs. 1-2. 64
200. Londo Ware. After de Cardi, ibid., p. 68, figs. 1-7. 64
201. Londo Ware. After de Cardi, ibid., p. 68, figs. 1-1. 64
202. Painted Grey Ware Design, Hastinapura. After Lal, "Excavation at Hastinapura and other Explorations in the Upper Ganga and Sutlej Basins," *Ancient India*, X & XI, 1954-55, pl. LXXIII-A. 67
203. Painted Grey Ware Design. After Lal, ibid., p. 41, fig. 9-62. 67
204. Painted Grey Ware Design. After Lal, ibid., p. 43, fig. 10-64. 67
205. Painted Grey Ware Design. After Lal, ibid., p. 43, fig. 10-70. 67

206. Painted Grey Ware Design, Ahichhatra. After Lal, ibid., p. 142, fig. 37-1. 68
207. Painted Grey Ware Design, Ahichhatra. After Lal, ibid., p. 142, fig. 37-2. 68
208. Painted Grey Ware Design, Ahichhatra. After Lal, ibid., pl. 142, fig. 37-5. 68
209. Painted Grey Ware Design, Panipat. After Lal, ibid., p. 142, fig. 37-7. 68
210. Painted Grey Ware Design, Panipat. After Lal, ibid., pl. LXXIII-B. 68
211. Painted Grey Ware Design, Panipat. After Lal, ibid., p. 142, fig. 37-9. 69
212. Anthropomorphic Figure, Copper Hoard, Bisauli. After Lal, "Further Copper Hoards from the Gangetic Basin. A Review of the Problem," *Ancient India*, VII, 1951, pl. V-1. 69
213. White Slipped Ceramic Design, Central India. After Sankalia, *Prehistory and Protohistory of India and Pakistan*, pl. XXII, fig. 83. 69
214. Ceramic Design, Central India. After Sankalia, ibid., pl. XXII, fig. 83. 69
215. Ceramic Design, Nevasa. After Sankalia, Deo, Ansari, and Erhardt, *From History to Prehistory at Nevasa*, fig. 107. 70
216. Ceramic Design, Nevasa. After Sankalia, Deo, Ansari and Erhardt, ibid., fig. 107. 70
217. Ceramic Design, Nevasa. After Sankalia, Deo, Ansari and Erhardt, ibid., fig. 107. 70
218. Ceramic Design, Nevasa. After Sankalia, Deo, Ansari and Erhardt, ibid., fig. 108. 70
219. Ceramic Design, Nevasa. After Sankalia, Deo, Ansari and Erhardt, ibid., fig. 108. 70
220. Painted Jar. Daimabad. After *Indian Archaeology*, 1958-59, p. 17, fig. 8. 71
221. Painted Jar, Burujird, Susa II. After Herzfeld, op. cit., fig. 158. 71
222. Ceramic Design, Navdatoli. After Sankalia, *Prehistory and Protohistory of India and Pakistan*, pl. XXIII, fig. 84. 71
223. Ceramic Design, Tekwada. After *Indian Archaeology*, 1956-57, pl. 19, fig. 8. 71
224. Ceramic Design, Nagda. After *Indian Archaeology*, 1955-56, pl. 15, fig. 5. 72
225. Ceramic Design, Nagda. Ibid., pl. 15, fig. 5. 72
226. Ceramic Design, Nagda. Ibid., pl. 15, fig. 5. 72
227. Ceramic Design, Nagda. Ibid., pl. 15, fig. 5. 72
228. Capital, Pataliputra. After Waddell, *Report on Excavations at Pataliputra*, pl. 11. 81
229. Column Type, Persepolis Apadana. After Herzfeld, op. cit., pl. LVIII. 81
230. Column Type, Persepolis Apadana. After Herzfeld, op. cit., pl. LVIII. 81
231. Wooden Column, Qumm. Modern. After Herzfeld, op. cit., fig. 322. 82
232. Wooden Column, Sabzawar. Modern. After Herzfeld, op. cit., fig. 322. 82
233. Wooden Column, Taq-i-Bustan. After Herzfeld, op. cit., fig. 322. 82
234. Vaisali Lion Capital. After Ray, *Maurya and Sunga Art*, fig. 1. 83
235. Lauriya Nandangarh Capital. After Ray, ibid., fig. 2. 83
236. Achaemenid Campariform base. After Pope, (ed.). *A Survey of Persian Art*. 85
237. Ivory Inlay, Nimrud, Assyria. After Frankfort, *Art and Architecture of the Ancient Orient*, fig. 39. 89
238. Greek Grave Stela. After Richter, *Handbook of Greek Art*, fig. 101. 89
239. Gold Rhyton, Hamadan. After Ghirshman, *Persia from the Origins to Alexander*, fig. 290. 89
240. Masarh Lion. Patna Museum, Patna. 92
241. Griffin, Pataliputra. After Piggott, "Throne Fragments from Pataliputra," *Ancient India*, IV, 1947-48, p. 102, fig. 5-1. 92
242. Persian Bronze Leg. probably Achaemenid. After Piggott, ibid., p. 102, fig. 5-5. 93
243. Ringstone, Mohenjo-daro. After Marshall, op. cit., pl. XIII-11. 94
244. Sherd, Charsada. After Wheeler, *Charsada*, pl. XIX. 98
245. Ceramic Design, Prehistoric Period, Iran. After Herzfeld, op. cit., fig. 59 C. 98
246. Figurine, Susa. After Pope, op. cit., pl. 74, fig. B. 98
247. Early Mediterranean Figurine. After Gangoly and Goswami, *Indian Terracotta Art*, p. 6, b. 99
248. Elamite Figurine. After Gangoly and Goswami, ibid., pl. opp. p. 8. 99
249. Figurine, Mohenjo-daro. After Gangoly and Goswami, ibid., p. 6, c. 99
250. Figurine Typical of North-West India. After Gangoly and Goswami, ibid., p. 6, e. 100
251. Terracotta Figurine, c. 250-100 B.C. After Wheeler, *Charsada*, pl. XXI-2. 100
252. Terracotta Figurine, c. 250-100 B.C. After Wheeler, ibid. pl. XXII-3. 100
253. Terracotta Figurine, c. 250-100 B. C. After Wheeler, ibid., pl. XXIII-12. 100
254. Plaque, Lauriya Nandangarh. After Gangoly and Goswami, op. cit., p. 6, d. 101
255. Phoenecian Structure, Amri. After Ackerman, "West Asiatic Ancestors of the Anda," *Marg*, V, p. 29, fig. 7. 112
256. Terracotta Stupa, Nasik. After Sankalia and Deo, *Report on the Excavations at Nasik and Jorwe 1950-51*, pl. XXIII-2. 112
257. Terracotta Stupa, Nasik. After Sankalia and Deo, ibid., pl. XXIII-3. 112
258. Domed Hut. After Benisti, "Etude sur le stupa dans 1 'Inde ancienne," *Bulletin de L'Ecole Francaise d'Extreme Orient*, L, facs. I, 1960, p. 43, fig. 1. 113
259. Stupa Depicted on East Gate of Sanchi Stupa I. After Benisti, ibid., p. 43, fig. 2. 113
260. Ceramic Design, Susa I. After Herzfeld, op. cit., fig. 23. 117
261. Seal or Amulet, Tepe Giyan. After Herzfeld, ibid., pl. XVI. 117
262. Seal Jamdat Nasr Period. After Herzfeld, ibid., fig. 72. 117
263. Seal, Tell Bashir, North Syria. After Herzfeld, ibid., fig. 138. 117

264. Button Seal, Tepe Giyan. After Herzfeld, ibid., fig. 5. 117
265. Medallion, Bharhut. After Cunningham, op. cit., pl. XXXVI-5. 118
266. Coping, Bharhut. After Combaz, *L'Inde et L'Orient Classique*, pl. 16. 119
267. Stepped Pinnacle, Susa. After Combaz, ibid., pl. 13. 120
268. Stepped Pinnacle, Mesopotamia. After Combaz, ibid., pl. 13. 120
269. Sumerian Solar Symbol. After Herzfeld, op. cit., fig. 80. 122
270. Inlay on Assyrian Harp Box. After Frankfort, *Art and Architecture of the Ancient Orient*, pl. 38. 127
271. Persepolitan Capital. After Porada, *Ancient Iran*, fig. 79. 127
272. Monster, Mohenjo-daro. After Marshall, op. cit., pl. XCVII-23. 127
273. Necklace of Symbols Depicted on Stupa I, North Gate. After Maisey, *Sanchi and Its Remains*, pl. XXXIX-15. 128
274. Necklace of Symbols Depicted on Stupa I, North Gate. After Maisey, ibid., pl. XXXIX-16. 128
275. Necklace of Symbols, Assyria. After Maisey, ibid., pl. XL-1. 128
276. Harappan Seal. After Combaz, op. cit., pl. 73. 135
277. Mesopotamian Motif. After Combaz, ibid., pl. 73. 135
278. Medallion, Bodhgaya. After Agrawala, *Indian Art*, pl. XXXI, fig. 94b. 135
279. Bhaja Vihara. After Fergusson and Burgess, *Cave Temples of India*, pl. XCVI-2. 140
280. Pilaster, Pitalkhora, Near Cave 4. After Deshpande, "The Rock Cut Caves of Pitalkhora in the Deccan," *Ancient India*, XV, 1959, pl. LXA. 140
281. Bodhgaya Relief. After Agrawala, op. cit., pl. XXX, fig. 87B. 140
282. Bhaja Vihara. After Burgess, *Buddhist Cave Temples and Their Inscriptions*, p. 5-2. 141
283. Kanheri Chaitya. After Burgess, ibid., pl. XLI. 141
284. Development of Column Capital. After Brown, *Indian Architecture* (Vol. 1), pl. IX. 141
285. Terracotta, Indo-Greek Stratum, Sar Dheri. After Gordon, "Early Indian Terracottas," *Journal of the Indian Society of Oriental Art*, IX, 1943, p. 183, fig. 2. 143
286. Terracotta Figurine, Turang Tepe. After Porada, op. cit., fig. 18. 143

MAPS

1. Map of Ancient Cultural sites in Western Asia. After Porada, *Ancient Iran*. 164
2. Map Showing the Sites of Ancient Indian Cultures. After Banerjee, *The Iron Age in India*. 165
3. Map of Buddhist Sites in India. From *Archaeological Remains, Monuments, and Museums*, 1964 (Archaeological Survey of India). 166

Introduction

As suggested by the title, this study is a review of early Indian art in relationship with the art of Western Asia. Although many of the questions which are dealt with from this viewpoint may have been appraised before, there have not been any studies which consider the question of affinities as a point of departure and thus evaluate these affinities in a continuous manner.

Continuity is an essential factor in understanding the interrelationship between Indian and Western traditions. The position of Indian art vis-à-vis Western Asia in any period is entirely linked with the contacts it experienced in preceding periods. For this reason many opinions which have been expressed regarding an indebtedness of Indian forms to Occidental prototypes to some extent miss the mark. Also significant in the assessment of artistic traditions and of equivalent artistic motifs in West Asian and Indian repertoires, is the symbolic character of these motifs.

Thus, essentially this work is a re-evaluation of early Indian art motifs in the light of preceding and contemporary Occidental traditions. Especially in the protohistoric period this re-evaluation inevitably leads to a re-assessment of historical conclusions regarding the sources of Indian cultures and their connections with cultures further West.

To a large extent the role of Western "influence" in Indian Art has been controversial. As a result, the views expressed here are sometime a reiteration of views that have been put forth by art historians. However, this is coincidental. All of the suggestions proposed in this study have been arrived at independently. On the other hand, these same views occasionally turn out to be in disagreement with the opinions of some critics or scholars. Once again, this disagreement was not anticipated.

The prime consideration in this analysis of Indian art—with particular reference to parallels—has been the understanding of motifs and their probable meanings. By and large art motifs or symbols have permanent values which supersede the cultural context in which they appear.

Although this work is based upon extensive and widespread material and recent data has been as far as possible incorporated, it has not been proposed to exhaust all available sources nor to uncover obscure elements. Rather, this extensive evidence is considered as a whole in order to determine the fundamental meaning of recurrent forms and tendencies. Most of our interpretations are based upon elements that appear over and over again in a variety of contexts. It is this very recurrence that is shown to be significant. Thus many references are to fairly standard works and to highlights in Indian and West Asian art.

It must be pointed out that although Indian elements are reviewed in relationship with Western forms, this study is of Indian and not of Western traditions. Therefore, research in Indian material has been more exhaustive. As it is impossible to fully cover and sort out all the available material on relevant Occidental art, references are confined to outstanding works in the latter field. The wide scope of this work is a consequence of its basic intention to present an evaluation of early Indian art which takes into account origins and affinities and treats these determinant features as continuous rather than as pertinent only to certain periods or schools. Thus, although the examples discussed in the following pages proceed from sources far apart in space and time, the links between them are clear. These links form the nucleus of this work. From this viewpoint it is hoped that the material covered will prove to be coherent and selective.

This work begins with an appraisal of the art and symbols used by protohistoric potters and concludes with an evaluation of the Bharhut-Sanchi tradition—which, in a sense marks the rebirth of Indian sculpture and anticipates its culmination. Classical Indian art or culture may be said to represent a synthesis of protohistoric and Vedic traditions and this synthesis seems to be visibly achieved or anticipated for the first time at Bharhut.

A large portion of the research carried out here has been based on reliable secondary sources. An extensive bibliography lists these sources. In view of the unusually broad scope encompassed by this research, it seemed necessary to base interpretations upon established and assimilated evidence. When possible, original works and monuments in Museums were examined and photographed. Other illustrations have been reproduced from published sources.

It is hoped that notwithstanding the large number of existing studies on different aspects of Indian art, archaeology, and history, this current work will be of value and cast new light upon the meaning of many elements in Indian art and the fundamental connection which unites artistic symbols spread over miles and millennia. The salient conclusion suggested is that many Indian and Occidental art motifs are the product of an ancient and common tradition which has tenaciously survived for thousands of years. While this point is not entirely novel and has been intimated in many criticisms, here it is demonstrated clearly with many widespread examples. On the other hand there is relatively little specific evidence which points to the fact that Western art altered the course of Indian forms within the periods under consideration.

As regards terminology, a fairly fluid system is followed in the interest of readability. Certain terms as Harappan and Indus Valley Civilization or Culture, proto-historic and bronze age or chalcolithic, Western Asia and Mesopotamia etc. are used interchangeably though they have somewhat different connotations. However, on the whole we have tried to preserve accuracy in this respect and to avoid any incorrect expressions. As a guide for the Proto-historic periods we may refer to Sankalia's *Prehistory and Protohistory in India*. Sankalia points out that the terms "Bronze Age" and "Civilization" may be properly applied only to the Indus Valley Civilization proper and its extensions.

References to India, comprising Baluchistan, are inclusive of the regions incorporated in present day Pakistan.

This study is founded entirely upon artistic evidence. Interpretations are independent of literary or religious meanings which were wrought around the ancient and permanent values of the motifs and symbols discussed. The more specific and variable connotations with which later religions endowed ancient formulae did not alter their original and permanent significance. Thus, although this work does not make any reference to legendary or iconographic texts, there is no inherent conflict between our interpretations and any interpretations which may be derived from written material.

The consideration that Indian Art reveals affinities with Western traditions has no bearing upon its essential originality. From earliest known times India has had her own identity, all the more striking in view of the diversity pervading it. Many ethnic combinations, traditions, languages, and political divisions have constituted "India," yet India is and always was a distinct unity with its own ideals and culture. In the first century A.D.—when she was divided into fighting states—Arrian commented in his *Indica*: "On the other hand, a sense of justice, they say,

prevented any king from attempting conquest beyond the limit of India."[1] As there has existed for centuries a definite political and geographical India, so India's art has always represented its thoughts, philosophy, and traditions. Whatever the affiliations of this art, there can be no serious doubt cast upon the essential Indianness of its themes, purposes, or style.

As this is not an analysis or criticism of style, it is beyond our scope to evaluate the features constituting the permanent essence of Indian art. A few of these features are summarized by Iyer: narration by detailed re- petition, size determined by importance of figures, flying suggested by attitudes not wings, human and divine figures portrayed in the same way, veins and bones not visible, grace and rhythmic sweep, virility and feminity stressed, ornamentation essential in both figures and inanimate objects, filling of all available space with no provision for voids, sculpture is conceptual, materials used are not denatured or concealed, quality of serenity pervades all figures—expression of detached tranquility even in the dancing Shiva.[2] All of these elements can be understood in the light of Indian symbolism and philosophic aesthetic attitudes.

Without considering Indian religions and philosophy as a foundation, no genuine evaluation can be made of the basic character of Indian art. As phrased by Zimmer: "Indian symbols of art voice the same truth as Indian philosophy and myth."[3] Actually this is true of any art.

For example, we cannot but be surprised by the erotic sculpture in Indian temples unless we understand that worldiness and spirituality are complementary not antagonistic in Indian thought which aims at achieving a synthesis of the dualities of life. In the same way, Indian life and art, the religious and the secular, are not sepa- rate entities.

In view of the intentions and limitations of this study, a simple assertion of the originality of Indian art will have to suffice. Stella Kramrisch states: "There is something so strong and at the same time so unique in Indian works of art, that its "Indianness" is felt first of all, and what it is, is seen only on second thought..."[4]

None the less, in order to determine when and from where some of the different features comprising early Indian art enter the scene, we will try to isolate elements within Indian art which have foreign parallels and to determine whether these elements are transient or permanent.

The nature of these parallels will also be studied in order to understand whether they are cognates of a common culture, the result of foreign contacts, or simply coincidental. Our interest in these questions lies in the light they throw upon the larger issue of India's long term cultural relationship with the West. The inherent value and originality of Indian art are neither verified nor challenged here, but accepted as an affirmed premise.

[1] R. C. Majumdar, *Classical Accounts of India* (Calcutta, 1960), p. 23.
[2] Bharatha K. Iyer, *Indian Art: A Short Introduction*, (Bombay, 1958), p. 38.
[3] Heinrich Zimmer, *Myths and Symbols in Indian Art and Civilization*, (New York, 1946), p. 195.
[4] Stella Kramrisch, *Indian Sculpture*, (Calcutta, 1933), p. xi.

The Art and Affinities of Early Chalcolithic Cultures in North-West India and Baluchistan

1. AMRI-NAL CERAMICS

THE KNOWN history of art in India begins essentially with painted pottery. These pots, the early artistic efforts of a community, are already surrounded by a tradition which perhaps we can call a symbolism, be it conscious or unconscious—and this tradition or symbolism is remarkable because it survives for millennia.

With this painted pottery of the earliest known agricultural communities of India we become introduced to an issue which becomes a refrain in later artistic and cultural history. The issue is that of origins—from where do these earliest impulses arise? This question is a leading one and it leads naturally to possible prototypes of outstanding motifs. Often the potential prototypes are found in regions to the west of India, and yet, the parentage is a dubious one. Similar motifs cannot be treated as the same motifs. Parallels may be coincidental or the result of commerce. And even if a relationship is postulated, chronological priority, though significant, is not a final criterion for determining which is the parent motif and which the off-spring. As a literature can be part of a people for centuries before it takes on a final written form, so an artistic tradition may exist in a culture long before it is expressed and what material ultimately reaches archaeologists is only a sampling. There is always a chance that new excavations will upset the chronological scheme.

Here we will examine those motifs in Indian art which have counterparts in art further west. The scope of this investigation will take us from proto-historic art to early Buddhist art—from one beginning to another beginning. Through several millennia we will find that the thread of continuity is not lost. Rather this thread may suggest significant generalities and conclusions bearing upon the sources of the impulses that led to the creation of Indian art. A group of art motifs is symbolic of a culture: it constitutes a picture of a community. There seems to be no doubt that the source of an artistic impulse is the same as the root source of the culture that has

1

produced it. So indirectly our thread may suggest some conclusions bearing upon Indian origins.

India's earliest known agricultural communities have revealed themselves in the mountains and deserts of Baluchistan and Sind, areas which can be shown to have significant links with early cultures of regions to the west. It is equally significant that recent excavations have come up with evidence suggesting that these agricultural cultures shared certain elements with the Harappan Civilization. The question of whether these two facts put together may be taken to imply Western origins for the Harappan Civilization will be postponed for a later section of this study.

In this work we will evaluate in each section Indian art motifs and patterns which are comparable with similar motifs in West Asian complexes. On the basis of this comparative examination we may be able to draw some conclusions or suggest generalities regarding sources, movements, and continuity.

The first group of patterns will be those of the Amri culture, named after the site of Amri in Sind, and to an extent related with the Nal style of Baluchistan. Recent excavations at Amri have been conducted by the French Archaeological Mission.[1] These excavations have disclosed four periods. Period I represents the Amri culture and reveals an evolved and refined ceramic. This pottery has a buff or pinkish paste and the outstanding designs are panels framed in multiple lines and sometimes filled with checkers, bands of diamonds, chevrons, loops, and scale patterns. The use of red or ochre paint as a secondary colour is distinctive. Period II is an intermediate one of Harappan infiltration, and Period III represents the typical Harappan culture and, in the last phase, Jhukar elements. The Amri Harappan style reveals close correspondences with the pottery of Mohenjo-daro, Harappa, Chanhu-daro and even Lothal. Amri shares with Chanhu-daro a predilection for peacocks. The fourth occupation is of the Jhangar people.

Apart from ceramics, Amri yielded little material, a circumstance perhaps attributable to climatic conditions under which metals and other substances have been destroyed.

Closely connected with the Amri pottery is that of the Kot Diji culture which is believed to have begun more or less contemporaneously with Amri.[2] A comparison of the Amri and Kot Diji traditions has suggested that the two shared a common local background. However, at Amri strong influences from Baluchistan are superimposed, whereas Kot Diji evolved further, removed from these currents.[3]

The Amri excavations have suggested that this culture in its initial stages was inspired by Western traditions as its earliest ceramic repertoire revealed parallels with Susa, Musyan, and Jamdat Nasr. However, more specifically, nothing has been concluded regarding the exact origins of the earliest Amri settlers.

Gordon has pointed out the fact that the earliest known wares of Sind and Baluchistan were crude and handmade—and that it is reasonable to assume that wheel thrown pottery came from the West where these traditions had greater antiquity.[4] Although not demonstrable, he proposes that potters may have made their way to Baluchistan via Khandahar.

This suggestion is based upon a controversial point in the history of art, the

[1] *Pakistan Archaeology*, I, 1964, pp. 57-65; Casal, "Rapport Provisoire sur less Fouille exécutées a Amri, Pakistan," *Arts Asiatique*, VIII, 1961, facs. 1; Casal, *Fouilles d'Amri*, 1964.

[2] J. M. Casal, op. cit., 1964, p. 55.

[3] Casal, ibid., p. 55.

[4] D. H. Gordon, "The Pottery Industries of the Indo Iranian Border," *Ancient India*, X and XI, 1954-55.

premises that a precedent for a motif or a technique in one region implies a direct relationship between it and a similar and later motif or technique. The question of the extent to which any early expression can be taken as a prototype for later similar expressions in another region perpetuates itself through art history. More specifically we will find ourselves confronted with this question throughout this work. The interpretation of this problem bears upon the entire interpretation of early Indian art and culture.

In the ceramic traditions of North-West India, elements are repeatedly encountered which can be referred to earlier Occidental antecedents, but which cannot be specifically linked with them.

Fig. 1

If the Amri excavations have not disclosed any precise source of North-West Indian chalcolithic cultures, neither have they elucidated the question of Harappan origins. The discovery at Amri and at Kot Diji of a Harappan complex succeeding the local ones, suggested a possibility that the Indus Valley Civilization might prove to be indebted to the Amri culture. However, further investigations have proved that at Kot Diji[5] and at Amri, Harappan ceramics and Harappan Culture are intrusive and have not evolved from Amri traditions.[6]

On making a general survey of Amri-Nal pottery designs we find that the majority are essentially simple combinations of lines and solids. As such the meaning of comparisons with similar lines and solids in the ceramic industries of other cultures is uncertain. Yet some correspondences are so persistent and enduring as to imply a relationship, although the degree and nature of this relationship cannot be defined.

Fig. 2

Starr analyses specific common designs as the step motif, chevrons, sigmas, and crosses.[7] In some instances we find certain extremely interesting designs which at a glance do not seem particularly similar, yet upon second thought, as shown by Starr, would suggest development based upon a common symbolism or, perhaps more accurately stated, a common stylization. For example, Starr has pointed out the loop with suspended lines. Figure 1 is from Amri and variants are seen in figures 2 and 3 from Samarra and Tell Halaf respectively. In figure 3 the representation of a man is suggested. A Harappan variation of the loop with suspended lines can be seen in figure 4.

Fig. 3

Special attention may be drawn to several equivalent patterns in view of the reappearance of some in later Indian art. Figure 5 represents a typical checker-board design on a bowl from Amri. Figure 6, a checker-board design from Ur, is more or less identical. The checker-board is not an unusual motif in Harappan pottery. Further afield, it may be mentioned that the checker-board is a common feature in Cretan architecture. It appears as an architectural ornament in frescoes in the Palace of Minos.

Fig. 4

Possibly meaningful is a similar sequence in relation with the step motif as seen in figures 7 and 8. Counterparts of the step motif occur at Western sites like Tali-i-Bakun, Sialk I and Susa I.[8] Starr's example of this motif from Susa I seen in figure 9 shows an association with a brush-like object suggestive of scenery along a river bank. Similarly, figure 10 from Nal depicting a sort of triangular step with an animal head in the background suggests an outdoor scene. However, this interpretation is lost in the Harappan version of the step design

[5] Casal, "Archéologie Pakistanaise. Les Fouilles de Kot Diji," *Arts Asiatiques*, VII, 1960, facs. I.
[6] Casal, *Fouilles d'Amri*, 1964, p. 63.
[7] R. F. S. Starr, *Indus Valley Painted Pottery*, 1941, pp. 39-42.
[8] Starr, ibid., pp. 39-42.

Fig. 5

Fig. 6

Fig. 7

Fig. 8

Fig. 9

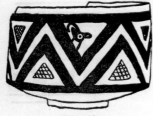

Fig. 10

which occurs on seals and inlays as for example in figures 11 and 12. It is interesting to note that a correspondence again can be seen between the step design here and its use as an architectural motif, in this case, in Assyria, Persia and India. Figure 13 shows an example of the step motif as seen on an Elamite seal, figure 14 its adoption as an architectural motif on an Assyrian seal, plate 1 its use as a pinnacle at Persepolis and plate 2, its occurrence at the Stupa of Bharhut.

The above examples have been described in order to illustrate the fact that many designs, the significance of which escapes us in the minor arts, much later often assume a more elaborate form in architecture. Of course, there is always the possibility that the similarity is a coincidental one—yet in the quest for origins we cannot overlook the presence of prototypes, however simple, within a native artistic tradition before proposing foreign inspiration.

2. QUETTA POTTERY

The culture of the Quetta Valley suggests further speculations on the early relationship of Baluchistan with Iran and Mesopotamia in general. Excavations conducted under W. A. Fairservis have provided systematic information on the sites of Kechi Beg, Karez, Damb Sadaat (Mian Ghundai), and Kili Ghul Mohammad. Fairservis' finds led him to the tentative conclusion that Mesopotamian pottery designs diffused to the East—to Sind, Kalat and the Quetta Valley.[9]

An interesting trend noted by Fairservis in the Quetta Valley is related by him to a general development ultimately resulting in the Harappan Civilization. This trend is an integration of Iranian traits which later give way to Indian cultural traits in ritual, artifacts, and agriculture.[10]

The above development, if it could be conclusively demonstrated, would imply an original Western impetus behind the Quetta Culture and even behind the Indus Valley Civilization. Although the relationship between the Quetta Culture and Harappan Civilization is not defined, Indus Valley motifs, like the pipal leaf or the Brahma bull, do coexist with the Iranian ibex and antelope.[11]

The typical pottery of the Quetta Valley, which is called the "Quetta" Ware, is a buff ware with predominantly geometric motifs like opposed triangles, oval motifs, stepped motifs, zigzags, etc., painted in purplish brown or black. The design is generally confined to a panel between rows of multiple horizontal lines. This ware is dated between 2100 to 1950 B.C.[12]

In addition to the so-called Quetta Wares, numerous other plain and painted proto-historic and historic wares have been found and described by Fairservis. Some predominant designs of the Quetta pottery, as for example, the step, overlap with those of Amri-Nal, and thus can be said to share the same Western counterparts. This is to be expected and as we examine the material remains of other proto-historic and later cultures of India from the viewpoint of their relationships with Western art, it will be seen that many fundamental motifs are extremely widespread and interrelated both in space and in time.

Stuart Piggott has tabulated Quetta motifs from the point of view of their occurrence at sites in Iran.[13] The specific interest of these parallels is perhaps

[9] W. A. Fairservis, *Excavations in the Quetta Valley, West Pakistan*, 1956, p. 259.
[10] Ibid., p. 360.
[11] Ibid., p., 360.
[12] Ibid., p. 256.
[13] S. Piggott, "A New Prehistoric Ceramic from Baluchistan," *Ancient India*, III, Jan., 1947.

lessened by the fact that the motifs are essentially very simple and very widespread. Yet these same qualities enhance the general interest of the parallels as they suggest a more fundamental relationship between the ceramic industries that resorted to a similar language. It is to be expected that however simple the designs on proto-historic pots may have been, they were not without meaning. Whether this meaning was symbolic or merely a traditional artistic stylization, whether this meaning was remembered in its original form, transformed or even forgotten, the recurrence of expressions from culture to culture cannot but be significant.

The sites of Tal-i-Bakun, Susa I, Musyan, Giyan, Sialk, and Anau are noted by Piggott as providing precise parallels for Quetta motifs, including the diagonal step, chevrons, zigzag lines, opposed triangles, thin line step, diagonally divided squares, and the degenerate thin line step.

Fig. 11

Among the above mentioned designs attention may be drawn to the so-called opposed triangle motif as shown in figures 15 and 16 and a divergent form seen in figure 17. Parallels can be brought forth not only from other Indian sites and from Iran but also from random sites as far afield as Mesopotamia, Crete and even, as pointed out by Herzfeld, China.[14] Figures 18 to 23 illustrate forms of opposed triangles of the Jamdat Nasr period from Mesopotamia, from Crete, and from Honan, China. The opposed triangle motif occurs in Harappan pottery as seen, for example, in figure 24.

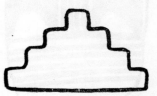

Fig. 12

These triangular designs are shown by Ghirshman in the case of pottery from Sialk to be clearly a stylization of animal designs.[15] The process of abstraction can be seen in figures 25A and B after Ghirshman. The question remains as to whether in the Quetta ware this pattern was similarly intended to represent something other than a geometric design, as geometric motifs decidedly dominate the Quetta repertoire.

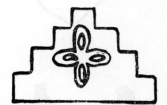

Fig. 13

In Minoan Crete the opposed triangle design lends itself to two interpretations. Figure 21 is again clearly a stylized animal. Figure 22 however is more apt to represent the double axe which was an important element in the Minoan religion. Figure 20 could be either.

From the above examples, which are by no means exhaustive, it is seen that the simplest equivalent designs can be interpreted in more ways than one and that a variety of conclusions could be proposed on the basis of their recurrence in different cultures. The opposed triangle motif upon which we have chosen to dwell a bit is only one of numerous patterns that have an equally widespread distribution and similarly lend themselves to multiple interpretations. It would appear that the longevity and wide appeal of these designs is to some extent a result of their flexibility. Thus, apparently motifs or patterns can have more than one function. They can serve either symbolically or merely decoratively or both and they transform themselves to serve the artistic requirements of a community as these requirements are developed. This would seem to be the secret of their survival through the ages.

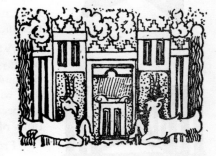

Fig. 14

An excellent example of such survival is the tree motif. Although this motif is a most basic and obvious design, its religious significance merits consideration. Throughout Indian art—indeed throughout many other arts as well—the tree has naturally been an object of great veneration in view of its obvious association with the idea of fertility. Undoubtedly, the tree's artistic appeal has also contributed to its popularity. In Quetta Ware the tree is represented summarily in two basic ways as shown in figures 26 and 27. Neither of these forms is unique. Both have equivalents,

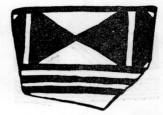

Fig. 15

[14] E. E. Herzfeld, *Iran in the Ancient East*, 1941, p. 41.
[15] R. Ghirshman, *Iran*, 1957, pp. 32-34.

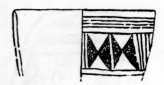

Fig. 16

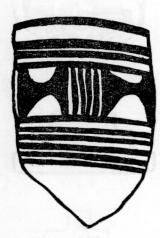

Fig. 17

Fig. 18

Fig. 19

Fig. 20

among many others, in the Ubaid repertoire as shown in figures 28 and 29. The tree is a common subject in Harappan art where its treatment—as we shall see later when dealing with art motifs of the Indus Valley Civilization—leaves no question about its role as an object of reverence.

An important aspect of these early simple representations of trees is the fact that they may be considered as prototypes for later elaborate forms like the Tree of Life, which is represented in Assyrian, Persian and early Buddhist art. In evaluating the interrelationship between these later forms, it is essential to begin at the beginning and thus to note that both the Indian and the Western examples had their own similar early prototypes. If there are any doubts about the fact that these representations survived—rather than were forgotten and re-created—they may to some extent be dispelled by a more specific example, that of the tree surrounded by a rail, depicted both in Harappan and later in Buddhist Art. In both these arts this motif is not a casual one but is fundamental and traditional. Therefore, we may consider that the tree motif, in spite of its natural simplicity and generality, constitutes a link on the one hand between Indian and Western cultures and on the other between Indian proto-historic and early Indian Buddhist cultures.

Among the designs described by Piggott and noted above is the "degenerate thin line step." Here again we are dealing with a motif which is exceedingly simple yet versatile and as such widespread. Once more its recurrence in different ceramics is significant, and yet because fundamentally our design is just a wavy line we must be cautious about basing any conclusions upon this recurrence. Piggott plausibly considers this line to be a degeneration of the step motif. However, the design simultaneously suggests two other interpretations—a river and a snake. Both these motifs, like the tree, are filled with religious meaning and as such are dominant in Indian and Western art from prehistoric to modern times. Such examples of equivalent artistic expressions could be easily multiplied. With some variation we would find that almost every Quetta design has its counterpart. And as we move on with our study of designs in Indian ceramic industries, it becomes apparent that their relationship with the repertoires of Western communities and their own interrelationships are exceedingly intricate. These relationships embrace not only parallels in basic motifs but also, as we have seen, significant parallels in their abstraction and treatment.

A final example may be considered. In our discussion of the Amri-Nal symbolism we have referred to the loop with suspended lines and its adaptation to represent the human figure. A further extension of the loop with suspended line pattern ties it in with the comb motif—also popular in Harappan ceramics—and which in turn has been interpreted by Starr[16] as a highly stylized animal. Thus we see that abstractions of originally divergent patterns can merge.

From the above material, which poses many questions, several conclusions suggest themselves. The first is that the connections in pottery motifs which we have been discussing are not to be considered insignificant, any more than similarities in linguistic expressions should be considered insignificant or historically irrelevant.

Similarities in artistic expression are most significant and the complexity of their interrelationships would appear to be representative of similarly complex interrelationships among the peoples who painted them. A second conclusion coming to mind is that on the basis of these fluidly related patterns it is difficult to pinpoint the nature of the association between the artists who created them. It is certain only that these people, although they had their own distinctive cultures and artistic

[16] Starr, op. cit., figs. 86, 87 and 88, p. 55.

traditions, were indeed in some way related. Thirdly, it becomes increasingly apparent that already in the repertoires of these early communities we meet with motifs that have a tradition behind them and that this tradition survives—in India right through to the historic period.

Returning to the question of the relationship of the Quetta Culture to Western Asia we have already referred to the view of Fairservis that its pottery reflects motifs diffused from Mesopotamia and that more specifically Quetta originally was to some degree dependent upon Iranian inspiration. A similar view was expressed earlier by Gordon: "It has been shown that there was without doubt an eastward movement of Iranian pottery motifs via Sistan and Kandahar into the Quetta-Loralai-Kalat area on its way to the Indus."[17]

A long general commentary can be made in support of these views—and perhaps some in refute; however this issue of the source of cultural impetus embraces not only the Quetta Culture but most proto-historic communities in general. The patterns and designs discussed above must be viewed as part of a more comprehensive whole before they can be of help in clarifying the nature of the relationship between India and Western Asia in the proto-historic age.

Of special interest at the site of Damb Sadaat are the finds of two fragmentary female clay figurines because their modelling brings to mind the Harappan limestone torso on the one hand and early Yakshi figures on the other hand.[18] The similarity with the Harappan torso is significant because the early date of the latter has been questioned by some scholars. The Quetta figure seems to confirm the existence of a realistic "modern" although subsidiary trend in proto-historic sculpture to which Indian sculpture of a very much later date may be related.

An interesting insight into the Quetta Culture has been provided by the British expedition to Kalat.[19] This expedition has led to the tentative conclusion that the wares of Baluchistan and Sind represented variants of a single common culture which was submerged with the advent of the Quetta folk.[20] The full implications of these finds are not as yet clear but a very early connection with Iran seems evident,[21] as well as the intrusion of new cultural or artistic patterns.

3. KULLI

The culture known as Kulli or Kulli Mehi, named after the type site of Kulli in the Kolwa region of South Baluchistan, and traced at Mehi, Shahi-Tump and at several other sites, represents the third important so called Buff Ware Culture of Baluchistan.[22] Here again there is much to be said on the basis of similarities in ceramics regarding the position of Kulli vis-à-vis Mesopotamia and Iran. However, the Kulli Culture judged from its pottery appears in a different role from the Amri-

[17] Gordon, "Sialk, Giyan, Hissar and the Indo Iranian Connections," *Man in India*, XXVII, 1947.
[18] Fairservis, op. cit., p. 226 and figs. 17b and c.
[19] Beatrice de Cardi, "British Expeditions to Kalat 1948 and 1957," *Pakistan Archaeology*, I, 1964.
[20] Ibid., p. 24.
[21] This material related to early Hissar pottery has been found at levels with Carbon 14 dates of 3300 to 2700 B. C. See *Pakistan Archaeology*, I, 1964, p. 24.
[22] The division of the prehistoric cultures of Iran and Baluchistan into the broad categories of Buff Ware and Red Ware cultures is a very schematic one. It was proposed by McCown and has been followed by Piggott. However, D. H. Gordon criticizes this scheme on the grounds that it is incomplete. Cf. Gordon, "The Pottery Industries of the Indo Iranian Border," *Ancient India*, X and XI, 1954-55, p. 176. Further recent discoveries have revealed an overlap between buff and red ware cultures. Cf. de Cardi, "New Wares and Fresh Problems from Baluchistan," *Antiquity*, XXXIII, 1959.

Fig. 21

Fig. 22

Fig. 23

Fig. 24

Fig. 25A

Fig. 25B

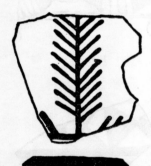

Fig. 26

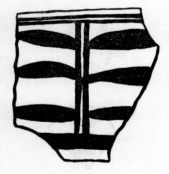

Fig. 27

Nal or Quetta complexes, both in terms of its relationship with Western Asia and its relationship with the Harappan Civilization.

Kulli painted ware by virtue of its elaborate character—as compared with Amri-Nal or Quetta Ware—can be more easily assessed in some respects. Parallels and differences in composition and details are more specific and symbols occur more as accessories than as basic motifs.

The Kulli designs are painted generally in black, although occasionally red is used—a pale red or whitish slip is common—the black on red wares being considered by Piggott as reflective of Harappan influences. The pottery itself is typically buff or pinkish.

The naturalistic scenes depicted on the Kulli pottery are stereotype. They consist of an elongated animal, occasionally felines, but generally humped cattle (apparently a cow and a bull) shown in a setting of symmetric trees and often rows of minute stylized horned animals which look like goats. Other symbols float in the background producing a crowded effect.

The symbols filling in the background of the Kulli scenes described above consist among others of triangles, rosettes, W and S shaped figures, forms of the comb motif, and circles with dots in the centres which may be considered a reiteration of the main animal's eyes. Here again then in a new setting and in a somewhat different form appear the fundamental symbols which are not unique to the Kulli Culture but are widespread in ancient civilizations and endure through later art. In figures 30 and 31 some of these symbols as they appear in the Kulli traditions can be seen. In figure 30 the triangular device above the head of the cattle would seem to have an attributive significance.

But more striking in the Kulli ceramics are parallels in the general composition and conception of the naturalistic scene with a ware of Elam and Mesopotamia which has been designated as "scarlet ware" and attributed to Early Dynastic times (c. 2800 B.C.).[23] An example of this ware can be seen in figure 32, as compared with figures 30, 31, and 33 from Kulli. A ceramic from Bampur in Persian Makran has also been considered comparable with the Kulli ware and suggestive of a possible interchange of population between the Mashkai-Kolwa region and regions further west.[24]

It has been suggested that the technique used in the Kulli painted ware originated in Iran and that its occurrence at Kulli is due to the fact that Baluchistan is geographically an eastern extension of Iran.[25]

However there is a considerable amount of evidence that the Kulli Culture was similarly within the Harappan sphere of influence. The humped bull itself is an Indian motif par excellence and furthermore it is frequently depicted tethered to an object decidedly reminiscent of the so called "cult objects" prominent in Harappan seals. The pipal leaves which contrast with examples of trees depicted schematically by lines also reflect an affinity of the Kulli with the Indus Valley Civilization.

Recently a new link has been discovered at the site of Mundigak in Afghanistan.[26] The ceramics of this site reveal in some cases a close affinity with the Kulli style.

[23] Piggott, *Prehistoric India*, 1952, pp. 115-116.
[24] Ibid., p. 105.
[25] *Pakistan Archaeology*, I, 1964 (Report published by the Peabody Museum Expedition to West Pakistan in 1955).
[26] J. M. Casal, *Fouilles de Mundigak* (Memoirs de la Délégation Archéologique Française en Afghanistan, Tome XVIII), 1961.

It is interesting to note that these similarities pertain to period IV at Mundigak (c. mid third millenium B.C.). In this epoch Mundigak is transformed from a village to an urban center, though there is no evidence of the arrival of fresh immigrants.

Fig. 28

Thus we see that in the Kulli ceramic tradition specific similarities can be traced on the one hand with pottery further west and on the other with elements of the Harappan Culture. Whether this indicates that the Kulli people had a closer relationship with these two major spheres of civilization than the people of Quetta or Amri-Nal cannot be affirmed. It may be merely the more complex nature of the Kulli painted pottery that lends itself easily for comparison with other wares. In the Kulli designs, where the naturalistic scene is omitted, the simple lines or panels and the frieze of stylized diminutive horned animals are less distinctive.

Fig. 29

However there are additional interesting indications of the fact that the Kulli community might have been a large prosperous one in commercial and consequently cultural relation both with Mesopotamia and Iran and with the contemporary Indus Valley Civilization. These indications come in the form of artistic exchanges which fall into the category of current borrowings or in the form of foreign objects, either of which speaks for trade and foreign travel. Artistic parallels that can be attributed to this type of exchange must be distinguished from parallels bespeaking a common inheritance and bearing upon origins. Piggott suggested the fact that the Kulli settlements seem to have been small peasant communities.[27] However the existence of an active commerce both with Western Asia and with the Indus Valley Civilization does imply that as yet undiscovered larger Kulli settlements may have existed in proto-historic times.

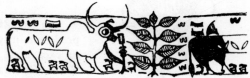

Fig. 30

Perhaps it is not so far fetched to propose that the presence of rather elaborate ceramics in itself may be indicative of a more elaborate cultural set up. As a matter of fact, recently recorded Kulli sites in Kalat were evidently large permanent settlements built of heavy stone masonry.[28] Further investigation may well reveal that sites, as for example Edith Shahr, were indeed extensive urban centres.

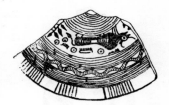

Fig. 31

A clear example of artistic borrowing is seen in figure 34 illustrating a pot found at Susa. This sort of hybrid implies a transfer of ideas which is a result of fairly direct communication. Artists, merchants, or objects from Kulli must have made their way to Susa and directly inspired the creation of designs like this. The Mundigak designs can be similarly interpreted as a product of direct contact. Figure 35 from Mundigak may be compared with figure 30 from Kulli.

Fig. 32

A group of carved soft-stone vessels typical of South Baluchistan and found at various Mesopotamian sites also constitute an interesting link.[29] These incised vessels, a group of which has been found at Mehi, and two examples in the Indus Valley, are evidence of connexions with the Harappan culture as well as with sites further west.[30]

Fig. 33

An additional very general link between the Kulli Culture and the Indus Valley as well as Mesopotamian Civilizations is the presence of a substantial number of terracotta figurines. On the other hand, the distinctive features of these Kulli baked clay objects speak of the fundamental independence of the culture that produced them. The majority of the figures were of humped cattle

Fig. 34

[27] Piggott, op. cit., p. 113.
[28] "British Expeditions to Kalat by Beatrice de Cardi in 1948 and 1957," *Pakistan Archaeology*, I, 1964, p. 28.
[29] Piggott, op. cit., p. 110.
[30] Ibid., pp. 116-117.

Fig. 35

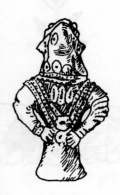

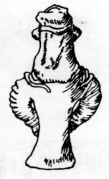

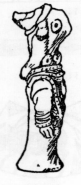

Fig. 36

painted with stripes. The female figurines, an example of which can be seen in figure 36, follow a prescribed formula indicating that the Kulli figurines are evidently connected with a mother-goddess or female goddess cult.

The widespread character of the mother-goddess cult in proto-historic and even earlier ages as well as its survival in historic and modern times is well established. There is considerable evidence of its early importance in India, in Western Asia, and Crete. As a matter of fact, more difficult to explain is its apparent lack of prominence in the Amri-Nal and Quetta complexes, and at various late Harappan sites.

The Kulli figures relate the Kulli Culture to a complex embracing broadly the whole of Western Asia, the Aegean, and the Indus Valley. E. O. James has summarized the profound antiquity, longevity and widespread influence of the mother-goddess.[31] His analysis is of special interest in that the areas in which the mother-goddess cult flourished—Western Asia, the Indus Valley, the Aegean and Crete—to a large extent coincide with the areas in which we are able to point out emparented art motifs from prehistoric to later times. Thus the Kulli figurines are a part of a widespread cult which can be traced back to the fifth millennium B.C. and which has survived in India and in the West even up to present times.

4. CULTURE OF THE ZHOB VALLEY

In the Zhob Valley in Northern Baluchistan, an area broadly classified as a predominantly red ware culture, a number of prehistoric sites have been explored or excavated. Important among them may be considered Dabar Kot, Sur Jangal, Rana Ghundai and Periano Ghundai. A survey carried out by W. A. Fairservis[32] in the Zhob Loralai districts—now in West Pakistan—has much amplified the information earlier gathered by Sir A. Stein and Ross.[33] The site of Dabar Kot may be considered a representative one. A sequence of cultural assemblages is recorded from pre-Harappan, through a Harappan occupation, and into the historic period.

A predominant ceramic distinctive of the Zhob Culture has been described as "bull" pottery by Brigadier Ross who identified it at the site of Rana Ghundai. Fairservis designates this pottery as Sur Jangal painted variant 2. This sophisticated Zhob pottery, which antedates Harappan levels, appears to be intrusive and is considered to have affinities with the painted pottery of Hissar I in Northern Persia.[34] However the stylized animal frieze is a basic, generalized, and favourite motif as well as one that lends itself easily to abstraction. Therefore, parallels may be considered representative of a common artistic outlook or background rather than indicative of direct borrowings or intrusion.

Figures 37 and 38 from Rana Ghundai depict the typical Zhob animal frieze. These designs are comparable with examples from Kulli. Figures 39 from Sialk and 40 from Northern Mesopotamia are also similar in conception and illustrate the universality of this motif. Further, the formalized animal border typifies a ware known as Togau ware identified around Kalat and attributed to a period antedating the Indus Valley Civilization.[35] An example of this motif seen in figure 41 was found

[31] E. O. James, *The Cult of the Mother Goddess*, 1959, p. 11.

[32] Fairservis, *Archaeological Survey in the Zhob and Loralai Districts, W. Pakistan*, 1959.

[33] Ross and McCown, "A Chalcolithic Site in Northern Baluchistan," *Journal of Near Eastern Studies*, V, 1946.

[34] Piggott, *Prehistoric India*, 1952, p. 129.

[35] de Cardi, "British Expeditions to Kalat," *Pakistan Archaeology*, 1, 1964. Beatrice de Cardi notes that Togau ware migrated to Sind and was discovered at Pre-Harappan levels at Amri.

at Mohenjo-daro, but is not at all typical of Harappan ceramics and might be an import.

In addition to the formalized animals, other geometric patterns in the Sur Jangal painted repertoire also show similarities with Western motifs. We meet with a familiar abstraction like the loop with suspended lines as seen in figure 42 and its variations in figures 43 and 44 which can be compared with figures 2 and 3 from Samarra and Halaf. Figure 45 from Rana Ghundai I is especially interesting and can be seen to have something in common with figures 3 and 46 from Tell Halaf and Samarra respectively. Both the Rana Ghundai and the Halaf figures would appear to be evolved from designs of loops or angularized shapes with suspended lines. Other still simpler motifs like groups of parallel lines, zigzags, scales, lozenges, etc., can to a still greater extent be related to counterparts from other ceramic repertoires.

The bull pottery evolves in the subsequent period, becoming progressively more abstract and coarse. Extremely interesting is a design shown in figure 47 from Ross's Rana Ghundai III period which reproduces the rhythm of the stylized animals—in fact, is derived from them, and yet once again can be described as a variant of the loop with suspended lines. This example, correlated with the Sialk sequence seen in figure 25 or with a Togau sequence,[36] reveals progressive stylization and substantiates the view that much geometric decoration is a development of representational motifs.

In figure 48 we see a late Zhob design which seems to be a revival or a survival of an older tradition. Both the subject and the treatment have a more ancient "feeling" about them than the designs they succeed. Our cup is decorated with two symbols—the snake and the bird, which are among the earliest and most enduring expressions of man's religious emotions. All the more convincing of their religious import is the association of these symbols with one another and possibly with the cult of the mother-goddess which in the Zhob Culture is attributable to this period. As regards the source of this design we may consider the implications of comparison with very similar early motifs from Iran. Figures 49 and 50 illustrate examples of birds in flight and the snake motif from Tell Halaf and Persepolis. In these examples both the intention and the execution of the symbols reveal an extraordinary affinity with their Zhob counterpart. Furthermore, all three examples follow a parallel system of abstraction.

This incident of kinship between Zhob and Persian pottery motifs is of particular interest in view of the fact that the Zhob example does not appear to be intrusive in its culture. Furthermore, it is considerably antedated by its Western prototypes. Thus the Zhob motif does not suggest the arrival of immigrants or a contemporary cultural exchange. Consequently, the question arises as to just how this distinctive symbolic design did emerge as a part of the Zhob repertoire. Significant is the fact that the contemporary Zhob mother goddess cult also appears to be a development new to this period; yet there is no evidence of its being an introduction from an outside culture. Consequently, it seems as if something in the cultural atmosphere of the Zhob communities stimulated the renaissance of an old fundamental tradition, a tradition constituting the common nucleus from which later West Asian and Indian proto-historic communities developed.

Supporting the above view of a cultural rebirth from within is the fact that in this period—called the Zhob Cult phase by Fairservis and coinciding with Ross's Rana Ghundai III level—there is some evidence of association with the Harappan

[36] de Cardi, "New Ware and Fresh Problems from Baluchistan," *Antiquity,* XXXIII, 1959, p. 20, fig. 3.

Fig. 37

Fig. 38

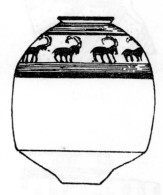

Fig. 39

Fig. 40

Fig. 41

Fig. 42

Fig. 43

Fig. 44

Fig. 45

Culture. Also, in the Quetta Valley at the contemporary site of Damb Sadaat III, a possibly religious structure was excavated in which both Harappan and Zhob elements appeared together. The general conglomeration of material has been interpreted by Fairservis as a blending of Harappan influence with the Zhob cult which was probably indigenous to Baluchistan.[37] Thus it would seem that at this time the Zhob communities enjoyed a shift in orientation either brought about by or leading to broader cultural contacts. However, the essential changes were evolved apparently from internal resources.

Figure 51, representing a typical Zhob figurine, illustrates its individualistic and unmistakable traits. Yet, as we have seen, the basic cult of which these idols are presumably representative is widespread. Even the intentional disfiguration of the figurines seems to be derived from a very old tradition. In figure 52 from Ur, attributed to the Al Ubaid period, we see an example of an equally morbid although very different goddess. The mouthless Kulli idols described earlier are similarly calculatedly disfigured.

The Zhob cult then, like the Kulli one in its essence, derives from an extremely ancient tradition, the manifestations of which have been traced to paleolithic times. According to E. O. James[38] this cult had its cradle-land in the Caspian region whence it diffused as far as India. However, its growth and its diffusion was not continuous or complete nor did this cult apparently enjoy the same prestige throughout its long history. As we have seen, and will see again, in certain areas and periods it is conspicuously and curiously absent. To conclude our evaluation of the role of the female goddess in the Zhob Culture, we may summarize by pointing out that if worship of this deity suggests a widespread and age-old parentage with other peoples also worshipping a female deity, the personality of the Zhob goddess is distinctive, attesting to the fact that the cultural complex of her followers similarly was indigenous.

5. CULTURAL DIFFUSION

In the course of this Chapter we have seen that in almost all the Baluchistan pottery industries, designs show to a greater or less extent similarities with designs typical of various early Mesopotamian and Iranian cultures. However, the nature of these similarities is such that we find it difficult to base any historical conclusions on them. And further explorations and excavations, for example at Pirak in Baluchistan or at Mundigak in Afghanistan, are revealing more and more significant and intriguing artistic links which do not make up any logical chain.[39] Very often the similarities in question are of such an elemental nature, so widespread, and so long living, as to preclude their being proof of anything. On the other hand, we have seen that these similarities are unquestionably something more than coincidental, particularly parallels in symbolism and abstraction. Herzfeld remarks regarding the recurrence of abstract early Iranian designs from Sind to China that something more than a simple "migration of symbols" is implied "because not only are the symbols the same, but their place on the vessels, their combination and sometimes the shapes of the vessels are similar. The manner in

[37] Fairservis, *Archaeological Survey in the Zhob and Loralai Districts, West Pakistan*, 1959, p. 308.

[38] James, *The Cult of the Mother Goddess*, 1959, p. 20.

[39] Cf. J. M. Casal, *Fouilles de Mundigak* (Mémoirs de la Délégation Archéologique Française en Afghanistan—tome XVII) 1961; R. L. Raikes, "A New Prehistoric Bichrome Ware from the Plains of Baluchistan (West Pakistan)," *East and West*, XIV, 1965; R. L. Raikes, "A Supplementary Note on Pirak Bichrome Ware," *East and West*, 1964-65.

which the symbols are used and the intellectual contents of the decoration are related."[40]

A further problem in the correlating of ceramic relations occurs when we discover that motifs on a ware which is not intrusive but apparently a development of the preceding local tradition—as for example, the pottery of Rana Ghundai III[41]—show a close affinity with motifs abroad. In this case the similarity cannot be directly attributed to foreign penetration, but it is more probably the exponent of an older heritage that periodically reasserts itself. This seems to have been the situation in the Zhob communities as reflected in the emergence of the mother goddess cult. This cult, as we have seen, is common to West Asian communities and of very ancient origin. However, in the Zhob, Kulli, and Harappan cultures there is no evidence that it was introduced by newcomers. Yet this is not to say that it is unrelated to the Occidental forms of a similar cult. Our view is that the Indian mother or female goddess cult is not a subsidiary of the Mesopotamian one, but rather a parallel development.

Fig. 46

Similarly in ceramics, we may suggest that if in some instances similar motifs may prove to be the result of Mesopotamian, or more directly Iranian penetration, in other instances related patterns are not indicative of recent migrations or contacts. We have reviewed in this Chapter a number of equivalent symbols or patterns met with at diverse sites in North-West India and Baluchistan on the one hand and still further west on the other. Although these patterns might have been transmitted by immigrants or infiltrators, there is no conclusive evidence of migrations or upheavels pointing toward an influx of new peoples. In fact, immigrants are not in all cases associated with new artistic elements. We may recall in this connection evidence put forth by Banerjee and others associating the Painted Grey Ware with the Aryans who now appear to have been immigrants from the West. It is most interesting to note that these immigrants apparently did not bring with them ceramic designs, but rather adopted motifs from a local repertoire.[42] Thus the presence of a new population does not always correlate with the presence of new artistic elements. We can therefore suggest that the designs discussed above, which are common to Indian and Western Asian repertoires, to a large extent are parallel developments of an older common tradition. Perhaps this tradition was not consciously remembered, but it continued to influence the artistic expressions of the people who inherited and in turn diffused its essence.

Fig. 47

Fig.48

Though many fundamental motifs and concepts represented in the chalcolithic pottery traditions of North-West India undoubtedly had precedents in Western ceramic repertoires, there is no evidence that they were always directly transmitted from West to East by influxes of people or by trade. If in some instances migration along specific routes is ultimately proven to be responsible for the appearance of Iranian designs in India, in other cases, as we have seen, significant similarities crop up quite unaccountably.

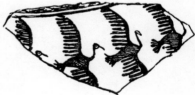

Fig. 49

For example, there is no direct evidence suggesting that a motif such as the opposed triangle which has been noted at various sites in India, Mesopotamia, Crete and even China was spread by a series of migrations. In each cultural complex this motif had its own meaning. In Iran it merged into an asbtract animal form; in Crete it occurred as a double axe and as a stylized animal. In Quetta it seems to have been a simple geometric design, and in Harappan ceramics it occurred most

[40] Herzfeld, *Iran in the Ancient East*, 1941, p. 39.
[41] Ross and McCown, "A Chalcolithic Site in Northern Baluchistan," *Journal of Near Eastern Studies*, V, 1946.
[42] Banerjee, *The Iron Age in India*, p. 102.

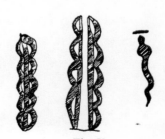

Fig. 50

Fig. 51

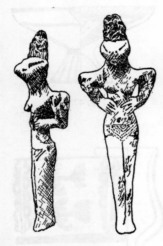

Fig. 52

typically as a border. However, parallels in the treatment of this motif—specifically as its appearance between parallel lines imply some underlying connection. It is suggested that such artistic or symbolic parallels are all the offsprings of motifs which were conceived many cultural generations earlier in a focal region and which gradually and often indirectly diffused.[43] The chronological priority of the West Asian examples indicates that the direction of diffusion probably was from the West to India rather than vice versa. However, motifs may have remained in a ceramic tradition pending expression for several periods and when they ultimately appeared or reappeared they could no longer be considered foreign. In Indian repertoires, basic symbols, patterns and designs—as for example, the so called fish scale which has evolved from loops, or the schematizations of animal forms or elaborations of simple geometric elements—may be described as related to but not immediately borrowed from motifs of foreign artistic traditions.

Viewed in this light the relationship between parallel Indian and Occidental designs becomes clear. Similarities are expected and natural even when it is not possible to trace the line of descent. In effect it can be said that there is often no line of descent but that the diffusion of artistic concepts was spread by a centrifugal movement—from a West Asian nucleus to outlying areas like India and Crete.

We have realized in this Chapter a similar characterization of parallels, together with indications that both West India and their historical antecedents are not further west in the center. Although these parallels might be a barrier, inasmuch as implications or indications, there is no implication of these designs as particularly pertaining towards an arrival of the people in fact, hungers are said to have been associated with pottery and the century. We have tried to imply that in the main evaluation pot finds by figurine and culture or indeed, the Painted Grey Ware with the Aryans who now appear to have been immigrants from the West. It is most interesting to note that these ornaments appear to did not bring with them ceramic designs, but rather adapted motifs from a local repertoire.[43] But the prevalence of a new population does not always correlate with the presence of new artistic elements.

We can therefore suggest that the designs discussed above, which are common to Indian and Western ceramic repertoires, to a large extent are partly developments of an older ceramic tradition. Perhaps this tradition was and repeatedly remembered, but it continued to influence the artistic repertoires of the peoples who inherited and in turn utilized its reserves.

The style many fundamental motifs and vocabulary replaced and replenished in the think of the pottery tradition of Northwest India indubitably had precedents in Western ceramic repertoires, there is no evidence that they were not themselves inherited from West to East by influence of people or by migration. For some interesting migration along appellation and, in ultimately, process to be responsible for the appearance of Iranian designs in India, in other instances we have seen, significant similarities crop up quite unaccountably.

For example, there is no direct evidence suggesting that a motif such as the opposed triangle, which has been noted in various areas in India, Mesopotamia, Crete and even China, was spread by a series of migrations. In each cultural complex this motif had its own tradition, in case it settled into an artistic manifestation in Crete it appeared as a double axe and also existed widely. In Chinese it seems to have been a simple geometric design, and in Harappan ceramic it received more ...

[43] This view may be correlated with Fairservis' analysis. Cf. Fairservis, *The Origins of Oriental Civilization*, 1959, p. 83. Fairservis notes two forms of cultural spread, a direct method called "actual transmission" by a bearer and an indirect method called "stimulus diffusion."

The Indus Valley Civilization

1. ORIGINS

INTRIGUING problems concerning the origins of the Indus Valley Civilization have repeatedly been appraised by archaeologists concerned with India and have been answered since the discovery of Harappa and Mohenjo-daro in various ways. Nevertheless the last word has not yet been said on the subject.

About these unanswered questions regarding the antecedents and affiliations of Harappan Civilization Piggott wrote:

"The fact is that, on present showing we must frankly confess our ignorance of the real origins of the Indus civilization, and can say no more than that in the simpler societies of Baluchistan and Sind the necessary technological level upon which a civilization could be built did in fact exist. In this civilization as we know it, we are confronted with a fait accompli, the circumstances and occasion at which the first decisive steps were taken towards its foundation still elude us. Refuge in a theory that 'ideas of civilization' were somehow prevalent in Western Asia in the fourth and third millennia B.C., and were thus responsible for the genesis of the Indus civilization, seems unrealistic and at variance with what we can infer of the emergence of civilized societies elsewhere. A frank confession of our ignorance seems the wiser course."[1]

Continuing excavations are revealing fresh material day by day but the essential question still remains a matter of interpretation. Relationships and differences in material remains as well as simplified forms suggesting a nucleus from which more complex ones may have developed constitute some evidence. But as yet this evidence is inconclusive and the beginnings of Harappan Culture still elude us. For example, Harappan forms were seen to gradually infiltrate Amri ceramics rather than develop from the former. However, even if we eventually uncover the immediate source of the Harappan cities, the fundamental issue of understanding the impulses behind the rise of such a sophisticated, distinctive and a far reaching civilization remains.

[1] G. Clark and S. Piggott, *Prehistoric Societies*, 1965, pp. 200-201. The above criticism of the view attributing Harappan Civilization to ideas which spread from the West is evidently directed at Wheeler's theory. See note 2 *infra*.

This issue cannot be specifically settled by further excavations, although the proposed explanations must be related to the material evidence these excavations reveal.

In this Chapter we will examine the evidence of art motifs from Harappan sites and attempt to evaluate the nature of their relationship with art from West Asian cultures. On the basis of these relationships we will try to understand the position of the Indus Valley cities vis-à-vis the cities of Mesopotamia.

In the preceding Chapter we put forth the view that the peasant cultures focussed in Baluchistan, from which the Harappan Civilization to some extent may have evolved or bifurcated, could be considered as localised cultures in some way related to agricultural communities further west but not necessarily their offshoots. In this light we may consider whether the Indus Valley cities may be similarly related to but not directly derived from or even inspired in their Mesopotamian counterparts.

In general, the distinctive elements of Harappan Civilization that separate it from the agricultural communities discussed in the preceding section are the elements that even today separate great cities from village settlements. This simple comparison may explain how it can be possible for an immense metropolitan civilization to emerge from small rural communities. We may recall in this connection that Mundigak was seen to have transformed itself from a rural settlement into an urban complex. The view that Harappan Civilization might have evolved from local settlements without external intervention does not imply that outside stimulus had no role in the formation of the Harappan cities and towns.[2] However, stimulus is an unending process. What is required is a favourable combination of socio-economic and intellectual factors preparing the ground for these stimuli to take root and produce an outstanding response such as is manifest in the birth and development of the Indus Valley Civilization.

2. POTTERY

Harappan painted pottery attests exactly as we would expect both to the distinctiveness of the Indus Valley artistic tradition and to some fundamental affinity with the wares of Baluchistan and cultures still further west. Harappan designs are varied both as regards subject matter and treatment—thus suggesting that they are derived from more than one cultural stream. The complexity of the Harappan ceramic tradition as a whole may be representative of the complexity of the Indus Valley Civilization itself. Much though we study the repertoire of Harappan motifs, their similarities with Western motifs, their distinctiveness, and their various internal trends, it seems impossible to completely separate one tradition from another or to make generalizations about relationships with Western patterns. There are many designs that are the same as those seen in Mesopotamian or Iranian ceramics, others that are similar, and others that have no equivalents at all. Nothing specific can be said referring to Harappan painted pottery as a whole as regards either the regions or periods from which parallels can be drawn. We shall see that Indus Valley motifs can be correlated with motifs from ceramic industries antedating them by more than a millennium as well as with motifs post-dating the end of this civilization as

[2] Wheeler, *The Indus Valley Civilization*, 1960, p. 101, suggests that the builders of the citadels of Harappa and Mohenjo-daro were innovators with architectural leads from elsewhere. He considers that the pre-existing population may already have been urban and that the domination was "dynastic" rather than cultural. In this connection we may note that architecturally and in planning the Harappan cities are superior to those of Mesopotamia. It is possible to agree with Wheeler that very generally the "idea" of civilization could have migrated, though specifically this concept is difficult to translate into actual developments.

such. Parallels can be drawn relating the Indus Valley designs on one hand to designs from earlier or later periods at sites where other ceramics coexist with Harappan material, and on the other to ceramics as far afield as Crete. Sometimes a design—such as the intersecting circle discussed below—which becomes outmoded in the region where we meet it earlier, crops up after a considerable gap in a Harappan context.

If therefore we try to build up a sequence of events or cultural relationships on the basis of this ceramic material, we find the evidence highly confusing. On the other hand if we adjust our interpretations to fit the rhythm of this same evidence, we find a picture that is very clear. We will try to put forth our interpretation of this picture after examining in detail the designs and symbols in the Harappan repertoire and their relationship with motifs in other contexts.

Although our discussion is concerned with decorated pottery, it is important to bear in mind the fact that by far predominant in Harappan communities are plain, utilitarian pots, which are as a whole without foreign precedents. This individuality seen in the everyday Harappan wares is a significant fact that should be kept in mind while evaluating the painted pottery, particularly when our evaluation leads to the assessment of elements with foreign antecedents. In addition, mention may be made of some examples of incised ware and also of some knobbed pottery—whose closest parallels seem to be Cretan jars of the Middle Minoan III period.[3]

The designs on Indus Valley pottery run the gamut from simple to complex, from naturalistic to conventionalised, and include geometric, animal and plant motifs with even some examples of human figures. Unlike the pottery of the simple cultures of North-West India as a whole, Harappan vessels with their overall patterns convey a generally involved impression produced by the combining of several designs and by the lack of any empty space. A crowded effect is further created by the absence of any distinction between essential supplementary motifs. The same emphasis is given to the entire design. The aesthetic attitude as illustrated in the Harappan ceramic patterns has been described by Mackay as "horror vacui"[4] and to some extent survives in later Indian sculptures.

Geometric designs constitute a large portion of the Harappan ceramic repertoire. Some of the geometric motifs, as we have seen earlier, may be abstractions of representational ones and can be considered as fundamentally belonging to an undefined group of interrelated designs which recur sporadically throughout Western Asia. For example, chequers, triangles and the comb motif may be evaluated in this category.

Such designs notwithstanding their simplicity may be proposed to represent the survival of an artistic tradition whose nucleus was common to regions extending from Crete to North-Western India. The reasons for not dismissing as coincidental the recurrence of even simple and elemental geometric motifs have been explained in the preceding section. Briefly we may repeat that these motifs have been shown to be conventionalized and abstracted in certain similar ways throughout various cultures. Equivalent abstractions suggest a definite common pattern which can scarcely be repeated so widely without some sort of a relationship being implied.

The checkerboard with its variations is a fairly common Harappan design. It has counterparts throughout an area which is seen to be within what may be called the Western Asian sphere of influence, although its popularity is not constant.

[3] Marshall, *Mohenjo-daro and the Indus Valley Civilization*, 1931, p. 315.
[4] Mackay, *Chanhu-daro Excavations*, 1943, p. 89.

Modifications of the checkerboard were the main motif in Pirak Ware of Baluchistan. We have commented earlier on the checkerboard pattern to show its retention as a later architectural motif in Crete. If we consider as variants of the checkerboard similar triangular arrangements or designs with alternate squares hatched or filled with dots and circles, etc., we can probably be safe in describing this design as universal in the area with which this study is concerned.

An interesting example of the traditional checkerboard motif is seen in a sherd from Harappa—one of the few examples of Indus Valley pottery depicting human figures, reproduced in figure 53. Its role in this particular context is difficult to determine. Possibly it is simply a space filler although the adjoining figures and symbols would appear to have a special significance. Similar arrangements of checkerboards alternating with representational panels are not without parallels. Examples may be noted from Kulli,[5] the Khurab Cemetery in Persian Makran[6] and Tepe Giyan.[7] It appears as if the Harappan examples antedate the Western ones mentioned, thus suggesting that their relationship is not a direct one but rather the result of a connexion antedating both.

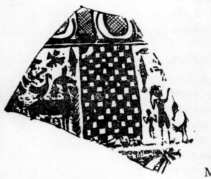

Fig. 53

Mackay plausibly suggests that checkerboard patterns are derived from basketry.[8] Triangular patterns may be similarly inspired. It is likely that the cultural sources of these various motifs overlap and one origin for a particular type of design does not preclude the existence of additional sources.

Simple triangular patterns appear in the Harappan repertoire, but somehow are not usual. The opposed triangle motif is a more common one, typically as a border. Its role in the Indus Valley tradition cannot be ascertained since there do not seem to be any internal clues to its development. However it is as much of a guess to say it had no value outside of a decorative one, as it is to attribute any intentional symbolic meaning to it. There is evidence that in other ceramic traditions this motif did have special importance. We have discussed above possible associations of this design with various concepts. In Cretan ceramics it seems to suggest the double axe; in Iran we have seen its merging into a stylized animal motif. It has been further suggested that its association with solar motifs as seen on an Elamite pot may have some bearing upon its significance.[9] Which if any of these possible roles was represented by the Harappan forms is not clear, but we may propose that the opposed triangle pattern might have had some traditional value in Indus Valley art even if this original value was not clearly remembered. We may repeat that the universality, simplicity and frequency of this design should not mislead us into overlooking its possible importance. In later Indian sculpture repetition is a main convention for placing emphasis upon a significant symbol however simple—and it is not out of the question that a similar intention underlay repetitive Harappan motifs like this one.

The comb motif in Indus Valley pottery has been much commented upon and interpreted in various ways. We have already made some comment in connection with its occurrence in Baluchistan. This particular design is an outstanding illus-

[5] Piggott, *Prehistoric India*, 1952, p. 192.

[6] Ibid. Piggott's date for the Khurab Cemetery is 2000 B. C. or later. Herzfeld, *Iran in the Ancient East*, 1941, p. 91, attributes the Khurab Cemetery to the mid-2nd millennium B. C. Cf. Herzfeld's fig. 183.

[7] Cf. Herzfeld, op. cit., p. 91, fig. 180. Herzfeld proposes a date of c. 1400 B. C. on the basis of Minoan parallels.

[8] Mackay, op. cit., p. 97.

[9] Ibid., p. 100.

tration of our view regarding the fundamental significance of ceramic designs as a whole, and the ultimate relationship existing between recurrent forms however far apart in space or time.

The Harappan examples of the comb motif are both antedated and post-dated by Mesopotamian and Iranian counterparts. Herzfeld illustrates early forms of this design from Tell Halaf and Tepe Gawra which we have reproduced in figures 54 and 55. In these examples the symbols depicted are apparently combs. However at Tepe Giyan a similar device illustrated in figure 56 clearly takes on the form of an animal. According to Herzfeld the association of the comb and animal and their merging into a so called comb animal is not without symbolic foundation.[10] As regards the design itself we have already shown how animal figures at Sialk have been stylized to the extreme, resulting in an abstraction of their original forms which revert to a simple geometric pattern. Thus we see the flexibility and adaptability of ceramic designs as well as their adherence to an underlying tradition of symbolism.

In certain instances the comb appears to be associated with heraldic birds.[11]

The comb motif in Harappan pottery occurs both in the simple form similar to the Sialk abstraction seen in figure 57 and in a more complex form which seems to be related to the Tepe Giyan example. Figures 58 and 59 from the Indus Valley repertoire can be compared with figures 56 and 57 from Giyan and Sialk respectively. An additional example of the comb motif as a background symbol in a Kulli scene which was shown in figure 30 may be recalled for further comparison.

Starr points out the association of the comb symbol in Harappan and Baluchistan ceramics with the rayed circle as seen in figure 59.[12] A similar association of large horned quadrupeds in Mesopotamian and Iranian painted wares with solar symbols further brings out the interrelationship between the intentions underlying the Indian and Western designs. The close similarity between the circular devices associated with the combs in figures 56 from Iran and 59 from Harappa indicates that the connexion between these forms was not superficial but that both designs illustrated a common concept or were evolved from a common symbolism.

Majumdar has described the comb motif as tree branches and has illustrated the similarity between some examples of the so called combs with plants or trees.[13] The identification of the comb motif in Indian ceramics with animals on the analogy of Iranian counterparts may still be open to question. However the association of the rayed circle and the close affinity of the Indian with the Western designs are suggestive. On the other hand these associations do not preclude the possibility of this motif in some cases, as proposed by Majumdar, being a schematic representation of branches or leaves. We have already put forth the view that the intentions underlying proto-historic designs often overlap.

If the Harappan designs we have been discussing until now may be considered as belonging to a common West Asian repertoire, an Indus Valley pattern par excellence is seen in figure 60. This has been described as the intersecting circle motif and, although it is not exclusive to Harappan Culture, it certainly is an Indus Valley hallmark. Outside of the Indus Valley Civilization, its occurrence at Amri or Kot

[10] Herzfeld, op. cit., p. 81.
[11] Ibid.
[12] R. F. S. Starr, *Indus Valley Painted Pottery*, 1941, p. 82.
[13] N. G. Majumdar, "Exploration in Sind," *Memoirs of the Archaeological Survey of India*, 48, 1934, pl. XX, fig. 22 and pl. XXVIII, fig. 13.

Fig. 54

Fig. 55

Fig. 56

Fig. 57

Fig. 58

Fig. 59

Fig. 60

Diji and at Nal[14] might be attributed to Harappan influence. However there are examples even of this pattern further west which apparently antedate the Indian ones. As a matter of fact the Mesopotamian examples seem to be limited to Halaf levels.[15] Occurrences of this pattern are also noted in the Minoan period in Crete.[16]

Ernest Mackay in his interpretation of this motif's migration quotes and supports the following opinion expressed by Mallowan.

". . . Perhaps these early potters of Assyria and Syria moved eastwards and in some region yet unexamined carried on that tradition for which we seem to find comparatively late evidence in India."[17]

Although there is no contra-indication that this pattern was in fact brought to the Indus Valley by potters from the West, its prominence as an Indian motif suggests an alternate explanation. It would appear logical that this intersecting circle pattern could have been inherited from a diffused ancient tradition and that it subsequently developed within the Harappan Civilization as a typically Harappan expression. Time taken by the process of diffusion may explain the fact that this design appeared belatedly in the Indus Valley. As a matter of fact the Indus Valley Civilization itself is a relatively late one in the ancient world so it is not surprising that it reproduces later motifs met with elsewhere considerably sooner.

Dr. Mode has expressed the view, with which our interpretation is in accordance, that motifs like the intersecting circle pattern "form part of an older tradition which is the common background for Indian and the Syrio-Aegean culture."[18] However his reference to the fact that this motif has been seen at Kot Diji to be pre-Harappan requires revision in view of the recent Amri excavations discussed above. We have seen that the pre-Harappan level at this site —with which Kot Diji is correlated—was in fact subject to Harappan influence. Thus a pre-Harappan motif at Amri or Kot Diji cannot be considered pre-Harappan as such.

Although artistic, like linguistic, parallels may often be validly used as a clue for the reconstruction of ancient migration, it must not be assumed that there is no other explanation for their occurrence. Designs or symbols, expressions and beliefs, even legends and ideas may be passed on from person to person or culture to culture until they take root very far from their point of origin both in space and in time. Actually it is to be expected that the further away they recur from their known sources the more time elapses between the expressions.

In this connection it may be well to interrupt our examination of designs to bring out the fact that although it now appears that the Indus Valley Civilization post-dates the Early Civilizations of Mesopotamia and Iran, it has not been possible as yet to reach the earliest levels of the former at all sites. Consequently it is not out of the question that, if we were to find that Harappan Culture has considerably earlier beginnings than assumed to date,[19] our evaluation of artistic relationships

[14] Piggott, op. cit., p. 88, fig. 5.

[15] Starr, op. cit., p. 74; E. Mackay, *Further Excavations at Mohenjo-daro*, 1938, p. 221; Mackay, *Chanhu-daro Excavations*, 1943, p. 94.

[16] Sir Arthur Evans, *Palace of Minos*, 1921-1936, I, pl. V—intersecting circle design in MM III period and R. W. Hutchinson, *Prehistoric Crete*, 1962, fig. 27 in the E. M. III period.

[17] Mackay, *Chanhu-daro Excavations*, 1943, pp. 94-95.

[18] Heinz Mode, *The Harappan Culture and the West*, 1961, p. 9.

[19] Wheeler, *Civilizations of the Indus Valley and Beyond*, 1966, p. 70, refers to recent borings, conducted by G. F. Dales, which show the earliest Mohenjo-daro levels to be 39 feet below the present surface, i.e., very early.

might have to be somewhat altered. However at present there does seem to be an established direction of influence diffusing slowly from the West towards India. This influence was not necessarily direct; in other words specific cultural features were not necessarily introduced as such into India, but rather they were absorbed as a part of Indian civilization in due course as the result of a natural culture spread.

In figure 61, a Harappan motif is illustrated which apparently has no counterparts in Western ceramics. This is one of the few Indus Valley designs, apart from some plant or animal forms,[20] which seems to be totally without earlier Western parallels and its source and significance escapes us. However its unusual shape is distinctive enough to suggest that it may have been more than purely decorative. Its reproduction on a Jamdat Nasr period Elamite Seal showing Harappan influence[21] further suggests that it was considered typical of the Indus Valley and therefore probably was not a random form and did have some representative or symbolic meaning. The exclusiveness of this design attests to the independence of the Harappan ceramic tradition. This independence is also seen in the combinations, style and relative frequency of even those patterns which do have counterparts elsewhere. Thus a pattern like the intersecting circle is also distinctively a Harappan one, although it is not unknown in other wares.

Fig. 61

Figure 62 again illustrates a design which strikes us as distinctively Harappan yet is not without parallel in the West. This design can be described in various ways. Starr calls it a "contiguous circle" pattern—Mackay describes the same motif as representing a group of pottery vessels,[22] Starr refers to a single foreign parallel from Tell Halaf.[23] A Cretan design from a late Minoan II vase may be related to the Indus Valley pattern. Figures 63 and 64 from Crete showing variants of the intersecting circle and so called contiguous circle patterns respectively can be compared with figures 60 and 62 illustrating Harappan examples of similar designs. Plate 3 illustrating a painted jar from Mohenjo-daro shows the manner in which the above described designs are treated by the Indus Valley potter. The combination of three more or less distinctively Harappan motifs on this particular vessel may have been intentional. However even if these symbols had no extraordinary purpose, the vase illustrates admirably the Harappan ceramic style and its general dissimilarity from foreign ceramic traditions, notwithstanding the fact that a majority of the Indus Valley designs are not unrelated to designs in other repertoires.

Fig. 62

Also common in Harappan painted pottery is a design generally described as the fishscale, illustrated in figure 65. This motif has been considered a development of the loop pattern.[24] The fishscale, along with patterns like the checkerboard or triangle, is by no means exclusive to the Indus Valley. In Northern Mesopotamia it occurs in the Halaf period.[25] Figure 66 illustrates the fishscale as it occurs in the Tell Halaf repertoire. At some Mesopotamian sites and in some periods this motif is conspicuously absent.[26]

Fig. 63

[20] Starr, op. cit., p. 87; Marshall, op. cit., p. 328.
[21] Henri Frankfort, *Cylinder Seals*, 1939, pl. VIIIa.
[22] Mackay, ref. Marshall, *Mohenjo-daro and the Indus Valley Civilization*, p. 328.
[23] Starr, op. cit., pp. 63-64, and fig. 118.
[24] Starr, op. cit.,, p. 28, fig. 9.
[25] A. L. Perkins, *Comparative Archaeology of Early Mesopotamia*, 1949, figs. 29-32.
[26] Starr, op. cit., p. 28. According to Starr the fishscale does not occur at Samarra, Susa I, Al' Ubaid, Musyan or Jamdat Nasr, i.e., not in Elam or Southern Mesopotamia. This motif does occur at Sialk, Tepe Giyan and at Tal-i-Bakun. Note a similar motif seen in fig. 66A from Ur of the Ubaid I period.

Fig. 64

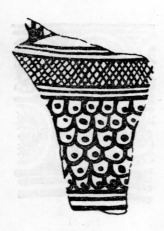

Fig. 65

Fig. 66

Fig. 66A

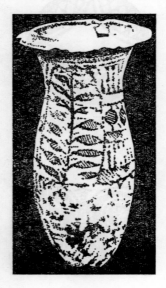

Fig. 67

Before proceeding with an evaluation of plant and animal forms seen in Harappan pottery, we may briefly recapitulate some generalities which suggest themselves at this point. Although the preceding discussion of geometric designs has not been exhaustive, it is representative of the relationship between Harappan and Western geometric motifs. We hope to have successfully demonstrated that the majority of Harappan geometric motifs are not without Western counterparts and that often though not invariably these counterparts antedate the Indian versions. However it is not possible to pinpoint either the areas or the periods from which parallels with Indus Valley designs can be drawn. Nor is it possible to specify the nature of parallels—they vary from general similarities to exact duplicates. We also hope to have suggested that most of the ceramic motifs are highly traditional and thus their recurrence is not merely coincidental. Even a pattern which is developed locally from a simpler one—such as the fishscale design from loops—is not without a parallel development abroad. More complex worked over designs—like the comb in association with the rayed circle—similarly have parallels in other repertoires.

In addition to geometric patterns, plant and animal designs, both stylized and naturalistic, occur in Harappan pottery and are interesting from the viewpoint of their relationship with designs in Western Asian repertoires.

Perhaps most popular of all floral patterns throughout the world, in many periods and in various mediums, has been the rosette. This design combines natural with symmetric and geometric beauty; it is representative as well as symbolic. We will have occasion to discuss this pattern again later, but at present it may be mentioned that in contrast with Mesopotamia and Crete, the rosette in Harappan painted pottery seems to be absent as a motif in its own right. However it does occur in continuous designs as in the repetitive intersecting circle pattern which results in a kind of four-petalled rosette but without a center.

Harappan plant motifs as a whole are distinctively naturalistic and would apparently constitute a purely local development within the Indus Valley. The general feel of these designs is new to the ceramic field we have been surveying until now. On the other hand, we now become familiarized with certain forms like the pipal leaf and with certain aesthetic attitudes like informality that will remain permanently in Indian art.

Although no doubt parallels can be drawn between some Harappan and Western plant motifs, we can suggest that these are either casual coincidental similarities or a direct result of current contacts. Unlike the geometric designs we have been discussing, the plant forms in general do not seem to share a background of symbolism or conventionalization with Western counterparts. The parallels with the pottery of other Indian proto-historic cultures imply a more direct relationship or interchange of influence. For example the pipal tree in figure 30 from Kulli is very near in conception to the Harappan form shown in figure 67. Mundigak renderings of the pipal can in turn be related to Kulli influence.[27] Similarly the motif shown in figure 67A, possibly a lanceolate leaf, is a common Indus Valley form and is seen at Nal.[28] There is no basis upon which these forms can be presumed to have evolved independently, that is, without direct contact.

Although schematized or conventionalized forms, as for example, the spiky tree seen in figure 68 along with an unusual shield-like shape, or the leaves in figure 69 are not without parallels abroad, as a whole the Harappan treatment of vegetation illustrates a new interpretation of art and nature.

[27] Casal, *Fouilles de Mundigak*, 1961, V; figs. 64-170 and 173.
[28] Marshall, op. cit., p. 325.

Moving on to a discussion of animal designs which were far less popular in Harappan ceramics or at least seem so from the remaining sherds, we find as pointed out by Starr, that these designs once again appear to be dominated by forms and artistic conventions typical also in the West.[29] In general (but with notable exceptions) animal motifs in the Harappan repertoire, like the geometric ones, can be considered representative of a cultural strain within the Indus Valley which retained the heritage of Western Asia. In the same way as the geometric designs and symbols, Harappan animal designs may be related to forms seen in the ceramics of Baluchistan, Iran and Mesopotamia without being necessarily connected directly with them. In other words the Harappan forms reveal an affinity with Occidental ones, but need not have been immediately influenced by their foreign counterparts, or vice versa. Although a more direct relationship is not precluded, particularly as regards Baluchistan, parallel animal forms would appear to reflect an older common tradition.

Parenthetically we may draw attention to the general absence of animal forms from Minoan vases and the prevalence of floral forms which constitute the distinctive decorative element in Cretan ceramics.

A very occasional motif in Harappan ware is the animal file which we have discussed to some extent above. We have illustrated an example of the animal file from Mohenjo-daro, figure 41[30]. As we have already seen, this motif is of considerable antiquity and occurs widely in the Western Asian sphere.[31] Its occurrence in the Indus Valley is relatively infrequent but, as we have seen, this motif has a somewhat more prominent role in the wares of other proto-historic Indian communities.

A very interesting pattern of probable Iranian origin which to some extent ties in with the so called file design is illustrated in figures 70 and 71. Comparable is a similar pattern on a vessel from Nal seen in figure 72.

Examples of this motif occur also in the Harappan phase at Amri.[32] Herzfeld illustrates a similarly conceived pattern seen at Susa I and derived from Persepolis.[33] Our figures 73 and 74 for comparison with the Indian forms of this design are after Herzfeld. The figures depicted are shown by Herzfeld to be abstractions or parts of animals. In figure 75 the appendices are seen to resemble antlers and the design approximates birds in flight. Herzfeld also states that the Harappan and Nal forms of this motif are of Iranian provenance.

Starr treats the device seen in figure 70 as a form of the sigma and chevron group of designs. On the other hand, a pattern as seen in figure 72 similarly may be associated with an animal file.

Sigma and chevron type designs are universal in Western Asian decorated ceramics. Arrow or heart shaped figures, V shapes, etc., may be considered as variants of the same fundamental motif. Figures 76 to 91 illustrate several forms of this fundamental pattern from widely separated sources. In some examples the suggestion of motion is halted and the design reverts to a simple and static geometric symbol.

[29] Starr, op. cit., p. 71.
[30] Marshall, op. cit., p. 322.
[31] Starr, op. cit., p. 72: from Susa 1—rows of small birds as borders; form Gawra (Al Ubaid period)—files of quadrupeds; from Fars—bird and animal files; from Hissar I and Sialk III—grouped birds, humans and quadrupeds.
[32] Casal, *Fouilles d'Amri*, II, fig. 90, 454.
[33] Herzfeld, op. cit., pp. 36-37.

Fig. 67A

Fig. 68

Fig. 69

Fig. 70

Fig. 71

Fig. 72

Fig. 73

Fig. 74

Fig. 75

Fig. 76

Returning to the more complex form in figure 70, its resemblances to a centipede has also been noted.[34] As we have already commented, one intention behind a design does not preclude the validity of an alternate underlying intention.

Naturalistic animals are seen in a few Harappan sherds. These bear a general resemblance to animal figures on some Iranian and Mesopotamian wares. Stylistic features like hatched bodies also have parallels as at Susa II and in the designs of the Jamdat Nasr period.[35] A closer relationship perhaps is implicated in the similarity between figure 92 from Mohenjo-daro and some of the naturalistic scenes from Kulli. The similarity between the Kulli scenes and Scarlet Ware discussed above may be extended to the Mohenjo-daro design. E. Mackay, in reference to an animal motif seen in figure 93, draws our attention to the devices above and below the animal.[36] He suggests that these may have been intended to represent rugous horns and points out similar objects associated with a similar animal on a Samarran painted dish.[37]

Unlike geometric forms, Harappan animal figures convey the impression of being not fully integrated in the Indus Valley reportoire. It will later become apparent that there is a considerable contrast between these animal representations on pottery and the typical "Indian" animals depicted on the seals.

Serpents and fish appear among the Harappan designs, possibly in relation to a religious symbolism which is either intentional or just in the nature of an undercurrent. This religious context can be expected to have at least partially been drawn from a background shared by other West Asian cultures. Snakes are a universal ceramic design and fish, especially associated with representations of water, are also widespread.

Outstanding among the Harappan animal designs, which as a whole are otherwise not typical of the Indus Valley Civilization, is the peacock. This bird, treated naturalistically and with great success, is a purely local figure especially popular at Chanhu-daro and Amri. Along with the Harappan plant motifs the peacock represents an indigenous cultural current. As far as its expression in ceramics is concerned, this current although not isolated, is certainly distinctive and the peacock's popularity as a Harappan ceramic design is undoubtedly due to its aesthetic appeal as much as to a possible association with a religious cult. Figure 94 from Chanhu-daro illustrates the peacock in association with a probable solar symbol, similar to the device seen with the comb motif in figure 59.

Human figures appear on a small unique group of sherds from Harappa. One such sherd has been illustrated in figure 53. Here the animal figure and background symbols as well as the checkerboard are not unfamiliar; however another scene in figure 95 depicting an extremely small headed fisherman with nets seems disassociated from other Harappan or West Asian designs.

The Harappan painted pottery is essentially a black on red ware. A very small percentage of the painted ware however is polychrome. Examples of polychrome ware from Harappa and Mohenjo-daro are in red and green on a buff slip. A Chanhu-daro sherd portrays a naturalistic scene of birds and animals in red with black outlines on a yellow ground.[38] The scarcity of the polychrome ware is interpreted by Mackay as indicating that this craft was a decaying one.[39]

[34] Marshall, op. cit., p. 322.
[35] Ibid., p. 324. Also for examples of Jamdat Nasr motifs, cf. Parkins, op. cit., fig. 13.
[36] Mackay, *Further Excavations at Mohenjo-daro*, 1938, p. 218.
[37] Mackay's reference is to Herzfeld's *Di Ausgrabungen von Samarra*, V, pl. viii.
[38] Mackay, *Chanhu-daro Excavations*, 1947, p. 88, pl. xxxvi, fig. 23.
[39] Mackay, op. cit., 1938, p. 227.

However polychrome ware as a whole was rare in the ancient Orient. Polychrome designs in a variety of colours recollect the Nal ware which could have been in some way connected with the Harappan examples particularly in view of the general absence of such ware elsewhere and its rarity even in Harappan ceramics.

That the polychrome pots may have had a special role is suggested by fragments from Mohenjo-daro depicting trefoils.[40] There are indications that the trefoil was a sacred symbol in Western Asia as we will see further ahead. This motif reappears in the Indus Valley, though with these exceptions, not as a pottery design.

Fig. 77

Although we have been thus far treating ceramics as an expression of art, it should be mentioned that to an extent pottery might be more accurately described as a craft. However since our knowledge of proto-historic artistic attitudes and repertoires is largely confined to ceramic designs, it becomes essential to evaluate this medium as an expression of art. In any case ceramic designs and styles are representative of the popular level of aesthetics as well as of the local outlook and conditions. As an expression of popular or folk art, which has seen the greatest continuity in any culture, the study of traditions manifest in ceramics or terracotta figurines is extremely valid.

Fig. 78

Considering then ceramics as an art, it is interesting to note that in the pottery of proto-historic peoples, we have often seen a sophistication approximating that of modern abstract art. This sophistication is significant because it is born of a long practised tradition.

Fig. 79

Ancient potters were thus artists with some freedom, as well as craftsmen dominated by definite and far-reaching conventions. Therefore we see in ancient ceramic designs, conventional abstractions of representational motifs as well as developments embroidered around simple essential symbols. Some forms seem over elaborated, others, carelessly simplified. In either case these artistic errors imply a degeneration, yet most designs show an understanding of classic forms and a succesful adaptation of these forms to the local spirit.

Fig. 80

We cannot determine precisely the extent to which traditional symbols seen in ceramics retained their values. Yet we do see that these patterns, symbols, and abstractions collectively had a meaning in the community that made and saw them. They may be said to illustrate the subconscious tradition of the culture in which they flourished. Thus we conclude that in so much as the Harappan ceramic repertoire is related to that of other cultures, the Indus Valley people shared with people who used similar artistic expressions, a common cultural heritage.

Fig. 81

More specifically, parallels and differences in motifs of the Indus Valley and West Asian ceramic repertoires reveal, as we anticipated, something of the nature of the relationship which seems to have prevailed between Harappan and Western cultures. An understanding of this relationship gives us added insight into the question of the origins of the Indus Valley Civilization. As stated at the beginning of this section, this question cannot be entirely answered by material evidence as in its broadest sense it involves an understanding of cultural impulses which leave no physical record. On the other hand an interpretation based upon artistic relationships—which are a fundamental aspect of culture—may be valuable towards increasing this understanding.

Fig. 82

From our evaluation of the pottery industries of North-West India and Baluchistan, we concluded that many decorative and symbolic elements which had great antiquity and wide prevalence in Western Asia were reflected in these chalcolithic cultures. We interpreted their recurrence in the Indian communities as indicative of the fact that these communities shared with their Western Asian counterparts a common heritage. We further suggested that if in some cases this heritage was transmitted directly

Fig. 83

[40] Ibid., pl. lxviii, figs. 10 and 15.

Fig. 84

Fig. 85

Fig. 86

Fig. 87

Fig. 88

Fig. 89

from Western sources to India by immigrants, in many other instances a gradual and generalized cultural diffusion was responsible for its spread.

In the pottery tradition of the Indus Valley we have seen that to an equivalent extent a similar relationship links Indian with Western wares. It is seen once again that on the basis of parallels in ceramic motifs, which are so widespread and unrestricted to any particular period or region, we cannot accurately postulate anything beyond the existence of some fundamental underlying relationship. At the same time this fundamental relationship is a definite and significant one.

Starr has concluded from his study of Indus Valley painted pottery that Harappan motifs with Western parallels are evolved from earlier prototypes and that the Western dominated designs have a laboured appearance pointing to a conscious retention of an earlier style.[41]

Starr further suggests that in the "mélange" that made up the Western elements in the Harappan repertoire Halaf seems to have been the main contributor.[42] However we cannot pinpoint any particular source for these parallel motifs in view of the numerous incidents of such parallels throughout the West Asian sphere and in all periods. Yet it is significant that many Harappan patterns are related to much earlier Western forms. And although such parallels, which are referable to various periods in West Asian prehistory, have been considered to be indicative of a series of foreign influxes each introducing its own ceramic designs,[43] this need not be the only explanation. It would appear probable that the Western forms were not necessarily prototypes for their Indian successors, but rather an earlier manifestation of a common tradition, a tradition that spread through multiple channels. Immigrants were only one means by which cultural elements were extended. Equally or more important in the long run must have been other forms of transmission, as for example, Fairservis' stimulus diffusion or trade or contact between neighbouring settlements. Perhaps even religious movements stimulated the spread of certain symbols.

There is evidence that Harappan Civilization was more closely connected with the neighbouring cultures of Baluchistan. We have seen above that Harappan traditions overlapped with local elements at Amri and have commented on indications of communication and cultural exchange between the Indus Valley and Baluchistan. Thus, whereas Harappan pottery reveals a fundamental and general relationship with West Asian ceramics, its relationship with the Baluchistan wares is closer. But as yet there is no specific evidence that Harappan Civilization evolved from these simple complexes.

The question still remains as to whether the Harappan Civilization evolved from these simpler settlements and achieved its unique brand of greatness with or without the benefit of immediate outside intervention. We will be in a better position to consider this problem further ahead after reviewing the balance of artistic evidence. However it may be noted that there is no evidence in the ceramic material evaluated above which suggests that foreign intrusion was responsible for the development of or altered the course of Harappan artistic traditions. Although this evidence is negative, it is meaningful.

The ceramic material of the Indus Valley reveals one further feature of importance. It suggests that two strains contributed to this culture. One can be considered as containing and propagating a common Western Asian tradition. This strain produces

[41] Starr, op. cit., p. 88.
[42] Ibid., p. 99.
[43] Ibid., p. 99. Starr suggests that the Indus Valley was repeatedly host to wanderers from Iran and Mesopotamia.

lineage designs of great antiquity and widespread popularity. A second strain is new in the ancient Orient. Its designs, mostly of plants and trees, are fresh, unrestrained, and inspired in a local natural atmosphere.

These two traditions in ceramics may be correlated with two fundamental elements to which Harappan Civilization as a whole is attributed. Professor Sankalia describes these two strains as the Iranian, which he proposes came to Sind via Baluchistan and possibly Afghanistan, giving birth to a number of village cultures en route, and the indigenous, which was of local origin.[44]

Fig. 90

Mackay has commented upon the fact that the naturalistic Harappan designs contrast with both the earlier pre-Harappan and the later Jhukar patterns. He suggested on these grounds that perhaps the Harappan Culture was imposed temporarily, later to disappear or become assimilated.[45] There are a number of considerations however that would tend to go against this view. A basic one is the fact that these naturalistic ceramic patterns appear to be a purely indigenous development and thus one that would not be in a position to impose itself temporarily upon an earlier tradition. On the other hand even the geometrically oriented designs and symbols have a long history and a firm position in Indian ceramics.

We will be better able to understand the interplay of these two strains after studying other aspects of Harappan art, especially the seals which reflect a tradition quite different from that seen in the painted pottery.

Fig. 19

3. SEALS

The Indus Valley seals are perhaps one of the most distinctive features of Harappan Culture. The objects depicted upon them as a whole are unique both in subjects and in treatment though here again there is evidence of contact with Western Asia. Yet this contact appears to be of a different nature than that suggested by parallels in pottery motifs, as here there are no indications of elements evolving from forms seen in the West in earlier periods. There are some seals that are undoubtedly of Western inspiration, but these are in the minority and not integrated into the Harappan glyptic tradition. They appear to be indicative of occasional cultural exchange rather than a common cultural background.

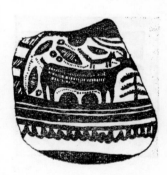

Fig. 92

This general disparity between the traditions revealed in pottery and in the seals seems paradoxical. But if successfully interpreted it provides an important clue to our understanding of the Indus Valley culture as a whole.

In this section we will study Harappan glyptics with particular reference to its relationship with Western artistic traditions. We will try to show that while there are points of contact—including the basic fact of seals being common in Western as well as in the Harappan Civilization—fundamentally the form, subjects, and treatment of the Indian seals differ from the Western ones and point to a different source. It is interesting to note however that a number of symbols which have prominence in West Asian pottery and are conspicuously absent in Harappan ceramics do appear in the Indus Valley seals.

The Indus Valley seals are of several different types, but the most popular form is the stamp seal of steatite measuring about one inch square.

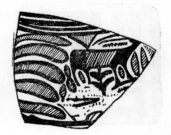

Earlier than this type is a group of miniature seals or amulets, which were found at Harappa at levels antedating Mohenjo-daro. At Harappa the size of these seals was found to diminish as the lower strata were reached until seals measuring from

[44] H. D. Sankalia, *Prehistory and Protohistory in India and Pakistan*, 1962, p. 178.
[45] Mackay, *Chandu-daro Excavations*, 1943, p. 101.

Fig. 93

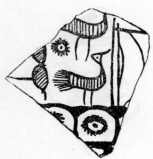

Fig. 94

0.36 inches to 0.6 inches in length and 0.6 inches to 0.25 inches width became almost exclusive.[46]

Vats draws attention to the fact that these miniature seals lacked knobs or a hole and suggests that they were not intended for stamping. Thus they may have been amulets and meant to be carried. The range of inscriptions and devices depicted on these small seals is limited. There are no representations of unicorns or any of the other usual animals. However the object described as an "incense burner" by Vats and which generally accompanies the unicorns on the regular size seals is depicted in a few examples. Other devices illustrated in these miniature seals include the crocodile, fish, the pipal leaf, diagonal cross, and swastika.

Before we proceed to discuss the typical square steatite seal generally depicting an animal figure, it may prove interesting to study some groups of seals or amulets which are less prevalent but which would seem to have special symbolic significance.

A class of so called button seals, mostly made of faience, and decorated with linear designs merits particular attention. The symbols depicted on these buttons once again relate the Indus Valley with Western Asia as well as with later India. The most common design on these seals is the swastika. The absence of this symbol from Harappan pottery was difficult to interpret. Herzfeld discusses the distribution of the swastika and comments upon its absence or rarity in Sumer, Akkad, Babylon and Assyria.[47]

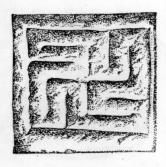

Fig. 95

In Iranian pottery however the swastika appears in a variety of forms. Figures 96-98 illustrate some examples of Indus Valley button seals with swastikas. It can be seen that as yet the convention of turning this symbol for symbolic reasons only to the right has not been established. The swastika occurs also on Minoan seals and pottery.[48] Like some of the ceramic motifs we have commented upon earlier, the swastika is a versatile and adaptable symbol, a fact which may partially explain its longevity. Its earliest connotations, possibly associated with solar symbolism, may have been consciously or subconsciously retained in Harappan times or may have been altered, but undoubtedly its occurrence was not fortuitous.

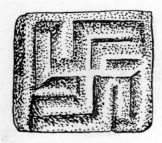

Fig. 96

Other devices on these button seals include crosses, circles, and squares. Figures 99 to 103 illustrate these devices and may be compared with figures 104 to 106 of buttons from Western sources. The direct implications of these parallels are not easy to draw, as once again we are dealing with very elemental forms. Figure 107 is somewhat more elaborate and is comparable with seals from Ur similarly decorated.[49] A proto-Elamite counterpart has been noted for figure 99.[50] The occurrence of this pattern can be further noted on some of the pottery of Baluchistan.[51] One or two of the button seals have devices which are apparently adapted from the step pattern discussed earlier.[52] It can be seen that if we were to extend our field of parallels for these linear motifs to include pottery, we might refer to a very large number of counterparts.

Fig. 97

[46] M. S. Vats, *Excavations at Harappa*, 1940, p. 325.
[47] Herzfeld, *Iran in the Ancient East*, 1941, p. 21, note 13, with the exception of two examples of graffiti as far as Herzfeld knows. However note for example a lion swastika on an early Dynastic Cylinder in Frankfort, *Cylinder Seals*, 1939, pl. xiv e; cf. fig. 137.
[48] Sir Arthur Evans, *The Palace of Minos at Knossos*, 1921-1936, I, p. 121, fig. 90 a; pp. 185, 515, 640; II, p. 197.
[49] C. J. Gadd, "Seals of Ancient Indian Style Found at Ur," *Proceedings of the British Academy*, XVIII, 1932, pls. ii and iii.
[50] Marshall, *Mohenjo-daro and the Indus Valley Civilization*, 1931, p. 374.
[51] Stein, *Memoirs of the Archaeological Survey of India*, No. 37, pl. xv.
[52] Marshall, op. cit., p. cxiv, figs. 520-521.

Two seals or stamps have been recovered from Quetta with cruciform designs. We have illustrated these in figures 108 and 109. Figure 109 may be compared with a seal from Harappa depicting an eagle on the obverse and a simple cross on the reverse. Both faces of the odd Harappan rhomboid seal are shown in figures 110 and 111.

A group of seal impressions found most commonly on baked clay tablets or triangular prisms give every indication of having religious significance as well as a religious function. These probable amulets illustrate in miniature scenes evidently taken from some aspects of the Harappan cult. Here while parallels may be drawn as we shall see with Mesopotamian practices, these parallels are superseded by the essential distinctiveness of the rituals. In fact, most striking about these Harappan sealings is their identification with later Indian traditions.

The difference in conception between these amuletic impressions and the usual Harappan seals is bound to have some implications. A number of these impressions were found in defined areas suggesting that they were associated with some religious center.[53] It may be inferred that if these sealings served a specifically religious purpose, the conventional seals had a secular function. That is not to say that the objects depicted upon the latter were devoid of symbolic value, for in most ancient and even in current cultures art and religion are not disassociated. Both in the fine arts and in minor arts there is considerable overlap between the spiritual and the artistic expressions of man.

Returning to our amuletic impressions, we may first refer to a scene showing a procession of four figures each bearing a standard. Mackay describes this impression as Egyptian in character.[54] However the general conception of a religious procession with standards is widespread. We have reproduced the scene in figure 112 and draw attention to the unicorn and to the typical object which is seen generally in front of animals on the seals.

A few sealings of outstanding interest portray figures seated crossed legged on a dais like a yogi. It can be seen in figures 113 and 114 that these figures anticipate later Indian ascetics or even divinities. It is further suggested that the Harappan examples were prototypes for the later figures. In other words, the Harappan religion contained a nucleus from which later traditions evolved. Thus if some broad aspects of Indus Valley worship—like the mother goddess cult—were shared with other Western cultures, in other respects the Harappan religion was distinctive. If traditions which once widely prevailed in the ancient Orient survived along with many of their symbols, more specifically Indian traditions and symbols have similarly survived and retained their distinctiveness.

In figure 113 not only is the central figure's pose familiar to historic India, but also the worshippers and the vertical cobras flanking him are familiar associations. Attention may be drawn to the significance of the cobras paying homage along with kneeling worshippers to the meditating divinity, as in later Indian art nagas pay their homage to Buddha. This scene and also the later Buddhist ones may represent a resolution of the opposition between the forces of the earth and the power of heaven. The inherent antagonism between the serpent symbolic of the female earth—a negative as well as a positive force—and the masculine powers of heaven is a fundamental subject in ancient art.[55] Its appearance in the Indus

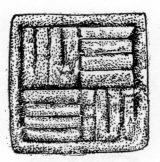

Fig. 98

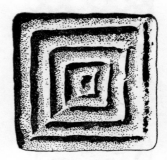

Fig. 99

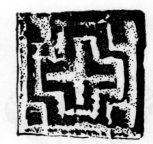

Fig. 100

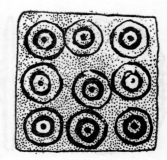

Fig. 101

[53] Mackay, *Further Excavations at Mohenjo-daro*, 1938, p. 349.

[54] Mackay, ref. J. Marshall, *Mohenjo-daro and the Indus Valley Civilization*, 1931, p. 395.

[55] Heinrich Zimmer discusses this subject in his books: *The Art of Indian Asia*, 1954, and *Myths and Symbols in Indian Art and Civilization*, 1946. He draws attention to the duality represented by the association of the serpent with the bird symbol of the sun and skies as seen on a

Fig. 102

Fig. 103

Fig. 104

Fig. 105

Fig. 106

Valley suggests an original link between the Harappan and West Asian traditions. However the Harappan treatment of this subject simultaneously indicates an independent and well developed local tradition which survives intact into historic times. Striking about this amulet and later similar scenes is the fact that both represent not the annihilation of the destructive aspect of the serpent or earth but the peaceful submission of these forces to the divine power. On the reverse of this amulet, the gharial, the fish and the swastika are depicted suggesting that these figures had some role in Harappan religion. In figure 114 the seated personage which appears to be wearing bangles and a tassel like appendage behind his headdress is associated with domestic animals. Also on the same tablet is depicted a recurrent scene, a man in a tree attacking a tiger below. The reverse of this sealing depicts a humpless bull near a trident headed post, a standing figure, and an unusual structure possibly of a sacred character.[56]

Several other such scenes of an apparently religious character give us additional glimpses of Harappan ritual and further represent the existence of a well defined, local cult. Yet analogies with illustrations of Western rituals or figures are not absent. Some of these parallels, like the Gilgamesh figures which we will discuss further ahead, can be attributed to cultural interchange. But still other analogies need not imply an originally common source. Many such parallels can have been independently evolved. More specifically, subjects like attacks upon wild animals,[57] sacrificial scenes with the participation of animals,[58] or even bull vaulting scenes[59] are general and although they have counterparts in Western Art these could be coincidental. For example, although it is possible that the Cretan and the Harappan representations of bull vaulting were derived from an originally common source, the general absence of further parallels elsewhere and of repeated examples of such scenes in associated contexts suggest that the Minoan and Harappan representations were independent.

According to Dr. C. L. Fabri,[60] the Cretan and Harappan rituals were connected and the artistic renderings also related. Dr. Fabri illustrates a Knossos clay sealing and frescoes which he feels show affinity with Harappan seals. Dr. Fabri attributes this similarity to contact rather than to a common origin. However, scenes depicting various religious offerings or sacrifices are instinctive in any culture, thus precluding the necessity of occasional parallels being connected.

Sumerian goblet attributed to King Gudea of Lagash and dated c. 2600 B. C. Zimmer suggests the formula may have originated in Sumer and spread both to the East and the West. Cf. *Myths and Symbols in Indian Art and Civilization*, p. 74.

[56] Vats, op. cit., p. 129.

[57] Ibid., pl. xciii-308.

[58] For example figure 115. The obverse includes pictures of two figures standing face to face on their hind legs and a female upside down with plants issuing from her womb. The reverse of this amulet seen in figure 116 depicts a woman seated on the ground and a man with a sickle shaped object in his right hand. Marshall and Vats interpret this terracotta sealing as depicting a human sacrifice and identify the beasts as belonging to a class of officiant genii familiar in the Aegean and also found at Ur by Woolley. Marshall suggests: ".... that the conception of these animal genii arose independently in Greece, Mesopotamia and India is hardly conceivable but whether it originated in East or West has yet to be determined" (cf. Vats, op. cit., p. 42 and Marshall, op. cit., p. 70). However the relationship between the Harappan genii and the Aegean and Mesopotamian ones cannot be established without further evidence. Also the participation of animals in religious rites is not an unusual concept and could have been evolved independently.

[59] Mackay, *Further Excavations at Mohenjo-daro*, 1938, pls. cii-5 and ciii-8.

[60] *Asiatic Society of India, Annual Reports*, by Fabri, 1934-35, Section VIII, "Miscellaneous Note," pp. 93 to 100. Fabri refers to a Mohenjo-daro clay sealing, Dk 9281 and a Black steatite seal, Dk 832.

In ceramics we met with many symbols which although elemental were bound by specific conventions, associations and abstractions. Thus the repeated recurrence of these symbols was interpreted as being more than coincidental. However (excepting the button seals) in the Indus Valley amulets, although some subjects may be similar in conception to subjects in Western art, the Indian and the Western expressions are not further connected repeatedly by recurrent forms and details. Therefore the more or less analogous motifs need not ultimately be derived from a common source. Specifically no basic relationship with Western Asian art or cults can be inferred from the Harappan amulets. What can be clearly seen however is a precise relationship between Indus Valley forms—although depicted in miniature—and details of later Indian religious art. We are not referring here to a stylistic connection, although in certain instances even this is evident, but to similarities in details like posture, ornaments, or associations of motifs.

Fig. 107

We have noted above the role of a male ascetic or divinity in the Indus Valley. Reference may be made to a seal reproduced in figure 117 depicting this figure in a form—apparently three-faced—which anticipates Siva. A number of other seals or amulets are evidently associated with fertility and the female goddess. In figure 115 we see the representation of a female upside down with a plant issuing from her womb. In another elaborate scene[61] a deity is depicted standing between branches of a tree, possibly a pipal, faced by a supplicating figure and a composite animal. In the foreground are seven standing figures with long plaits and plumed headdresses. In a number of sealings a figure similarly stands between pipal branches which are inverted to form an arch.[62] These illustrations indicate the existence of a tree cult associated with fertility. However, more interesting from the viewpoint of a connection with later Indian art or religion are representations of trees surrounded by a railing or platform as can be seen for example in figures 118 and 119.

Fig. 108

A very interesting and elaborate amulet depicts on one face an interlaced motif which is compared by Mackay to a device on a seal from Lagash.[63] Twists are not seen often in Harappan art, but another interesting example from a copper tablet is illustrated in figure 120. Similar patterns are common in pre-dynastic Egypt[64] and in Sumer especially in the early periods where they are known to have had a talismanic significance.[65] The Indus Valley representations of such designs probably had equivalent connotations and possibly they are survivals of an early symbolism and associated with interlaced pottery patterns. The reverse of the amulet mentioned above illustrates a scene with figures and trees interpreted by Mackay as possibly representing a tree marriage.[66] An object to the left is similar in shape to a typical Harappan painted vase.

Fig. 109

Depicted on an amulet which evidently also illustrates some involved ritual is a two-headed antelope. Although such figures are rare in the Indus Valley, it is worth noting, in view of their prominence in later sculpture, that they do exist. This two-headed animal seen in figure 121 may be compared with a jugate tiger head from Harappa seen in figure 122 and with a two headed antelope on a copper tablet illustrated in figure 123. We shall shortly see that multiheaded,

[61] Marshall, op. cit., pl. xii, fig. 18.
[62] Vats, op. cit., pl. xciii-307 and 317.
[63] Mackay, op. cit., pl. xc-23, p. 354.
[64] Marshall, op. cit., p. 400.
[65] Mackay, op. cit., p. 354.
[66] Ibid., p. 355.

Fig. 110

Fig. 111

Fig. 112

Fig. 113

Fig. 114

Figs. 115-116

interlocked and other fabulous creatures are fairly prominent in the Indus Valley repertoire, a hint that their recurrence in historic Indian art may be attributed to a Harappan heritage. However, this issue must be postponed for consideration in a later section.

We may draw attention to our figures 121 and 122 and compare them with 3rd millennium seal impressions from Susa shown in figures 124 and 125. The Iranian impressions are discussed by Stanley Casson[67] who suggests that they may have been prototypes for the Achaemenid bull capitals. Casson notes the fact that this motif is not a continuous one, but one that recurs at intervals, as for example, again in the Luristan bronzes. He interprets this sporadic recurrence as possibly implying an existence in some as yet uninvestigated region such as the Kurdish mountains.

It is difficult to evaluate the connection between the Susian and Indian sealings and their bearing if any upon later Achaemenid and Maurya capitals. However, it is of interest to note, without as yet drawing any conclusion, that the Persian protomes have no early architectural prototypes and that the proto-historic Iranian addorsed animal forms have counterparts broadly speaking in the Indus Valley.

We may conclude our selective survey of amulets with the mention of a three-sided prism depicting on one face a tree and a buffalo attacking a man, on the second, a tree, a goat and a three-headed animal, and on the third, a picture very much resembling footprints.[68] Tentatively these footprints or feet may be associated with later Buddhist sculpture in which their sacred character is established.

Earlier we suggested that unlike the amulets which apparently depicted religious scenes, the conventional Indus Valley seals may have had a secular function, perhaps for identification or labelling.

The majority of the typical Harappan seals skilfully portray one of several animal figures in a state of passivity. These animals, most commonly unicorns or bulls—along with the standard objects in front of them—have nothing about them which suggests any association with motifs typically seen on seals or elsewhere in Iran, Mesopotamia or the Aegean. However an important minority of these seals are comparable with Western Asian seals and motifs. It is important that this subsidiary group of seals with Mesopotamian parallels be correctly evaluated as the interpretation of the Indus Valley Civilization's position vis-à-vis Mesopotamia to some extent hinges upon them.

The most notably Westernized of the Harappan seals depict semi-human and semi-bovine creatures attacking a tiger. These figures are distinctly similar to bull men illustrated on more or less contemporary Sargonid seals. The Sargonid figures have been associated with the Gilgamesh legend on the basis of context although none of the artistic representations are connected with the epic by an inscription.[69] The Gilgamesh epic is an involved narrative describing at one point the destruction of wild beasts by Gilgamesh—legendary King of Erech, and his friend Enkidu—the bull man.

[67] Casson, "Achaemenid Architecture: The Aesthetic Character," *A Survey of Persian Art*, 1938, Chapter 16, edited by Pope.
[68] Mackay, op. cit., pl. xcii-12.
[69] Hemi Frankfort, *Cylinder Seals*, 1939, p. 63.

The seal cutters of the Sargonid age had inherited a multitude of fabulous creatures from the Early Dynastic Period, but only the bull man was successfully retained. Figures of the human faced bull also are seen but are poorly executed.[70]

The reappearance of bull men in the Indus Valley in a context related to the Sumerian epic, that is in the act of attacking wild beasts, and in a form duplicating that of Enkidu, implies a direct transfer of this motif from one culture to the other. It is not probable that the Harappan and the Sumerian forms here were both derived from an earlier common prototype, as further parallel developments are not widely recurrent and as the Harappan examples of this motif did not take root but occur more as an odd and isolated group among the conventional seals.

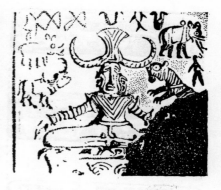

Fig. 117

It is for this latter reason as well as for the fact that the Sumerian figures apparently antedated the Harappan ones that we preclude the probability of this motif originating in the Indus Valley. Thus evidence for a common origin or a Harappan origin for the Enkidu seals is not convincing, and we are left with the conclusion that the bull man figure migrated from Mesopotamia to the Indus Valley.[71] The implications of this migration must not be exaggerated. The transference of an occasional motif between contemporary cultures, particularly when there is evidence as we shall see that these cultures were in commercial contact, cannot be interpreted as implying any profound relationship between the two communities and certainly not as implying that one of these cultures sprang from the roots of the other. It is within reason to assume that along with the Enkidu figure, the Gilgamesh legend migrated to the Indus Valley, but there is no evidence that it was originally held in particular reverence there, as apparently the seals on which the bull man is depicted were not religious objects. However many of the devices seen on them have been taken from a religiously oriented repertoire, and, eventually, aspects of the Mesopotamian epic and cult might have become absorbed.

Fig. 118

It is not possible to determine as yet by what conventions the selection of motifs for seals were limited or what they signified. Any speculations on this matter would be tentative. However, if the devices were in any way associated with or representative of groups into which the population was divided, it is within the realm of possibility that the bull men seals were the mark of a small community of foreigners from the West.

Fig. 119

Figure 125 illustrates a bull man from a Sargonid seal. He is depicted always in the same fashion with a human torso and face and with the horns, tail, and hind legs of a bull. Figure 126 from Mohenjo-daro, as can be seen, is similar to the Mesopotamian personage in conception and detail. However it is interesting to note that in the Indus Valley representations a tiger is substituted for the lion always fought by Enkidu. Figure 127 depicts a hero grabbing two tigers by the throat and has been compared with an Egyptian motif[72] but its identity is not as clear cut as in the preceding sample. The horned personage in figure 128 from an engraved copper tablet is perplexing and has been interpreted by Marshall as possibly Gilgamesh himself[73] and by Mackay as a divine hunter in a costume of

[70] Ibid., p. 82.
[71] Marshall, op. cit., p. 76, endorses the view that the resemblance between the Sumerian and Indus Valley forms is too marked to be chance or derived from a common prototype and consequently must be attributed to a borrowing.
[72] Mackay, op. cit., p. 337. This figure is compared with a scene on an ivory handle from Gebel Arak.
[73] Marshall, op. cit., p. 76.

Fig. 120

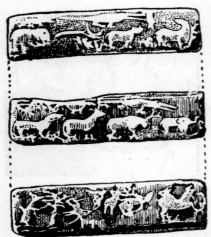

Fig. 121

Fig. 122

Fig. 123

Fig. 124

leaves.[74] The use of horns as a symbol of divinity is an established convention in Western Asia and Crete.

Another group of seals depicts composite or mythical animals some of which may be considered comparable in idea with West Asiatic monsters. However the Harappan and the Occidental fabulous beings are of a different breed and execution. The ones on the Indus Valley seals are usually portrayed in the same way as the natural beast standing in profile and in a state of inactivity and, unlike the bull men, they do not look out of place in the Harappan repertoire. Their treatment as seen in figure 129 also approximates that of the realistic animals and their inspiration is evidently indigenous—to the extent that Mackay has proposed, "It is not outside the bounds of possibility that the conception of a composite animal originated in India and spread from there gradually to the West by the land route."[75] There is no further evidence to substantiate this view or to suggest further implications.

What is notable in this connection is the prominent role held by fabulous beasts in later Indian sculpture, as well as in the sculpture especially of Assyria and Achaemenid Iran to whose influence the historic Indian forms have been attributed by many scholars. The extent to which proto-Indian prototypes might have inspired the historic versions of composite creatures will be considered further ahead.

In the course of our study of the Harappan amulets a number of scenes are encountered in which both natural and mythological creatures participated. In one such scene described above a fabulous animal part bull, part goat, and with a human face stands behind the supplicating figure.[76] The recurrence of composite creatures on the regular seals suggests that these were taken from the Indus Valley religious repertoire. The same conclusion can obviously be drawn about the Siva prototype who appears on amulets and again on a seal. It is likely that even some of the simple animals depicted had a role in religious traditions.

A familiar Harappan monster, who is portrayed on several seals, has been considered as perhaps representing a divinity. This creature is illustrated in figure 130 and may be compared with the Sumerian human headed bull seen in figure 131. The Sumerian form appears on cylinders for the first time in the Third Early Dynastic Period.[77] The Harappan composite monster is more imaginative, combining for example ox like forelegs, tiger like striped hind quarters, short curved horns, an elephant trunk and tusks and a human face. Figure 130 however, representing a bearded human faced ram from Mohenjo-daro, resembles the Sumerian figures somewhat more closely.

One interesting seal[78] illustrates a dancing figure in front of a unicorn. We will shortly discuss the seals depicting this animal which is almost always associated with a cult object described as a sacred brazier[79] or incense burner. However in this particular example the dancing monkey or masked human figure replaces the cult object. Frankfort refers to similar "monkey imps" on Cretan and Mesopotamian intaglios and says of this figure, "... he personifies the evil of which the worshipper

[74] Mackay, ref. J. Marshall, *Mohenjo-daro and the Indus Valley Civilization*, 1931, p. 399.
[75] Mackay, *Further Excavations at Mohenjo-daro*, 1938, p. 333.
[76] Marshall, op. cit., pl. xxii-18.
[77] Frankfort, op. cit., p. 51.
[78] Mackay, op. cit., lxxxviii-316 and described on page 334.
[79] Piggott, *Prehistoric India*, 1952, p. 102.

desired to be free."[80] This Mohenjo-daro seal is exceptional and difficult to classify.

A number of other Harappan seals are unique and do not lend themselves to any generalized comments or comparisons. Some of these have been illustrated in figures 132-136 as they are extremely interesting. Figure 132 has been interpreted as a five or six limbed swastika ending in horned heads[81] and perhaps is comparable to a Mesopotamian animal swastika depicted in figure 137.

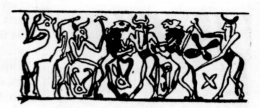

Fig. 125

Seals representing plant forms are rare. Figure 138 depicts a tree. One seal has also been found illustrating a boat[82] which is unexpected and quite out of keeping with the nature of the rest of the motifs.

Until now we have been reviewing the exceptional Indus Valley seals and sealings and considering their points of relationship with Western motifs. Before proceeding to study the remaining typically indigenous seals, let us briefly recapitulate. We have shown so far that while certain parallels can be drawn between motifs on Harappan and Western Asian seals or amulets these in general are neither as recurrent nor as unmistakable as parallels in ceramic symbols. Exceptional are the so called button seals which illustrate many of the same elemental symbols seen in the ceramics of the ancient Orient as a whole. The similarities between Harappan and Mesopotamian art as seen thus far in the Indus Valley glyptic tradition can be attributed largely to contemporary borrowings or to parallel independent evolution. Although it is not out of the question that some similar forms may be the result of a common cultural origin, neither is it obvious that such is the case. The evidence of evolved repeated parallels widespread in time and space, such as we have seen in our study of pottery motifs, is not present in the case of seals. Rather the parallels we have seen in the Indus Valley glyptic tradition are limited to occasional examples of similarity in varying degrees between more or less contemporary repertoires.

Fig. 126

The connection between the Harappan seals described above and their Western counterparts may be summarized as a superficial though important one for establishing the existence of cultural intercourse between Western Asia and the Indus Valley. However, a basic relationship does not exist between the more typical motifs depicted on the great majority of the seals and motifs abroad. Exceptions of course are seals which had been transferred from one country to another or seals directly copied from a foreign prototype.

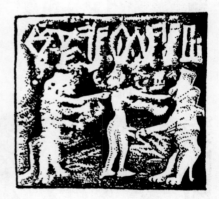

Fig. 127

The usual subjects repeatedly illustrated on the Harappan seals are fairly limited and stereotyped. The most frequently depicted animal—always seen with heart shaped trappings—appears to be a unicorn, but may have been intended to represent the Indian ox in profile with one horn hidden. At least two sealings have been found in which an animal similar to the so called unicorn or urus bull, but with two horns visible, is represented along with the object which invariably accompanies the unicorn. However the two horns in these examples are of a different shape from the single one seen on the unicorn.[83]

The cult object appearing below the unicorn has been described as an incense

[80] Frankfort, *Journal of Egyptian Archaeology*, XII, p. 94.
[81] Mackay, op. cit., p. 333.
[82] Ibid., p. 340, pl. lxxxix.
[83] Mackay, op. cit., p. 326.

Fig. 128

Fig. 129

Fig. 130

Fig. 131

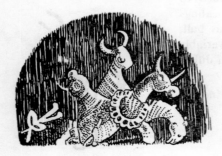

Fig. 132

burner by Marshall and Vats. However this explanation though plausible is not unquestionable and alternative identifications have been offered.[84] That this object was held in reverence is suggested by the fact that it appears alone on a Mohenjo-daro seal[85] and on three miniature sealings from Harappa. Figures 139 and 140 illustrate two of the unicorn seals. Variations are seen in minor details but not in any essential elements. Both the animal figures and the accompanying cult object are essentially without parallel outside of the Harappan sphere of influence. We have seen earlier in figure 30, illustrating a Kulli sherd from Mehi, a cow tethered to an object which approximates the Harappan incense burner.

Second in popularity is the short horned bull who is depicted with remarkable success in a state of anger and looks ready to charge. With this figure is associated a manger like object which is suggestive of basket work.[86] One unusual seal illustrates two bulls in combat.[87]

The humped Brahmani bull is seen on a number of seals without any associated cult object. Figure 141 illustrates this animal at its best. The seal cutter's familiarity with this Indian beast par excellence is apparent and the bull's restrained strength is skilfully portrayed. If there has been any question about the artistic qualities of the Harappan seals at their best, this example should dispel them and at the same time relate the Indus Valley glyptic tradition to historic Indian art. Similarly the seals depicting elephants, as for example figure 142, may be considered as containing in a condensed form the nucleus of a realistic school of Indian sculpture the current of which throughout the centuries remains unaffected by artistic traditions in other lands.

The remaining seals, some of which are very well done, less frequently illustrate the buffalo, the rhinoceros, the tiger, the gharial and goats, both human faced and normal. Just a few examples have been found of antelopes which are a common subject on Sumerian seals. One antelope seal from Mohenjo-daro[88] has been considered an import on the basis of subject, material (fine white marble like stone), and treatment, all of which are unfamiliar.

The foregoing survey of Indus Valley glyptic art has shown this tradition to be essentially indigenous. The brevity of our commentary on the seals which are without counterparts as compared with the lengthier discussions suggested by those very few seals which are in some ways comparable to Western expressions, should not be interpreted as a lack of emphasis on the former. On the contrary, this brevity is an indication of the extent to which the Harappan seals are disassociated from West Asiatic traditions.

The implications of this independence of the Indus Valley artistic tradition as seen in the seals will be considered shortly. But first we will continue our survey with a mention of the important evidence provided by the seals of commerce between Harappan and Mesopotamian civilizations.

[84] For example, Agrawala, *Indian Art*, 1965, pp. 31-35.
[85] Marshall, op. cit., pl. xiii-20.
[86] Mackay, op. cit., pl. lxxxix-370.
[87] Ibid, pl. xcix-661. Mackay comments upon the fact that this motif is not Sumerian or Elamite but is common on the walls of tombs in Egypt, p. 328.
[88] Mackay, op. cit., p. 322 and pl. xcv-479.

Apart from the importance of the finding of Harappan seals as well as other objects[89] in Mesopotamia as conclusive proof that the two regions were in contact[90] and as evidence for dating the Indus Valley Civilization,[91] these discoveries present an interesting problem of artistic relationships.

A number of the Indus Valley style seals found in Mesopotamia show permutations of motifs and techniques the interpretations of which bear upon our evaluation of the fundamental relationship between proto-historic India and the West. Frankfort, on the basis of parallels in the seals as well as other common points, has considered that many parallels not explicable by trade must revert to a common cultural substratum.[92] He adds: "But if the seal cylinder belonged together with a variety of other inventions to the common stock of the Indus and Mesopotamian Civilization, then the discovery of earlier remains than any yet found at Mohenjo-daro or Chandu-daro should reveal a more extensive use of the cylinder seal in India." Frankfort expressed this view about 25 years ago but no evidence seems forthcoming to support his suggestion. Nor do the few examples of Harappan cylinders found have any definite relationship with traditional cylinder seals of Western Asia.[93] The implications of the above would seem to be that the Indus Valley and the Sumerian glyptic traditions evolved independently. The seals showing combined Harappan and Mesopotamian features or unconventional Harappan traits may be attributed to a cultural interchange as a result of commerce.

Figure 143 illustrates a glazed cylinder seal of Indian style and workmanship which was found at Tell Asmar in a stratum dated c. 2500 B.C.[94] It depicts the typically Harappan elephant, rhino, and gharial. A seal from Ur depicts the Indus Valley Brahmani bull with a scorpion, but along with the manger which traditionally accompanies the short horned bull.[95] This seal and the Tell Asmar one just described have grooves at each end which were not used in Mesopotamia beyond the Jamdat Nasr Period. Frankfort interprets this detail as implying an early Western influence accounting for the presence of cylinders in India.[96] Furthermore a Jamdat Nasr seal depicts a type of a monster unique in Mesopotamia but familiar in the Indus Valley—the bull with an elephant trunk.[97] Another seal from Tell Agrab of the Second or First Early Dynastic Period again shows a

Fig. 133

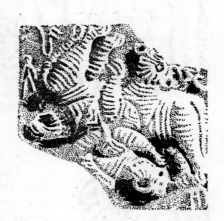

Fig. 134

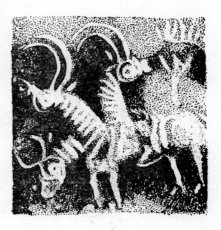

Fig. 135

[89] For example: inlay work, pottery, a die and etched carnelian beads, the Indian origin of which is probable. Cf. Marshall, op. cit., pp. 104-5; Piggott, op. cit., pp. 208-209; Frankfort, op. cit., p. 306; Leemans, *Foreign Trade in the Old Babylonian Period*, p. 33, regarding beads.

[90] Sumerian objects in the Indus Valley are few and not of defined origin. Exports from the West apparently consisted largely of perishable items. Indian exports in the historic period were to a large extent luxury items. Cf. Leemans, op. cit.

[91] See Appendix—Chronological Notes and cf. Piggott, op. cit., pp. 208-9; Frankfort, "The Indus Civilization and the Near East," *Annual Bibliography of Indian Archaeology*, 1932-34.

[92] Frankfort, *Cylinder Seals*, 1939, p. 307.

[93] Ibid., p. 304.

[94] Frankfort, "The Indus Civilization and the Near East," *Annual Bibliography of Indian Archaeology*, 1932-34, p. 3. Eighteen Indus seals were found at Ur but not in well dated contexts.

[95] Frankfort, *Cylinder Seals*, 1939, p. 305.

[96] Ibid., p. 305.

[97] Ibid., p. 307.

Fig. 136

Fig. 137

Fig. 138

Fig. 139

Brahmani bull with a manger but is otherwise Mesopotamian in execution and in some details.[98]

The above examples suggest that commerce between the Indus Valley and Mesopotamia existed from the Jamdat Nasr period.[99] As regards Iran there are some indications of contact in the Hissar III culture.[100] At Lothal further evidence of active intercourse between Harappan communities and the West has come to light (See Chapter III—3, Harappan Outposts).

Commercial exchange is a potent means of spreading cultural traits and influencing artistic repertoires. We can therefore certainly expect that both the Harappan and the Mesopotamian Civilizations were affected by the knowledge they gathered from merchants and imported objects, and that certain artistic subjects, forms or ideas thus acquired may have taken root in foreign lands. In fact, earlier we have attributed to cultural exchange stimulated by commerce, the presence of the bull men in Harappan seals. Inversely, the occurrence of some monsters in the Mesopotamian repertoire might have been an Indus Valley contribution as suggested by Mackay. However this type of influence exercised through contact upon an already developed culture and upon a formulated artistic tradition must not be confused with the sort of influence that has bearing upon the fundamental development of a culture or alters the trend of its art. The influence resulting from trade between two flourishing contemporary communities is limited to occasional artistic expression. It does not have anything to do with origins or basic impulses and its impact stimulates progress but does not effect any significant change in indigenous currents.

The Harappan seals were apparently conceived and conventionalized before their forms or context could have been guided by foreign ideas. Essentially they represent an independent tradition from the beginning. Parallels with Western forms generally refer to contemporary cultures suggesting that they are attributable to cultural exchange rather than to a common origin. We have just seen the evidence that this exchange was stimulated by commerce.

Based on the knowledge that between India and the West well established trade was carried on, and considering the superficial quality of the influence that Sumerian Mesopotamia might have exerted upon the Indus Valley as a result of this trade, we may confirm that in essence the Indus Valley glyptic tradition reveals no fundamental dependence on or association with Western Asia. At the same time we may refer to intercourse in order to account for parallels in subjects or ideas that would not seem to have evolved independently.

The above conclusion does not further imply that no common roots relate the Indus Valley with Western Asia. Just the opposite view has been

[98] Ibid., p. 306.

[99] Studies on Mesopotamian sea borne trade identifying the "Meluhha" of the Mesopotanian texts with the Indus Civilization are of interest in this connection. Cf. Oppenheim, "The Seafaring Merchants of Ur," *Journal of the American Oriental Society*, LXXIV, 1954, and Leemans, op. cit.; an alternate theory is put forth by S. N. Kramer, who identifies "Meluhha" with Ethiopia and "Dilmun" with the Indus Valley Civilization. Cf. Kramer, "Dilmun: Quest for Paradise," *Antiquity*, XXXVII, 1963.

[100] Piggott, op. cit., p. 209.

expressed on the basis of our study in pottery. However it very much appears as if these common roots or a common "substratum" antedate the development of the seals. Unlike potters, the seal cutter had no perpetual medium through which ancient common forms or symbols could survive as seals were not inevitably the equipment of ancient communities. Harappan ceramics with great conservatism retained and transformed inherited motifs which at some point in antiquity had been seen on the pots. However at the time when the heritage shared by India and the Near East was being diffused, no prototype for either the typical Harappan stamp or the Sumerian cylinder was as yet known. Thus the glyptic traditions of prehistoric India and of Western Asia developed along different lines.

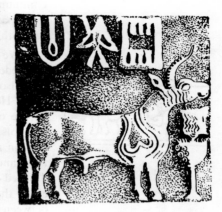

Fig. 140

The above suggestion accounts on the one hand for the basic dissimilarity between motifs seen in Harappan and Mesopotamian seals and on the other for the difference in the forms of the seals themselves. It also takes into account some early connection as evident in the shared concept of manufacturing and using seals, a concept which though widespread is by no means universal. Thirdly it clarifies the exceptional closeness in form and context seen between the Indus Valley so called button seals and some early stamp seals from Mesopotamia and Iran. These seals and some miniature seals from Harappa retained old and common symbols such as are also seen in pottery. The buttons or miniature seals may also be considered as having possibly provided a simple form from which the regular Indus Valley seals were evolved. The elemental geometric motifs that have survived in these buttons, not the animal forms of the conventional seals, represent the ancient heritage which linked proto-India with Western civilization.

Although the early stamp seals as we have seen antedated cylinders in Mesopotamia and Iran, with the advent of the Sumerians they were superseded by the latter. Stamp seals from Syria of the Halaf period and button seals from Tel-i-Bakun, Sialk III, Giyan V and Hissar I in Iran[101] to which we have referred and which have counterparts in the Indus Valley are interpreted by Piggott as suggesting that Harappan Culture was related more closely to Iran than to Mesopotamia. In this connection he writes, "The fact that Harappan Culture is characterised by stamp seals should indicate that its eventual antecedents are likely to be found in Persia."[102] He adds, however, "but it is curious that stamp seals are unknown in any of the Baluchistan cultures, the couple from North Baluchistan already mentioned in Chapter IV being of Harappan type and probably, imported from the plains . . . "[103]

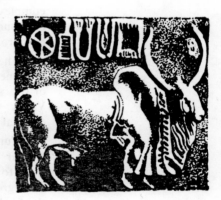

Fig. 141

It does appear at first surprising as Piggott points out that Harappan Civilization which as far as pottery is concerned seems closely related with Baluchistan, in the matter of seals has no links with other Indian chalcolithic

[101] Piggott, op. cit., pp. 184-85.
[102] Ibid., p. 185.
[103] Ibid., p. 91. The reference to seals in Baluchistan are to an irregularly shaped steatite example from the Nal cemetery engraved with a vulture whose foot is on a snake and which is cross hatched as in pottery drawings and to a copper stamp seal also found at Nal.

It may be suggested that these examples perhaps were not imported, as the description suggests that they differed from the conventional Indus Valley forms but were rather copies inspired in Harappan prototypes yet executed according to local imagination. However in either case they may be attributed to Indus Valley influence.

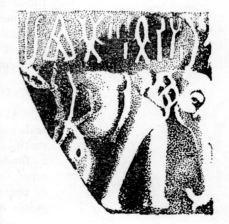

Fig. 142

communities. But further consideration suggests an explanation for this apparent discrepancy. A tentative interpretation presents itself which may shed some light upon this problem.

Fig. 143

We may propose in this connection that the remote and perhaps Iranian antecedents of Harappan Civilization were in fact West Asian as suggested by Piggott and also inferred from the evidence of ceramic motifs and of button and miniature seals. However these antecedents stimulated only the early unformulated beginnings of the cultures which later evolved in North-West India. Thus we see parallels in symbols and in some early forms of seals which are common to the Indus Valley, to Iran and to Mesopotamia. Yet the formulated glyptic traditions seen in Western Asia and proto-India were developed independently after the early impetus which diffused from Iran eastward had been absorbed. Consequently we do not see in either the form or content of the seals any further evidence of underlying relationship between Harappan and West Asiatic Civilizations.

As regards the general absence of seals of any kind in the Baluchistan cultures, it may be suggested that this absence does not preclude an ultimate derivation of Harappan culture from some of these earlier simpler communities.

To say that the Indus Valley Civilization to some extent evolved from less complex chalcolithic settlements, is not to claim that the Harappan and Baluchistan communities were identical or even that all essential elements of Harappan Culture had prototypes in underlying or earlier communities.

The Harappan Civilization was a unique development in the ancient Orient and one which in many respects had no counterparts. As we stated at the beginning of this section, the seals may be considered as an outstanding feature of the Indus Valley which is without precedent or parallel except perhaps as regards the original idea.

Furthermore, as we suggested earlier, the general impression conveyed by regular Harappan seals is that they were used for secular purposes and thus their form and function probably developed belatedly to fulfil the requirements of a growing and complex society. Consequently the general absence of seals in the far less complex agricultural societies which preceded the Harappan Civilization can be understood as a lack of necessity, and this absence ceases to be a paradox. On the contrary, in the light of the foregoing interpretation it becomes expected. The only remaining question is whether the early button type seals which could have served as buttons, stoppers[104] or amulets were at all known in North-West Indian agricultural settlements, even if they apparently were out of fashion because they met no further requirement. A few odd examples of seals like those found at Nal and at Quetta as well as the general diffusion of these seals and their recurrence in post-Harappan times suggests that although not popular they could not have been entirely unknown.

CONCLUSION

At the beginning of this section it was anticipated that the study of Harappan seals would lead to different conclusions from those suggested by the study of pottery motifs. While the designs which decorated the Harappan painted pottery showed a fundamental relationship with designs and symbols seen in West Asian repertoires, the Indus Valley seals do not reveal any comparable similarity in form or content with the glyptic traditions of Mesopotamia and Iran. Although certain points of contact are evident, these are exceptional and attributable not so much

[104] Herzfeld, op. cit., p. 13.

to a common origin as to influence spread by commerce or perhaps in some cases to coincidence. The only examples in which a more basic relationship with the West seems evident are a class of so called button seals and some of the earlier miniature seals from Harappa, the symbols on which are comparable with those on Iranian and Mesopotamian seals of pre-Sumerian times.

Although it appears at first as if the conclusions arrived at from our study of Harappan ceramics and seals in relationship with Western forms are discrepant, they are in fact complementary and relevant. These two conclusions—one for the seals and one for pottery—together suggest a possible explanation of the nature of the Indus Valley's original debt to the West and at the same time are testimony to the subsequent independence of this culture.

Earlier we proposed the view that the migration of pottery symbols and patterns represented a diffusion of culture from the West to the Indus Valley. Although migration of people may have contributed to this diffusion, as pointed out above, actual influxes of population were not wholly responsible for this cultural and artistic spread.

Toward resolving the question of how Harappan Civilization as we know it came into existence, several suggestions are proposed. Artistic evidence indicates that after original stimuli which had diffused from the West were absorbed and adapted to the local milieu, the Indus Valley Civilization developed spurred on by its own momentum and feasibly without further outside intervention. Harappan pottery retained traces of an original Western heritage which had reached the Indus Valley region much earlier. Seals, however, were a newer development and thus do not reveal any fundamental affinity with Occidental forms.

But, even in Harappan ceramics, we saw a distinctive cultural strain that is independent of any other tradition. This indigenous strain produced vessels with naturalistic flowing designs. Inversely, even in the seals we see some evidence of an earlier heritage shared with Western Asia, which is manifest in the geometric symbols on the miniature seals.

In conclusion it may be repeated that Harappan Civilization appears to have evolved in the Indus Valley independently of Western Asia—except for a very early original stimulus. This stimulus evidently fell upon exceptionally fertile ground, took root and in combination with an indigenous tradition resulted in an outstanding and prosperous civilization. Many favourable circumstances must have converged to contribute to its flourishing. Even today with the accelerated diffusion of cultural traits and advances, many stimuli fall on sterile soil. It is not everywhere and at any time that a civilization as extensive and advanced as that of the Indus Valley thrives.

On the other hand there is no reason why Harappan Culture could not have evolved itself without direct external intrusion in the form of new population influxes. Once a process of growth and development is set into motion, even the smallest cultural nucleus can make great progress. Similarly, as proven time and time again by history, once decay sets in nothing can prevent the ultimate collapse of even the greatest empires.

4. TERRACOTTA AND SCULPTURE

The terracotta tradition of the Indus Valley as regards its relationship with Western cultures shows evidence of fundamental links especially in reference to the mother goddess cult. Simultaneously this tradition illustrates an independence of Occidental forms and an explicit connection with historic India as seen in the de-

tails of the Harappan and later figurines. The above pattern of associations fulfils the expectations to which our study of Harappan pottery and seals led and does not conflict with the conclusions suggested in the preceding section. A problematic issue arises in the analysis of the fact that the mother goddess cult as evident in the prevalence of baked clay female figurines seems to have been concentrated at certain sites.

More complex and subject to possibly controversial evaluations are the remaining examples of Indus Valley sculpture as these reveal the existence of totally divergent schools. The discrepancy between the sculptured figures and terracottas and the limited number of the former, make it difficult to generalize about similarities and differences with West Asian traditions and connection with historic Indian sculpture.

Nevertheless Harappan sculptures provide further interesting insights into the Indus Valley artistic tradition. It has been pointed out in connection with our discussion of the Baluchistan female figurines that the mother goddess cult was of great antiquity and widespread, though not universal. Therefore the evidence that this cult flourished in the Indus Valley is not unexpected. Rather it again confirms the existence of an early common civilization. But very perplexing is the absence of evidence for the existence of a flourishing mother goddess cult at Indus Valley sites further south or in the Quetta and Amri-Nal Cultures. As we have seen earlier only in the Kulli and Zhob complexes were female figurines of conventional types found in significant numbers.

A number of suggestions could be offered in an attempt to explain these lacunae. A guess may be hazarded to the effect that worship of the female goddess was concentrated at certain religious shrines or holy places and that thriving cities developed around sacred centers. This suggestion has some support in the fact that even in Harappan communities, Harappa and Mohenjo-daro yielded a larger proportionate number of female figurines.

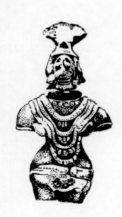

Fig. 144

The Indus Valley statuettes on the whole are typical and unaffiliated with Occidental counterparts. These figurines, a good example of which is illustrated in figure 144, may have been either votive figures, or cult images. They are more pleasant in appearance than the bird-like Kulli figurines or the morbid hooded Zhob statuettes and are generally dissimilar from Mesopotamian figurines, although, as we shall see, comparable details may be significant. Several Harappan specimens are seen with infants and one figure appears to be pregnant, but the majority of the figures suggest feminity more than fertility. On the other hand these two conceptions are intermingled and may embrace a third destructive or funerary symbolism as well.[105] It has been pointed out that the goddess cult often combined the ideas of motherhood and virginity[106] and it is possible that both of these attributes were associated with the Harappan figures.

The study of Indian terracotta art has been enlightened by Stella Kramrisch's distinction between ageless (usually modelled) and "timed" (usually moulded) figures.[107] In the former group there is unbroken continuity from Harappan to historic times, while the latter group reflects stylistic changes of the periods in which the figures were created.

[105] The presence at Harappa in funerary urns of tiny bird cages—possibly associated with the dove which is believed to have been sacred to the mother goddess—may represent the funerary aspect of this cult. Cf. Vats, *Excavations at Harappa*, 1940, p. 453; Mackay, *Further Excavations at Mohenjo-daro*, 1938, p. 295; Hutchinson, *Prehistoric Crete*, 1962, p. 210.

[106] James, *The Cult of the Mother Goddess*, p. 41; Vats, *Excavations at Harappa*, 1940, pl. cxx-22 to 26.

[107] Kramrisch, "Indian Terracottas," *Journal of the Indian Society of Oriental Art*, VII, 1939.

Coomaraswamy has studied Indus Valley figurines in relationship to both Mesopotamian terracottas and to later Indian types.[108] He has defined the traits of the Harappan figurines and compared these with traits seen in Sumerian and historic Indian models. This comparison has revealed that some characteristics are common to Mesopotamia and the Indus Valley, some are common to the Indus Valley and later India, and some characteristics appear in the terracottas of all three traditions.

The most notable details of the Harappan female statuettes are their elaborate ornaments and headdress. Generally naked except for a girdle, these figurines wear impressive many stranded necklaces with pendants. The pendants are sometimes stamped with rosettes. Similarly styled girdles and heavy necklaces remain in favour throughout Indian art history, and even details like the rosettes continue to be seen. Whether the rosettes in this context had purely ornamental value or an additional underlying symbolic intention cannot be conclusively ascertained. There is much evidence however that this attractive motif had a predominantly symbolic significance in early Western art as well as in Indian art of the Buddhist period.

The rosette appears through early West Asian and in Minoan art as a pottery design. In Harappan ceramics as we have seen, it is absent except as an all over pattern of intersecting circles. Rosettes commonly occur on cylinder seals and later as a dominant decorative motif in architecture. Herzfeld comments in connection with the rosettes in Achaemenid architecture:

"The rosettes, repeated thousands of times at Persepolis, and recalling the chrysanthemum of Japan, must have been a symbol of magic virtue, for they are found on square marble slabs, under the pivot-stones of all doors hidden from sight and with face downwards, i.e., facing the 'lower world'"[109]

We have discussed in the preceding chapter the transferrence of elemental motifs, first seen in ceramics, into architecture of later periods. In the light of evidence that such transference is significant, and that these elements survived for thousands of years retaining their symbolic connotation, we may anticipate the importance of the rosette in Buddhist monuments and suggest that this motif is derived from a far reaching and widespread ancient symbolism.

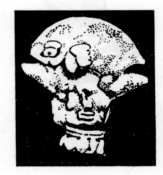

Fig. 145

Returning to the rosettes which adorn the Harappan figurines in several examples, as in figure 145, they are seen on the headdress, a convention which recurs in historic terracottas from Taxila and other sites.[110] It is also significant that rosettes are associated with female statuettes in the West, as can be seen in figure 146 representing a Mesopotamian goddess from Tello dated c. 2300 B.C. In these examples the use of floral ornamentation as a natural and beautifying accessory merges with a further deeper connotation perhaps connected with fertility or with divinity.

The headdresses displayed by the Indus Valley terracottas are interesting and on the whole distinctive—although in some cases comparable with foreign forms.

Stella Kramrisch with her unique insight has drawn attention to the underlying intention of representing the head as the seat of man's higher possibilities and making this potentiality manifest in horns, cranial bumps or oversized heads.[111] She has pointed out the fact that in time-bound terracottas such devices are disguised as

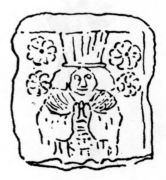

Fig. 146

[108] Coomaraswamy, "Archaic Indian Terracottas," reprinted in *Marg*, VI, 1952-53.

[109] Herzfeld, *Iran in the Ancient East*, 1941, pp. 233-234.

[110] Gordon, "Early Indian Terracottas," *Journal of the Indian Society of Oriental Art*, VXI, 1942, pls. viii-ix.

[111] Kramrisch, op. cit., p. 97.

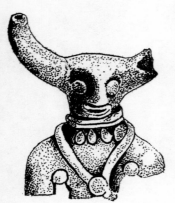

Fig. 147

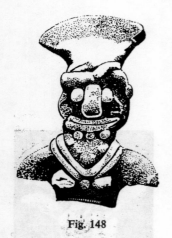

Fig. 148

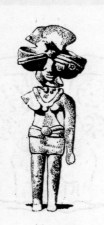

Fig. 149

headdresses and has further related the Usnisa—a cranial protuberance, representing the surpassing of the human state—to this fundamental convention.

It is interesting to consider the Harappan headdresses in the light of the above interpretation which clarifies the fundamental purpose underlying such elaboration. It would seem that from this viewpoint, the more carefully executed of the Indus Valley goddesses or female statuettes—although modelled—might be considered time-bound to the extent that they reflect a conventional and unmistakable style, and treat cranial extensions as headgear.

The accuracy of Kramrisch's analysis is confirmed by several Harappan terracottas in which the horns are unconcealed, as for example, in figure 147. Mesopotamian goddesses as well as kings or priests are similarly depicted with crowns, horns or other elaborate headgear.

Several distinctive types of feminine headdress are recurrent in the Indus Valley. One seen in figure 148 is fan shaped and may be compared with Western examples.[112] However this shape is relatively vague, and more or less parallel forms could easily be coincidental. Quite distinctive and unique is a popular headdress with pannier like projections at the sides, as seen in figure 149. Black soot like stains have been found in some of the panniers suggesting they may have been receptacles for tiny lamps, or were annointed with ghee which has become carbonized.[113]

A number of the figurines wear cone like ornaments. These have been compared with similar objects seen on second millennium figurines from Tello, and have been identified by Phyllis Ackerman as large conventional cow ears.[114] These cones are seen in figure 150 from Mohenjo-daro.

Other attributes of the female figurines establish a relationship between the Indus Valley and the Near Eastern and Cretan chalcolithic cults. In particular the numerous clay model doves that were found may have been linked with the goddess figures. The association of the mother goddess with the dove has been noted as early as the 5th millennium at Arpachiya[115] and is well known in Mesopotamia as well as in Crete. Further relationship with Western Asia is also suggested in the figure of a woman with a tray of round cakes.[116] This terracotta from Mohenjo-daro, according to Ackerman, may be associated with certain Ishtar rites featuring seven baked cakes.[117]

Nemerous terracotta triangular shaped objects, also generally referred to as "cakes", have been found at Indus Valley sites and were thought similarly to have had a ritual role. At Harappa itself a jar was found half filled with these clay triangles.[118] However, at the Harappan site of Kalibangan these so-called "cakes" were found interspersed with charcoal on the floors of houses, apparently to prevent them from becoming slushy.[119]

Various other Harappan antiquities were apparently associated with fertility and mother goddess worship. We have described above an amulet depicting a female figure with plants issuing from her womb (figure 115).

[112] Mackay, *Further Excavations at Mohenjo-daro*, 1938, p. 260. References are made to parallels in Asia Minor and Syria.
[113] Ibid., pp. 260-261.
[114] Ackerman, "Cult Figurines," *A Survey of Persian Art*, 1938, edited by Pope, Chapter II, p. 204, note 1.
[115] James, op. cit., p. 23.
[116] Marshall, *Mohenjo-daro and the Indus Valley Civilization*, 1931, pl. xcv-12.
[117] Ackerman, op. cit., p. 203.
[118] Vats, op. cit., pl. viiia.
[119] Cf. "Excavations at Kalibangan," *Indian Archaeology*, 1960-1961, p. 31.

Numerous objects identified as *lingas, yonis* and baetylic stones form a link between the chalcolithic cult and aspects of later Shaivism. Terracotta figures of males are in the minority, but somewhat less scarce at Harappa than at Mohenjodaro. The examples found illustrate varied attitudes and attributes. Several figures of horned males have been found;[120] other figures wear turbans,[121] and one statuette seems to have its hair wound in a spiral cone.[122] A fairly elaborate male wears a kilt with bosses and with a four-band necklace;[123] and another seated figure has a beard that curls under.[124]

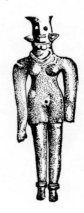

Fig. 150

On the whole, however, these examples are not especially revealing. They are indifferently or inexpertly executed and do not call for any special comment as regards either their affinity with other traditions or their distinctiveness.

Of considerable interest are some out of the ordinary terracottas of different styles. Many of these, such as grotesque figures, suggest relationships either with Mesopotamian or later Indian artistic traditions, or with both. However such parallels although interesting and possibly significant are not dependable for two reasons. To begin with many of the Harappan examples are not sufficiently well produced to be reliable evidence of any determinable artistic or religious intention. Secondly, the distinctive types are not sufficiently numerous to be evaluated as a group and thus compared as a whole with other material from the viewpoint of similarities in either concept, details or style.

A few terracottas represent human headed beasts or monsters.[125] Several examples have been found of moulded masks, some horned[126] and one representation has been found of a moulded double head.[127] A grotesque dwarflike figure seen in figure 151 is vaguely reminiscent of the dwarfs in early Buddhist monuments, but on the other hand may be merely inaccurately made.

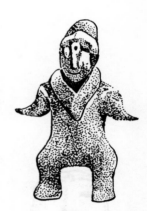

Fig. 151

Mackay has drawn attention to the possible significance of some of the above mentioned figures and to several Western parallels.[128] However, as we have just explained, it is not possible to draw definite conclusions from the interpretation of these terracottas and the likelihood remains of similarities being coincidental.

Numerous clay model animals have been found at Indus Valley sites, the majority of which represent humped bulls. Figures of cows are notably absent. Humped cattle were also found in large quantities at Kulli sites where they are painted with stripes. The Harappan terracottas bear traces of a red wash or slip. Other animals occurring in smaller numbers include the elephant, the rhinoceros, occasional dogs, turtles, monkeys, pigs, goats, etc. Figure 152 of a couchant ram is described by Mackay as having a "Sumerian look."[129]

Fig. 152

We have already commented upon numerous dove figurines, an example of which is seen in figure 153, and their probable association with the mother goddess cult.

Fig. 153

120 Vats, op. cit., pl. lxxvi, figs. 21 and 22.
121 Mackay, op. cit., pl. lxxv-8.
122 Vats, op. cit., pl. lxxvi-19.
123 Ibid., fig. 12.
124 Mackay, op. cit., pl. lxxiv-24.
125 Mackay, op. cit., pl. lxxviii-7, lxxi-1, lxxxi-2. These examples may be related with some of the monsters depicted on the seals and thus also with composites illustrated in later Indian sculpture.
126 Ibid., pl. lxxvi-2.
127 Ibid., pl. lxxvi-8.
128 Ibid., p. 268.
129 Ibid., p. 291.

Some of these terracotta animals although elemental in conception, are successfully executed and show the modeller's familiarity with his subject. As has been seen in the seals, the realism of the best figurines is comparable in quality to that characterizing later Indian sculpture, notwithstanding the modesty of the small Harappan figures. The characteristically Indian humped bull or elephant brought out the best in the Indus Valley craftsmen and are a link with historic Indian art which was similarly at its best when depicting these familiar indigenous animals. In protohistoric times, and subsequently, figures of bulls or elephants were naturally uninfluenced by any foreign traditions.

The prevalence of terracotta animals may be representative of a religious orientation directed at the animals depicted. That the figurines were not toys or simply decorative objects is suggested by several bits of evidence. The absence of model cows is notable as well as the fact that some figurines had holes possibly for suspension as amulets. The model doves are presumed to have been associated with the Harappan mother goddess cult on the basis of a known association in other civilizations, and we may infer that at least some of the other animals had similar connections. This brings us back to the humped bull and its known relationship with Siva in later times. The presence of a Harappan Siva prototype suggests that the bull figurines might have been associated with a cult in which this deity was predominant, a cult possibly distinct from that of the mother goddess and fundamentally unrelated with Western religions.

Of great artistic and historic interest are the few remaining examples of Harappan sculpture in the round. It is only unfortunate that there is so little material available as this scarcity casts some doubts upon the way in which the existing examples may be interpreted. It is difficult to draw conclusions on the basis of a few odd pieces and yet the possible implications of these works cannot be overlooked.

Perhaps the most outstanding of the Harappan statues is a bearded bust of a male apparently wearing a shawl decorated with trefoils. This personage, found at Mohenjo-daro and illustrated in figure 154, has been evaluated and re-evaluated many times since its discovery, but it still remains an enigma. Although the context in which it was found is convincing as far as its antiquity is concerned,[130] its artistic heritage is not easy to determine. In some respects this figure seems attuned to Mesopotamian sculpture. The formality, the short beard and brushed back hair, the use of inlay and the trefoil motif are characteristic of Near Eastern traditions. On the other hand, the closing narrow eyes—whose contemplative gaze fixed on the tip of the nose has been described by Kramrisch and subsequently by other writers as an attitude of Yoga,[131] the thick neck, and the statue's general personality are distinctive. If this figure who has been considered a priest or a deity is not a product of Sumerian traditions, neither does he as a whole easily blend in with other Harappan or later Indian sculpture. This figure is not a hybrid or a mixture of the Indus Valley and Mesopotamian schools. Rather it is a unique exponent of a sophisticated and as yet unidentified artistic tradition.

Comparable with this bust, but not of the same calibre are a few other figures. One, also bearded, limestone head with long narrow eyes shows the hair gathered in a bun at the back; another shaven figure is similarly coiffed. A terracotta head found at Kalibangan (on display at the National Museum, Delhi) is of the Harappan period and seems to reflect something of the style illustrated in the above noted sculptures.

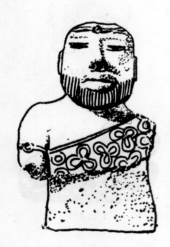

Fig. 154

[130] Piggott, *Prehistoric India*, 1952, p. 186.
[131] Kramrisch, *Indian Sculpture*, 1933, p. 4.

Attention may be drawn to the trefoil which adorns the robe or shawl of the statue in figure 154. This motif is an established sacred symbol in Sumer and Crete.[132] Although its occurrence in this context might be attributable to specific Western influence, there is some evidence that the trefoil was assimilated and significant in the Harappan repertoire. Figure 155 illustrates a pedestal that may originally have held a sacred object and is decorated with trefoils. Other fragments of vessels or inlay have also been found with this motif. An example of figure of eight motifs which appears with the trefoils on the Mohenjo-daro statue's robe has also been noted at Harappa on a silver ornament.[133] Both trefoils and figure of eight designs occur on etched carnelian beads which have been found in Mesopotamia as well as at Harappan sites and in recent times in Sind.[134] We have earlier commented on these beads as being of probable Harappan provenance and providing evidence for trade that took place between proto-historic India and the West. Evidence from Lothal discussed in the next chapter further substantiates the view that etched carnelian beads were of Indian origin.

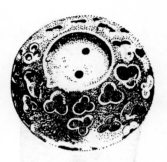

Fig. 155

Perplexing and interesting from a different standpoint are two small torsos from Harappa, one of a dancer, whose naturalism and plasticity are unique. Both of these figures were found in Vats' stratum V[135] associated with other objects of either red or grey stone. However the circumstances of the findings have been considered not fully satisfactory by archaeologists and some doubts have been cast about their authenticity as proto-historic works.[136] Particularly interesting is an affinity in treatment between the red sandstone torso reproduced in figure 156 and later Yaksha figures. The grey limestone dancing figure seen in figure 157 is also very well executed. Its abnormally thick neck may mean that it had more than one head or an animal head. The former possibility leads to a tentative association of this figure with Siva Nataraja, although the evidence is not adequate to ascertain such an identification.

Fig. 156

The discovery at Quetta of two fragmentary figurines illustrated in figures 158 and 159, which are similar to the Harappan torso in their realism and which similarly have been described as reminiscent of early Yakshi figures, is significant.[137] These fragments may be considered as evidence that both the Quetta and Harappa figures were in fact third millennium works and thus may be considered representative of a naturalistic tradition in proto-historic sculpture.

It remains, before concluding this section, to mention an outstanding bronze figurine from Mohenjo-daro. This statuette of a dancing girl, shown in figure 160, testifies to the existence of a sophisticated artistic tradition and has no equivalents in foreign cultures.

In this section we have tried to show through an interpretation of Indus Valley terracottas and sculptures that the proto-historic artistic tradition of India was defined and independent. We also have implied that in many respects this tradition survived and could be identified with the artistic attitudes expressed in early historic Indian sculpture. Although the evaluation of clay and stone figures to an extent may be

[132] Henry Heras, "The Trefoil Decoration in Indo-Mediterranean Art," *Rajah Sir Annamalai Chettiar Commemoration Volume*; E. Mackay, *Further Excavations at Mohenjo-daro*, 1938, pp. 411 and 666.

[133] *Annual Report of the Archaeological Survey of India*, 1928-29, p. 76, pl. xxx.

[134] J. H. Marshall, *Mohenjo-daro and the Indus Valley Civilization*, 1931, p. 516.

[135] Vats, op. cit., p. 140.

[136] Piggott, op. cit., pp. 185-186.

[137] Fairservis, *Excavations in the Quetta Valley*, 1956, p. 226, figs. 17 b and c. These figurines were found at the site of Damb Sadaat III. The dates for Damb Sadaat II-III are given as 2450-1650 B.C.

Fig. 157

Fig. 158

Fig. 159

Fig. 160

less clear cut than the interpretation of ceramic or glyptic motifs, the models them-selves reveal defined traditions. That these formulated traditions were largely independent of Occidental schools and were linked with later Indian art, can be more distinctly seen than explained. Nevertheless, at the same time, many details—such as nudity, rosettes, elaborate ornaments and headdresses—imply a relationship with, though not dependence upon, Western Asia. We suggest that this relationship, manifest in such ancient, widespread and enduring formulae was an early and elemental one.

5. THE BALANCE OF EVIDENCE

In the preceding evaluation of Indus Valley art vis-à-vis Western forms and motifs, we have refrained from referring to other material aspects of Harappan culture or to the balance of general evidence which though not conclusive has much bearing upon the problems of Harappan origins and relationships. However the conclusion to which our study of ceramic designs, seals, and modelling led, have been guided by all else that is known of Harappan Civilization.

The primary intention of this part of our study has been to present a continuous picture of the tangible elements in proto-historic Indian art in reference to Occidental forms, and to interpret any similarities or parallels that were revealed. A secondary intention however has emerged in the course of this survey. This is to analyze the origins of common motifs, and thus to analyze the origins of Harappan Culture, since the two issues to an extent are inseparable. And a third important issue also comes up in connection with the evaluation of art motifs and Western associations. This is to draw attention to the evident continuity between forms and subjects in proto-historic and later Indian art. This continuity as we shall see further has bearing upon the evaluatiom of certain elements in early Buddhist art as regards their dependence on or independence of earlier parallel forms in Mesopotamian and Iranian art.

In the course of this study our conclusions and opinions have been revealed as they were suggested by the material under consideration. Briefly we may review these conclusions. Harappan ceramics reveal significant affinities with Meso-potamian and Iranian traditions. These affinities are attributable to an ancient cultural diffusion. A second independent strain in Indus Valley painted pottery is evidently a local development. Similarly, Harappan seals are visibly evolved independently of West Asian traditions. Fundamental parallels are manifest only in a group of early miniature seals which are considered to reflect the same early cultural diffusion as parallels in ceramics. A group of seals are evidence of trade which flourished between Mesopotamia and the Indus Valley. Terracotta and sculp-ture again are seen to have largely evolved disassociated from Western trends. This consensus of material is interpreted as implying an original very early spread of influence moving from the West toward the Indus Valley Civilization. This influence could have stimulated the initial unformulated stages of Harappan development. However subsequently Harappan Civilization, as we know it in a formulated state, evolved without further Occidental intrusion. Parallels, especially in ceramics, re-present an early cultural diffusion and distinctive traits represent subsequent inde-pendence. Commercial exchanges are viewed as superimposed upon an established artistic tradition.

In this section we present a brief general summary of some additional Harappan material and of the conclusions and opinions to which this material may lead, in order to see the position which our study and views have in the whole

picture. Details upon which the chronology of the Indus Valley and other chalco-lithic communities is based (in some cases tentatively) and details of West Asian chronology are given in the Appendix.

As we have stated earlier, the essential question of Harappan origins has not been decisively solved, but remains still a matter of interpretation. Notwithstanding the material which is being added to day by day, certain fundamental issues are as fluid as ever. This work has suggested a number of generalities which are felt can cast some light upon this fundamental enigma, but it must be acknowledged that these views cannot be proven beyond a doubt.

A number of scholars have tried to determine who the authors of the Indus Valley Civilization were on the basis of the Harappan script as known from the brief inscriptions on the seals. Several attempts have been made to decipher this script but these are controversial and inconclusive. And even if an incontestable transcription were achieved, it remains to be seen whether it would reveal the ulti-mate source of Harappan Culture. As far as can be judged, the Harappan script is unique and without direct descendants.[138]

The language of the script has been described as Dravidian by Father Heras and related to Sumerian.[139] His view is of interest in connection with the survival, just above the plains of Mohenjo-daro, of a Dravidian language spoken by the Brahui people. However a complication arises in that the Brahuis are ethnically unrelated to Dravidian-speaking peoples of the South.

The racial composition of skulls found at Harappan sites has been evaluated and found to be representative of a cosmopolitan community. Four types were distinguished: the Mediterranean, the proto-Australoid, the Mongolian and the Alpine. Although the number of adequately preserved skeletons is limited, the dominant strain appears to have been the Mediterranean, a long headed type asso-ciated with early agricultural settlements everywhere in Western Asia.[140] The above evidence is subject to divergent interpretations and proves conclusively only the existence of more than one element in the Indus Valley Civilization. This diversity is in harmony with the cultural pattern suggested by the Harappan artistic tradition.

The architecture and planning of the cities of Mohenjo-daro and Harappa suggest the existence of a centralized and well organised society. Both cities were dominated by an acropolis or citadel which apparently was the seat of the ruling powers and also the economic nucleus of the community as deduced from the presence of great granaries. The social structure as inferred from the archaeological evidence perhaps had something in common with the Mesopotamian kingdoms administrated by priest-kings from a temple which was also the governmental center of the city states. However beyond this general apparent similarity many aspects of the Harappan Civilization and cities were distinctive. The layout of the streets was more systematic than in Sumer, perhaps suggesting that the Indus Valley cities were planned for expansion rather than haphazardly developed.[141] The drainage system was similarly superior. On the other hand the starkness of the buildings, the absence of any sculptural ornamentation, is disappointing. Also conspicuous is the absence of any evident public structures or temples. Remains of several buildings have been tentatively suggested as possible temples but these are not at all outstanding. Con-

[138] Piggott, op. cit., p. 178.
[139] Heras, "Two Proto-Indian Inscriptions from Chandu-daro," *Journal of the Bihar and Orissa Research Society*, XXII, Pt. iv; Heras, "The Origin of the Sumerian Writing," *The Journal of the University of Bombay*, VII, July, 1938.
[140] Piggott, *Prehistoric India*, pp. 145-148.
[141] W. H. McNeill, *The Rise of the West*, 1965, p. 99.

versely, the remains of a Great Bath at Mohenjo-daro are impressive and unique. It is assumed that this complex of buildings dominated by a large bath or tank 40 feet × 24 feet[142] had a significant role in the religious life of the people.

Wheeler noted an early Harappan building technique employing baked brick reinforced with timber, in a mode alien to baked brick, but natural to mud brick constructions. The timber decayed in the Indian climate and the brickwork collapsed. Wheeler states that this error was not repeated and further comments:

"... but its occurence in the early phase suggests that the master builder concerned had been a foreigner accustomed to methods appropriate to a drier climate and inexperienced to Indus conditions. Here if anywhere we have a hint of direct intrusion from abroad. Of its wider implication, if any, nothing can be affirmed without further excavation."[143]

The above view may be evaluated against the evidence of essential differences between the Harappan cities and known cities of the West. The superiority of the former in some respects would suggest that the people of Mohenjo-daro and Harappa did not learn from foreigners but rather evolved their own cities and learned from their own mistakes.

The remains of burials and cemeteries of the Harappan period have not left us material comparable with finds as from the Royal Cemetery at Ur for example. The largest number of graves, about fifty-seven, were found in Cemetery R 37 at Harappa. Here the bodies were discovered in an extended position, occasionally with personal ornaments and toilet objects. In some instances animal bones were found in the graves and a large grave accommodated a number of pottery vessels, a maximum of forty—but usually around twenty.[144] One burial revealed a body wrapped in a shroud in a fashion known in Sumer in Early Dynastic and Akkadian times.[145] Other Indus Valley skeletons were found in lanes or pits, perhaps having met a violent death. These may not have been deliberate burials.[146]

In short the evidence of Indus Valley burials, like the architectural remains, are controversial as regards their association with West Asian material. There are both essential differences and some similarities, the interpretations of which are not within the sphere of this work. However this evidence does not conflict with our interpretations of the Indus Valley artistic material. Still other finds further indicate that Harappan Civilization was distinctive yet had certain points in common with the West.

Some of these common features are referable to contemporary Mesopotamia and attributable to cultural exchange. Others refer to much earlier cultures of Iran and suggest a more fundamental relationship. The Harappan metal industry for example preserves elements of an early Iranian tradition using the primitive flat copper or bronze axe.[147] On the other hand bronze pins or rods with animal or spiral tops may have reached Harappa, Mohenjo-daro and Chanhu-daro from a region between the Caucasus and Turkestan and suggest trade or intermittent arrival of people from these nomadic regions.[148]

[142] Piggott, op. cit., p. 163.
[143] Wheeler, *Early India and Pakistan*, 1959, pp. 102-104.
[144] Wheeler, "Harappa 1946. The Defences and Cemetery R 37," *Ancient India*, III, Jan. 1947; Piggott, op. cit., p. 205.
[145] Ibid., p. 206.
[146] Ibid., p. 204.
[147] Piggott, op. cit., p. 199.
[148] Piggott, "Notes on Certain Metal Pins and a Mace Head in the Harappan Culture," *Ancient India*, IV, 1947-48.

The extent to which the foregoing material is subject to controversial evaluations is apparent from the totally divergent conclusions to which it has led many prominent scholars. The Harappan Civilization has been described as Aryan and as non-Aryan, as purely indigenous and as intrusive. The Indus Valley has been placed at the periphery of West Asian civilization and it has been considered as the possible nucleus of this civilization. It has been criticized as stagnant: it has been praised as genial.

However the most realistic interpretations of Harappan Culture have taken into account two unmistakable traditions which it reflects, a fundamental tradition shared with Western Asia, and an indigenous tradition born and nurtured on Indian soil. The specific roles played by these two traditions have been suggested by the foregoing evaluation of art motifs in which the indigenous elements were found to be distinguishable from elements common to the entire ancient Orient. Similarly a third group of elements were attributed to cultural interchange. It appears from the nature of the artistic features derived from the three sources just mentioned that the oldest impulses were those which the Indus Valley shared with Western Asia. Coomaraswamy hinted at this when he pointed out that the further we go back in history, the nearer we come to a common cultural type; the further we advance the greater the differentiation. He observes that the chalcolithic culture everywhere shared matriarchy, the cult of productive powers of nature, the mother goddess and development of the arts of design. We may add to Coomaraswamy's comment that this chalcolithic culture shared not only the conception of design but as we have seen many specific elements of this art. Coomaraswamy summarises: "We must now realize that an early culture of this kind once extended from the Mediterranean to the Ganges Valley and that the whole of the Ancient East has behind it this common inheritance."[149]

It is feasible that with the early diffusion of this simple culture the indigenous Harappan elements became fertilized and ultimately gave form to the Indus Valley Civilization as a distinct culture. There does not seem to be any definite evidence in the Indus Valley Civilization of a Western culture having superimposed itself upon an indigenous tradition or having transplanted itself in a vacuum. The features which in Harappan art and culture are comparable with Occidental traits are elemental fundamental symbols, an originally neolithic mother goddess cult, simple implements. All that has shape and personality, such as script and town planning, is not basically comparable with the material equipment of Western traditions.

We may summarise our study of Harappan art by evaluating its relationship with Occidental traditions from four general viewpoints.

Art may be described as illustrating: (a) a culture's aesthetic attitudes and abilities; (b) its religious beliefs; (c) its physical environment; and (d) social conditions. Considering from these four viewpoints the Indus Valley traditions vis-à-vis Mesopotamia, we may propose that the aesthetic attitudes and abilities of Harappan art were independent of the West. Similarly, as a representation of physical environment Harappan art was inspired in its own surroundings. As regards social or material conditions and conventions, to the extent that these are represented in Harappan art, we detect points of contact with the West as well as essential differences. Such contact has been seen for example in styles like similar coiffeurs; in technical details, as in the use of inlay, and in customs as in the use of seals. Finally as regards religion we see differences but also common elements like the existence of a mother goddess cult and the recurrence of similar symbols. That the mother

[149] Coomaraswamy, *History of Indian and Indonesian Art*, 1927, p. 3.

goddess cult was the same and not independently evolved in the Indus Valley and the West is suggested by evidence of certain common associations—like the rosette or perhaps the dove.

In conclusion, our picture of the Indus Valley as seen in its art is that of a culture which flourished long and independently in its own environment and thus had the opportunity to develop a personal and distinctive tradition. The artistic survival of this tradition beyond the downfall of the community that gave it form is attributed to two circumstances. First, to the fact that its roots were ingrained in the indigenous environment and secondly, to the fact that this tradition was genuine and faithful to the temperament and beliefs of the people who nourished it. Consequently, as long as the fundamental character of the people remained unchanged their artistic tradition survived the vagaries of upheavals, destruction and new influxes.

This prolonged independence of Harappan Culture is seen side by side with a twofold relationship with Mesopotamia and Iran. One aspect of this relationship is the result of intercourse which included trade and travel. But another more fundamental relationship as is manifested in the use of common symbols and a common cult is the result of a very early association. This association was the common point of departure from which the West Asian and Indus Valley cultures dispersed. We have already stressed the fact that this common element was not spread exclusively by migrations of people from the West to the Indus Valley. Natural and inevitable processes of diffusion were also responsible for propelling cults, symbols, or techniques throughout the ancient Orient. The survival of artistic elements through space and time and their facility for absorption in new environments can be attributed to their simplicity, flexibility, and elemental appeal.

3

Post-Harappan and New Chalco-lithic Traditions, Extensions of Harappan Culture, and the Dawn of a Historic Age

1. GENERALITIES

THE LONG post-Harappan chapter of Indian proto-history has been archaeo-logically a relatively blank one until recently. However, current excavations are uncovering a great deal of material which is on the one hand elucidating, but on the other, difficult to interpret. Artistically this epoch is still unsatisfac-tory in the sense that it has not revealed the roots of early historic Indian traditions.

The general picture is one of simplicity in contrast to the impressive ruins of Mohenjo-daro or Harappa. Even at fully excavated sites like Hastinapura where continuous occupations have been traced from proto-historic to historic times, the material exposed on the whole has not been artistically outstanding. As regards Western affinities, there is much to be said but the evidence is not conclusive. The post-Harappan material is diversified and suggestive of several co-existent cultural complexes and trends. Currents of disintegration, transformation and growth create a complex picture. This period is one which, even after the recent discoveries of archaeologists, has provided little material for art historians. In view of this lack, interpretations of artistic traditions have been often based on Vedic texts. Evidently the Vedic age is materially a step backward, yet this period flows into the historic age and into a culture which we clearly recognize as "Indian" with its formulated religious, social, and artistic traditions, traditions which as we shall see revert back to Harappan times in some ways. For example, the Asokan regime may be compared to the Indus Valley Civilization in that both were extensive and highly centralized.

53

In the era which succeeds the Harappan heyday, the eclipse of this Empire is followed by a new lease on life in Saurashtra as well as its gradual transformation in this new homeland. Meanwhile, in the Indus Valley Civilization changes are also in evidence. Different cultures come on the scene: the Cemetery H people with their uniquely elaborate ceramics at Harappa, and in Sind, the Jhukar folk with their elemental equipment and seals which once again have strong Western affinities.

Elsewhere in India, neolithic and chalcolithic complexes follow their own patterns of development. Ceramic evidence has begun to focalize these various cultures and to suggest relationships among themselves and abroad.

Everywhere, however, the question of origins is paramount. This question leads to the matter of Aryan penetration. In some cases directly and in others indirectly changes have been associated with movement of peoples and culture throughout the ancient Orient from around 2000 B.C. As yet however specific events cannot be reconstructed with any measure of certainty. Ultimately, India enters the iron age and the historic period.

Here we will continue the evaluation of motifs seen in the ceramics of Indian cultures from the viewpoint of possible affiliations with Western material. Although these finds may be inconclusive as far as their specific historic implications are concerned, it is hoped that their general implications will be of interest and of value in illustrating a continued or renewed connection with the ancient Orient, a connection which once again is often referable to Western designs of much earlier times. In very broad terms it may be anticipated that the similarities in ceramics or glyptic motifs which we will discuss can be evaluated from two viewpoints. If they be not coincidental, parallels could represent new influxes. Or they could represent the survival of elements which diffused from the West in older times.

2. NEW COMMUNITIES WITH ANCIENT AFFINITIES AT CEMETERY H, JHUKAR, AND SHAHI TUMP

Beyond the city limits of Harappa, to the south, an important Cemetery, referred to as Cemetery H, was discovered which is subsequent to the Harappa period and which apparently belonged to people who were new in the locality. Excavations have demonstrated two periods in Cemetery H, both later than the Harappan Cemetery R 37. Several segmented faience beads found were comparable with a Minoan example dated c. 1600 B.C.[1]

About 24 burials— extended inhumations— were attributed to the earlier period, sometimes accompanied by food offerings and always by a large number of pottery vessels.[2] The latter burials, about 140, were fractional burials in large urns without accompanying grave goods. The ceramics of both periods are essentially similar, suggesting a continuous culture notwithstanding the difference in burial habits which conversely would seem to imply some upheaval.

The Cemetery H pottery, as well as other pottery from the mounds associated with this culture, is well made and elaborately decorated. It is of a red material with a brilliant red slip and painted in black. The designs of the pots are intricately thought out and executed. As a whole the sophisticated Cemetery H ceramic tradition is distinctive and without antecedents, yet many decorative or symbolic elements

[1] Piggott, *Prehistoric India*, 1952, p. 230.
[2] Ibid., p. 230.

which it incorporates have parallels in India and in the West. Some scenes depicted on the vessels have been interpreted by Vats as illustrating the fate of the dead[3] which is plausible in view of the obvious funerary function of the urns. The Cemetery H repertoire includes animal, human, plant, and geometric motifs in intricate combinations. Although the designs are conventional, not naturalistic, they are filled with movement and are not without a measure of realism.

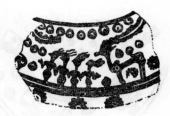

Fig. 161

The appearance of motifs which have been met before in ceramic traditions of other cultures in this new and apparently religious context is significant. It re-affirms that the essence of these motifs is not merely casual or decorative but that their purport is symbolic and thus their recurrence is not fortuitous. Among these familiar symbols, many of which are seen together in figures 165 and 172, attention may be drawn to rayed circles which are especially prominent, to fish, heart shapes, triangles, zigzags and other wavy lines— all reminiscent of flying objects— to stylized trees, and to peacocks.

Piggott summarizes the very general associations which the Cemetery H ware seems to have.[4] He comments upon the composition of this ware which recalls the Kulli landscapes and upon the similarities of the star and bird motifs to patterns on'pots from the Giyan II cemetery, attributed to c. 1500-1200 B.C.[5] But even more interesting are some of the human and animal figures whose treatment recalls that of early Iranian painted pottery. Herzfeld also points out this similarity.[6]

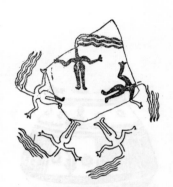

Fig. 162

Figure 161 depicts a Cemetery H type scene which has also been noted by Herzfeld. It represents an odd conglomeration of Iranian elements. The heads of the figures in this design show a remarkable affinity with figures on Sumerian painted pottery seen in figure 162, while the file recalls sherds of the Tepe Hissar I culture, as for example in figure 163. The ibex somewhat resembles a similar one on a Persepolis vase shown in figure 164. As regards the rayed circle, we have discussed above this motif and its association with the animal comb in Harappan and Iranian ceramics. Its appearance on the Cemetery H pots can hardly fail to suggest continuity of the tradition which invested this symbol with its particular meaning.

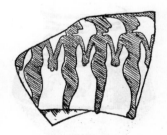

Fig. 163

Figure 165 from Cemetery H may be compared with a vase from Tepe Giyan seen in figure 166. This Iranian vessel has been attributed to the mid-2nd millenium B.C.[7] and thus is probably roughly contemporary with its Indian counterparts. It can be seen that in these two designs the subjects are similar—in other words, as noted by Piggott, in both examples birds are associated with rayed circles—but the treatment and the effect of the two pots are entirely different.

Stylised trees are depicted on some of the Cemetry H pots and lids and may be associated in concept on the one hand with the trees depicted on Harappan seals and on the other with the Assyrian Tree of Life. It is of interest to consider the pre-dominance of this motif in Buddhist sculpture where it has sometimes been attributed to a Western Asiatic influence. The significance of an early Indian precedent for this symbolic motif, albeit in an unpretentious medium, should not be over-looked, especially as in both instances the conventional symmetric tree or plant is used in a religious context. Figures 167 to 169 depict designs from Cemetery H which would seem to represent simplified plants or trees equivalent to the Tree of Life. These examples may be

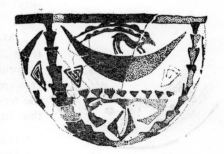

Fig. 164

[3] Vats, *Excavations at Harappa*, 1940, p. 208.
[4] Piggott, op. cit., p. 275.
[5] Ibid.
[6] Herzfeld, *Iran in the Ancient East*, 1941, p. 31,
[7] Ibid., p. 90.

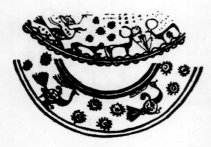

Fig. 165

Fig. 166

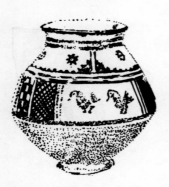

Fig. 167

compared with figure 170 representing a later Assyrian version of the Tree of Life embroidered on a royal tunic.

In figures 171 and 172, also from Cemetery H, the accent placed upon evidently sacred horns is notable. The importance and meaning of horns in the ancient Orient has been noted in connection with terracottas. Horned figures have also been seen on Harappan seals. Here the horns, disassociated from human representations, are kept within the animal realm; nevertheless they apparently have a sacred implication. The devices seen in figure 172, in the horns of the elongated humped bull, bear a significant resemblance to the objects shown in figure 164 associated with an ibex on a vase from Persepolis.

We are further reminded by this emphasis upon horns of the Minoan horns of consecration which played a prominent role in the Cretan religion and in turn were associated with a Mesopotamian cult.[8] Although no definite parallels can be drawn as regards all these horns, it is notable that they had a special value attached to them throughout the Western Asian cultural sphere. Whether this in fact implies a fundamental relationship is difficult to ascertain.

The precise meaning of the various parallels seen above is not entirely clear. There is no doubt that many elements of the Cemetery H repertoire are old and familiar in Western Asia and Baluchistan as well in the Indus Valley. However, from the viewpoint of style and composition, the Cemetery H ceramic tradition is quite new. Yet it certainly appears to be experienced and to reflect an Indian atmosphere as seen, for example, in the popularity of the peacock. Thus it may be proposed that the Cemetery H pottery represents a continued development of ancient Iranian elements which had been inherited earlier, rather than a new influx; but as to how, where and when such development occurred there are no clues.

Our present knowledge is insufficient to establish the above view or to lead to any further suggestions as regards the background or origin of the Cemetery H culture or the nature of its contact with the Harappan people.

In Sind, at the sites of Jhukar, Lohumjo-daro, Chanhu-daro, and Amri, we see a different picture of post-Harappan times. Especially at Chanhu-daro there is interesting evidence of a culture which is met with in and above the ruins of deserted Harappan settlements. This culture, known as Jhukar, is evaluated by Piggott as a barbarian community that arrived ". . . either as the destroyers of the Harappa civilization or following hard in the wake of the first raiders."[9]

The Jhukar pottery is a buff ware decorated in black and red. The designs are varied and comparable to some extent with Kulli and Amri as well as with Harappan motifs. Piggott viewed the Jhukar repertoire as representative of a native, non-Harappan substratum in the local population, with an infusion of strains from southern Baluchistan.[10] However, Jhukar motifs also have parallels further west.

Most of the Jhukar patterns represent either geometric motifs or stylized plant forms. Specifically, among the popular designs are included beads, plants with conventional long thin leaves, the ball and stem motif, chevrons, rhombs, loops, crescents and cruciform designs. Most of these motifs have been noted above in the repertoires of earlier Indian and Western cultures. Yet once again it is apparent that the Jhukar ceramic tradition as a whole is distinctive.

[8] Hutchinson, *Prehistoric Crete*, 1962, p. 226.
[9] Piggott, op. cit., p. 226.
[10] Ibid.

Mackay notes a relationship between Jhukar and Tell Halaf designs pointing out the occurrence in both cultures of red bands, checker patterns with crossed lines, zigzag patterns, rhomb motifs with incurved sides, horizontal and vertical hatchings as a border pattern, and the figure of eight.[11] Piggott points out the occurrence of the Jhukar plants with a double spiral at Sialk III and Hissar Ib as well as later in the Makran. However, these parallels are not interpreted by Piggott as suggesting that the Jhukar ceramic tradition was foreign. He writes: "On the whole there seems no reason to regard the Jhukar pottery as anything but a native product arising out of the disturbed conditions and folk movements after the fall of the Harappa Empire, when refugee tribes were leaving Baluchistan and settling in Sind."[12]

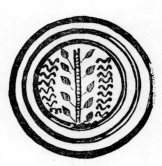

Fig. 168

The above view seems to confirm a conclusion to which we have been led by a comparison of Indian and Western ceramics in general. This conclusion is that the recurrence of decorative or symbolic elements in widespread cultures does not always imply migrations of people. Parallels between the Jhukar and West Asian pottery are a further example of the diffusion and survival of motifs through millennia and through changes of cultures and environments, a survival which is the lasting effect of a very ancient spread of traditions.

Fig. 169

On the other hand, the Jhukar seals and amulets and other small objects like implements or beads rather than ceramics, provide contradictory evidence based upon which Piggott suggests that this culture may have been one of outside barbarians. Piggott concludes in this connection regarding the origins of the Jhukar folk: "It is their portable objects that are significant and which give the clue to their origins." And again, "Here for once we can relegate pottery to a secondary place in estimating the content of these allied cultures."[13]

At Chanhu-daro numerous Jhukar seals of pottery, faience, stone, and metal were found. Although these seals are stamp seals they differ from the Harappan series. The Jhukar seals are usually round. They have no inscriptions and the decorative devices bear a closer resemblance to those of Western glyptic traditions than to the typical Harappan motifs. Parallels between Jhukar and Iranian, Mesopotamian, and Hittite seals are evaluated by Piggott as implying that the Jhukar seals are foreign to India and that their bearers immigrated from the West.[14] This view however cannot be reconciled with the different impression conveyed by Jhukar pottery and with the fact that the designs on Jhukar seals seem to be comparable with very much older Western motifs.

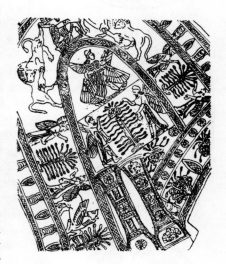

Fig. 170

Attention may be drawn to some general similarity between the devices depicted on the Jhukar seals as seen in figures 177, 178 and 181-183 and on some of the Harappan seals, for example, as illustrated in figures 96-103 and on the amulet shown in figure 120. This group of geometric motifs, seen also on chalcolithic Iranian and Mesopotamia button seals, seems to have ultimately evolved from a neolithic group of buttons. We noted above an affinity between some Harappan seals and these buttons. This affinity can be seen again in figures 173-180. Figures 173 and 174, illustrating neolithic buttons from Persepolis and Chagar Bazar, may be compared, for example with figures 175 and 176 from Harappa, figures 177 and 178 from the

Fig. 171

Fig. 172

[11] Mackay, *Chanhu-daro Excavations*, 1943, p. 129.
[12] Piggott, op. cit., p. 223.
[13] Ibid., p. 226.
[14] Ibid., p. 225.

Fig. 173

Fig. 174

Fig. 175

Fig. 176

Fig. 177

Jhukar levels at Chanhu-daro, and figure 179 from Tepe Giyan. Early seals from Sialk, an example of which is seen in figure 180, are also comparable. Figure 181 illustrates a coil pattern from Chanhu-daro, which has been compared with a design on a Hittite seal illustrated by Heine Geldern and interpreted as implying that the Jhukar examples were introduced by Western immigrants who were in contact with the Hittites.[15] The treatment of animals on the Jhukar seals is also similar to Western examples. Figures 182 and 183 from Chanhu-daro are compared by Herzfeld to seals from Tell Asmar and Asia Minor.[16] The Tell Asmar example is reproduced in figure 184.

In addition to the seals, the Jhukar people introduced other innovations which Piggott attributes to Western sources. These include pins, beads, and bone awls, perhaps used for mat weaving. Although the lack of sophistication of the Jhukar equipment and their primitive habitations may imply, as Piggott (note 13 above) and Gordon[17] suggest, a barbarian onslaught, these conditions could similarly represent a displaced and somewhat transformed culture of local origin. Casal suggests that Jhukar may be a phase of the Indus Valley Civilization born in Sind.[18] Possibly the Jhukar people were pushed into Sind by pressure from the West, but were not themselves of immediate foreign provenance. Some material may have been adopted as a result of contact with Western peoples, but it would appear as if the Jhukar traditions, at least as seen in the pottery, would have been indigenous. The prevalence of seals, notwithstanding the simplicity of the Jhukar culture, provides a contrast with earlier non-Harappan agricultural communities and suggests that these objects may have had a different function.

At Amri as well as Chanhu-daro, the Jhukar folk were in turn replaced by a culture known as Jhangar. Not much is known of the distribution and background of the Jhangar settlements. Their pottery—made on a tournette—was a grey or black ware decorated with simple incised designs like chevrons, triangles, or a herringbone pattern.

At Mohenjo-daro evidence of post-Harappan communities is lacking. Apparently this city was not occupied after the downfall of the Harappan Culture. Recent investigations have shown that Mohenjo-daro was gradually engulfed by mud and thus probably deserted after prolonged efforts to keep the city above water had failed.[19] However, in Baluchistan there are further indications of destruction and of new influxes. Whatever we may specifically deduce from existing evidence, the coincidence of the disintegration of the Indus Valley Civilization with the appearance of intrusive cultures and the supporting evidence of upheavals in Baluchistan, all after a period of comparative continuity, imply that new pressures were being exerted.

At Zhob, in the Rana Ghundai III C phase,[20] there is evidence of sacking and burning followed by the appearance of a new, coarse, boldly decorated ceramic. Figure 185 illustrates a Rana Ghundai IV bowl which belongs to this period. The pattern in general terms is reminiscent of wavy line designs in ceramics which are associated by Herzfeld with pictographic signs or seal impressions referring to hills,

[15] Geldern, "The Coming of the Aryans and the End of Harappan Civilization," *Man*, Oct. 1956, pp. 138-139, fig. 7 f.

[16] Herzfeld, op. cit., p. 70.

[17] Gordon, *Pre-historic Background of Indian Culture*, 1958, p. 80.

[18] Casal, *Fouilles d'Amri*, 1964, p. 69. (The Jhukar culture is represented at Amri in period III D. The preceding phase, III C, is marked by some transformation, but no rupture with the Harappan tradition.)

[19] Raikes, "The Mohenjo-daro Floods," *Antiquity*, XXXIX, 1965, p. 202.

[20] Piggott, op. cit., p. 214, dates this phase to c. 2000 B. C.; see also chronological notes.

valleys, or rivers, in other words, to landscapes.[21] The settlement of Rana Ghundai IV was again destroyed by conflagration and followed by a community using unpainted, either plain or embossed pottery.

The ceramics of post-Harappan times as described by Fairservis[22] in the Zhob, Loralai, and Quetta districts are diversified and interrelated. At Dabor Kot evidence of pottery suggests four periods, the latest being historic. An early pre-Harappan level, comparable to Rana Ghundai I and Sur Jangal I, is followed by an era of Harappan occupation. The post-Harappan period reveals Ghul Painted and Jhukar sherds. Fairservis' interpretation is that the Jhukar people occupied Rana Ghundai and raided Dabor Kot, ending the Harappan occupations and implying the beginning of the invasion of the Indus Valley.[23]

Fig. 178

The Ghul Painted pottery is a Quetta Valley ware dated by Fairservis between 1500-800 B.C.[24] There is evidence of a decline in population,[25] which is unexplained by Fairservis but might be a reflection of troubled times. The actual close of the prehistoric period is estimated by Fairservis to be about 1500-1400 B.C.,[26] a little later than Piggott's date of 2000 B.C. The artistic trends at this time are described by Fairservis as twofold—a maintenance of local styles related to the preceding periods and an influx of new traditions.[27] However, there is no demarcation between these styles. Fundamentally it appears as if the painted pottery were a continuing tradition with breaks and new trends representing upheavals but not a totally foreign and different artistic line.

Fig. 179

At Shahi Tump, in the ruins of a Kulli settlement, a cemetery was discovered by Sir A. Stein which has been equated by Piggott with movements from the West.[28] About twelve burials were found at Shahi Tump, associated with pottery and copper or bronze tools and ornaments as well as some beads and alabaster cups. The pottery is a distinctive grey to pinkish—sometimes buff—ware decorated in black or brown. Decorative motifs are geometric and include swastikas, squares, circles, angular spirals, chevrons, lozenges, and triangles. The Shahi Tump Cemetery repertoire has been compared with pottery from the cemetery of Khurab near Bampur in Makran dated approximately just after 2000 B.C. and located about 150 miles to the west.[29] It appears as if some contact or relationship between the Bampur region and Shahi Tump was of old standing since, as noted above, the earlier Kulli pottery with landscapes from the Shahi Tump occupation layers also had parallels with wares from Bampur. And at Mehi, a group of incised stone vessels had counterparts, attributed to trade, at sites near Bampur and Sistan.[30]

Fig. 180

The ceramic tradition seen at the Shahi Tump Cemetery, as noted by Piggott[31] and Herzfeld,[32] is evolved from a line of vases beginning at Persepolis. In Iranian ceramics a series of dishes and bowls are decorated with geometric motifs which convey a circular movement that often blends into an animated abstraction as of

[21] Herzfeld, op. cit., pp. 43-44.

[22] Fairservis, *Excavations in the Quetta Valley, West Pakistan*, 1956, and *Archaeological Surveys in the Zhob and Loralai Districts, West Pakistan*, 1959.

[23] Fairservis, *Archaeological Surveys in the Zhob and Loralai Districts*, p. 326.

[24] Fairservis, *Excavations in the Quetta Valley*, p. 348.

[25] Ibid., p. 359.

[26] Ibid., p. 345.

[27] Ibid., p. 359.

[28] Piggott, op. cit., p. 220.

[29] Ibid., p. 218. Stein, *Archaeological Reconnaissances in North Western and South Eastern Iran*, 1937, pp. 106-110.

[30] Piggott, op. cit., pp. 110-111, fig. 10 and also p. 118; Herzfeld, op. cit., p. 89, figs. 177-178.

[31] Piggott, op. cit., p. 218.

[32] Herzfeld, op. cit., p. 54.

Fig. 181

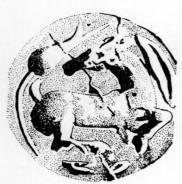

Fig. 182

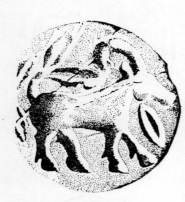

Fig. 183

Fig. 184

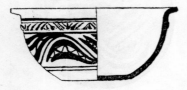

Fig. 185

animal horns. These motifs combine elements like crosses, swastikas, circles, or combs, as can be seen in figures 186 to 189. That the later Shahi Tump ware appears to be descended from this tradition may be seen in figures 190 and 191. However, the Baluchistan examples are executed with less precision and lack the animation of their Persian counterparts. The implications of this relationship are once again not completely clear. The nature of the connection between the Shahi Tump ceramics and neighbouring Iranian wares, beyond an original common root, is not easily defined. It would appear however that an early relationship was renewed by continued contact between the two regions.

An affinity between the Shahi Tump pottery and Painted Grey Ware of the Ganges Valley as regards fabrics and designs, in particular the swastika, has been noted by Sankalia[33] and by Banerjee.[34] The Painted Grey Ware, which will be discussed later, has been associated, though not conclusively, with the Aryans. The implications of this affinity between the Shahi Tump and Painted Grey Ware motifs are not certain but its existence is significant. It suggests that the Aryans, bearing a ceramic evolved from earlier Iranian traditions, did in fact arrive from the northwest, leave traces as at Shahi Tump, and subsequently settle in the Ganges Valley, where the Painted Grey Ware appears at a later date. Or, as Banerjee proposes, the Painted Grey Ware people may have adopted the Shahi Tump ceramic.[35]

As in the case of Jhukar, objects other than pottery associated with the Shahi Tump burials have been evaluated by Piggott as indicative of migrations, or more specifically of invasions.[36] In particular, weapons and copper stamp seals are considered of Western provenance.[37] Figures 192 and 193 illustrate two of the Shahi Tump seals, which are comparable with Jhukar examples from Chanhu-daro seen in figures 177 and 178.

The post-Harappan Cemetery H and Jhukar cultures and the culture of the Shahi Tump Cemetery are something of a puzzle. They reflect changing times, yet their ceramic motifs are still of the same lineage as those of earlier Harappan and Baluchistan traditions. As a matter of fact, even subsequent pottery designs descend ultimately from an ancient repertoire which pervaded a cultural sphere extending from Crete to India. The "Aryans" who dominated the West Asian scene from the second millennium apparently did not possess a tradition of painted pottery.[38] Thus a ceramic art which was associated with the newcomers could have been, as Piggott has pointed out, a local craft, perhaps kept up by subordinated women.[39] On the other hand, the pottery traditions following the downfall of Harappan Civilization are distinctive, not decadent forms of the Harappan or Kulli wares as might be expected if they represented the survival of a vanquished community under foreign domination. Thus these ceramics could alternatively represent cultures which were pushed into Baluchistan and the Indus Valley by

[33] Sankalia, *Prehistory and Proto-history in India and Pakistan*, 1962, p. 185.
[34] Banerjee, *The Iron Age In India*, Ch. V.
[35] Ibid., p. 102.
[36] Piggott, op. cit., p. 220.
[37] Ibid., p. 200.
[38] Herzfeld, op. cit., p. 110, notes that with the occupation of Western Iran by the Aryan tribes, after the 10th century B. C. and Sialk VI B, painted pottery came to an end. Painted pottery as such did not cease, but no fresh traditions are manifest on the Iranian plateau after Sialk VI B. Occasional examples apparently inspired in Sialk B are seen until about the 7th century B. C., cf. Ghirshman, *Persia from the Origins to Alexander*, pp. 287-293. A painted and glazed ware vase from Ziwiye attributed to the 8-7 cent. B. C. is depicted in E. Porada's *Ancient Iran*, pl. 36.
[39] Piggott, op. cit., p. 220.

pressures from the West,[40] or in some cases the presence of intruders from further afield.

However, these views are still tentative. Specifically, study of the relationships between post-Harappan and Western forms does not throw adequate light upon the cardinal question of what forces were immediately responsible for the downfall of the Indus Valley Civilization and what the origins of post-Harappan Cultures may have been. The salient feature of the artistic repertoires of these cultures, however, is as shown above, the continued reference of many decorative and symbolic motifs to very much earlier Western elements. As a whole, similarities between post-Harappan and Iranian artistic traditions could represent survivals of an earlier diffusion as well as more recent intrusions. Most probably a combination of both currents is involved.

Fig. 186

3. HARAPPAN OUTPOSTS

Probably well before the decline of Harappan Civilization in the Indus Valley, adventurous colonizers from the north migrated southward to Lothal and thence to other sites in Gujarat. Recent excavations have revealed much about these Harappan outposts which took new roots, thrived, and declined independently of the Indus Valley, perhaps due to similar circumstances. Particularly at Lothal there is once again significant evidence of connections with Mesopotamia. These connections were in the form of trade, but perhaps also more fundamental, for the ceramics described by Rao as a provincial Harappan style seem inspired in Iranian and North Syrian sites and in the Diyala regions.[41] In addition to this relationship with the West, there is evidence of influence from Central India and an associated evolution of pottery. Eventually the degenerating Harappan tradition became transformed into a new ceramic and the cultural picture changed.

Fig. 187

At the site of Rangpur a series of cultures has been identified which flourished and declined between 3000 and 800 B.C.[42] At pre-Harappan levels, Period I, microlithics were unassociated with pottery. The Harappan Culture in Period II A, dated from 2000-1500 B.C., produced the typical Harappan artifacts and ceramics which toward Period II B—circa 1500-1100 B.C., designated as Late Harappan—began to show degeneration. In the last part of Period II—designated as Period II C and attributed to 1100-1000 B.C.—Harappan ceramic is found in a state of transition. There is an overall effort to counteract the setback of the preceding period and in ceramics an attempt to revive earlier traditions. Simultaneously, the Harappan pottery undergoes an evolution and becomes transformed into "Lustrous Red Ware." The ceramic motifs of Period II C include geometric designs like hatched triangles, circles, horns and intersecting circles, as well as naturalistic subjects, especially the running antelope and bulls. In the subsequent stage, Period III, which lasted from 1000 to 800 B.C., the dominant ceramic is Lustrous Red Ware, though black and red ware is also prominent. In this new tradition Harappan elements still predominate and new features do not appear to be intrusive but rather are evolved of old motifs, although contact with other cultures may have exerted some influences.

Fig. 188

The Rangpur sequence is associated with finds at Lothal[43] where the Harap-

Fig. 189

[40] This possibility is noted by Wheeler, *5000 Years of Pakistan*, 1950, p. 33.

[41] Rao, "Further Excavations at Lothal," *Lalit Kala*, XI, 1962.

[42] Rao, "Excavations at Rangpur and other Explorations in Gujarat," *Ancient India*, XVIII-XIX, 1962-63.

[43] Rao, "Excavations at Lothal," *Lalit Kala*, III, April 1956 and March 1957; Rao, "Further Excavations at Lothal," *Lalit Kala*, XI, April, 1962.

Fig. 190

Fig. 191

Fig. 192

Fig. 193

pans originally settled in c. 2500 B.C. The Lothal excavations have thrown much fresh light on Indian proto-history. At this site the so-called mature Harappan era, designated as Lothal A, is dated between 2450 and 1850 B.C. The ceramic evidence shows that this culture was not transplanted in a vacuum but was preceded by a simpler agricultural and fishing society which produced a micaceous red pottery painted in black with dots, stripes, wavy lines, and horizontal bands. Lothal A has been divided into three phases. Phase II may be considered the prime of the Harappan regime as evident in advanced civic amenities like anti-diluvian platforms.

The Lothal pottery features conventional Indus Valley designs plus new motifs which are absent in the latter region, but not without parallels at Western sites. Designs like pairs of cranes or rows of birds with fish in their beaks appear at Lothal as well as at Susa D and Ugarit III. Wheat chaff and vegetable patterns are comparable with pottery from Susa D (see figure 197), Arpachiya and Giyan IV.[44] Stylistically the Lothal designs are naturalistic and less congested than their Indus Valley counterparts. But what appears to be altogether novel in painted pottery is a narrative tendency. Many of the Lothal animals, birds or serpents, are not mere pictures or parts of scenery but apparently involved in a story. Rao illustrates a jar depicting the cunning fox trying to get a bird in a tree to drop a fish.[45] We have seen for example at Kulli or in the Cemetery H ceramics, scenes, especially in the latter tradition, heavy with symbolic representations. And in Mesopotamian ceramic traditions figures in action are not uncommon. However, there does not seem to be any real precedent for the simple, clear, and well executed representations, evidently of familiar tales, that are met with at Lothal. Figures 194 to 196 illustrate three examples of the Harappan period of Lothal painted pottery. Figure 197 represents a design from a Susa II (or Susa D) vase which may have contributed some of the constituent elements of the Lothal repertoire.

The Lothal painted pottery, in conclusion, is a refreshing tradition which incorporates the Indus Valley style with its component West Asiatic elements. However, in addition the Harappan ceramics at these sites seem to have had an independent link with Western repertoires as seen, for example, in the treatment of bird motifs. And finally, even if we consider the Lothal style a provincial Harappan one, it has features lacking in the Indus Valley which represent the distinctive personality of this new homeland.

As regards Harappan seals, the Lothal finds are of primary interest as the process of manufacture has been disclosed at this site. Many sealings have been found bearing impressions of more than one seal which indicate that the seals were in fact used for sealing purposes and were not amulets. The predominance of seals in the period during which foreign trade thrived confirms their commercial function and perhaps explains their absence at many sites where trade did not flourish.

Lothal, although smaller than Harappa or Mohenjo-daro, seems to have been an outstanding industrial and commercial center. In the light of evidence that Lothal must have been a seaport, the remains of what is now proven to have been a dockyard are impressive testimony to the importance which travel or trade by sea had in proto-historic times. This evidence is linked with the discovery of "Indus like" seals in the Island of Bahrein,[46] with the finding of a Persian Gulf seal at Lo-

[44] Rao, "Further Excavations at Lothal," *Lalit Kala*, XI, April 1962.
[45] Ibid., pl. xii, fig. 35.
[46] Bibby, "The 'Ancient Indian Style' Seals from Bahrein," *Antiquity*, XXXII, 1958, pp. 243-46. Bibby suggests that these seals and similar ones found in the Indus Valley or in Mesopotamia are in fact native to Bahrein and that elsewhere they were introduced by Bahrein travellers or merchants.

thal,[47] and with other finds of both Indian and Western provenance all leading to the conclusion that commerce was a significant factor contributing to the prosperity of ancient civilizations. Two of the Bahrein seals are illustrated in figure 198. Also notable is the discovery at Lothal of what must have been a bead factory with drills, polishing stones, and unfinished beads. In this connection the finding of numerous etched carnelian beads is significant and confirms their Indian origin.

Fig. 194

The absence of mother goddess figurines is conspicuous at Lothal and is accompanied by the absence of other antiquities which at Harappa or Mohenjo-daro were associated with religious cults. No objects which could be connected with fertility, nor seals nor amulets representing Siva-like figures were found. On the other hand, clay or brick enclosures have been considered as perhaps connected with fire worship. The Lothal burials were in urns and associated with pottery as in the Indus Valley.

The fourth and fifth structural phases at Lothal, dated from 1900 to 1700 B.C. and known as Lothal B (1850-1700 B.C.), represent a degenerate Harappan Culture. This epoch is perhaps of even greater interest than the preceding period in terms of what it implies concerning the downfall of this society and the questionable role of foreign raids in bringing about this downfall.

It is significant that at Lothal a period of decay set in earlier than at Rangpur. The sequence is one implying that after an unfavourable turn of events, the Lothal Harappans moved on and founded new communities. There is no evidence in either case of invasions or of the intrusion of new cultures. Furthermore, it is now becoming clear with the help of Carbon 14 dating that the Indus Civilization in Saurashtra was on the decline by 1800 B.C., that is, before the Aryans could have effected this downfall.[48] Supporting this fact is evidence from the site of Rupar where Harappan pottery is followed by the Painted Grey Ware which as we shall see later has been associated with the Aryans. What is notable at Rupar is a gap between these two ceramic traditions, implying that the Painted Grey Ware people were not responsible for the destruction of the Harappans.[49] On the other hand, at Lothal, Rangpur, Chanhu-daro, and other sites, there is evidence of repeated floods, floods which perhaps also left their impress in the eroded platforms of Harappa and Mohenjo-daro.[50] That floods, which certainly were nothing new, could bring about the downfall of a civilization may imply that a degeneration and lack of discipline and a faulty economy had already begun to effect a downward trend. In the Indus Valley a weakening culture may have been struck its final blow by people who in turn had been displaced by the warrior nomads who descended upon Western Asia. However, there is no indication that the effects of the havoc being played in the North-West were directly felt in Gujarat. Here the decline of Harappan Civilization seems to have taken a more natural course, ending with its transformation and a new upward trend. There are no traces of Jhukar or Cemetery H people at Lothal or Rangpur, but the effect of other non Indus Valley cultures are felt. Intrusions from Central Indian complexes are seen, for example, in the Prabhas Ware which appeared in the late Harappan settlements of Kathiawar.[51] The extent to which cultures such as Eran, Navdatoli, or Ahar, whose early phases go back to 2100-1800 B.C., were instrumental in the downfall and subsequent alteration of

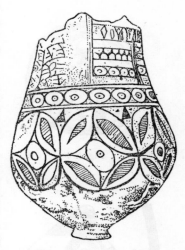

Fig. 195

Fig. 196

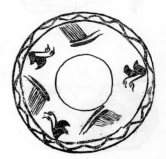

Fig. 197

[47] Rao, "A Persian Gulf Seal from Lothal," *Antiquity*, XXXVII, 1963.
[48] Sankalia, *Prehistory and Protohistory in India and Pakistan*, p. xii.
[49] Rao, "Excavations at Rangpur and other Explorations in Gujarat," *Ancient India*, XVIII-XIX, 1962-63, p. 193.
[50] Ibid., p. 197. Cf. Section 2, footnote 19 above.
[51] Ibid., p. 182.

Fig. 198

the outlying Harappan communities is not as yet clear but probably their role was not negligible.[52]

The close relationship which existed between Harappan Culture manifest outside of the Indus Valley and Western Asia is attributable to several sources. The so-called provincial Harappan ceramics have, as has been seen, parallels in Western traditions which are quite independent of the Indus Valley. Other points of contact between Lothal and the West are notable and could be attributed to the trade which is known to have flourished. A set of terracotta gamesmen and a gameboard similar to one found in the Royal Cemetery at Ur or to one in Queen Hatshpsut's tomb[53] could imply a novelty introduced by merchants, or a more basic cultural similarity. A terracotta model of an Egyptian mummy[54] found at Lothal is further evidence of direct or indirect contact with the West. Thus whatever affinity Lothal had with the ancient Orient was either inherited from the Indus Valley or transmitted from the West directly, to a large extent by sea. Perhaps one of the most significant implications of the discoveries at Lothal is the revelation of the extent to which the sea was a means of communication and possibly migration in proto-historic times.

The Lothal finds are supplemented by the further discovery of Harappan outposts on the Makran coast like Sut Kagen Dor and Sotka-koh. These sites have been considered trading posts.[55]

4. LONDO WARE

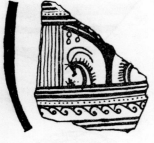

Fig. 199

Of special interest from the viewpoint of its similarity to Iranian ware and because of its distribution is a distinctive ceramic discovered by Beatric de Cardi in South Baluchistan.[56] This pottery, known as Londo Ware, is of special interest because of its similarity to Iranian ware and because its distribution has suggested that its makers arrived by sea. Londo pottery is described by de Cardi as "unmistakably a provincial and possibly hybrid version of the distinctive pottery of Sialk VI B."[57] At the same time the Baluchistan ceramic shows significant stylistic differences from Sialk, specifically, as noted by Miss de Cardi, a lack of vigour. On the basis that Sialk B may be attributed to 1250-1150 B.C.,[58] and allowing the Iranian influences travel time, the Londo Ware has been dated by Miss de Cardi at c. 1100 B.C. and attributed perhaps to displaced tribes migrating from the Persian plateau to Baluchistan.[59] The Londo motifs include parallel narrow bands, spirals, voluted scrolls, hachured triangles, and rayed discs and, notably with Sialk affinities, horses. Also apparently derived from Sialk, as noted by Miss de Cardi, are metopic groups of stylized trees flanked by addorsed antelope heads.

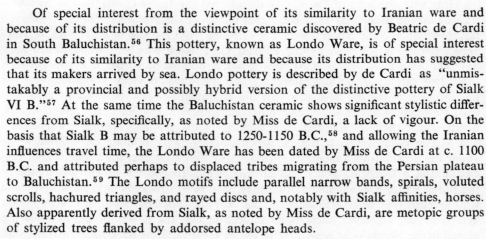

Fig. 200

Figures 199 and 200 illustrate two Londo sherds which can be compared with a Sialk prototype seen in figure 201.

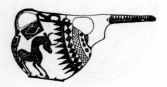

Fig. 201

[52] Sankalia, op. cit., p. xii.
[53] Rao, "Further Excavations at Lothal," *Lalit Kala*, XI, 1962, p. 29.
[54] Ibid., pl. xiv, fig. 46.
[55] Dales, "Harappan Outposts on the Makran Coast," *Antiquity*, XXXVI, 1962; Gordon, *Prehistoric Background of Indian Culture*, 1958, p. 75. Gordon notes the presence of several Kulli-like sherds at Sut Kagen Dor.
[56] de Cardi, "A new Prehistoric Ware from Baluchistan," *Iraq*, XIII, 1951; de Cardi, "On the Borders of Pakistan," Recent Exploration, *Art and Letters*, V, XXIV, No. 1, 1950.
[57] de Cardi, op. cit., *Iraq*, XIII, 1951, p. 67.
[58] Ghirshman proposes a later date for Sialk Cemetery B: 10-9 B. C., cf. *Persia from the Origins to Alexander*, 1964, pp. 277-280.
[59] de Cardi. Cf. articles noted above.

The Londo ceramic is perhaps the first example of a pottery which is evidently related to a West Asian tradition in subject, style, and atmosphere to an extent that its derivation from Iran would seem unquestionable. Furthermore, the Sialk designs of this period are complex and developed beyond the elemental geometric symbols and abstractions which made the evaluation of equivalent motifs in earlier periods so difficult. At the same time it is interesting to observe that the simple earlier patterns and groupings are not discarded but rather are absorbed in these later traditions. The Londo motifs are a simplification of their Iranian prototypes. Artistic trends in ceramics as well as in other mediums move as often toward simplification and abstraction as they do toward elaboration and crowding, so it is not always possible to postulate priority on these bases. However, in this instance, in view of the traditional evidence pointing toward a diffusion from West to East, the Baluchistan pottery may be considered an offshoot of the Persian tradition.

Cemetery B at Sialk is the last phase of this early site and is attributed to Indo-European or Aryan invaders. This necropolis is preceded by Sialk A or V which was destroyed. Of Sialk V only graves remain which contained a fine pottery, mostly grey black, and very rarely painted. As regards the artistic tradition of the Sialk VI B pottery, it is explained by Herzfeld as a continuation of the Nihawand-Luristan tradition.[60] However, certain elements like the horse at Sialk are clearly their own contribution.

Gordon and Banerjee have noted a similarity between Londo Ware and pottery found in cairn burials in Persia, Makran, and Baluchistan.[61]

The Londo Ware seems to imply an extension of the Indo-Europeans into southern Baluchistan fairly soon after their establishment at Sialk. Excavations of Londo sites should suggest further conclusions as regards this movement. However, it has been noted that trial excavations at Alizai in Kalat have complicated the matter of Londo pottery. At this site Londo sherds were found suggesting some degree of Hellenistic influence.[62] Banerjee refers to the as yet unpublished Alizai excavations and notes that two types of ware were found, an earlier red slipped and painted ware and a later whitish ware.[63]

5. PAINTED GREY WARE

Painted Grey Ware has been found at numerous sites in the Ganges Valley. Its importance, as summarized by Sankalia,[64] lies in its position—intermediate between Harappan and Northern Black Polished pottery—its association with traditional Mahabharata sites (like Hastinapura, Ahichhatra, Kurukshetra, etc.), and its likely affinity with Shahi Tump pottery in fabric and designs as well as

[60] Herzfeld, *Iran in the Ancient East*, p. 110. Ghirshman however attributes the Luristan bronzes to the 8-7 centuries B. C. or even later, a period subsequent to Sialk B. Cf. *Persia from the Origins to Alexander*, pp. 281-286. However the Luristan bronzes have been attributed to a period as early as 1500 B. C. Cf. Porada, *Ancient Iran*, 1965, p. 75. Porada proposes a wider chronological distribution for these bronzes, op. cit., Ch. VI, pp. 75-89.

[61] Gordon, op. cit., p. 156; Banerjee, *The Iron Age in India*, 1965, p. 44 and fig. 6. Banerjee attributes the cairn burials, associated with iron, to a period from c. 850-450 B. C., op. cit., p. 47. Cairn burials have also been reported on the Island of Umm en-Nar on the Persian Gulf Coast of the Oman Peninsula. The pottery from these burials has revealed an unexpected similarity (bespeaking sea borne connection) with Kulli ceramics and is attributed to an equally early date. Cf. Knud Thorvildsen, "Burial Cairn on Umm en-Nar," *Kuml*, 1962.

[62] British Expeditions to Kalat 1948 and 1957, under de Cardi, *Pakistan Archaeology*, I, 1964, p. 25.

[63] Banerjee, op. cit., p. 46.

[64] Sankalia, op. cit., p. 185.

possible affinities further afield. Similarity has been noted between the Painted Grey Ware and wares from sites in Thessaly as well as pottery from Shah Tepe in Iran,[65] although the Western examples were undecorated.

The identification of the Painted Grey Ware people with the Aryans, though based on so-called circumstantial evidence, in its association with epic sites, is supported by the regular recurrence of this evidence. In a recent study, N. R. Banerjee, after a careful evaluation of the available material connected with Painted Grey Ware, has maintained that the Painted Grey Ware users were in effect Aryans and notes the discovery of painted Grey Ware in Lakhyopir, West Pakistan.[66] He suggests that these folk were not demonstrably in contact with the cairn burial people of the Indo-Pakistan borders, but that both groups could be ultimately traced to Sialk VI B.[67] He further suggests, as noted above, that the Shahi Tump Cemetery was the source of the Painted Grey Ware ceramic. Banerjee maintains that the users of Painted Grey Ware knew iron about 1000 B.C. and that their knowledge of iron perhaps was obtained from Sialk VI.[68]

Excavations at Hastinapura[69] and Kausambi[70] have provided a picture of the sequences in which Painted Grey Ware occurs and have suggested a number of provisional conclusions concerning the origins of this tradition. At Hastinapura four periods preceding a fifth medieval period were recorded. The earliest occupations used a crude ochre coloured pottery found in rotted condition. At other sites to which we will refer a little later, this pottery was unassociated with the copper hoards originally believed to have been introduced by Aryan newcomers. Period II, dated c. 1200 to 800 B.C., with which we are concerned here was the Painted Grey Ware period. Most of the houses of Period II had mud or mudbrick walls or walls covered with plaster. This culture terminated with a flood and after a time gap was followed by Period III, dated from the early 6th century to the early 3rd century B.C. and featuring Northern Black Polished pottery and iron. The third period ended in a conflagration and was succeeded by Period IV, beginning in the early second century B.C. and lasting until the third century A.D.

B. B. Lal based on the Hastinapura material and other evidence supports the association of Painted Grey Ware with the Aryans.[71] According to him, the occurrence of this pottery between 1500 and 600 B.C. synchronizes with the arrival of the Aryans—that is people speaking an Indo-European tongue—who left traces in post-Harappan contexts. Lal further proposes that Hastinapura II coincides with the date of the Mahabharata battle.

G. R. Sharma who conducted the Kausambi excavations has come to similar conclusions. Correlating archaeological and linguistic material, he has proposed that Aryan penetration into India came in two waves.[72] He attributes to an early wave the Iranian elements in the Navdatoli culture which will be discussed later and to a subsequent wave the Painted Grey Ware. The earlier wave according to Sharma came in contact with the Harappans.

[65] Lal, "Excavations at Hastinapura and Other Explorations in the Upper Ganga and Sutlej Basins 1950-52," *Ancient India*, X-XI, 1954-55.

[66] Banerjee, op. cit., Ch. IV.

[67] Ibid., p. 67.

[68] Ibid., pp. 238-239.

[69] Lal, op. cit.

[70] Sharma, *The Excavations at Kausambi, 1957-59*, 1960.

[71] Lal, op. cit., pp. 150-151.

[72] Sharma, op. cit., pp. 9-10; Wheeler, *Early India and Pakistan*, 1959, p. 28, puts forth a similar suggestion.

Kausambi has been divided into four periods: Period I (c. 1165-885 B.C.) produced a mixture of pottery including red ware, grey and buff ware and coarse black and black and red ware; Period II (885-605 B.C.) produced both Painted Grey Ware and N.B.P. (Northern Black Polished Ware) with no gap between the two traditions.[73] In Period III (605-45 B.C.) the discovery of a hawk shaped altar upon which the *Purusamedha* sacrifice was performed was notable. According to Sharma this discovery points to a sacrifice performed by Pushyamitra Sunga in commemoration of his victory over the Bactrian Greeks. The fourth period at Kausambi is dated from 45 B.C. to A.D. 580.

Fig. 202

The Painted Grey pottery is a fine wheel-made ceramic, although some hand-made examples have been found. The designs, painted in black or chocolate, are simple geometric patterns. These include[74] horizontal bands, groups of vertical, oblique, or criss-cross lines, rows of dots or dashes alternating with simple lines or chains of spirals, concentric circles or semi-circles, sigmas, swastikas, rows of scallops, rows of circular wavy lines, and rows of chains bordering a circle. Associated with the Painted Grey Ware at Hastinapura and other sites, a smaller quantity of brown and black slipped pottery has been found with a limited variety of motifs. Figures 202 to 211 illustrate some of the Painted Grey Ware patterns.

Fig. 203

The Painted Grey Ware repertoire appears to be a simplification of old familiar symbols and patterns. The absence of any internal tendency toward abstraction or evolution in this tradition makes it difficult to evaluate in terms of relationships or sources. The Painted Grey Ware repertoire, apart from its significant affinity with the Shahi Tump pottery and apart from the widespread and ancient familiarity of symbols like the swastika, seems unprecedented. In Iran from where the Aryans, having bifurcated, presumably made their way to India, there is no comparable tradition of painted pottery. Wheeler suggests that the sudden appearance of the high class Painted Grey fabric implies technique that was previously perfected elsewhere.[75] On the other hand the simplicity of the painted decoration perhaps suggests a fresh local development. The static lines, dots, and circles which unsystematically decorate the Painted Grey Ware, do not seem especially symbolic in intension. Rather they appear to be elemental forms adapted to decorate as simply as possible, a traditionally plain ceramic.

Fig. 204

Perhaps it is not possible as yet to draw any positive conclusions from the Painted Grey Ware particularly as regards the association of this ware with the Aryans. This association has been disputed by Gordon.[76] However, current research material is establishing a connection upon increasingly reliable grounds. It may be noted that there appears to be a freshness and a simplicity in the Painted Grey repertoire suggestive of a new and young tradition, notwithstanding the ancient familiarity of its motifs. This simplicity is manifest in the absence of elaboration and of abstraction that could bespeak of long evolution and connections. Thus, artistically Painted Grey Ware could well represent Aryan newcomers.

The copper hoards[77] mentioned above in connection with the Hastinapura ochre pottery, consists of finds in the Gangetic basin of copper implements and

Fig. 205

[73] At Kausambi, Painted Grey Ware appears relatively late.
[74] Sankalia, op. cit., pp. 184-85.
[75] Wheeler, *Early India and Pakistan*, 1959, p. 28.
[76] Gordon, *The Prehistoric Background of Indian Culture*, 1958, p. 152.
[77] Cf. Lal, "Further Copper Hoards from the Gangetic Basin," *Ancient India*, VII, 1951; Lal, "Protohistoric Investigation," *Ancient India*, IX, 1953.

Fig. 206

Fig. 207

Fig. 208

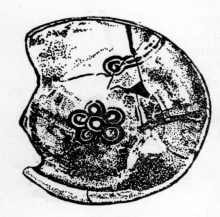

Fig. 209

characteristic anthropomorphic figures. These objects were originally considered intrusive in India and associated with Aryan penetration.[78] However, subsequently the hoards have been connected with the thick ochre washed ware which has been found underlying Painted Grey Ware at Hastinapura. The apparent absence of parallels for the Gangetic copper hoards has suggested that perhaps they may be attributed to an indigenous culture which was overcome by the Aryan Painted Grey Ware people. However, as Sankalia points out, ". . . the possibility of the Copper Hoard people being an earlier group of Aryans or Iranians cannot be ruled out."[79] A copper hoard anthropomorphic figure is illustrated in figure 212.

As yet the precise interconnection between post-Harappan cultures like Cemetery H, Jhukar, and Shahi Tump on the one hand and the Painted Grey Ware culture on the other is not established, but as we have seen above, a relationship is manifest between the Shahi Tump and the Painted Grey Ware ceramic traditions. While the post-Harappan cultures noted above could have materially contributed to the collapse of the Indus Valley Civilization, the Painted Grey Ware folk were further removed from this event. At the same time an association of the Painted Grey Ware users with the Aryans does not preclude at least some of the post-Harappan cultures similarly being Aryan[80]—either an earlier wave or the same people en route to the Ganges Valley.

The artistic evidence reviewed above in detail has suggested broadly that post-Harappan cultures (whose ceramics revealed a generalized, more than specific affinity with Iranian wares) represented displaced settlements, possibly in contact with Western cultures, rather than direct offshoots of Iranian traditions. Post-Harappan pottery and seals reflected elements which were seen to be millennia old, implying again that similarities with Occidental forms to an extent represented a common heritage as well as more recent contact. Artistic evidence has further suggested that the Aryans, lacking a ceramic tradition, evolved a new repertoire which utilized ancient decorative elements. The Shahi Tump Cemetery could feasibly, as suggested by Banerjee[81] and noted above, have inspired the Painted Grey Ware tradition. The Londo ceramics represent another aspect of Aryan extension.

6. CENTRAL INDIAN TRADITIONS

Turning our attention to Central India, it is interesting to note that the artistic expression of the cultures which flourished here between about 2000 B.C. and the historic period once again have affinities with Western Asia, affinities significant enough to imply Occidental origins for Indian forms. On the other hand, the routes by which forms and designs of vessels from the West reached Central Indian chalcolithic cultures are unknown. In this section we will review the artistic traditions of these cultures—many newly discovered—as regards parallels with West Asian forms and evaluate the possible conclusions which can be drawn from these parallels.

In Central India and the Deccan, late chalcolithic cultures have been discovered underlying the debris of the earliest historical cultures. The sources of these proto-historic cultures are yet unknown, but from ceramics it can be seen that they were in contact with one another. Sankalia questions

[78] Geldern, "Archaeological Traces of the Vedic Aryans," *Journal of the Indian Society of Oriental Art*, IV, 1936.
[79] Sankalia, op. cit., p. 225.
[80] This view is strongly maintained by Gordon, op. cit., pp. 77-88.
[81] Banerjee, op. cit., Ch. V.

Fig. 210

whether it is not possible that "these late chalcolithic cultures have been derived, as a result of very gradual diffusion, of the influences and people from Iran and other West Asiatic regions."[82] He points out that the chalcolithic cultures of the West were older and more elaborate adding, "so an eastward spread with the various folk movements in the second millennium is not impossible." In support of this view Sankalia advances evidence of pottery forms and patterns in addition to the material connected with blade manufacturing which has been traced to the West and to neolithic levels. However, with all of this it still cannot be ascertained whether these later Indian chalcolithic cultures were formed by newcomers or by indigenous people.

Fig. 211

These questions referring to origin of culture, to sources of peoples and sources of impetus, are notably reminiscent of the questions which introduced our study of the Harappan communities of Baluchistan and again our study of the Indus Valley Civilization. The Indian cultural expressions once again have no tangible known origins. Once again Western Asia is on the horizon with her earlier, more sophisticated cultures. And once again there are forms common to Occidental and Indian repertoires, forms prominent enough to raise the question of Western penetration but not sufficiently dominant to answer it affirmatively. The postulated immigrants perhaps are an early wave of Indo-Europeans or Aryans, although the ethnic implications of this term are not certain. Linguistically perhaps the Indo-Aryans can be pin-pointed, but the correlation of the linguistic and archaeological evidence is still tentative.

Views put forth earlier in this work regarding the impulses behind the earliest agricultural communities of Baluchistan and North-West India appear to anticipate Sankalia's suggestion for the origins of these later chalcolithic Indian cultures which are tentatively or questioningly attributed, as quoted above, to a "very gradual diffusion of influences and peoples from Iran and other Western Asiatic regions."

Fig. 212

The proto-historic painted pottery of Central India and the Deccan falls into several categories focussed on sites where the different wares predominate. However, there is considerable overlapping and with fresh excavations continually amplifying the ceramic picture, it will be some time before the new material can be assimilated, interrelated, and evaluated vis-à-vis Western traditions.

Excavations at Maheshwar and Navdatoli, at Nevasa, at Nasik, Jorwe, etc., have uncovered chalcolithic centres whose pottery traditions are of interest as a basis for comparative studies.

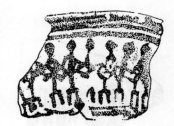

Fig. 213

The Ahar culture, concentrated in south-east Rajasthan produced a variety of wares including a black and red pottery, apparently the result of inverted firing. This technique was known to the late Harappan Civilization in Saurashtra and is presumed to have possibly been learned from Egypt.[83] Black and red vessels, especially bowls and cups, with painting in white, were profuse in Ahar and examples at Maheshwar and Navdatoli have been considered imports from this region.

The excavations at Maheshwar and Navdatoli, twin centers on the northern and southern banks of the Narmada river respectively, have uncovered the history of these sites from the Stone Age to the Muslim period.[84] Both sites were colonized

Fig. 214

[82] Sankalia, Subbarao and Deo. *The Excavations of Maheshwar and Navdatoli, 1952-53*, 1958, p. 249.

[83] Sankalia, *Prehistory and Protohistory in India and Pakistan*, p. 187.

[84] Sankalia, Subbarao and Deo, *The Excavations at Maheshwar and Navdatoli, 1952-53*, 1958; Sankalia, "The Copper and Stone Age Pottery of Maheshwar and Navdatoli," *Marg*, XIV, 1960-61.

Fig. 215

Fig. 216

Fig. 217

Fig. 218

Fig. 219

about 2000 B.C. by people who dwelled in huts and whose culture was still Stone Age, but whose pottery was advanced and beautiful.

The ceramics of the Maheshwar-Navdatoli culture is varied with a Painted Red Ware known as Malwa Ware predominant. The designs on this ceramic are painted in black and are essentially geometric, consisting of bands, lattices, diamonds, with hatching, zigzags, chevrons, crosses, wavy lines, circles, arches, and occasional stylized human and animal motifs. Contemporary with the Malwa Ware, in addition to the Ahar black and red pottery painted in white, was a white slipped ware decorated with special designs like dancing human figures and stylized deer. This pottery appears to have been a de luxe ware and it disappeared by about 1000 B.C. or earlier. Later, a distinctive pottery which is dominant at Nasik and Jorwe, referred to as Jorwe Ware, also makes its way to the Maheshwar-Navdatoli culture.

Figures 213 and 214 illustrate respectively a pattern of dancing figures and either a serpent or horns depicted on the above mentioned white slipped ceramic. In this tradition, parallels in the forms of the vessels as well as in the subjects have been noted at Sialk and Hissar with the Iranian examples antedating the Indian ones by several centuries. Sankalia considers these parallels as evidence pointing to Iranian penetration in two or three waves, the earlier in Period I and the later in Periods II and III. The cultures of Periods I and II are described as Early and Middle Stone Age, and that of Period III (c. 1000-500 B.C.) as proto-historic. Sankalia postulates two routes whereby Iranian influence can have made its way to Central India, one via Baluchistan and/or Afghanistan and Sind and a second via the Persian Gulf and Saurashtra.[85] Also pointing toward Iran are spouted basins, many examples of which were found and which were known in Crete and Egypt and were common in Western Asia but rare in India. The spouted bowl typical of Navdatoli is interpreted by Sankalia as ". . . not a direct copy of any one vessel from a particular site in Iran, but an adaptation of the idea which was current in Iran and Western Asia as far as Crete."[86]

In addition to pottery, the Maheshwar-Navdatoli excavations have disclosed beads and terracottas attributable to the proto-historic period. The faience and steatite beads, presumably locally manufactured, are comparable with examples from the Indus Valley and West Asian sites. Notable finds from Period III at Navdatoli were bird figurines, possibly doves, that may imply the existence of a mother goddess cult.

Typical of the chalcolithic period at Nasik and Jorwe, dated between about 1500 B.C. to 500 B.C.,[87] are orange coloured vessels and painted black on red pottery. The Jorwe-Nasik ceramics, overlapping to some extent with Nevasa, are decorated with geometric designs like bands or bands filled with strokes forming squares or double triangles. At Nevasa in the chalcolithic period, dated between 1500 and 1000 B.C.,[88] a similar black on red pottery predominated. Figures 215 to 219 illustrate some of these motifs from Nevasa. Their assured simplicity is reminiscent of early Baluchistan ceramics. In general the designs decorating the chalcolithic black on red pottery of Central India and the Deccan as a whole are oddly familiar.

[85] Sankalia, "The Stone Age Pottery of Maheshwar and Navdatoli," *Marg*, XIV, 1960-61, p. 35.
[86] Sankalia, "New Light on Indo-Iranian or West Asiatic Relations between 1700 B.C.—1200 B.C.," *Artibus Asiae*, XXVI, 1963, p. 317. In this article Sankalia suggests that the Iranian influence manifest at Navdatoli should be evident also at other Indian sites and advises further investigation. At the same time he acknowledges this influence to be general rather than specific.
[87] Sankalia and Deo, *Report on the Excavations at Nasik and Jorwe, 1950-51*, 1955.
[88] Sankalia, Deo, Ansari and Erhardt, *From History to Protohistory at Nevasa, 1954-56*, 1960.

The simple combinations of lines and strokes seem confidently dominant, unlike the hesitant painted Grey Ware decorations that appear on the vessels but do not really seem an integral part of them.

In the above mentioned traditions we can place our finger here and there upon a somewhat more complex motif that has been met with before in the Indus Valley,[89] in Baluchistan and in Western Asia. For example, a painted jar from Daimabad, seen in figure 220, depicts animals in action whose elongated hatched bodies are comparable with figures seen on the Susa II jar of figure 221. In figure 222 from Navdatoli a character with flying hair is comparable with Samarra or Cemetery H figures seen in our figures 161 and 162. The design depicted on a burial jar from Tekwada shown in figure 223 is reminiscent of the so-called file motif earlier noted in the Baluchistan and Harappan traditions (cf. figures 70 to 72) and compared with Iranian patterns as the one in figure 73. From Nagda in Ujjain and attributed to c. 1000 B.C.[90] come a few patterns that have especially clear counterparts. Figures 224 and 225 from this site may be compared with figures 167 and 171 respectively from Cemetery H.

Fig. 220

The animal seen in figure 226 could almost be on a vase from Persepolis.[91] As for the rayed circle in figure 227 this motif as has been seen is an old and widespread one in both Indian and West Asian traditions.

In conclusion, the motifs seen on the chalcolithic pottery of Central Indian cultures once again appear to have a fundamental relationship with Western Asia. At the same time these Central Indian traditions again also display an originality which overlies this affinity. Also notable is the fact that even in these later chalcolithic traditions some motifs like the file are survivals or the successors of very ancient symbols and designs. The exact implications of all this are not definite. However, in very general terms what we see is still more significant evidence that a common impetus was behind a ceramic tradition which broadly embraced Western Asia as well as North-West India, and which, we now find, also extended into Central India and the Deccan.

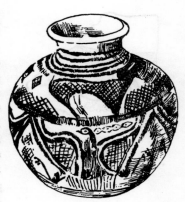

Fig. 221

Wheeler has summarized the conditions which apparently prevailed in Central India toward the close of the prehistoric period.[92] He describes a village population which, in the first half of the first millennium B.C., used microlithics, and a little copper or low grade bronze as well as painted pottery which was usually wheel turned. Certain pottery types like large and round bottomed bowls, flaring rims and spouted "teapots" were common. Urbanization gradually began and by about 500 B.C. innovations like iron, coinage, and new ceramics were absorbed.

Fig. 222

Before concluding our survey of proto-historic Indian art vis-à-vis Western Asia, a very brief mention may be made of the stone axe cultures of the South and the East and of the subsequent Southern megalithic culture associated with black and red ware. These complexes developed so belatedly that they seem to enter from prehistory into the iron age and the historic period, almost by-passing protohistory. The unsolved issues concerning these cultures are not unfamiliar. They pertain to matters of contact and of cultural sources as well as to the role of Western impetus.[93] However, as these cultures had practically no artistic tradition,

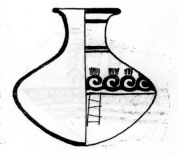

Fig. 223

[89] *Indian Archaeology*, 1958-59, p. 17, fig. 8.
[90] The jar depicted is from Phase I which produced a coarse grey ware. In Phase II Malwa Ware occurred and in Phase III Jorwe Ware, cf. *Archaeological Remains, Monuments and Museums*, published by The Archaeological Survey of India, p. 26.
[91] Cf. Herzfeld, *Iran in the Ancient East*, 1941, pl. xi, depicting a vase with an ibex.
[92] Wheeler, op. cit., p. 148-149.
[93] A recent appraisal of megalithic questions and the possible Western provenance of the Dravidians is given by N. R. Banerjee in *The Iron Age in India*, 1965.

Fig. 224

Fig. 225

Fig. 226

Fig. 227

the above problems are beyond the scope of this work which essentially deals with the evaluation of art motifs, that is, in particular with painted or sculpted designs. Thus we have not referred except indirectly to shape as of pottery vessels. In later Buddhist art, evolved architectural forms like the stupa are also treated as motifs resulting in a complete merging of decorative subjects, the objects they decorate, and their interrelated symbolism.

Finally, as we prepare to consider the artistic manifestations of the early historic period, we may expand a little on a point already mentioned above. It was stated at the beginning of this section that essentially the post-Harappan period is artistically unsatisfactory. Its only recurrent expressions are in pottery. Yet it is assumed to be in this period that Indian culture becomes crystallized, but leaving us no material evidence of the process.

Many elements which in later Indian art have been attributed to Persian or Mesopotamian influence, in the West, are referable to this period. Yet we cannot trace their routes of penetration, if indeed the Indian expressions are of Western origin. Zimmer suggests that perhaps during this period a basic Mesopotamian convention was adopted in India. The determinant animal vehicle or "vahana" placed beneath a divine image comes to symbolize the nature of the divinity and to remove any doubt as to who was being represented. This device as such does not appear in Indus Valley art and in Mesopotamia it has been traced back to 1500 B.C. Zimmer attributes its origin to a technique used in near Eastern writing.[94] Zimmer's theory is of great interest, but again it cannot be easily substantiated as regards Indian formulae.

After the Harappan Culture there is essentially no artistic tradition to which later Indian expressions can be related, a fact which makes an understanding of the Indus Valley Civilization all the more important. The post-Harappan artistic scene is fundamentally limited to ceramics, and even the ceramic traditions offer little that is really new— that has not been met with before. It thus appears as if the chalcolithic cultures of Gujarat and of Central India continued to develop as a result of an ancient momentum. Though new stimuli were undoubtedly provided in the form of continued influxes of Western Asiatic techniques, motifs, ideas, or people, the artistic influences are of an earlier and far reaching repertoire.

Until recently the vacuum between the Harappan and Mauryan artistic traditions could be attributed to lack of excavation. Yet now archaeological activity has uncovered a great deal of material, but none of it can be said to satisfactorily fill this vacuum. The artistic traditions of the Maurya Empire still seem to rise out of the blue with no evident indigenous roots. Developing forms have been imagined as preceding Asokan ones in perishable material, notably wood, but these probably were not formulated until later, in the early historic period, when a world which was developing philosophically, politically, and socially began to establish itself materially. Architectural traces of this new world are being uncovered at excavations of early historic sites.

It thus appears as if, with very gradual closing of the scene upon the chalcolithic world, new seeds were being sown imperceptibly, seeds of the iron age, of recorded history, of urbanization, of monuments, and of a new religious outlook which amalgamated philosophy, ritual, and popular cults, and put art to its service. And when under an optimum combination of circumstances the potentials of this new world were harnessed by the Mauryas, an Empire suddenly emerged which startled history as much as the earlier Indus Valley Civilization did several millennia earlier.

[94] Zimmer. *The Art of Indian Asia*, 1954, pp. 70-71.

7. THE EARLY HISTORIC AGE

Excavations in Central India and in the Ganges Valley have disclosed a number of sites with more or less continuous occupations from proto-historic to historic times. These sites in some cases coincide with legendary towns and their discovery has served to confirm the accuracy of literary material.

Central Indian cultures discussed in the preceding section enter the historic period with the introduction of iron, coinage, and a change over from painted pottery to plain wares. By the Maurya period the distinctive Northern Black Polished Ware is widespread. At Maheshwar and Navdatoli and at Nasik and Jorwe there is no break between the proto-historic and historic occupations. At Nevasa on the other hand there is a gap between the chalcolithic period, ending c. 1000 B.C., and the early historic period beginning as late as c. 150 B.C.

In the Ganges Valley the Northern Black Polished Ware[95] is the inevitable successor of Painted Grey Ware, sometimes, as at Hastinapura, with a break between occupations. The Northern Black Polished Pottery (NBP) has been considered a de luxe ceramic in view of its superior quality and the fact that examples were found mended with copper wire. This ceramic is of a lustrous black or blue, silvery brown, or even of a golden or pinkish fabric. A superficial resemblance to forged iron has been noted by Wheeler as well as a possible connection with the Persian taste for a metallic polish evident in Iranian masonry.[96] Parallels have also been noted between Northern Black Polished pottery and Hellenistic black glazed ware as well as the Roman Arretine ware, but these ceramics appear later than the Indian Northern Black Polished Pottery.[97]

Architectural remains attributable to the early historic era are being disclosed by excavators. The defences at Rajgir have been known for some time. At Kausambi still earlier fortifications have been discovered.[98] These fortifications began their existence c. 1000 B.C., showing similarity to Harappan constructions and gradually were altered with the addition of a moat and the guardrooms and towers which by the Christian era became the key to the whole defence. The discovery of a pre-Asokan stone palace at this site is notable.

Also attributable to this age, about the sixth century B.C., are the earliest known Buddhist stupas as at Piprahwa and Lauriya Nandangarh. When originally discovered, the Lauriya Nandangarh mounds were considered Vedic burial mounds.[99] In Bihar ruined mud brick stupas similar to the ones at Lauriya Nandangarh have been noted by K. C. Panigrahi at Saterh (Lakshmipur District) and at Durbhanga and Jaimangalgarh (Monghyr District).[100]

The above finds, which are being continually increased, are of interest in establishing the antiquity of architectural techniques, of practices like that of erecting stupas and in enlightening the history of many sites. However, there is little material antedating the Maurya period through which we can follow artistic developments. With the disappearance of painted pottery, a fundamental link with earlier chalcolithic traditions as well as with the old Western Asiatic world seems to vanish.

Minor antiquities of the historic period antedating the Maurya Empire are not lacking, but neither are they a homogenous representation of an evolving tradition.

[95] Nigam, "Northern Black Polished Ware," *Marg*, XIV, 1960-61.
[96] Wheeler, op. cit., p. 30.
[97] Nigam, op. cit., p. 37.
[98] Sharma, *The Excavations at Kausambi 1957-59*, 1960.
[99] Bloch, "Excavations at Lauriya," *Asiatic Society of India: Annual Reports*, 1906-07, p. 122.
[100] *Indian Archaeology*, 1958-59, p. 68.

Nor is there any medium which adequately expresses the association with the Western world which is known to have continued and perhaps was intensified in Achaemenid times.

To Iranian influence Wheeler has attributed the introduction in India of iron and coinage. Wheeler wrote that Achaemenid Persia transmitted to the kingdoms of the Ganges Valley "not merely a pattern of empire but also important new skills and abilities and above all the use of iron and coinage."[101] However, this view has been contested and it has been recently shown that both iron[102] and coinage[103] antedated Achaemenid penetration or influence. More recently Wheeler, acknowledging the discovery of iron in association with Painted Grey Ware at levels dated by Carbon 14 from 1100 to 1000 B.C., has stated, "It may now appear that the earliest civilization in the Northern plains was contemporaneous with and no doubt stimulated by the appearance of iron there alongside the distinctive pottery a little before or a little after 1000 B.C. But whether or not iron is proven to be a Persian innovation, there can be little doubt that the use of money came to India as a Persian idea."[104]

Although the study of numismatics as a clue to history is beyond the scope of this work, some comment may be made upon coins as an expression, if not of art, of a craft and as a medium which illustrated current symbols. Indian silver punch marked coins have been found at numerous sites of the early historic period. The symbols appearing upon these coins have been subject to various interpretations.

Whatever the implication may be, one cannot but be struck by the similarity between many of the symbols appearing on punch marked coins and characters or symbols on Indus Valley seals. Walsh's monograph on the Taxila coins[105] illustrates this similarity, which certainly appears to be more than a coincidental one. Its significance is heightened by the amalgamation between Harappan and Buddhist symbolism apparent in many of the marks and by the commercial context in which these apparently religiously oriented symbols occur both in Harappan and in historic times.

T. G. Aravamuthan has evaluated early Indian coinage in relationship with Harappan seals and with Greek coins.[106] He has been led to the rather extreme conclusion that both are descendants of the Harappan tablets, in his opinion, amulets.

It is difficult as yet to draw any substantial conclusions from these marks as regards a precise meaning vis-à-vis their Harappan prototypes. However, the recurrence of specific forms like the tree in rail, the swastika, or the wheel, which have a known symbolic value, plus the recurrence of many other similar marks merits attention.

In the absence of other art, as much as for their intrinsic value, terracottas have received the attention of many critics. However, even in this medium the finds do not seem to be expressive of a distinctive tradition equivalent to that manifest in the Indus Valley or even Baluchistan figurines. Until a subsequent stage

[101] Wheeler, op. cit., p. 24; Banerjee, *The Iron Age in India*, 1965.

[102] Subrahmanyam, *Journal of the Oriental Institute*, Baroda, XIII, 1963-64, "Appearance and Spread of Iron in India. An Appraisal of Archaeological Data."

[103] Sharma, op. cit., p. 13. Sharma points out that copper cast coins antedate the silver punch marked coins and that the occurrence of coinage synchronizes with the spread of Painted Grey Ware.

[104] Wheeler, *Civilization of the Indus Valley and Beyond*, 1966.

[105] Walsh, "Punch Marked Coins from Taxila," *Memoirs of the Archaeological Survey of India*, LIX, 1939.

[106] Aravamuthan, *Some Survivals of the Harappan Culture*, 1942.

when Indian terracotta art becomes a reflection of contemporary sculpture, human or animal terracottas cannot be identified with a flourishing tradition. However, examples of female statuettes and finds like the female figure on a gold plaque discovered in the relic casket of the Piprahwa stupa, or a similar figure from Lauriya Nandangarh suggest the survival or revival of a female goddess cult which seems to gain momentum in the next few centuries.

But all in all the dawn of history is not immediately accompanied by an evident surge of artistic activity. This activity appears to restrain itself until it is well formulated and gains the support of a prosperous Empire and until it is put to the service of organized religion.

Thus we are not in a position to vizualize artistically India's association with her contemporary, the Achaemenid Empire under whose influence Western Asia as well as a portion of North-West India had passed. Yet the effects of this association are illustrated subsequently in the Maurya Age as we shall see. The evaluation of Asokan art in the light of Iranian, or more broadly speaking West Asian influence, is a controversial subject. We shall try to consider this problem as a continuing issue not disassociated from the affinity which was evident between Indian and Iranian art in proto-historic times.

Heir to the Achaemenid Empire, the Hellenistic world also touched India. The impact of Alexander's invasion and the somewhat more enduring effects of his successors' penetration began to interact with Indian culture even as Iranian traditions became absorbed in the cosmopolitan Hellenistic regime. Once again the new impulses were not manifest immediately. The Mauryas, who rose to fame as Alexander disappeared from the Indian scene—so very soon after making his entry—carved an empire which was to an extent cognizant of Greek traditions but hardly seems to have been affected by them, except in so much as it inherited a cultural background in which Greek and West Asiatic elements were intermingled. The specifically Hellenistic elements in Indian art and culture begin to appear after early Buddhist sculpture is established. The interaction of Indian Buddhist and the Greco-Roman sculpture and the evaluation of the resulting school of art is a controversial subject which is outside the chronological scope of this work.

Before concluding this section, which has surveyed the position of historic Indian art antedating the Maurya school, it remains to take up the thread of commerce and the effects it may have had upon artistic expressions.

In our discussion of the Indus Valley Civilization we pointed out the ample evidence of trade that evidently flourished between Harappan cities and Sumer. From the Mesopotamian side it appears that with the fall of the dynasty of Larsa and the decline of the powers of Hammurabi of Babylon this trade suffered a decline and it is not until two centuries before Achaemenid times that it was renewed.[107] The Indian picture seems to coincide with the Mesopotamian one. As Harappan cities in the Indus Valley and then in Saurashtra dwindled and the post-Harappan scene became reduced to village settlements, little scope remained for commerce and all it implies in terms of prosperity and sophistication. After a gap, the renewal of commercial and thus cultural interchange coincided in India with new efforts toward urbanization and a widening horizon. There are varied indications that after about 800 B.C., India and the West traded by sea. References in the Buddhist Jatakas[108] to the presence of an Indian

[107] Oppenheim, "The Seafaring Merchants of Ur," *Journal of the American Oriental Society,* LXXIV, 1954.

[108] Kennedy, "The Early Commerce of Babylon with India," *Journal of the Royal Asiatic Society,* 1898, p. 268.

cedar beam in the palace of Nebuchadnezzar (604-562 B.C.),[109] and the occurrence of the word "Sindhu," presumably in reference to Indian cotton on a tablet in the library of Assurbanipal (668-626 B.C.),[110] are among these indications.

As in the case of contact resulting from military intrusion on the part of Persia, contact resulting from commercial intercourse did not leave any evident immediate even superficial marks. But the ultimate result of trade, of the movements of Cyrus at least as far as Afghanistan and Baluchistan, of Darius' annexation of the Indus Valley and the subsequent presence of Indian soldiers in his army, and finally of Alexander's campaign was, if belated, widespread. All of these events contributed to a new expansion of the West Asiatic horizon to encompass once again an area extending from Greece to India. As in proto-historic times it can be seen that Indian civilization never became absorbed within the cultural sphere of the ancient Orient. However, without sacrificing her identity, India received impulses from this West Asiatic culture and once again, stimulated by these impulses, formulated and crystallized her own traditions which in turn proved to inspire cultures further East.

The above picture is illustrated in early Indian Buddhist art which represents a tradition that reflects Harappan elements, the local atmosphere, and a religion which penetrates the very roots of Indian cults, philosophy and ritual. Yet this art is not unaware of Occidental forms and achievements. It reflects many of these forms several centuries after they are seen in West Asia, even as Indian ceramics often reflected motifs more than a millennium older in the West.

In the succeeding sections we will evaluate in detail the repertoire of early Buddhist art in relationship with the art of the ancient Orient. In this connection we will consider in particular the question of whether many common motifs were adapted to Indian art as a result of the recent contact with the Western world, or whether these motifs may have been inherited from Indus Valley times.

We have commented upon the fact that parallels in pottery motifs seemed to represent the effects of cultural diffusion. Apparently such diffusion has motivated the artistic world at all times. It may be effected by migrations, conquest, trade, or an imperceptible person-to-person chain of movements; but a spread of subjects, ideas, styles, or technique is undeniable in art as well as in other spheres. Over the centuries diffusion becomes accelerated. In proto-historic times, motifs spread over millennia; in the historic period they cover wide areas in centuries, even decades. However, the essential forces remain unchanged. The acknowledgement of a diffusion of artistic elements is not to be confused with the view that Indian art borrowed foreign forms. A spread of motifs or symbols implies the occurrence of parallel forms. On the other hand borrowed elements are viewed as unabsorbed and consciously superimposed upon an indigenous tradition.

As we enter further into the historic period, the perspective of our study of art motifs essentially changes. In proto-historic contexts these motifs are an essential foundation upon which events like migrations and relationships are tentatively reconstructed. However, with political history gradually establishing itself upon firmer footings with the help of legends, coins, inscriptions, and finally definite records, art motifs become relegated to the realm of purely artistic and cultural history. The evaluation of artistic traditions in a better understood society becomes an end in itself rather than a means to an end.

However, there is a specific challenge in the interpretation of early Buddhist art because it has no immediate precedent, because it reflects assimilated and trans-

[109] Ibid., p. 266.
[110] Ibid., pp. 252-53.

formed Harappan traditions, and because once again it displays a remarkable affinity with West Asiatic art. The implications of this affinity are not any more definite than they were in proto-historic times. Although the political history of the community that produced early Maurya art for example is known, the extent of a cultural bond with Iran as expressed in the Asokan monuments is as much subject to interpretation as the cultural links expressed in painted pottery or Harappan seals. Thus, notwithstanding a change in outlook, our evaluation of early Indian historic art vis-à-vis the West must continue in the manner of the preceding pages which dealt with proto-historic art or craft.

Notwithstanding the relatively more imposing mediums in which early Buddhist art appears, this new sculpture, once again, is the expression of a community—of its aesthetic standards, its potential, its contacts, its capabilities and its ideas.

The chalcolithic ceramic traditions are no less eloquent testimony to the nature of the cultures that created them than are the Asokan monuments or the Sanchi stupas. As dependably as other artistic expressions, ceramics contain clues to the prevalent cultural levels and reflect development or degeneration. Similarly, even monuments like those of Asoka, which were produced under royal patronage, are a key to the status of a community. The Maurya monoliths, the Buddhist stupas, and the minor arts, equally testify to the extent of contacts and communications, to the religious tenor, and to many other details in the life of a culture.

Thus, as much as in proto-historic times, artistic traditions now may be treated as a cultural index. Upon their interpretation hinges an understanding of a community's achievement and its relationship with foreign cultures. More specifically in the case of early India, Western Asia, particularly Iran, remains on the scene. The question of affinity with Iran, or a cultural influx of Western origin continues to colour our interpretation of Buddhist art. Occidental influence has been affirmed and rejected by critics of Indian art. Like proto-historic art, early Indian Buddhist art reveals an affinity with Western Asiatic and particularly Iranian traditions which may be stressed or minimized or interpreted in more ways than one, but which cannot be ignored.

THE ESSAY TOPICS AND...

4

Maurya Sculpture—
a Cosmopolitan Art with
Ancient Roots

1. INTRODUCTION

THE MONUMENTS attributed to the Maurya period are as unheralded as the Maurya Empire itself. Thus these monuments have provoked controversial verdicts as regards their originality and intrinsic value, much as the Asokan regime has been subject to judgements concerning the true intentions behind it. The extent to which Asokan monuments represented faithfully the contemporary pulse and potential of Indian art has been challenged as has been the true motivation behind Asoka's Dharma. Both the Asokan regime and Asokan sculpture which played a role in this regime bear the strong imprint of this Emperor's personality. But then great empires often have depended upon the direction of the rulers who carved and controlled them. This circumstance cannot be taken to mean that such kingdoms and their artistic, intellectual, social, or military achievements were superimposed upon the nation's true spirit.

The evaluation of Maurya art hinges to some degree upon the evaluation of its indebtedness to Western Asia and an understanding of its place in the development of Indian art as a whole. But these two contestable issues have been debated by critics for many decades.[1]

In this section the art of the Maurya period in relationship to Western Asian art will be reviewed, but not in an attempt to judge its originality or its aesthetic values. The purpose here is rather to draw attention to and analyze the elements which are common to Indian and Western artistic traditions and to consider the probable background of these elements. It is not possible to conclusively tip the scales to prove the significance or insignificance of Mesopotamian, Achaemenid, or Hellenistic influence, which are relative. Rather it is intended to underline the continuity

[1] See Section 5 of this Chapter.

78

which relates Maurya art to the Indus Valley tradition—the only known preceding developed art in India—as well as to the succeeding art of Bharhut and Sanchi. This continuity is further seen in the pattern of Maurya art's affinity with Iranian traditions.

In the Maurya sculptures an indigenous or traditional symbolic repertoire merges with an imperial style, creating an art which appears to stand isolated from preceding and succeeding traditions. Yet the Maurya monuments have left an unforgotten impression upon Indian art. The basic constituent elements of the Asoka stambhas (edict pillars), like the campaniform capital and crowning animals, recur repeatedly in the later sculpture of Bharhut and Sanchi, though their effect is strikingly dissimilar. The impression of controlled power conveyed by the imposing, perfectly proportioned, and superbly executed Sarnath monolith, does not survive Maurya supremacy. Later sculpture seems to draw its inspiration from a tradition in relief which apparently coexisted (largely in impermanent material) with the imperial school. The squat animal crowned columns which appear in the carvings of Bharhut and Sanchi are scarcely comparable with their svelte Asokan predecessors. But at the same time the recurrence of the Asokan pillars, albeit in such a changed style and context, suggests that they represent a form fundamentally attuned to the popular artistic atmosphere. And if the style of the ultimate achievement of Asokan artists—the Sarnath monolith—was not retained by their successors, their perhaps earlier attempts like the squat Vaisali pillar do not afford as great a contrast with the columns sculpted on the gateways of early stupas.

2. PATALIPUTRA AND ROCK-CUT CAVES

The rise to power of Chandragupta Maurya, Asoka's grandfather, can be considered a landmark in Indian history. It represents the culmination of an upward trend that had left few earlier traces, but must have been in operation for quite some time. A movement toward material progress and consolidation can be considered to have begun with the establishment of the iron and the historic age, perhaps initiated with the advent of Painted Grey Ware in the Ganges Valley. Resumed trade relations with Western Asia may be viewed as an example of this progress as well as a stimulus toward continuing advancement.

The Maurya capital at Pataliputra has been identified with the site of Kumrahar near Patna. Early investigations at this site by Waddell[2] disclosed the remains of an apadana (audience hall), the plan of which suggested similarities with the Achaemenid pillared hall at Persepolis. The descriptions of Megasthenes[3] and other classic sources testify to the grandeur of the ancient Pataliputra where gilded pillars adorned with gold vines and silver birds were comparable with the gilded cyprus and cedar pillars of Susa or Ecbatana.[4] The extent to which the Maurya columned hall was consciously based upon an Achaemenid prototype is a matter of opinion,[5] but that Pataliputra and its buildings were reminiscent of the Iranian capital is suggested both by classic commentaries and by the description of the ruins themselves.

[2] Waddell, *Report on the Excavations at Pataliputra*, 1903.

[3] Megasthenes, Seleucus' ambassador to Chandragupta Maurya.

[4] Cf. Ray, *Maurya and Sunga Art*, 1945, pp. 18-19; Majumdar, *Ancient India*, 1960, p. 107; Majumdar, *Classical Accounts of India*, p. 415.

[5] Wheeler, *Early India and Pakistan*, 1959, p. 177. "Inadequate though the evidence be, it is tolerably clear that we have here a Persian diwan or apadana or audience hall, and that we are confronted once more with a deliberate 'Persianization' that has peaks in the presence of imported ideas and imported master masons." Cf. Section 5 of this Chapter.

Recent excavations at Kumrahar[6] have supplemented our information regarding this site. Pataliputra was founded before the rise of the Mauryas by King Ajatasatru (c. 495-570 B.C.) who apparently was responsible toward the end of his reign for shifting his capital from Rajagriha. The pillared hall attributed to the Mauryas was burned down in the subsequent Sunga period. Its columns were found to have been about 32.5 feet tall rather than about 20 feet as estimated by Spooner.

In the area recently excavated at Kumrahar no other Maurya structures were traced. However at Bairat, the site of the Asokan Bhabru edict, excavations revealed heaps of polished and unpolished pieces of stone, believed to be portions of a pillar or pillars as well as a monastery and an interesting temple attributed to the Maurya period.[7] The temple consisted of a circular brick built chamber. On the outer face panels of plaster alternated with octagonal wooden columns.

On the whole the relative scarcity of structural remains of the Maurya age even at explored sites suggests that wood may have been the essential building material at the time. The use of wood is presumed to have extended to sculpture and has given some leeway in the imaginative reconstruction of pre-Maurya art. In fact, as is evident in subsequent Indian architecture, this tradition is inseparable from sculpture and thus the use of wood must have anticipated the use of stone as a medium for sculptors as well as for builders. The existence of wooden prototypes has further been deduced from the style of the earliest sculptured stone monuments. However the extent to which and the style in which pre-Maurya structures were decorated can only be guessed; there is no dependable evidence as to whether the full repertoire of early Buddhist art had been expressed earlier in wood or not. The decorative and symbolic motifs of Asokan monoliths, which are the essence of Maurya imperial art, are comparatively restricted. It is a little later, in the art of Bharhut and Sanchi, that the overflowing early Buddhist repertoire is first fully recorded. In the next section it remains to consider whether the varied subjects portrayed in these monuments—subjects which can be related to the Indus Valley tradition, to West Asian forms, and to Buddhist history, legend, and symbolism—were illustrated earlier in wood and ignored by Asoka (except in the Lomas Rishi cave) or were an impromptu development drawn from the wealth of material accumulated in centuries of artistic silence, material which suddenly gushed forth as if to compensate for its long restraint.

To Asoka, legend has attributed the building of 84,000 stupas. In the 7th century A.D. the Chinese pilgrim Hiuen Tsang records having seen hundreds of stupas in India and Afghanistan, of which few have survived. These early stupas were devoid of sculpture and thus do not contribute to our understanding of the development and sources of early Buddhist motifs. Subsequently some Asokan stupas were enlarged and embellished. It is with the addition of the surrounding railings and gateways that these monuments become a primary object of artistic efforts. And for the elaborately sculpted gateways of Bharhut and Sanchi as a whole there are no prototypes. It is an academic question, pertaining to the next section, whether the motifs incorporated in the stupa sculptures had prototypes in perishable material in the Maurya or pre-Maurya eras.

Also Maurya are the Barabar and Nagarjuni rock-cut caves. The three caves of the Nagarjuni group, the Gopika, the Vahiyaka and the Vadathika, bear inscriptions of Dasartha, Asoka's grandson. Of the Barabar group of four caves, three—the Karna Chaupar, the Sudama and Visva Jhopri—have Asokan inscriptions. However, the fourth and most interesting, the Lomas Rishi, has no inscription and thus

[6] Altekar and Mishra, *Report on the Kumrahar Excavations 1951-55*, 1959.
[7] Sharma, "Explorations of Historical Sites," *Ancient India*, IX, 1953, p. 153.

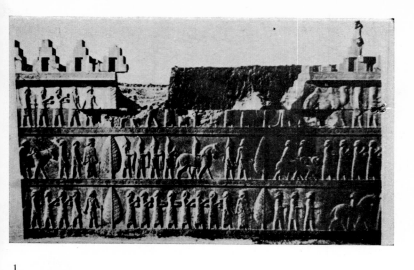

1

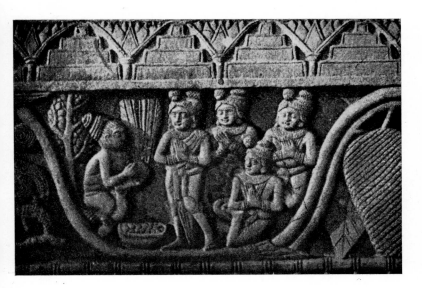

2

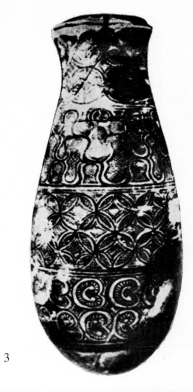

4

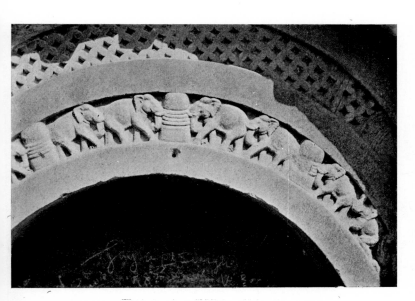

3

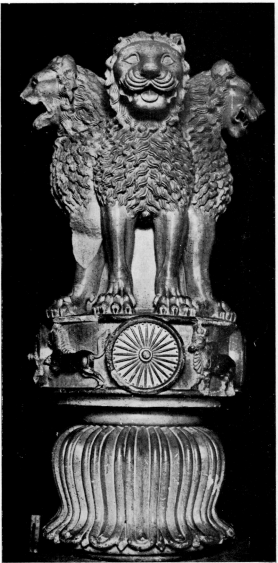

5

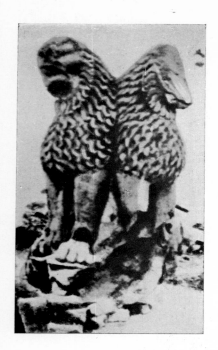

6

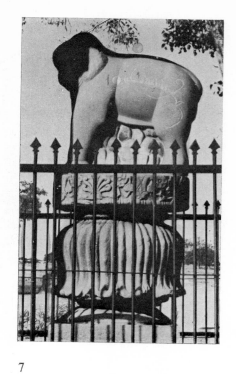

7

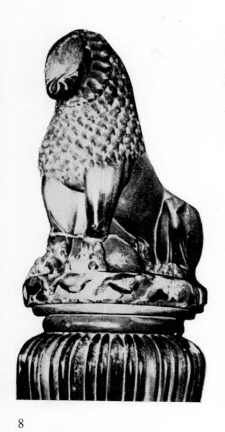

8

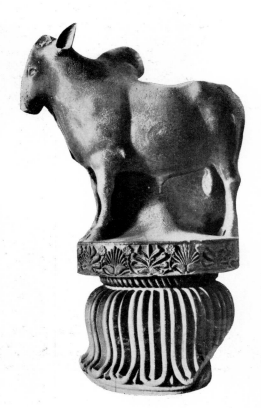

9

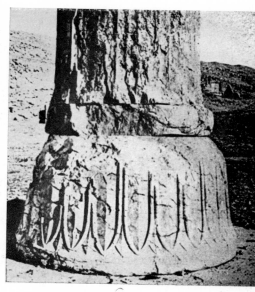

10

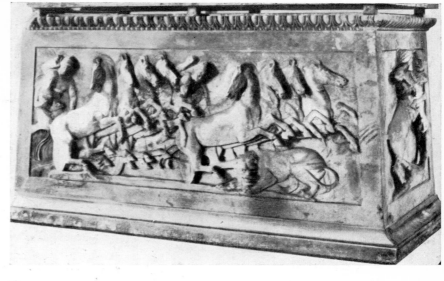

12

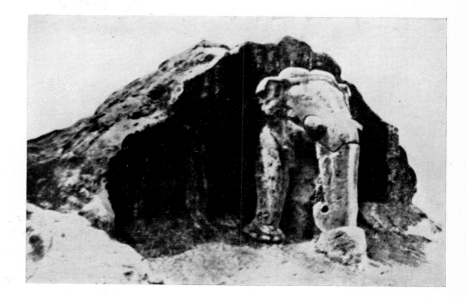

13

11

5

14

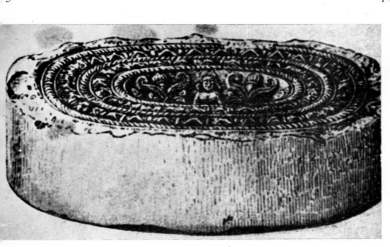

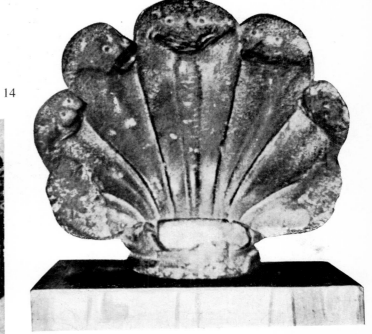

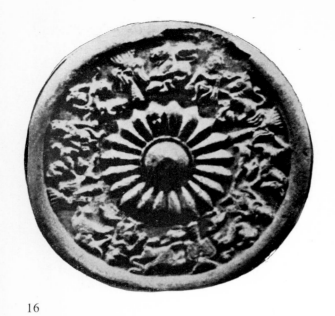

16

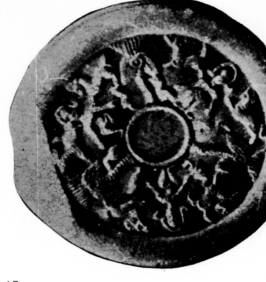

17

18

20

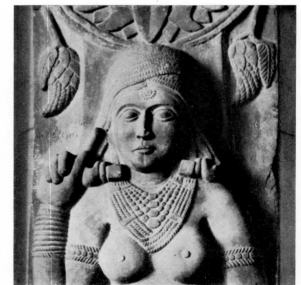

19

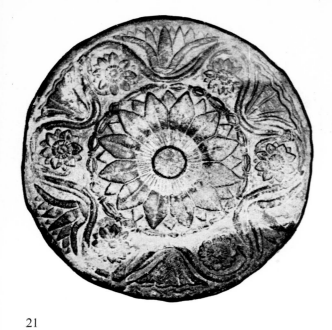

21

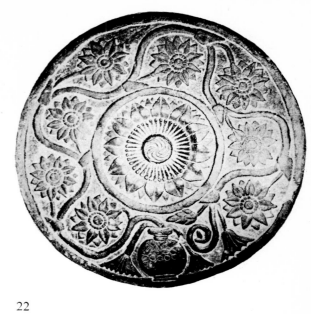

22

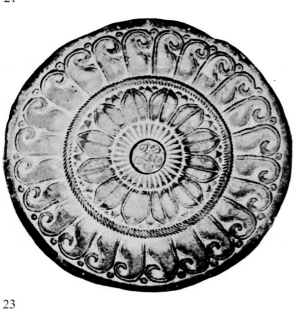

23

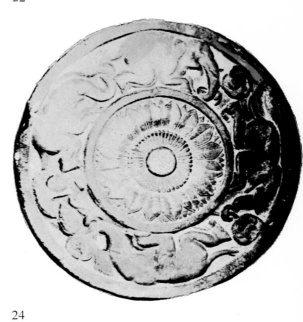

24

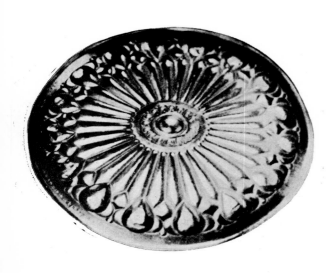

25

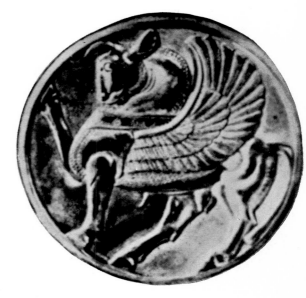

26

27

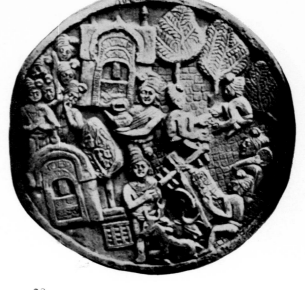

28

29

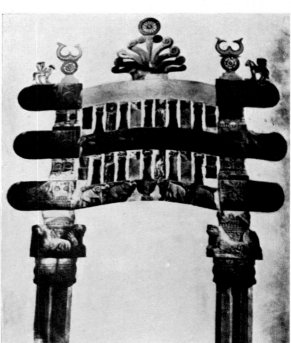

30

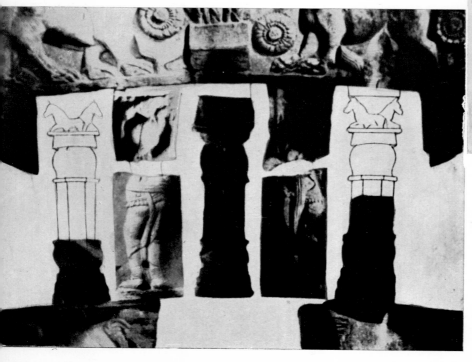

31

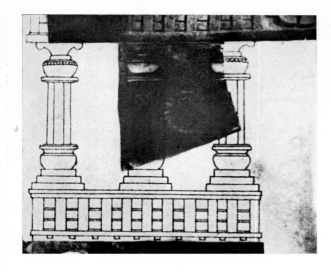

32

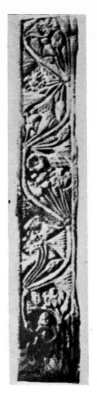

33

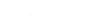

34

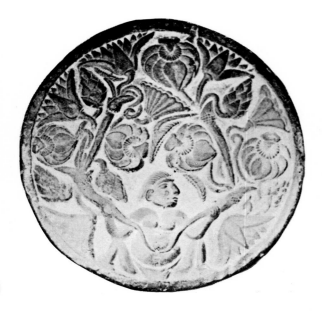

35

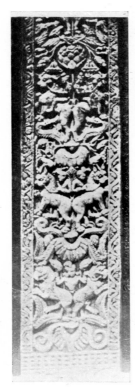

36

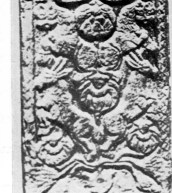

37

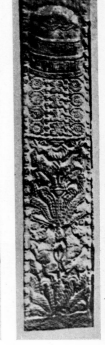

38

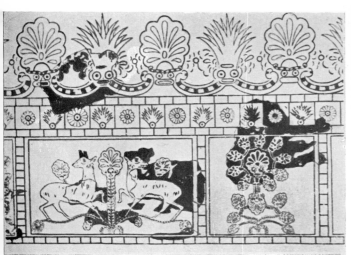

39

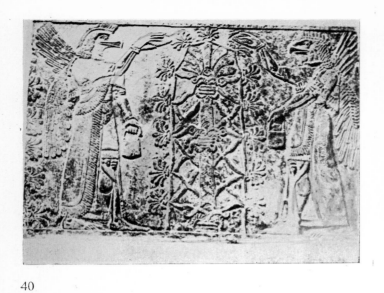

40

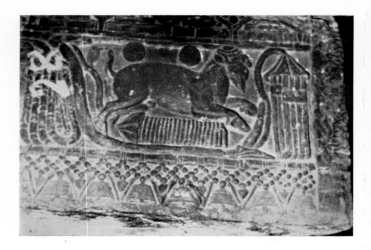

41

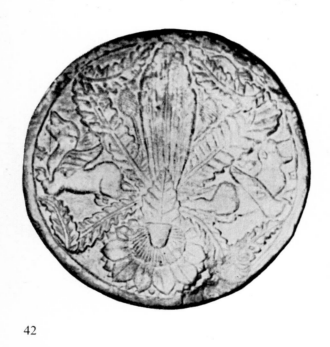

42

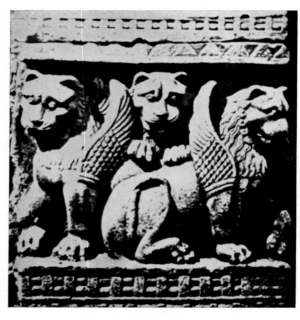

43

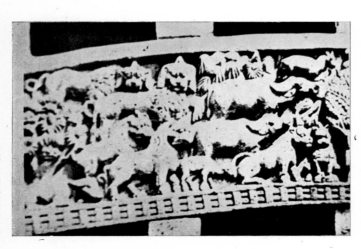

44

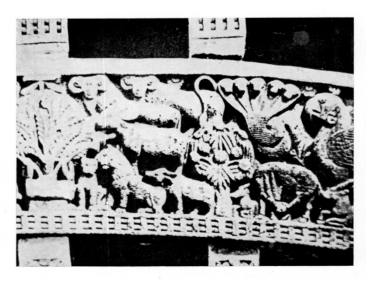

45

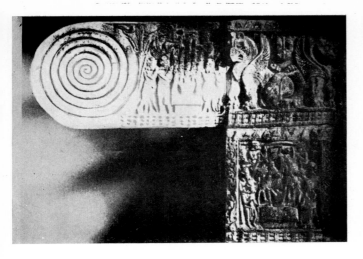

46

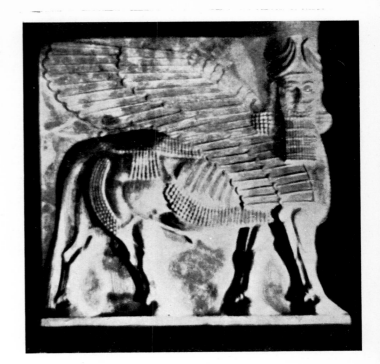

47

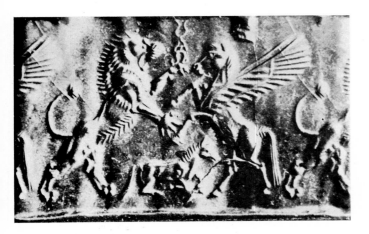

48

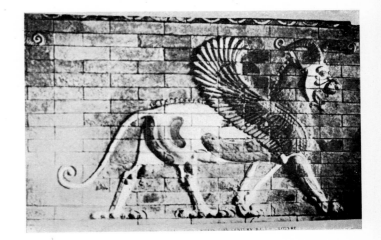

49

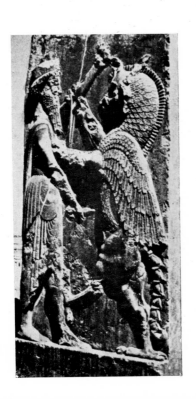

51

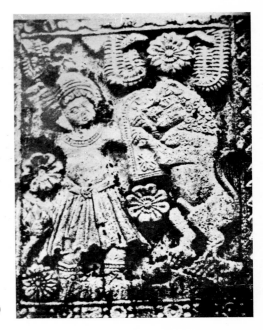

50

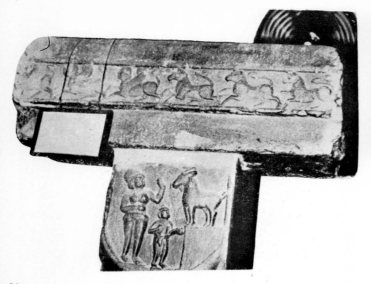

52

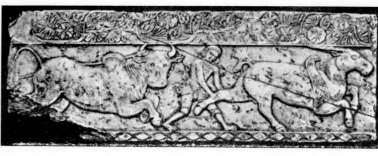

53

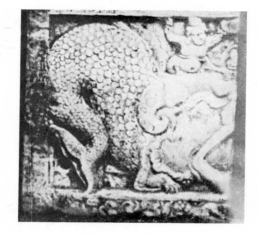

55

54

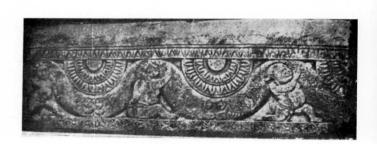

57

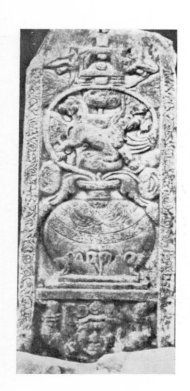

56

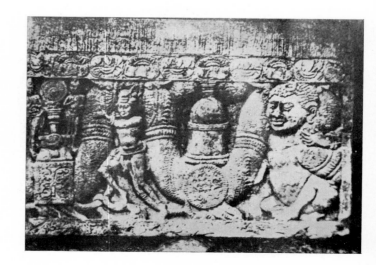

58

59

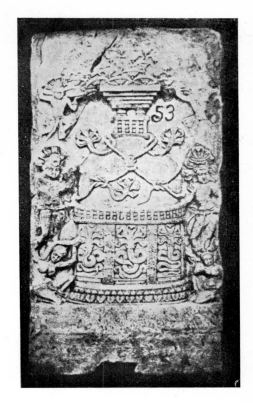

60

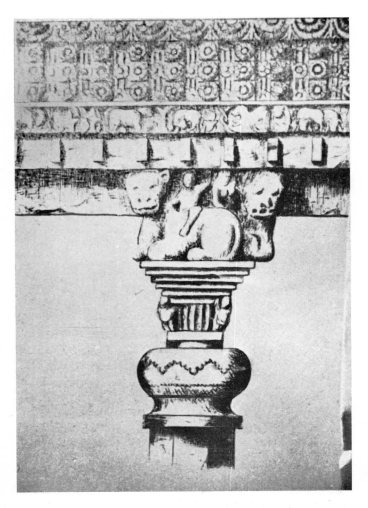

62

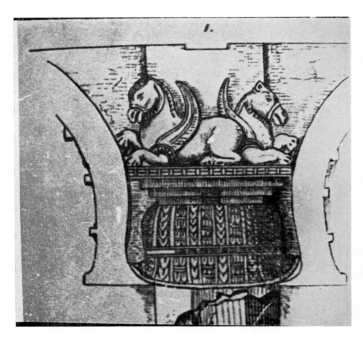

61

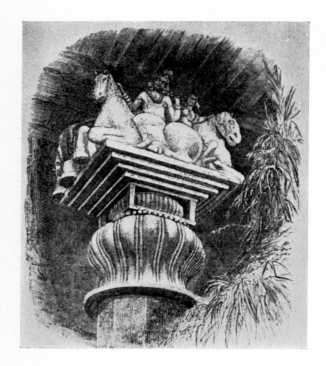

63

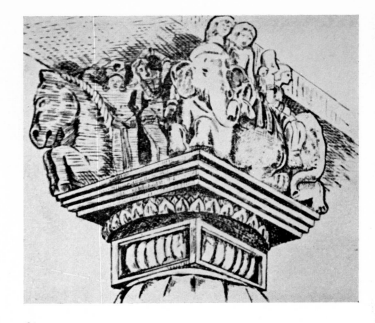

64

65

66

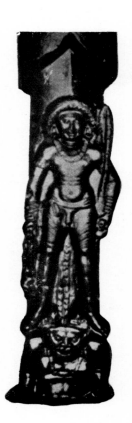

67

its date is not incontestable. However, assuming the Lomas Rishi cave to be Maurya[8] on the basis of stylistic features and the polished interior, the elephant frieze on its façade is perhaps the earliest remaining example of Indian sculpture in relief in an architectural context. This façade is illustrated in plate 4. Under the entrance arch are two carved lunettes, the upper one decorated with lattice work and the lower with a row or file of elephants paying homage to stupas. There can be no question that this façade is inspired by an informal Buddhist tradition. The Lomas Rishi elephants lack the heraldic air of the animals crowning the Asokan monoliths. Iranian inspiration appears not to have touched this cave. As always in Indian art, Western affinities are superseded when it comes to elephants or humped bulls whose representations cannot but reflect realism born of personal knowledge. It may further be remarked that the animal file is a motif of great antiquity and popularity as we have seen in our study of ceramics. Although its revival may not have been conscious or intentional, it still may be viewed as a link with old traditions.

Before proceeding with a discussion of the Asokan art, attention may be drawn to a capital discovered at Pataliputra by Waddell[9] and described by him as a "Quasi Persepolitan Colossal Capital." This capital is illustrated in figure 228. Waddell comments upon this discovery as follows:

"And the immense importance of this find is that it is the most Grecian sculpture yet found in India, excepting the capitals of Asoka's pillars and the 'Indo Grecian' statue and friezes of the Punjab; and that it is found within the palace precincts of Asoka's own capital and is probably of Asoka's own age."[10]

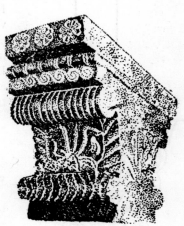

Fig. 228

The above described capital presents an interesting contrast with the capitals crowning the heraldic monoliths. Rowland draws attention to this capital and to a somewhat similar one in the Sarnath Museum[11] attributed to the first century B.C. The latter example reproduces the form of the Pataliputra capital, but the sculptures including a mounted horse and elephant are informal and naturalistic. The conglomeration of Iranian and Ionic elements in the Pataliputra capital is interpreted by Rowland as follows:

" . . . the Greek Ionic, the Persepolitan capital and the present variant at Pataliputra are all parallel derivations from one original form such as the Aeolic or as has been suggested by at least one scholar from a Sumerian pictograph symbolising polarity . . ."[12]

On the other hand Wheeler has considered this capital more simply as attributable to an early phase of transplanted Achaemenian craftsmanship.[13]

Wheeler's explanation has the merit of simplicity and can be supported by historic circumstances probably leading to patronization by the Mauryas of Iranian artists. Furthermore, the eclectic character of Achaemenid sculpture may be noted as a possible explanation of the Ionic features evident in the Pataliputra capital. However, the Pataliputra specimen in itself does not appear to be an offspring of Persepolitan prototypes (see figures 229 and 230) as much as an alternate development.

Thus Rowland's view artistically is more faithful to the nature of the Pataliputra capital. Rowland further notes a resemblance between the Indian

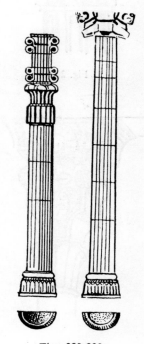

Figs. 229-230

[8] Ray, op. cit., p. 57.
[9] Waddell, op. cit., pl. ii.
[10] Ibid., p. 17.
[11] Majumdar, *A Guide to Sarnath*, 1947, pl. vii.
[12] Rowland, *The Art and Architecture of India*, 1953, p. 46.
[13] Wheeler, op. cit., p. 177.

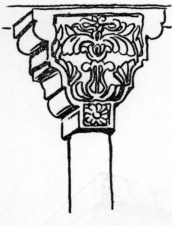

Fig. 231

Fig. 232

Fig. 233

capital and brackets found in houses of modern Kurdistan, suggesting that both forms are descended from folk traditions of great antiquity.[14] Herzfeld illustrates a series of wooden columns from Iran of recent date surmounted by "an Ionic type of impost" which he considers survivals of proto-Ionic forms."[15] More elaborate examples showing remarkable resemblance to the Pataliputra capital and dated to about the 7th century A.D. as well as to modern times are also reproduced by Herzfeld and in figures 231, 232, and 233.

The implications of these affinities can only be inferred, not conclusively demonstrated, in the light of present evidence. It may be noted however that the so-called proto-Ionic capitals were executed in wood and thus a similar form may have spread to India where wood also appears to have dominated early architecture. Figures 229 and 230, representing forms of Persepolitan columns, can be compared with the Pataliputra capital. Some affinity as well as differences are apparent. In conclusion it may be stated that the Pataliputra capital appears to have been generally inspired in West Asiatic traditions rather than specifically in a Persepolitan prototype. But the precise origin of this capital and its role in Indian sculpture is elusive. Its existence only proves that in some way Indian art became cognizant of Occidental traditions not only as expressed at Persepolis but also in a broader sense.

3. ASOKAN MONOLITHS

Clearer as we will see are the Asokan monoliths as regards their relationship with Western traditions, although this relationship too as will be seen below is subject to divergent interpretations. We are able to view the heraldic pillars as an integration of a distinct indigenous tradition—that is, a tradition with no foreign parallels—and of elements with equivalents in Iranian, West Asiatic, or Hellenistic art, however the Occidental contribution be appraised. The Maurya pillars are comparable with West Asiatic art from three viewpoints: that of subject or motifs inclusive of symbolism, that of style, and that of techniques. Our study is primarily one of motifs; however, it is not possible to disassociate these from the symbolism they reflect or their treatment.

Thus the problem of Asokan motifs and their possible indebtedness to earlier similar Iranian forms is an echo of the earlier problem presented by ceramics where, as we have seen, motifs appeared first in Mesopotamian or Persian traditions, and then, after an indefinite interval, in India. As in the case of much earlier painted pottery, similarities between Maurya and Persepolitan art can be hardly dismissed as coincidental. And again, it is a significant question whether parallel elements had similar values in Indian and Iranian contexts. Specifically, we may relate this question, for example, to the bell or lotus form which occurs in both Achaemenid and Maurya columns. The similarity between this form in the two traditions, in conjunction with other common features can be hardly viewed as fortuitous. However, it remains to consider whether the symbolism or significance, in other words the value which was attached to this shape in Iran and India, was the same.

The evaluation of Maurya sculpture in respect to Iranian forms is complicated by the fact that the latter art synthesizes West Asiatic and Greek traditions. The reciprocal influence exchanged between Greece and Western Asia over centuries has made it difficult to distinguish many artistic elements inherited by Achaemenid an also by Maurya artists. Thus it is not always clear whether Indian elements are referable to Greek or Mesopotamian counterparts or directly to Iran.

[14] Rowland, op. cit., p. 46.
[15] Herzfeld, *Iran in the Ancient East*, 1941, pp. 210-11, fig. 321.

The free standing monumental monoliths of highly polished chunar sandstone are unanimously accepted to be Maurya and probably Asokan. Although not conclusive, the typical Maurya polish is a fairly constant circumstantial evidence in favour of attributing sculptural works to this age. Asoka's seventh pillar edict further informs us of his practice of erecting pillars or inscribing pillars already in existence.[16] The style and polish of the columns however may be taken to imply that even if some of the surviving examples antedate Asoka, they still can be attributed to the Maurya age. Our interest in the Maurya pillars may be concentrated on those which have survived with their capitals, specifically the columns at Sarnath, Sanchi, Vaisali (or Basarh Bakhira), Sankissa, two at Rampurva, and Lauriya Nadangarh, illustrated in plates 5 to 9 and figures 234 and 235.

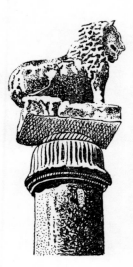

Fig. 234

These columns in general may be described as circular shafts tapering toward the top and surmounted by a campaniform or lotus capital with a central bulge. The transition from shaft to capital in some cases was achieved by moulding with rope and bead and reel designs. The capital itself, decorated with lotus petals, was surmounted by an abacus upon which the crowning figures rested.

The features shared by Maurya and Achaemenid pillars may be summarized as the campaniform shape in general, the lustrous finish, the heraldic crowning animals and some details in the treatment of the above elements. As regards differences, we may note the fact that the surviving Maurya columns were free standing whereas their Persepolitan counterparts were structural and that the Maurya examples alone were monolithic and with no base in contrast with the Persepolitan bell shaped base. The Maurya shafts were smooth whereas the Persepolitan shafts were fluted; however, at Pasargadae columns also had plain unfluted shafts.[17]

Among the similarities between Achaemenid and Maurya columns, attention may be drawn to two outstanding common features, the recurrent campaniform or lotus shape capital (or base in Persepolitan columns) and the crowning animals.

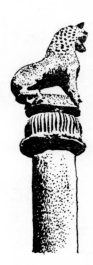

Fig. 235

As regards the Asokan capital upon which the abacus and crowning animal rests, divergent views have been expressed as to whether this form was intended to represent a lotus pedestal or was merely an adaptation of Achaemenid campaniform prototypes. These two interpretations, which we shall analyze below, are not mutually exclusive as the Iranian campaniform bases and capitals may have been ultimately derived from Egyptian prototypes. It has been pointed out in this connection that the role of the lotus in Egyptian and Indian mythology and iconography are essentially similar.[18] Symbolism is a fluid question however, subject to interpretation and not always a conscious factor. Thus it is not clear whether Achaemenid campaniform capitals and bases were intentionally lotus symbols, but this possibility cannot be excluded.[19] The rigid heraldic air of Persepolitan sculpture on the whole tends to overshadow its symbolic or devotional aspects. For example, the recurrent rosettes at Persepolis are so methodically incorporated into

[16] Basak, *Asokan Inscriptions*, 1959, pp. 111-13: "(IV) Thus says King Priyadarsi Beloved of the Gods....Having indeed surveyed (or considered fully) this (purpose) I have caused to be erected pillars of the Law of Piety...." "(X) Thus says (the King) the Beloved of the Gods.... wherever pillars of stone or slabs of stone exist, there this Edict of the Law of Piety shall be engraved so that it may have a long duration (or may long endure).

[17] Cf. Ray, *Maurya and Sunga Art*, 1945, pp. 32-34; Herzfeld, *Iran in the Ancient East*, 1941, p. 239.

[18] Mitra, "Further Note on the Origin of the Bell Capital," *Indian Historical Quarterly*, X, 1934, p. 133.

[19] de Mecquenem, "Achaemenid and Late Remains at Susa," *A Survey of Persian Art*, 1938, ed. by Pope, Chap. XVI B, p. 225. "The columns of the portals had a circular bell shaped base in the form of an inverted lotus," pl. xi.

the processional sculptures that their true symbolic function might have been over-looked were it not for the fact that they have been discovered under the pivot stones of doors where their role could hardly have been decorative.[20]

In the Maurya *lats* the probability that the campaniform capitals are intended to suggest a lotus pedestal in the round is supported by the general symbolism with which the columns as a whole seem to be invested. As we have noted throughout, evidence appears to be in favour of enduring artistic expressions having meaning in addition to an aesthetic appeal. The commemorative *stambhas* of Asoka, as mouth-pieces of religion, apparently embody a symbolism inherited from Vedic and proto-historic times. Coomaraswamy has maintained a general dependence of Buddhist iconography upon Vedic antecedents.[21] In this light the Maurya *dharma stambhas* appear to have incorporated the cosmic symbolism of Vedic sacrificial pillars. Thus Coomaraswamy views the campaniform capital as a lotus, symbolic of the water which supported the earth.[22]

In a series of articles[23] A. K. Mitra has written refuting Coomaraswamy's identification of the bell shaped capital with the Vedic lotus, though he agrees with Ramprasad Chanda that some connection may have existed between an Indus Valley cult of the animal standard and Maurya and Sunga pillar cults.[24] Mitra maintains that the lotus has only decorative rather than symbolic value. Regarding the lotus supports in the Bharhut reliefs, he writes:

"The significance of the flower being thus proved to be indeterminate and the decorative character of some of the figures on the lotus supports being obvious, the latter cannot be held to represent the supposed symbolic Mauryan bell capitals carrying animal figures."[25]

Following these premises, Mitra further concludes that the campaniform capital was "intrusive" in Indian art and that its adoption was but an "incident in the long history of the animal standard."[26]

In connection with Mitra's interpretation it may be proposed that if a tradi-tional symbolism is accepted for the Maurya *stambhas* as a whole, it is inconsistent to suggest that a component part of these *stambhas* did not similarly embody a sym-bolic meaning. Moreover artistic motifs and symbols migrate with meaning, and not devoid of it. Art is a means of expression and it cannot exist without something to express. Thus a form cannot endure without significance, and the view that to Maurya architects the bell was merely a decorative element seems unfaithful to the nature of art.

Accepting therefore a fundamental meaning or symbolism in the Maurya capitals and thus their association with the lotus pedestal, it may be considered whether this form, as it appears in Maurya sculpture, was determined by Achaemenid prototypes or evolved independently of them.

[20] Herzfeld, op. cit., 1941, p. 233.
[21] Coomaraswamy, *Elements of Buddhist Iconography*, 1935.
[22] Coomaraswamy, "Origin of the Lotus (so called Bell) Capital," *Indian Historical Quarterly*, VI, 1930, pp. 373-75.
[23] Cf. articles by Mitra in *The Indian Historical Quarterly*, "Mauryan Art," III, 1927, pp. 541-560; "A Bell Capital from Bhuvanesvara," V, 1929, pp. 693 ff.; "Origin of the Bell Capital," VII, 1931, pp. 213 ff; "Further note on the origin of the Bell Capital," X, 1934.
[24] Mitra, "Origin of the Bell Capital," *Indian Historical Quarterly*, VII, 1931, p. 219; Chanda, "Survival of the Prehistoric Civilization of the Indus Valley," *Memoirs of the Archaeological Survey of India*, XXXXI, 1929, pp. 34-35.
[25] Mitra, ibid., p. 216.
[26] Ibid., p. 225.

Achaemenid examples of campaniform members have been illustrated in figure 236 and plates 10 and 11 which may be compared with the Maurya versions seen in figures 234 and 235 and plates 5, 6, 7, 8 and 9. Notwithstanding expected differences between the Iranian and Indian forms, notably the presence of a bulge in the latter examples, an affinity is apparent. In view of an established artistic connection which linked Iran and India from proto-historic times and, perhaps more significantly, a political connection which existed under Achaemenid rule, and in view of the rise of the Mauryas just after the eclipse of Achaemenian power, it is almost inconceivable that Indian tradition was unaware of Persian precedents. And in view of this awareness it is further scarcely plausible that Maurya artists, ignoring Iranian forms, evolved similar forms independently.

Fig. 236

On the other hand, neither is it possible to reconcile an alien form with the indigenous symbolism which we have seen is embodied in the Maurya monoliths. Thus the artistic evidence as a whole suggests that the Achaemenid and the Maurya pillars reflected different but parallel aspects of a form familiar in Western Asia, a form which was conventional yet versatile. These two attributes, conventionalism and versatility, are the essence of artistic survival. Symbols have been seen to pass cultural boundaries and live through millenia, retaining certain conventional traits while absorbing new meanings and transforming old ones.

As the Iranian columns with their campaniform bases and capitals represented an expression already familiar to Indian traditions, Maurya artists were easily subject to their influence. This influence manifested itself in stylistic details and techniques[27] and also more subtly in the conception of imperial power transmitted from the Achaemenids to the Mauryas. In both the Achaemenid and the Maurya courts artists were patronized and commissioned to execute monuments which provided visible proof of the power, splendour, and piety of their Emperors. Thus Achaemenid influence was exerted upon a form established in Indian tradition and the Maurya capital cannot be considered intrusive. An artistic element is intrusive only when it is new and superimposed upon an existing tradition with which it does not blend.

The role of the animals crowning the Maurya columns can also be understood in the light of the foregoing interpretation. The crowning animals were not intrusive; in other words, Maurya traditions cannot be assumed to have adopted directly from Persepolitan art the concept of animal crowned pillars. Nevertheless Maurya expressions of this motif were not uninfluenced by a familiarity with the Achaemenid idiom.

Ramprasad Chanda has compared the Asokan pillars with animal standards known in Brahmanic mythology and has suggested that they were ultimately derived from a primitive tree cult.[28] In our discussion of Harappan amulets attention was drawn to a scene depicting a procession with animal standards. This amulet is illustrated in figure 112. R. Chanda has noted representations of animal standards on a

[27] Banerjee, "Origins of the Imperial Pataliputra School," *Journal of Indian Museums*, VIII, 1952, p. 61, draws attention to provisions made on axles of the wheel, on the abacus, and on the eyebrows of the lions of the Sarnath Capital for insertion of metallic pins indicating the process of inlay. Banerjee notes that this technique was not favoured by Indian craftsmen except at Gandhara and suggests that its application in Maurya Art may be of Persepolitan origin.

[28] Chanda, "The Beginnings of Art in Eastern India," *Memoirs of the Archaeological Survey of India*, XXX, 1927, p. 33.

Babylonian boundary stone and in an Assyrian base relief attributed to the time of Ashurnasirpal (885-860 B.C.).[29]

The addorsed animal protome which is a hallmark of Achaemenid sculpture may possibly be ultimately related to the ancient terracotta or stone amulets mentioned above as, for example, the amulet illustrated in figure 124. In this connection a similar protome discovered at Harappa and seen in figure 122 is notable. Similarly conceived are a series of pins with theriomorphic heads which have been found at West Asian sites as well as in the Indus Valley.[30] Although such pins are obviously remote from Achaemenid or Maurya pillars in intention and effect, their interest lies in the fact that animal headed pins recur in the Luristan tradition along with other examples of addorsed animal figures. The Luristan bronzes are close antecedents to Achaemenid art.

The extent to which the above mentioned amulets or pins represented traditions which survived in Achaemenid sculpture is not certain. However, if the Iranian capitals are at all referable to these sources, the fact cannot be overlooked that Maurya animal crowned pillars had similar antecedents in India. Herzfeld has maintained that columns with theriomorphic imposts antedated Achaemenid examples.[31] Indian tradition was similarly acquainted with animal standards before they became transformed into symbols of Maurya power and *dharma*. And notwithstanding their similarities, the Asokan *stambhas* are in essence animal standards whereas the Iranian pillars are intended to support buildings. Thus whatever the technical or stylistic debt of the Asokan monoliths to Achaemenid pillars, the former monuments cannot be viewed as an imitation of a Persian concept. The intricate symbolism which is evidently embodied in the Maurya *dharma stambhas* could not have been wrought around a foreign idea. We have suggested that the meaning of a motif or symbol may be transformed in a new cultural environment. However, an entire complex symbolism cannot be evolved out of the blue to account for an intrusive form.

The Achaemenian structural columns and the Maurya monumental pillars have been respectively derived from older related traditions. Thus they may be considered parallel developments as regards their conception. But in execution, the Maurya monoliths bear some imprints of Achaemenid sculpture. Because the Iranian pillars with their campaniform bases and crowning animal illustrated forms with which Indian tradition was familiar, Maurya artists may have learned from their Achaemenid predecessors an arrangement of elements, an air of heraldry, and certain stylistic details. In essence however the Asokan *dharma stambhas* seem to reflect a proto-historic symbolism as seen in the Harappan amulet illustrated in figure 112 which survived or was revived in popular cults and was acknowledged in the developing Buddhist and Brahmanic traditions.

Maurya art, in relation to earlier Iranian tradition, appears to demonstrate an underlying continuity in the pattern of India's receptivity toward Western forms. From proto-historic to Maurya times parallel elements have appeared in the arts of India and Iran, and from the beginning, as far as we know, these elements on the whole were met first in the West.

In respect to proto-historic ceramic motifs, we attributed similarities to a diffusion of culture from a nucleus west of India, which were interpreted as resulting to an extent in parallel expressions, rather than as constant intrusions of Meso-

[29] Ibid., p. 32.
[30] Piggott, "Notes on Certain Metal Pins and a Mace Head in the Harappa Culture," *Ancient India*, IV, 1947-48.
[31] Herzfeld, op. cit., p. 208. "Long before Pasargadae, the prototype of the theriomorphic impost, which is the most striking feature of Achaemenian architecture, existed in Asia Minor."

potamian elements into Indian culture. In respect to the Maurya and Achaemenian traditions an equivalent relationship can be postulated. A fresh spread of culture from an Occidental nucleus, perhaps remotely propelled by movements of Indo-European speaking peoples, was the ultimate impetus behind the Maurya Empire. As in Harappan times, this remote spread or impetus acted as a stimulus. The Maurya Empire itself with indigenous roots was the result. The Achaemenid regime may be viewed not as a prototype for the succeeding Maurya Empire but as an antecedent. Yet, along with its local heritage, the Asokan Empire undoubtedly inherited many elements from the West. This is visible among other things in the art of the Maurya regime. Hence it is proposed that Western forms were not intrusive, that is, not transient foreign elements superimposed upon Indian traditions, but that India in Maurya as in Harappan times was within the West Asian cultural sphere, albeit at its perimeter, and thus naturally shared certain artistic features with the Western traditions.

As regards the art of animal figures which crowned Asoka's pillars, it is of interest to consider their relative affinity with West Asian and especially Persian art. The preserved Persepolitan imposts are double protomes of animals in four types: bulls, lions, a fantastic leonine animal, and the human headed winged bull—the old Assyrian lamassu. Herzfeld notes the absence of the sphinx or the hybrid griffins that appear on the door-jambs and of the horses of Pasargadae or the rams of Anatolia and states, "The animals are a stereotyped selection from a preceding multitude."[32]

In comparison we may note that the surviving Maurya crowning animals—single and addorsed lions, bull, and elephant, all real—are apparently also selected from a repertoire which anticipated Asokan sculpture. Whether this preceding repertoire was executed in perishable material or was as yet unformulated and pending artistic expression, it seems to have existed as a cultural tradition that had certain elements in common with Western Asia. Thus Maurya sculptors evidently chose their forms not from Persepolis, but from a tradition cognizant of ancient Occidental art as well as of Vedic symbolism. In effect, details in the treatment of Asokan animals reveal as many similarities with Mesopotamian art in general, as with the Persepolitan protomes in particular. To illustrate this point we may note for example that the treatment of the eyes and the mane of the Sarnath lions is in accordance with conventions widely apparent in Assyrian, Iranian, and Hellenistic sculpture.

Critical appraisals of Asokan sculpture have generally recognised two distinct though overlapping traditions. One is dominated by a formal precision which attains perfection in the Sarnath capital. The second style, exemplified perhaps by the Sankissa elephant, is characterised by a heavy naturalism. The latter tradition has been described as an Indian or indigenous one, inferring that the more elegant or accomplished former style is in some respects intrusive. And, in fact, as we have just noted, certain mannerisms in the execution of Maurya lions are anticipated in Western sculpture. However, both naturalism and a more formal accomplished technique have coexisted in Indian art from Harappan times. Opposed yet intermingled traditions, noted in Indus Valley ceramics, seals, and in the few remaining examples of sculpture in the round, have been attributed to two parallel strains in Indian art. The so-called popular or indigenous strain from proto-historic times represented a self-contained tradition inspired fully in the local atmosphere and unaware of foreign culture. Simultaneously in the Harappan and subsequently in the Maurya Empires, an accomplished formal tradition flourished in Indian art,

[32] Herzfeld, op. cit., p. 242.

a tradition proven to be fully aware of artistic efforts abroad. In Maurya and in Harappan art the "indigenous" self-contained strain is manifest in relaxed naturalistic lines and in an emphasis upon bulk, thick lines, and heavy forms. But, the more sophisticated of the Maurya sculptures, with their contrasting meticulous conventional craftsmanship, are also of an ancient lineage, a lineage which can be derived from the formalized Harappan seals, or the figure in a trefoil robe (figure 154) who reminds us so much of Sumerian counterparts. The humped bull which crowns the Rampurva pillar combines the careful polished execution of the formal Asokan style with a natural freedom and forcefulness evidently descended from Harappan traditions. This figure demonstrates the error of attributing the conventional sophistication of Asokan sculpture directly to Iranian or Hellenistic impetus. It is not because of foreign intervention that Asokan sculpture attained its high degree of accomplishment. Rather it is because of its inherent sophistication and consequent eclecticism that this sculpture incorporated foreign technical achievement and absorbed something of the traditions of culture further west, traditions which it must be remembered were originally affiliated. Built upon a common core and developed within a common sphere, Indian and West Asian cultures are joined in a complex relationship. Evolved from connected proto-historic forms, reinforced by the effects of Aryan movements, and later mutually subject to Hellenistic influence, the arts of India and ancient Iran cannot but reveal significant parallels. To completely isolate in these parallels ancient inheritance from more recent borrowings (i.e., foreign influence) appears in the light of present material to be almost impossible.

In the Asokan columns considerable importance is given to the square or more commonly round abacus upon which the crowning figures rest. This member is variously decorated with animal or floral motifs. The abacus is omitted in the Persepolitan pillars, and its role of pedestal in the Maurya *stambha* might be primarily symbolic rather than functional in intent. The abacus of the Sarnath column is of particular interest. It depicts four Buddhist wheels separating four animals— the bull, the horse, the lion, and the elephant. The Indian symbolism these figures and the Sarnath column as a whole embody is interpreted by Rowland as a combination of ancient West Asiatic and Vedic cosmology.[33] The treatment of the animals on the plinth, in particular the horse, has been compared with objects in Western art. Rowland relates their realistic manner to the style of a Hellenistic horse on a Bactrian silver bowl.[34] Dr. Niharanjan Ray suggests a similarity with a horse in relief depicted on the "Sarcophagus of Amazons."[35] He considers the Maurya lion and bull inspired in Achaemenid prototypes and the elephant related to horned elephants depicted on early Seleucid coins.

In this work until now emphasis has been in general on motifs rather than on stylistic considerations, except for outstanding ones. However, at this point it may be noted that it is upon a question of style that a direct dependence of Asokan sculpture upon Occidental precedent is postulated. Specifically, the stylistic aspects of the Sarnath abacus as well as of other Maurya sculptures are considered Western enough to imply that they were executed by Western artists, or at least artists trained in Western—either Achaemenian or Hellenistic—traditions and techniques. And in view of the cosmopolitan orientation of the Maurya regime,

[33] Rowland, *The Art and Architecture of India*, 1953, p. 45.
[34] Ibid., p. 45.
[35] Ray, op. cit., 1945, p. 41. The sarcophagus of the Amazons is a Hellenistic work (in Vienna). Cf. Mitra, "Mauryan Art," *Indian Historical Quarterly*, III, 1927, pp. 541-560 and p. 218, fig. 298.

it is not improbable that, as proposed by Wheeler,[36] the Maurya court employed foreign craftsmen as did the Achaemenid court before it. However, it must be stressed that the implications of this circumstance should not be over-estimated. As we hope to have shown, Asokan sculpture is not an adaptation of Iranian, Hellenistic, or Mesopotamian traditions, except to the extent that these traditions were originally related. The Asokan *stambha* is essentially a standard while the Achaemenid column is an architectural unit. The contribution of Occidental schools to Maurya art may be regarded as a technical one, responsible perhaps, as suggested earlier, for certain superimposed stylistic details and certain techniques, but not for any fundamental motifs, forms or concepts.

Fig. 237

The abacus of the Rampurva lion, the Lauriya Nandangarh, and the Sanchi pillars depict geese in rows or in the last example in pairs separated by a honeysuckle motif. A knop and honeysuckle motif or palmette is seen on the abaci of the Rampurva bull and Sankissa capitals with a bead and reel border in the latter example. These floral motifs, the bead and reel border, and a cable moulding seen in some cases on the necking between the capital and the abacus are conventional motifs also found in the sculpture of Iran, Mesopotamia, and Greece. Their reappearance in Maurya and subsequent Indian sculpture implies that these motifs were not casually adopted from the West, but that they, like the rosette, had a more fundamental symbolic significance. Whether this significance was intentional or formalized and forgotten may be difficult to ascertain. However, persistent motifs have been shown to be neither coincidental nor borrowed superficially for their ornamental value, but rather basic and meaningful. Thus recurrent motifs, like the honeysuckle palmette, were not superimposed on the Indian repertoire, but may be viewed as the common property of the artistic traditions in which they appear.

To summarize, similarities between the Maurya and Achaemenid pillars seen in figures 234 to 236 and plates 5 to 11 and figures 229 and 230 include the occurrence in both of campaniform capitals and crowning animal figures, perhaps the lustrous finish,[37] and a distinctive monumental effect produced by both the Indian and Persian columns. In other features, like the treatment of the lion faces and manes, the characteristic floral or bead and reel motifs of the abaci, and perhaps the style of the animals on the abacus of the Sarnath pillar, Maurya sculpture is seen to be generally related to West Asiatic art as a whole inclusive of Hellenistic traditions. Figures 237 to 239 and plate 12 from Occidental sources illustrate some of the above mentioned features which are comparable to elements to the Maurya *stambhas* of figures 234 and 235 and plates 5 to 9.

Fig. 238

Offsetting these similarities are the numerous elements in which the Maurya pillars differ from Iranian counterparts. Important is the difference in intention behind a free standing monument and an architectural support. Animal crowned structural Maurya columns have not survived in a complete state. However, to whatever extent destroyed or undiscovered examples of Maurya architectural columns were anticipated in earlier Achaemenid architecture, the free standing monolith cannot be interpreted merely as an extension of the architectural pillar. Rather, the Asokan *stambhas* apparently incorporate the intentions of proto-historic standards as depicted on a Harappan amulet (figure 112), or Vedic pillars, and of a West Asiatic tradition of commemorative monuments.

[36] Wheeler, *Early India and Pakistan*, 1959, p. 173. Wheeler maintains that after the destruction of the Achaemenid Empire, Persian artists and craftsmen found a new home under the Mauryas.

[37] Ray, op. cit., p. 34.

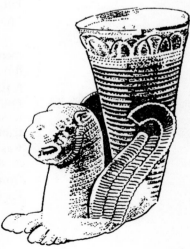

Fig. 239

As regards dissimilar details, these include the absence of an abacus in Perse-politan pillars and the absence of a base in the Maurya ones. Finally, we may draw attention to a difference in proportions and to the totally different aesthetic effect of the Indian columns.

The above noted points seem evident and familiar; yet, their interpretation has proven to be controversial and has led to conflicting evaluations of Asokan art.

It may be proposed that perhaps a more accurate understanding of Maurya art vis-à-vis the West can be achieved by realizing that this art represents not de-pendence upon or independence of Western Asian traditions but affinities of several types. We have shown of related Indus Valley and Mesopotamian motifs that these motifs are suggestive of several things. They indicate a common cultural substra-tum, subsequent cultural intercourse, and perhaps in a few cases simply coincidence. Similarly, elements common to Maurya and Western Asiatic, particularly Iranian, art are representative of diverse though overlapping relationships.

As interpreted above, the campaniform shape appears in its Iranian and Indian manifestations to have been derived from the lotus.[38] Thus its recurrence in the Achaemenid and Maurya traditions suggests fundamentally or originally related symbolism. The presence of crowning animals in the Achaemenid columns may be derived from wooden prototypes in Asia Minor,[39] whereas the Maurya examples have their own early prototypes. The campaniform or lotus shaped members as well as crowning addorsed animals are traditional in both early Indian and West Asiatic art and can be interpreted as parallel expressions derived from related tra-ditions. In other words these forms are products of a common cultural background. However, the combination of elements as they appear in the Maurya columns would seem to imply a more direct dependence on Achaemenid prototypes.

Similarities in artistic conventions of formalized decorative elements, like the treatment of lions or the honeysuckle motif, may also be viewed as parallel expo-nents of related artistic traditions. These parallels, like the parallels in ceramic motifs, are conventional and widespread. Such persistent and recurrent formulae again imply an underlying common symbolism, even if this symbolism be remote, trans-formed, or unremembered, and they represent a common cultural background.

On the other hand, stylistic similarities such as perhaps the Hellenistic "feel" of the horse on the Sarnath abacus as well as some parallels in composition are attri-butable most probably to direct Western intervention. Similarly, the typical Maurya "polish" is a technical element possibly learned from Iranian craftsmanship.

The features in Maurya sculpture which can be directly derived from Acha-menian traditions—elements of technique, composition and style—testify to the flourishing of current cultural interchange. Although Mauryan India was essentially a recipient in this interchange by virtue of its later chronological position, the cos-mopolitan character of Achaemenid art and of the Achaemenian Empire testifies to some possible earlier contribution on India's part. We may recall the substantial tribute in gold dust paid by India to Iran, or the ivory from Sind with which Susa was embellished,[40] and also Achaemenid references to the presence of foreign artists at the Iranian court. Thus, the probable presence of artists or artistic know how from the West in India was anticipated by the presence of foreign, possibly even Eastern, traditions in Iran. In this light, Achaemenian elements in Asokan art may

[38] This probability is noted by Ray, op. cit., p. 32. It has also been suggested above that the Achae-menid capitals may be derived from Egyptian lotiform prototypes. Cf. Capart, *Egyptian Art*, 1923, pl. xxxvii.

[39] Herzfeld, op. cit., p. 208.

[40] Ghirshman, *Iran*, 1954, p. 166.

be viewed as representing one aspect of a cultural exchange, an exchange which India to some extent reciprocated. Asoka's internationally oriented religious activities may be noted as an area in which Indian traditions were directed toward the West.

Finally, the monumental air common to Achaemenid and Maurya sculptures may be to some extent the effect of similar circumstances. The direct and personal relationship between the Emperors and the craftsmen whom they patronized was responsible for the powerful and accomplished character of monuments that were executed for the specific purpose of commemorating Imperial and divine glory.

In short, the Maurya *stambhas,* evaluated from the viewpoint of their relationship with Western Asia, reveal primarily a common background from which India and ancient Oriental cultures emerged; secondly, subsequent cultural intercourse in which India apparently was largely a recipient; and, thirdly, circumstantial similarities. The repertoire of this common background or substratum had its origins in proto-history and was replenished by continued cultural diffusion over millenia. As migrations, conquests, and commercial, religious or political contacts contributed to this diffusion, borrowings—often, as in the pre-Maurya period, leaving no contemporary record—become relegated to a "common substratum" from the viewpoint of subsequent periods. An appreciation of this pattern is fundamental in interpreting the nature of the connections linking Indian and West Asian traditions over thousands of years.

It is notable that in the course of cultural diffusion artistic elements must have appeared as intrusive—that is, new and unassimilated—in Indian contexts. However, by the time elements like the campaniform capital or the palmette come to our notice they are generally seen to be established and absorbed in Indian traditions. This may be attributed partially to the fact that Maurya art has come to light without known antecedents.

4. FURTHER ASPECTS OF MAURYA ART

Although the monumental pillars are the backbone of known Maurya sculpture, our understanding of this tradition is amplified by a number of contemporary works. In some cases the dating of these other sculptures is controversial. However, as our conclusions regarding these works and their relative position vis-à-vis Western artistic traditions do not hinge upon a specific narrow chronology, we will by-pass this controversy. Accepting as a working hypothesis that Maurya polish is a fairly consistent if not conclusive chronological guide, we shall assume the sculptures under discussion as a group to be Maurya.[41]

The Dhauli elephant represents the so-called "indigenous" strain in Maurya sculpture. It is stylistically related to the Sankissa capital and has been attributed to the twelfth or thirteenth year of Asoka's reign.[42] This elephant, seen in plate 13, is executed in a naturalistic style characteristic of Indian elephants from Harappan times. Though it was carved of rock in Asoka's time, the sculpture is patently of local inspiration.

The tradition manifest in the Dhauli elephant represents the same strains of which Indus Valley art was composed. Indian art from earliest times has been moved by two distinguishable but merging sources of inspiration; one, which can be described as popular, derived its impetus from the immediate environment and a local heritage. A second equally indigenous source of inspiration but encompassing a

[41] Ray, *Maurya and Sunga Art,* 1945, pp. 48, 106-07, note 9 and p. 108, note 48.
[42] Ibid., p. 35.

wider horizon was moved by its awareness of international artistic traditions, techniques, and potentials. Naturalism and flowing freedom can be named as hallmarks of the popular strain and realism with restraint as well as more accomplished techniques characterize the latter cosmopolitan tradition.

The remaining sculptures attributed to the Maurya period may be divided into animal sculptures, anthropomorphic sculptures, ringstones, and terracottas. The zoomorphic figures, many fragmentary, as a group reiterate the conclusions suggested by the animals crowning the Maurya pillars. They reveal stylistic differences ranging from a relative crudeness to a more refined technique and reflect, like the Maurya pillars, varied points of affinity with Achaemenian sculpture.

Among these figures attention may be drawn to the following: a fragmentary lion head found at Masarh (Bihar) now in the Patna Museum (figure 240); a Naga Canopy from Rajgir in the Indian Museum, Calcutta (plate 14), the Lohanipur and Salempur (Muzaffarpur District) addorsed bull capitals which originally were parts of structural columns, now in the Patna Museum (numbers 10974 and 2770 respectively), a pair of griffins excavated by Waddell at Patna (number 5582 in the Indian Museum, Calcutta, cf. figure 241), and other fragmentary remains.[43]

Fig. 240

As in the Asokan *stambhas,* among the above remains, figures of lions and bulls are recurrent. Their treatment can be related to one or another of the crowning animals. As regards their position vis-à-vis Occidental sculpture, these figures supplement the conclusions which were suggested by our evaluation of the pillars. More specifically, for example the lion head in the Patna Museum, illustrated in figure 240, reveals an affinity with Achaemenian sculpture which has been analysed above and may be further seen by comparing this figure with figure 239 from Iran. Thus these figures fall in with integrated traditions; one seen in the naga canopy of plate 14, in which popularism predominates, and another, seen in the Masarh lion of figure 240, in which accomplishment and restraint are stressed. Realism permeates both the popular and the more sophisticated strains in Maurya sculpture. This realism tends toward naturalism in the popular aspects of Indian art and toward conventionalism in more sophisticated works.

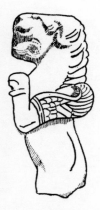

Fig. 241

The Salempur and Lohanipur addorsed bull capitals are of interest in that they served architectural purposes and thus can be linked, on the one hand, with earlier Achaemenian capitals, and on the other with structural pillars as seen subsequently in the Western Indian cave temples and sculpted in the Sanchi gateway reliefs. The question of origins in connection with structural capitals crowned with addorsed animals seems less clear than the origin of the monolithic pillars discussed above. The absence of indigenous prototypes for such structural pillars and their more mechanical function, which cannot be as satisfactorily supplemented by a background of symbolism, leaves some doubt. Furthermore, the remains are incomplete and so limited as to preclude any valid generalizations. We have commented above upon Herzfeld's statement that wooden prototypes preceded the Achaemenian columns. Possibly this circumstance can be extended to the Indian examples as an alternative to the latter being an adaptation of an Iranian concept. Later Indian examples suggest that structural animal crowned pillars were not unusual in Indian architecture.

An unusual subject among the above sculptures is the naga canopy now in the Indian Museum. Stylistically refined, yet certainly indigenous in conception, this sculpture, seen in plate 14, if Maurya, further demonstrates a merging of the popular and the sophisticated strains which constitute Maurya art. The canopy was presumably attached behind the head of a human figure.

[43] Ray, op. cit., pp. 106-07, note 9.

The pair of griffins excavated by Waddell at Kumrahar has been discussed by Piggott[44] who identifies them as throne fragments. In this light their affinity with Achaemenid forms, for example, as shown by Piggott, with a throne depicted in the Naqsh-i-Rustam reliefs, merits consideration.[45] One of the Pataliputra griffins shown in figure 241 may be compared with a Persian bronze leg seen in figure 242 and attributed to the Achaemenid period. Piggott draws attention to a similar griffin found in Afghanistan which he notes "may be a significant pointer to contacts between Persia and India in Achaemenid times."[46] Further examples of bronze chairs or thrones of either the Achaemenian or Sassanian periods are also pointed out by Piggott as comparable to the Pataliputra griffins. In India, similar forms are seen in the Amaravati sculptures and in a griffin found at Mathura and dated approximately to the first century A.D.[47] These sculptures are subsequent to the Pataliputra throne fragments. However, iconographically their relationship to the *simhasana* may have some bearing upon origins. The precise implications of the affinities in concept and detail between the griffins and similar forms seen on Iranian thrones are not clear. Some doubt remains as to whether the Indian examples were adapted from Achaemenian prototypes or were a parallel development.

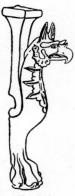

Fig. 242

To a greater extent than animal figures, early Indian anthromorphic sculptures are controversial as regards dating and identification. The following works perhaps can be attributed to the Maurya period: two standing Yakshas, discovered at Patna and now in the Indian Museum, Calcutta, one of which is headless; a standing Yakshi discovered at Didarganj in Patna, now in the Patna Museum; a nude torso and a face fragment, both discovered at Lohanipur in Patna and now in the Patna Museum; an architectural fragment depicting a sorrowing woman from Sarnath, now in the Indian Museum; and fragmentary heads.[48]

The above works, whether they be attributed to the Maurya period or in some cases to the subsequent Sunga period, represent a fresh aspect of early Indian sculpture. In comparison with other Maurya art, the Yaksha and Yakshi figures are notably devoid of affinities with Iranian sculptures. Ramprasad Chanda has noted that the treatment of the garment worn by the Patna Yakshi, specifically the full front and sewed borders, is comparable with the lower part of the Median costume as depicted in Achaemenian reliefs.[49] However, details like these are superseded by a complete dissimilarity in conception and feeling between the anthropomorphic Maurya sculpture and Achaemenian or West Asiatic figures.

The interpretation of the discrepancy between the Iranian and Indian treatment of the human form in contrast with the affinity which we have noted in the treatment of decorative and animal motifs is notable. That, regardless of its affinity in some instances with West Asiatic forms, all Maurya art—the monoliths with their capitals and crowning animals, the art represented by the Dhauli elephant, as well as the anthropomorphic figures—was a genuine creation of an indigenous tradition is confirmed by subsequent Indian sculpture which retained all the motifs met with in the Maurya age. However, it may be said that with their lack of similarity to foreign forms, the Yakshas essentially reflect popular traits. This predominating popular tradition, however, is not without an accomplished refinement and a measure

[44] Piggott, "Throne fragment from Pataliputra," Appendix to Wheeler's "Iran and India in Pre-Islamic Times," *Ancient India*, IV, July 1947-January 1948, pp. 101-103.

[45] Ibid., p. 102, figs. 5-9.

[46] Ibid., p. 103.

[47] Ibid., p. 101.

[48] Ray, op. cit., pp. 106-7, note 9.

[49] Chanda, "The beginnings of Art in Eastern India with special references to sculptures in the Indian Museum," *Memoirs of the Archaeological Survey of India*, XXX, 1927, p. 35.

of sophistication which is seen in varying degrees in the style and technique of the figures and also perhaps in some details which have parallels in West Asiatic art. These superficial parallels suggest at least an awareness of Occidental forms which further implies a wider artistic scope and consequently a measure of cosmopolitanism.

As we shall see in the next section, post-Maurya art is considered to have evolved from the more popular elements expressed in the Maurya period. However, the art of Bharhut and Sanchi incorporated the motifs seen in the monumental Asokan art as much as it did more popular subjects. Stylistically, perhaps, and technically the new schools were heirs to the art of low relief and heavy forms associated with the more popular Maurya works, like the Yaksha statues or the Dhauli elephant, rather than to the aloof, technically perfect, and measured style of which the Sarnath monolith is a hallmark. Nevertheless, the popular and cosmopolitan aspects of Maurya art overlapped and naturally contributed to subsequent traditions.

Significant as stylistic considerations are, they cannot be separated from content in the evaluation of an artistic tradition. And the content of Asokan art as a whole survived his age though certain stylistic accomplishments of this art did not. This circumstance can be explained not by by-passing the accomplished Maurya monuments as artificial or superficial, but by understanding that the conditions which these monuments reflected ceased to exist. Consequently, a new cultural state of affairs was expressed in a new style. The patrons of the arts in the Sunga period were primarily devotees, and most logically the works they commissioned replaced with other qualities the sophistication, technical perfection, and monumental proportions which characterized the Asokan monoliths.

Our understanding of Maurya art has been extended by the discovery at various sites of objects which have been described as ringstones. These stone discs sculpted in relief, although not conclusively datable, reveal stylistic affinities with Maurya and Sunga sculpture. In several cases dating on grounds of style and polish is supplemented by stratigraphic and paleographic evidence.

The significance of the ringstones lies in their far reaching links and merged affinities. These objects are apparently inspired in popular fertility cults that are inherited from Harappan times. From this viewpoint a possible relationship with Indus Valley perforated discs, also believed to have been associated with fertility rites, is suggestive. The Harappan ringstones, an example of which is illustrated in figure 243, were not discussed earlier as artistic expressions as they are mostly undecorated and crudely executed. However, a connection with the later discs which are profusely sculpted and depict female divinities, is not improbable. Notwithstanding their inspiration in popular forms of religion, the Maurya and Sunga ringstones reveal strong affinities with West Asian art. The occurrence on the discs of conventional Occidental ornaments like the honeysuckle or cable mouldings confirms the view expressed above that these motifs were not borrowed from the ancient Orient by Indian art, but rather constituted a common repertoire. If an imperial atelier, like that of Asoka, may be considered to have borrowed foreign decorative elements, a similar explanation can scarcely account for the recurrence of these elements on objects which evidently are not products of the court, but rather have obviously been conceived in a purely popular tradition. The fact that on these ringstones, which can be expected to illustrate only assimilated motifs, we find decorative elements which are widespread also in Western Asia, is significant. The implications of this fact appear to be, as we have already proposed, that to a large extent the relationship between India and Western Asia was fundamental and underlied even the popular cults. To this relationship can be attributed the most

Fig. 243

important of the elements shared by the traditions of Maurya India, Achaemenid Iran, and the Hellenistic Orient. More specifically, it may be said that the relationship which resulted in parallel artistic elements in the arts of Maurya India and the West are seen to be assimilated in popular Maurya art, and thus must have antedated this art considerably.

The Maurya ringstones further attest to the impossibility of isolating the popular and the imperial traditions in Maurya art. Incontestably popular in subject and intention, these discs, which are if not a survival than a revival of proto-historic traditions, often reveal a technical perfection which is on a par with the most accomplished and sophisticated of Asokan sculpture. John Marshall who drew attention to the connection between the Mohenjo-daro and Harappan ringstones and the elaborate examples of the early historic period, has commented regarding two of the latter: "For jewel-like workmanship and exquisite finish these two objects are unsurpassed by any other specimen of stonework from ancient India."[50]

Relatively few examples of the Maurya and Sunga stone discs are published. So far specimens of these discs are known from Taxila, Rupar, Mathura, Sankissa, Murtaziganj, Kosam, Rajghat, Jhusi, Vaisali, and Patna. The absence in many examples of a central perforation is notable and perhaps suggests that these discs were either votive tablets or were themselves objects of worship rather than as suggested by Marshall[51] yonis analogous to Indus Valley rings similarly interpreted. Whatever their precise role, the connection of the ringstones or stone discs with a fertility cult is apparent from the presence of the mothergoddess as a fundamental motif. The sculpted stone discs fall into two groups. One group which has a central hole, as seen in plate 15, is decorated with a fairly limited and conventional number of designs. These ornamental designs belong to a series which we have seen to be the common property of West Asian and Indian repertoires like the honeysuckle. The possible symbolic undertone expressed by the application of such decorative patterns in this context should not be overlooked, although specific implications cannot be determined. Nevertheless, as we have seen throughout the survey of ceramic motifs, continuing and widespread motifs owe their survival to something beyond aesthetic value, and conventionalism can often be attributed to an underlying symbolism. The workmanship seen in this group of discs is accomplished and refined and their polish is typical of Maurya work.

A second group of discs lacks the central perforation but replaces this by a central depression. These discs, two examples of which are illustrated in plates 16 and 17, are more profusely and variedly decorated. The honeysuckle is replaced by lotus motifs, which are conspicuously absent in the first group of stones. The somewhat more elaborate and less rigid mothergoddess figure is associated with a profusion of real and imaginary bird and animal figures like the unicorn, sphinx, winged lion, griffin, elephant, horse, deer, rhinoceros, ram, lion, peacock, owl, cock, or duck. Geometric motifs like the taurine and others also occur. Occasionally the lotus in association with other motifs replaces the mothergoddess herself. In content and treatment similarities with medallions of Bharhut and Sanchi may be noted, although the latter are more developed. In view of their greater affinity with Sunga sculpture, the unperforated discs may perhaps be considered subsequent to the perforated examples. In the former series more so-called "Indian" elements appear to have surfaced anticipating post-Maurya traditions. The effervescence of Sunga sculpture may be interpreted as a manifestation of popular spirit, but there is no basis for viewing as non-indigenous the more contained Maurya

[50] Marshall, "Guide to Taxila," *Archaeological Survey of India—Annual Reports*, 1920-21, p. 21.
[51] Marshall, *Taxila*, 1960, I, p. 503.

ringstones. As we have seen, free flowing crowded designs coexisted with more restrained decorative motifs even in proto-historic traditions.

As regards the motifs themselves, the elements depicted in the ringstones and subsequently in Sunga sculpture reveal, if anything, more parallels with West Asiatic art than we have met with in the limited repertoire of Maurya columns and free standing sculptures. Winged and fabulous creatures or the recurrent rosette, for example, are as typically "Persian" as they are Indian and, as noted, have very ancient prototypes in both Mesopotamia and the Indus Valley. Thus, from the viewpoint of subject some relationship with Occidental art is evident in post-Maurya as well as in Maurya sculpture, and the later tradition cannot be considered as revealing a repertoire which is "indigenous" in contrast to that of the preceding age. But because of their profusion, the Sunga motifs, which are incipient in the stone discs and which can be related to Buddhism or to more elemental cults, have been described as more "Indian" than their Maurya antecedents. Furthermore, the post-Maurya motifs, notwithstanding parallels in West Asiatic traditions are artistically integrated. Thus our attention is not so much drawn to the fact that in conception they are related to—though not derived from—foreign forms.

However, we have shown that although sophisticated and technically accomplished, the Maurya motifs with foreign affiliations are equally integrated in Indian art from the viewpoint of symbolism and even stylistic convention. But, in Maurya art the elements which are in common with, usually not borrowed from, Occidental forms are not overshadowed in a medley of other material. Rather, due to their isolation and heraldic treatment, similarities with Western elements seem accentuated. This stress appears to an extent to account for the emphasis which has been perhaps unduly placed upon the foreign affinities of Maurya traditions.

The above analysis may be summarised by noting that Maurya art, in contrast to post-Maurya traditions, cannot be viewed as less "Indian or indigenous." In other words, Maurya art, in its merging of popular and more sophisticated expressions, is as faithful to Indian proto-historic, especially Harappan, traditions as the subsequent Sunga school. In fact, Maurya art reveals greater affinity with the more accomplished Indus Valley artistic specimens than does Sunga sculpture. We may say that post-Maurya traditions reveal a closer relationship than Maurya traditions do with the future art that is evoked by the term "Indian." From this viewpoint only can we accurately refer to Sunga sculpture as more "Indian" than the earlier sculpture of the Maurya age.

It remains to consider briefly the terracottas in the Maurya period. The study of terracottas presents many difficulties because to a great extent their style is elusive and dates are uncertain. We have earlier referred to Stella Kramrisch's differentiation between "ageless" and "timebound" terracottas. The latter group reflects the stylistic developments of its period and hence can be dated with reasonable accuracy by comparison with contemporary sculpture. However, surviving Maurya sculpture is essentially monumental and sophisticated whereas terracotta has always been a vernacular medium. The predominantly popular Maurya works, which may provide a point of departure for evaluating terracottas, are themselves to some extent controversial and stylistically seem to anticipate post-Maurya traditions.

Recent excavations have placed the study of terracottas on a somewhat firmer footing. At Charsada,[52] for example, Wheeler discovered, in strata dated from 250 to 100 B.C., female figures of a type which Coomaraswamy had attributed earlier

[52] Wheeler, *Charsada*, 1962, Chap. IX.

to the second millennium B.C.[53] At Ahichhatra[54] equivalent figurines belong to pre-Sunga levels, that is 300 to 200 B.C. It now appears as if Coomaraswamy's dating based on stylistic features may have been too early, but more important is the fact that these features remained basically unaltered from proto-historic times until the Maurya age. We have already drawn some attention to this fact in our discussion of Indus Valley terracottas.

The implications of the endurance of the conventions in accordance with which terracotta figurines were executed are considerable. In Mohenjo-daro and Harappa female figurines represented a determined style. That this distinct style survived down to minute details, like the ornaments or the rosette headdress, is significant. It cannot but mean that the cult represented by the figurines also survived.

We have already commented in the earlier parts of this work upon some aspects of the mother goddess cult and its far reaching penetration. It is apparent that terracotta traditions of Western Asia as well as India were largely devoted to this cult, in view of the recurrent predominance at different times and in dispersed regions of female figurines with enhanced feminine characteristics. The Indian figurines in their fundamental attributes—like nudity plus elaborate jewellery or even association with the rosette—are related to West Asiatic examples revealing similar traits. Thus figurines created in the Maurya age reveal the same underlying relationship to Western figurines as their Harappan prototypes. Nevertheless, stylistically the Indian terracottas seem distinctive.

The distribution of terracotta female statuettes is not universal, nor is their history as far as we know; terracottas are sometimes conspicuously rare. Notable for example is the dearth of terracotta material in Achaemenian contexts. In India we have seen the fading of this tradition in post-Harappan art; its subsequent history is as yet uncertain until such times as moulded examples are datable by comparison with contemporary sculpture. However, it is impressive that bridging gaps of space and time, terracotta figures re-emerge, retaining age-old characteristics like rosette adornments, profuse jewellery or accentuated feminine characteristics.

It is of great interest that the terracotta figures which represent indigenous traditions and features par excellence are at the same time intimately related to Occidental forms. The Indian figurines are unmistakably "Indian," although out of context there may be some doubt as to their age. We may note in this connection that the better made of the so-called "ageless" figurines are not without style and that the surviving style seems to have been Harappan rather than that of other proto-historic traditions like Kulli or Zhob. On the other hand, many details as well as the fundamental concept and intention of these modelled statuettes are duplicated in other Indian and Occidental terracottas of all ages. Thus it may be concluded that the mother goddess cult refers, even in Maurya times, back to a common nucleus, to a point of origin whence these traditions spread and acquired their respective distinctive features. In India these distinctive features are again ancient, their origins reverting to Harappan or earlier times and more specifically to a popular stratum within the Indus Valley Civilization.

At Charsada, an exceptionally interesting and unique find links the mother goddess cult of the early historic period with its Harappan antecedents. Here in a stratum attributed to about the third century B.C. Wheeler discovered a fragment of a small bowl depicting several figures in relief apparently enacting a ritual scene.[55]

[53] Coomaraswamy, "Archaic Indian Terracottas," *Marg*, VI, pp. 24-27, 1952-53.
[54] Agrawala, "The Terracottas of Ahichhatra," *Ancient India*, IV, July 1947—January 1948, pp. 106-08, pl. xxi a.
[55] Wheeler, op. cit., pl. xix, p. 102.

Fig. 244

Fig. 245

Fig. 246

Two nude steatopygous female figures are seen holding hands in a manner reminiscent of Indus Valley amulets.[56] Even the pigtail distinctly resembles Harappan prototypes. The implications of this bowl, considering the context in which it was discovered, are tentative in the absence of further corroborating objects. However, if its estimated early historic date is correct, it seems to signify a survival in the minutest details of a specific cult involving a female deity over, as far as we know, approximately two millennia. The Charsada sherd illustrated in figure 244 may be compared with plate 18 from a Mohenjo-daro tablet.

The Charsada sherd is also of outstanding value due to an affinity which its figures seem to have with some motifs on early prehistoric painted pottery from Iran. Once again the precise implications of this affinity are as yet elusive but not to be ignored. Figure 244 may be compared with the prehistoric Iranian design seen in figure 245. The personages in both examples are apparently related. In broad terms this relationship may be proposed to indicate the survival through millennia of a tradition containing religious and artistic elements which embraces both Iran and India.

Although female figurines represent the more distinctive efforts of terracotta art, this tradition has also fashioned male figures and model animals which however are in general less elaborate and do not on the whole suggest, significant parallels with Occidental traditions. Model animals, such as elephants or bulls, executed with varying degrees of spirit and proficiency, represent an "ageless" popular tradition which has scarcely changed from Harappan to modern times.

Figures 246 to 253 illustrate a series of female terracotta figures from Harappan, Maurya, and Western traditions. These examples reveal on the one hand a similarity in conception between Western and Indian mother goddesses, and on the other a continuity between the Indus Valley and Maurya forms of the female divinity. Figures 251 to 253 convey the same sense of proportion as the Harappan terracottas. These last examples are of the type referred to by Wheeler as "Baroque ladies"[57] and attributed by Coomaraswamy[58] to a much earlier period. The ornaments and the headdress depicted in figure 252 are reminiscent of the rosettes seen in some Indus Valley terracottas. Comparable with the above forms are the mother goddess figurines depicted on the ringstones or stone discs described above and representations on a gold leaf plaque found at Lauriya Nandargarh seen in figure 254 and on the Piprahwa Stupa.[59] The association of the mother goddess type with discs apparently associated with fertility, on the one hand, and with Buddhist remains on the other, reveals that the cult was versatile and adaptable to somewhat primitive or elemental as well as relatively more developed religions.

In conclusion it may be said that early historic terracottas, even tentatively dated, provide evidence indicating the endurance of Harappan artistic and religious traditions and simultaneously illustrate that, even on a popular level, Indian art and Indian cults had Occidental counterparts. This relationship between Indian and West Asiatic expression in terracotta does not suggest any borrowing but rather points to a very early common origin.

[56] Wheeler noted the following Harappan seals or amulets in connection with the above mentioned sherds. Marshall, *Mohenjo-daro and the Indus Valley Civilization*, v. III, pls. cxi, 356-357, cxv, 11-16; Mackay, *Further Excavations at Mohenjo-daro*, pl. lxxxvii, 235, lxxxix, 347, xcix a.
[57] Wheeler, op. cit., p. 104.
[58] Coomaraswamy, op. cit., pp. 24-27.
[59] Cf. Agrawala, *Indian Art*, 1965, fig. 44f.

Thus, the terracotta material complements the conclusions to which our analysis of Maurya artistic traditions and its Western relationships has led. These conclusions may be summarized as follows. Maurya art is interpreted as composed of two strains: a sophisticated strain which developed under imperial patronage and drew its inspiration from the wider world of which Maurya rulers were aware, and with which they were in contact; and a second popular strain inspired in the local environment and heritage. These two aspects of Maurya art have been shown to be not only over-lapping, but inseparable. Most Maurya sculpture combines sophisticated and popular elements and its character is determined by the predominance of popular or more sophisticated traits. A perfect example of this blend is the Rampurva bull. Both, a more sophisticated and an essentially popular art, were traditional in India, and the Maurya manifestations of these intermingled strains can be related in many ways to proto-historic prototypes.

Fig. 247

Parallels in Maurya and Iranian or West Asiatic art refer both to the more popular as well as to the more cosmopolitan aspects of the Indian tradition. The view that the Asokan school in opposition to the balance of Maurya art depended upon Achaemenid inspiration is not supported by our evaluation of this art as a whole. It has been shown that the Maurya repertoire is not a random adaptation of foreign forms, but illustrates a symbolism evolved of a long tradition. Within this symbolism parallels with Achaemenian art like the campaniform capital suggest a parallel frame of reference and thus an older common origin. Furthermore terracotta, a purely vernacular medium, has revealed the survival of a mother goddess cult which once again points to an ancient relationship between Indian and West Asiatic forms.

Conventional decorative styles and elements such as the honeysuckle, bead and reel, or cable moulding, the rosette, and aspects of treatment of animals, for example, triangular eyes—common to Maurya and West Asiatic sculpture—also suggest an intentional pattern of symbolism rather than coincidental parallels. The migration and survival of artistic elements are moved by deeper currents of convention and symbolism. Casual forms with no significance beyond their decorative values do not endure, nor have they the strength to survive and flourish in a new artistic environment. Thus these elements may also be referred to a common frame of reference rather than to borrowings on the part of Asokan craftsmen. The absence of pre-Maurya examples of such forms may be attributed to the fact that they were executed in perishable material and did not survive.

Fig. 248

However, in its technical accomplishment which did not outlive the Maurya regime, there is a likelihood that Maurya art may have been indebted more directly to Achaemenian precedent. The cosmopolitan orientation of the Maurya court was bound to have led to cultural and artistic interchange. A similar circumstance prevailed in the time of the Indus Valley Civilization. However, this condition cannot be interpreted as a dependence of Indian artistic expression upon foreign inspiration. Rather, the Maurya court and the artistic efforts it sponsored were aware of foreign traditions and thus incorporated something of this awareness into their own work. Thus the sophisticated monuments have some affinity with earlier Iranian forms but this affinity was in harmony with, not at the expense of, indigenous, that is independent, attitudes.

5. AN APPRAISAL OF CRITICISM

It remains to review the divergent opinions of art historians concerning Maurya art in order to consider the position which our interpretations hold in relationship to the consensus of critical conclusions.

Fig. 249

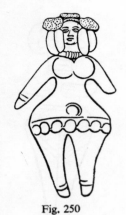

Fig. 250

Fig. 251

Fig. 252

Fig. 253

This work has been essentially oriented toward evaluating the motifs in Indian art which have equivalents in Western traditions and analysing the origins of these parallel expressions. Although, most often, similar forms have priority in Occidental traditions, we have not assumed this priority to indicate that Indian art invariably borrowed these forms. We have shown rather that from proto-historic times, Indian and Western traditions appear to have developed in relationship with one another and that common motifs and common symbols could not be transplanted or imposed devoid of their values. If a common or related value is accepted for the similar elements, these elements cease to be intrusive, superimposed, or borrowed, but rather may be considered an integral part of the artistic repertoire in which they appear, although belatedly. More specifically, if Occidental expressions antedate their Indian counterparts, the latter tradition represents a later development, but not inevitably a borrowed one. For example, the bell shaped member and the animal crowned pillars may be considered as forms parallel to earlier Achaemenian ones, rather than imitations of the former. The absence of these elements in pre-Maurya art is attributable to the fact that this art had no expression in permanent material.

In our interpretation of Maurya art vis-à-vis Iran and Western Asia we have not yet considered the general question of Western "influence" as such on Indian art. To some extent Occidental "influence" must have been exerted upon Maurya art since this art could not have flourished in a vacuum. We have seen that the Maurya craftsmen, enjoying imperial patronage, were conscious of efforts made by earlier Western traditions, especially those of Achaemenian art. But the impact of earlier Achaemenid culture and its artistic formulae were no more specifically responsible for the achievement of Maurya art than the Achaemenid Empire could have been directly responsible for the Maurya regime. Rather Iranian precedent may have provided a stimulus to both Maurya rule and Maurya art.

In its relationship to Iran and Western Asia, Maurya art repeats the relationship which seems to have prevailed between Harappan Civilization and Mesopotamia. The Maurya and the Indus Valley Empires and artistic traditions knew no Indian precedent of an equivalent caliber. Both cultures emerge in the wake of Western achievement. Yet neither Harappan nor Maurya culture can be said to have been overshadowed by Western precedent. Rather, stimulated or inspired by this precedent, they were able to make a unique response due to their inherent potential and favourable circumstances.

Intermingled with the West Asian elements with which Maurya art was familiar, are some features that seem to be more Greek than Asiatic. And occasionally in Asokan monuments, affinity with Greek tradition, as seen in the Pataliputra capital for example, rather than with specifically Achaemenian forms is perceptible. However, the distinct "Hellenistic" tradition that flourished in Greece and Western Asia subsequent to Alexander's invasions was no older than the Maurya Empire and this tradition did not make itself felt artistically in a substantial way until a later stage. Some Greek features may be considered to have penetrated Asokan art as part of the West Asiatic or Iranian traditions which were in themselves eclectic. The Achaemenian style was to some extent a blend of earlier traditions that flourished in the ancient Orient and these traditions were much involved in a reciprocal relationship with the art of Greece. Thus we see once again that, as in around the third and second millennia B.C., India and Greece were independent centers at the perimeter of a cultural sphere whose nucleus seems to have been in Western Asia.

In our study of parallels between Maurya and West Asian art, we have referred

to theories proposed earlier by A. K. Coomaraswamy.[60] His interpretations cannot be proven conclusively, as they hinge upon the existence of hypothetical perished material. However, on the basis of previous trends in Indian art and the pattern of its relationship toward Western traditions, it appears that Coomaraswamy's insight may be to a large extent accurate. Specifically, Coomaraswamy has maintained that West Asiatic and Persian elements migrated to India in pre-Maurya periods. He notes the following Maurya, Sunga and Early Andhra motifs which antedate Hellenistic influence and suggests parallels in Sumerian, Hittite, Assyrian, Mycenian, Cretan, Trojan, Lycean, Phoenician, Achaemenian, and Scythian cultures: Winged lions, griffons, tritons, formally posed animals in profile or addorsed and affronted, animal combats and friezes, sun-car with four horses, bay wreath and mural crown, tree of life, mountain and water, palmette and honeysuckle (blue lotus), rosette and petal moulding (rose lotus), acanthus, reel and bead, lotus or "bell" (so-called "Persepolitan") capital, symbols on punch marked coins, spiral, volute, labyrinth and swastika. Coomaraswamy maintains that because in general surviving examples of these forms are first met with in historic India during the Maurya and Sunga periods, they are incorrectly assumed to have entered India at this time, whereas a motif is not necessarily invented or borrowed at the time of its first appearance in permanent material. As a matter of fact, according to Coomaraswamy, a first appearance in stone is almost proof of earlier occurrence in wood. Coomaraswamy reasons that to assume the above motifs as Maurya imports presupposes a lost and different pre-Maurya art, "fantastic" in view of the conservative character of Indian art. Consequently he accepts that pre-Maurya motifs were the same as Maurya and post-Maurya motifs.

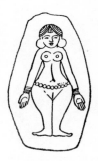

Fig. 254

More specifically, as we have already seen, Coomaraswamy states that the Asokan lotus or "bell" capital cannot be considered a copy of the Persian form as the resemblances are not sufficient to justify such a view. He believes that both are parallel derivations of an older West Asiatic form.

Coomaraswamy's views have been challenged because his contention cannot be conclusively demonstrated. Although his theory that Maurya and Sunga motifs penetrated the Indian repertoire at an earlier stage must remain hypothetical, there is some circumstantial evidence to support it. We have seen that the motifs common to Indian and Western art were pregnant with symbolic or conventional significance and that this symbolism was deeply rooted in Indian tradition. In fact, some antecedents, as for the fabulous creatures of the Sunga period, were seen in the Harappan seals or amulets. In our evaluation of ceramic motifs we have tried to show that the migration and survival of even the simplest elements depended upon their having more than decorative value, and that once these motifs were transplanted with their symbolic or conventional values, they could not be viewed as intrusive or alien in any tradition. Similarly, the motifs which appeared in the Asokan or later Sunga monuments, subsequent to an earlier existence in Iran, must have originally migrated with their conventional or symbolic values and thus cannot be viewed as alien forms in an Indian context. Whether these motifs were, as Coomaraswamy suggests, originally formulated in wood, or were merely pending artistic expression, they almost certainly belonged, as Coomaraswamy believes, to a pre-Maurya symbolic repertoire.

The above evaluation has been contested by a number of critics. Benjamin Rowland, for example, classifies Maurya art as a temporary "foreign intrusion" officially sponsored by the court and apart from the tradition of Indian folk art

[60] Cf. Chapter IV, 3 *supra*; Coomaraswamy, *History of Indian and Indonesian Art*, pp. 11-14, 1927.

which has historical continuity. He says: "The official foreign art sponsored by Asoka endured no longer than the rule of the Dharma which he sought to impose on his Indian Empire . . ."[61] The style of the Sarnath column, as well as the technique of stone carving was, according to Rowland, imported not later than the consolidation of the Maurya Empire. Rowland further considers that much of Maurya art was the work of foreign artists employed by the court.

We have already explained our belief that the popular or folk elements within Maurya art and the more sophisticated art of the court with foreign awareness were not entirely separate entities, but rather represented two intermingled strains, both having historical continuity. Yet it is evident that the technique which culminated in the Sarnath monolith did not survive the Maurya regime.

Dr. Nihar Ranjan Ray shares Rowland's view that "Maurya court art failed to make any notable contribution to the growth of Indian art except that it directly helped the fixation of the latter in permanent material."[62] He also maintains that this court art did not take cognizance of folk tradition which first affirmed itself at Bharhut. Although he acknowledges that some decorative features shared by Achaemenid and Maurya columns may have been derived from a common West Asiatic heritage, Dr. Ray considers that so far as the crowning members of the column and general effect are concerned, the Indian debt is a more immediate one to Achaemenid and Hellenistic art.[63] He further suggests that the idea of imperial suzerainty was made a reality by the Achaemenids, perhaps inferring that the Maurya considered the former exemplary. Ray also maintains that the Mauryan royalty were all Hellenophiles, and summarizes:

"From primitive animal standards to such monumental works it must have been a long journey, but royal will and state resources, individual taste and ideology of a benevolent autocrat and perhaps also a foreign hand and inspiration so potently at work at the Maurya court achieved the end of the long and arduous journey within a very short space of time."[64]

At the same time Dr. Ray does not fail to stress the originality manifest in the Maurya columns: "The indigenous and original contribution to creation of this item of Mauryan art is therefore undeniable."[65]

Although Maurya art achieved monumental proportions and a technical perfection within an unexpectedly short time, undoubtedly stimulated by Western precedent, this accomplishment may be viewed as a reflection of a more generalized achievement. To the extent that the Asokan Empire rapidly attained its own level without direct Western intervention, Asokan art was similarly capable of rapid progress. Whatever inspiration Western, more specifically Achaemenid, precedence may have provided Maurya art by way of its well-known earlier existence or even by way of technical assistance, the Asokan monuments illustrated the power and the specific character of the Maurya Empire.

John Marshall is of the opinion that Asiatic Greeks executed some of the Maurya monuments. Marshall's view is contested by Vincent Smith primarily on the basis that the Indian works are superior to the Persian models, since Achaemenid art is not without elements of decadence. Vincent Smith, like Coomaraswamy, affirms

[61] Rowland, *The Art and Architecture of India*, 1953, p. 47.
[62] Ray, "Mauryan Art," Chapter XI, p. 388, in *Age of the Nandas and Mauryas*, 1952, edited by Sastri.
[63] Ray, *Maurya and Sunga Art*, 1945, p. 34.
[64] Ibid., pp. 30-31.
[65] Ibid., p. 34.

that certain forms of Asokan art and plastic decoration are derived from wooden prototypes. John Marshall is of the opinion that Maurya art essentially reflected Hellenistic influence. In this connection he writes:

"... Every argument indeed, whether based on geographical considerations or on political and commercial relations which are known to have been maintained between India and Western Asia, or on the happy fusion of Hellenistic and Iranian art visible in these monuments, indicates Bactria as the possible source from which the artist who created them derives his inspiration."[66]

However, the conspicuous scarcity or absence of early Hellenistic monuments in India, and the fact that Hellenistic artistic traditions were just being formulated at the time of Maurya cultural and political supremacy, suggest that Bactria was not as yet in a position to materially influence or stimulate Maurya traditions. Marshall's extensive excavations at Taxila,[67] which had been annexed to the Persian Empire, invaded by Alexander, and subsequently was under the Mauryas, Bactrian Greeks, and Scythians, disclosed at the earliest city of Bhir Mound (dated between the 6th or 5th century and the 2nd century B.C.) only minor antiquities. Marshall considered his finds essentially representative of Hellenistic influence, although a number of antiquities are reminiscent of the Achaemenid style. The Bhir Mound finds include terracottas, seals, jewellery, coins, and pottery. The affinities which these objects seem to have with Western antiquities indicate the presence of a mixed population and many imports, but there is little material which seems to have any bearing upon the style of the Maurya monuments.

Vincent Smith presents a middle of the road view of Maurya sculpture, noting that Maurya works are superior to Achaemenid art.[68] Smith further maintains that certain forms of Asokan art and plastic decoration are derived from wooden prototypes and that their translation into stone was based on foreign examples.

Zimmer has described Imperial Maurya art as a provincial exponent of the Achaemenian tradition and devoid of indigenous roots. He writes:

"This particular and quite special phase of Buddhist Imperial Art represented in the royal columns of Asoka was of non-Indian origin. It was a provincial reflection of a proud heraldic style developed in Persia, at the court of the Achaemenid King of Kings."[69]

This view is surprising in the light of the emphasis Zimmer has otherwise placed upon continuity in Indian art and the endurance of its ancient symbolic repertoire. That the Maurya *stambhas* bypassed ancient Indian traditions and were meaninglessly adapted from Persian models, yet endured as a motif in subsequent sculpture, even in essentially popular sculpture, does not seem to be probable. Both in *Myths and Symbols in Indian Art and Civilization* and in *The Art of Indian Asia*, Zimmer has analysed the permanence of symbols in Indian art, symbols originating in many instances in Mohenjo-daro, Chanhu-daro, and Harappa. He pertinently quotes from W. Andrae:

"He who marvels that a formal symbol can remain alive not only for millennia but that it can spring to life again after an interruption of thousands of years, should remind himself that the power from the spiritual work, which forms one part of the symbol, is eternal."[70]

[66] Marshall, *Guide to Sanchi*, 1955, p. 103, note 1.

[67] Marshall, *Taxila*, 1960.

[68] Smith, *A History of Fine Art in India and Ceylon*, third edition, p. 63.

[69] Zimmer, *The Art of Indian Asia*, 1954, p. 231.

[70] Zimmer, *Myths and Symbols in Indian Art and Civilization*, 1946, p. 169, quotation from W. Andrae, Die Ionische Saule, Bauform oder symbol 1933 ack.

Zimmer continues:

"The life strength of symbols and symbolic figures is inexhaustible, especially when carried forward by a highly conservative traditional civilization such as that of India. Very often, as during the greater part of the history of India, evidence for the continuity may be woefully lacking; the materials in which the forms were rendered—wood largely and clay—were perishable and have simply disappeared. Oral traditions, furthermore, and the fleeting features of popular festivals, are practically impossible to reconstruct in detail for the centuries and centuries behind us. . . . Every so often tangible evidence appears. . . . Evidences of the existence in the third millennium B.C. of forms that were by our scholars thought to have evolved very much later cannot and must not be lightly shrugged away."[71]

From the standpoint of Zimmer's own insistence upon the significance of proto-historic precedence for many symbols in Indian art, we may once again refer to Harappan amulets depicting animal standards as a possible original point of departure for the Asoka *stambhas*, as well as to other elements like the Indus Valley representations of the humped bull that certainly anticipated the crowning figure of Asoka's Rampurva capital.

Stella Kramrisch has similarly drawn attention to the profound dependence of Indian art upon its proto-historic antecedents. And in effect, Indian art of the historic age as we know it commences with the Maurya monuments. We have seen that these works, notwithstanding their sophistication and Occidental affinities, did not reject Indus Valley traditions but distinctly reiterated them. Kramrish comments upon the endurance of Harappan art as follows:

"In the second half of the third millennium B.C. Indian art had passed its zenith in the large towns of the Indus Valley. Between this, the most ancient art of India, and the cosmopolitan art of the third century B.C., with the Mauryan Court in Pataliputra (Patna) on the Ganges as its centre, lie about two millennia wherein few monuments have been excavated as yet. Into this void falls the age of the Vedas. Its hyms are rich in imagery, whereas (although accompanied by signs of a script) the images and figures of India's more remote past have no known verbal equivalent. The tradition however remains unbroken for the themes and forms of the art of the Indus Valley during the third and second millennia B.C. are continued in Indian art when it re-emerges in the third century B.C."[72]

As regards the specific sources of Maurya art itself, Kramrisch summarizes the conclusions to which all the material reviewed here seems to point. She writes:

"Hellenism left its undeniable traces in Mauryan India . . . (finds at Basarh, the ancient Vaisali).[73] Equally obvious is the impression that Persian achievement had made on Asoka. But neither altered the trend of Indian sculpture. Considering the sculpture of Harappa, it is impossible to deny that Maurya sculpture is of the same stock as that of the Indus Valley and that the artistic attitude of this ramification in the Ganges Valley, as well as those of Persia and Greece, as far as their affinities go, have probably the same root, and that as far as the paleolithic age."[74]

In other words, Kramrisch acknowledges an awareness in Maurya art of Greek and of Iranian achievement but notes that these Occidental features of style were transitory. The enduring elements of Asokan art are of Indus Valley "stock." But

[71] Ibid., pp. 169-70.
[72] Kramrisch *The Art of India*, 1954, p. 10.
[73] Refers perhaps to terracotta heads with Hellenistic traits found at this site.
[74] Kramrisch, *Indian Sculpture*, 1933, p. 11.

even in originally Harappan elements some community with West Asian traditions existed. Thus an ancient relationship reasserted itself in the forms which were common to the artistic traditions of Buddhist India and the Western world. Those motifs or forms, which represented an ancient common repertoire rather than recent superficial borrowings, can perhaps be identified by their survival in the post-Maurya period.

The critical opinions referred to above are representative of the controversy which Maurya art has provoked through more than half a century of study. It has been evaluated as a provincial exponent of Achaemenian traditions on the one hand[75] and as a source of inspiration to Western art on the other.[76] A substantial number of scholars like Havell,[77] Bachhofer,[78] Wheeler,[79] Khandalavala[80] and others[81] have considered the Asoka *stambhas* to be to a greater or less extent the work of foreign craftsmen, whereas other critics have proposed that similarities in Persian and Indian columns may rather be attributed to the presence of Indian artists in the Achaemenian atelier.[82] The view that Occidental craftsmanship was responsible for Asokan achievement has not been advanced without qualification. Khandalavala, for example, has written in this connection that foreign influence is undeniable and natural, but adds, "that is quite different from ascribing any particular work to foreign craftsmen on the ground that such a degree of excellence could not have been achieved by early Indian craftsmen themselves. Such an attitude is illogical."[83]

The symbolism expressed in the composition of Asokan columns as a whole and in their component parts has also been subject to a series of interpretations. Critics have associated this symbolism with West Asiatic or with purely Indian traditions in varying degrees.

[75] Zimmer, *The Art of Indian Asia*, 1954, p. 231.

[76] Agrawala, *Indian Art*, 1965, p. 109. "The strength of the team invited from India for the building operations by the Achaemenian kings is not known but it seems to have been considerable looking to the favourable reputation which India enjoyed amongst the nations of antiquity. India was radiating her philosophy, religious ideas, art and culture amongst her neighbours on the periphery and beyond it...."

[77] Havell, *Ideals of Indian Art*, 1920, p. 17. "That Asoka made use of foreign craftsman to assist in carrying out his colossal architectural enterprise is evident from the purely Persepolitan design of the clustered columns which flank the entrances."

[78] Bachhofer, *Early Indian Sculpture*, 1929, p. 3, writes of Maurya sculpture: "The impetus was extraneous and it came from Persia, namely from the Persia which Alexander the Great had invaded.... What is highly probable is that a number of Persians fleeing the victorious Alexander had settled on Indian soil..."

[79] Wheeler, *Early India and Pakistan*, 1959, p. 173, writes regarding the Maurya Empire: "Here was a new home for the accomplished artists and craftsmen of Persia. And hither they came."

[80] Khandalavala expresses a similar opinion: "With the downfall of the great Persian Empire at the hands of Alexander, it appears that West Asiatic builders and craftsmen, Persian and Colonial Greeks, many of them settled in Persia, found their way to India and took service under the Mauryas: Though Persia was defeated, the ancient world continued to associate Imperial pomp and power with everything Persian." (Smith, *A History of Fine Art in India and Ceylon*, third edition, p. 19, note A-1.)

[81] For example, Percy Brown in *Indian Architecture*, 1942, I, p. 9; Sivaramamurti in *Indian Sculpture*, p. 17; Sarasvati in *Survey of Indian Sculpture*, 1961, pp. 26-27, more conservatively suggests: "... But even artistic practice and tradition of which we have any knowledge in the Pre-Mauryan epoch cannot by themselves explain the ease and mastery with which stone of huge and heavy dimensions was handled by the artists and this is a fact that remains a mystery...." He adds that foreign inspiration is not an impossibility.

[82] Cf. Agrawala, op. cit., p. 109; Prakash, *The Foundation of Indian Art and Archaeology*, 1942, pp. ii-iii.

[83] Khandalavala, *Indian Sculpture and Painting*, 1938, p. 11.

Grunwedel[84] and Fergusson,[85] for example, stress the West Asiatic sources of various conventional elements in the Asokan art, noting their Assyrian origin. This point is significant, although both writers consider that Indian art borrowed these elements directly from Achaemenid Iran.

Benjamin Rowland,[86] discussing the Sarnath pillars, sees in the choice of animals on the abacus, a merging of West Asiatic and Vedic symbolism. He notes an Achaemenian style in the stiff heraldic style of the lions, the mask-like character of the lion heads and the triangular figuration of the eyes. We have suggested that these features perhaps do not represent merely superficial elements of style, but more fundamental conventions. Therefore, in a broad sense, they may have been originally symbolic.

Havell, although he considers the plausibility of Western craftsmanship in the Asokan pillars, considers their symbolism Indian. He attributes the Buddhist pillars to Vedic sources and considers Aryan traditions as a foundation for the art of Mesopotamia as well as India. As regards the campaniform capital, he writes:

"This symbolism is so characteristically Indian and so widely diffused in early Buddhist art that the mere coincidence of 'bell shaped' capitals occurring in Persia hardly justifies the name which archaeologists have given them. Perhaps Persia borrowed the idea from India, the land of the lotus, together with the flower itself. But it is much more probable that it was evolved by the carvers of sacrificial posts in Vedic times, when the Aryans occupied the valley of the Euphrates and were in contact with Egypt in Iran. Certainly the Apadana of Persepolis was not an original creation, but as M. E. Blochet says, 'a compromise between the oldest works of Assyrian art and the most grandiose specimens of Greek Architecture.' Were it not that the palaces of the Aryan kings in Mesopotamia were built of sacrificial wood, we might yet discover the prototype of the Persepolitan pillar."[87]

It is not unlikely that the Maurya pillars incorporated several overlapping symbolic meanings. We have seen before that even the simple symbolic elements met with in ceramics were versatile and could be demonstrated to contain different values. Similarly the Asokan *stambhas* appear to be related to Western, Buddhist and Brahmanical frames of references.[88]

Sivaramamurti has analysed Maurya art as an "indigenous idea" upon which foreign elements were superimposed.[89] The Asokan pillars in conception were derived, according to Sivaramamurti, from *dhavaja* standards raised before temples of Indian deities, but their details were imported from abroad.[90]

[84] Grunwedel, *Buddhist Art in India*, 1901, pp. 17-18.

[85] Fergusson, *History of Indian and Eastern Architecture*, 1910, pp. 58-59. Regarding the honeysuckle ornament on the Allahabad column, Fergusson comments: ". . . and it is almost a literal copy of the honeysuckle ornament we are so familiar with as used by the Greeks with the Ionic order. In this instance however, it is hardly probable that it was introduced directly by the Greeks, but is more likely to have been through Persia, from Assyria, whence the Greeks also originally obtained it. The honeysuckle ornament again occurs as the crowning member of a pillar at Sankisa in the Doab, halfway between Mathura and Kunauj, this time surmounting a capital of so essentially Persepolitan a type that the design of the whole capital came from Persia. . . ."

[86] Rowland, op. cit., p. 44.

[87] Havell, *Handbook of Indian Art*, p. 44.

[88] Rowland, op. cit., p. 44, refers to the varied symbolism manifested in the lions which crowned several Asoka *stambhas*.

[89] Sivaramamurti, op. cit., pp. 16-18.

[90] Ibid., p. 18.

From the preceding commentary it can be seen that notwithstanding considerable differences of opinion, Asokan art on the whole is viewed unanimously as a complex tradition composed of indigenous plus foreign elements. Perhaps more accurately, Maurya art may be said to be composed of elements with affinities in Occidental traditions plus distinctive traits with no equivalents in earlier or contemporary Western art. From this viewpoint the controversial evaluations of the Maurya artistic repertoire and style become reduced to a question of emphasis. Essentially all the divergent opinions referred to above at some point converge in acknowledging both groups of elements. Thus, although our conclusions are perhaps oriented more toward the interpretations put forward by Coomaraswamy or Kramrisch, these conclusions have not aimed at resolving the critical controversy or at appraising the intrinsic value of Maurya art.

Rather, the foregoing study of Maurya art vis-à-vis the art of Western Asia and Harappan art has been aimed at analysing parallel elements and their probable origins. We have tried to show that parallels between Maurya and West Asiatic art are referable to a series of relationships between the two traditions. Fundamentally, similar motifs or symbols are derived from an ancient common ancestry which may be related back to Harappan times or even earlier. For example, animal crowned columns in Achaemenian and Maurya art are parallel manifestations of ancient related traditions, or an originally common tradition. These forms are magnified translations of the simple but significant symbols represented in proto-historic times by terracotta amulets shaped as addorsed animal protomes, by animal crowned pins, or by illustrations, as on seals, of animal standards.

On another level, for example, the conventional floral motifs depicted on the abaci of the Asoka *stambhas* probably pertain to a repertoire which subsequently diffused to India from the West. These conventional decorative motifs seem to represent a later influx of artistic traditions, but they are absorbed in the Asokan columns and apparently have retained their symbolic implications consciously or subconsciously. Their integration in Indian art is evident from the fact that these motifs survive in post-Maurya sculpture. Because, as suggested above, they contain an inherent symbolic value, conventional decorative motifs which are prevalent in Indian and Occidental repertoires may also be interpreted as parallel manifestations rather than as alien or borrowed forms in Indian art.

Coomaraswamy considers that on the whole early Indian art has greater affinity with Assyrian art than with the subsequent Achaemenian art. He writes: "Further the resemblances are usually much more evident as between early Indian art and Assyrian art of about 800-1200 B. C. than as between Indian art and contemporary Achaemenid art . . ."[91] Whatever the relative relationship of Maurya and Sunga repertoires to Assyrian and Achaemenid traditions, there seems to have been some cultural and artistic diffusion from the ancient Orient toward India referable to the pre-Achaemenian period. However, the precise points of departure from which Mesopotamian artistic elements began to migrate and the period in which they settled in India cannot be determined in the light of presently known material. The absorbtion of these same elements in Iranian and Assyrian sculpture also makes it difficult to isolate these forms.

Finally, also evident in Maurya sculpture are occasional elements which do not endure, which do not seem to have indigenous antecedents, and in general are of alien spirit. For example, the prancing horse on the Sarnath column's abacus illustrates such an element. The attitude and style of this animal may be considered

[91] Coomaraswamy, "Origin of the Lotus (So-called Bell) Capital," *Indian Historical Quarterly*, VI, 1930, pp. 373-75.

an adaptation of Hellenistic experience which made its way into the Maurya tradition through direct contact with Western art. Elements in this category which appear only "in passing" in Indian sculpture may be viewed as superimposed upon an indigenous tradition and thus may constitute borrowings. On the whole, aspects of the Maurya style can be viewed as transient whereas the motifs of this tradition are essentially an integral part of Indian art.

Post-Maurya Art—An Affirmation
of Popular Traditions

1. ORIGINS OF THE SUNGA REPERTOIRE

THE COLLAPSE of the Maurya Empire was echoed in sculpture by the end of a
style which has been associated with Asoka. Post-Maurya traditions, for which
Bharhut and Sanchi mark a point of departure, are expressed in a new idiom, one
no longer reflecting Imperial patronage but rather the direct patronage and devotion
of the people. Thus this new sculpture is relatively less cosmopolitan and is no
longer as receptive to effects of direct contact with Occidental art. Consequently,
the sculpture of Bharhut and Sanchi, or of monuments related to the Bharhut
and Sanchi tradition, are not Westernized as regards subject or technique but may
be classified as an essentially popular and thus indigenous tradition. The artistic
strain which was evident in the freer flowing and more crowded of the Harappan
ceramic designs or in the Maurya stone discs now becomes fully formulated in
the Sunga period and lays a foundation for later Indian art.

Yet post-Maurya sculpture contains many elements which are notably em-
parented to forms in West Asiatic sculpture. These parallels are not in style or
composition, but consist essentially of motifs. As a whole such motifs appear
thoroughly integrated in the Buddhist repertoire and retain little stylistic affinity
with their Occidental counterparts.

Sunga sculpture scarcely reflects the impact of either earlier Achaemenian sculp-
ture or contemporary Hellenistic traditions. Thus, although the conception of many
elements in the Bharhut and Sanchi tradition may be ultimately traced to an original
West Asiatic source, their Indian manifestation is a thoroughly assimilated one.

The presence of Greek elements in the North-West seems to have had little
effect upon Sunga artistic traditions. Only to the extent that the Western elements
themselves were subject to Indianization, did they succeed in blending with this
art. As a distinct and alien form of expression, Hellenistic traditions were apparently
overlooked or bypassed by the sculptors of Bharhut and Sanchi. Several expla-
nations can be offered for this situation, including the power of absorption which

is characteristic of Indian culture, but one essential circumstance seems fundamental. This may be noted as the basically popular nature of Sunga art. A cosmopolitan artistic idiom, although rooted in local soil, is aware of foreign traditions. On the other hand, a predominantly popular artistic movement is essentially confined to its own surroundings and heredity. Thus, those elements it may share with foreign repertoires can be interpreted as representing a common heritage rather than recent superficial acquisitions.

Specifically, the mythological and other forms in Sunga art which can be equated with similar Mesopotamian, Achaemenian, or Hellenistic expressions may thus be considered, as proposed by Coomaraswamy, to reflect an earlier relationship between Indian and Western cultures. These forms, with their fluid symbolic connotations, represent diffusion from Western Asia.

We tried to show in our evaluation of Maurya sculpture that motifs common to Indian and Iranian art, like the campaniform member or the animal crowned pillar, were parallel expressions. However, we admitted an awareness on the part of Maurya artists of the Occidental interpretations of these parallel motifs. This awareness resulted in certain superficial mannerisms which Asokan art may have adopted more directly from Iranian sculpture. Subsequent Sunga art, lacking the cosmopolitan character of its predecessor, dispensed with these mannerisms. It retained, however, certain conventions and the essential motifs which were met with in Maurya times. In addition, Sunga art expressed many other motifs that Maurya traditions, as far as we know, had not formulated in stone except partially in the stone discs. There is no evidence that these additional motifs, as for example, fanciful composite animals, migrated to India in either the Maurya or Sunga periods. Their absence from surviving Maurya monuments is conspicuous and there is no evidence that Sunga art was directly cognizant of West Asiatic prototypes. Furthermore, many Sunga motifs, as for example, the tree of life, resemble Assyrian or even earlier forms, and this resemblance points to the fact that their diffusion began at a period well before Maurya art emerged. In some cases, proto-historic prototypes may be postulated for Sunga expressions, as for example, human faced bulls. This motif was known in Harappan as well as in Mesopotamian art and subsequent Indian and West Asiatic renderings can thus be logically parallel derivations. Subsequent contact or diffusion, however, may have more directly influenced the similarity apparent in the forms assumed by later Assyrian, Achaemenian, and Indian sculptured editions of this proto-historic motif.

It is of interest to note that although the Maurya repertoire, though transformed, was more or less fully absorbed in Sunga sculpture, the latter was not similarly anticipated in full in the Maurya tradition. Thus many elements of which Indian art was aware have left no trace in the monumental sculpture of the Maurya period.

Sunga artists converted almost every aspect of living, historical and religious tradition, and art into sculpture. Sculptures, monuments, and architectural forms become translated into decorative or symbolic elements and incorporated into the Sanchi repertoire. These subjects were assimilated and familiar to the Sunga artists and demonstrably had ancient roots, sometimes reaching as far back as the Indus Valley. Yet there is no earlier artistic record for many of these Sunga motifs. Consequently, these motifs in Maurya and pre-Maurya times, either existed pending expression in stone, or alternatively were lost, destroyed, or remain undiscovered. Artistic elements like oral traditions may be said to have a real existence within a culture even before they become crystallized and then recorded or expressed in permanent material.

Thus, within the traditional yet apparently newly formulated Sunga repertoire, elements equivalent to Occidental forms must be interpreted as similarly traditional and assimilated. They do not stand isolated and cannot be considered, in contrast with the balance of the Bharhut or Sanchi repertoires, as recently borrowed from Hellenistic sources.

The conservatism and survival value of Indian art (and culture) has been repeatedly stressed by critics. These two features may be recalled in support of the contention that, to a large extent, Sunga art reflected an ancient repertoire.

Motifs unmistakably related to West Asian counterparts were an integral part of the Sunga tradition and in general are of the same relative antiquity as this tradition itself.

2. BHARHUT AND THE MEANING OF THE STUPA

The rails and remaining gateway of the Buddhist stupa at Bharhut mark the conversion of an important symbolic monument into an object of art. Apparently, in the post-Maurya period the emerging tradition felt the need for an adequate and permanent receptacle for its artistic efforts. As this tradition was essentially supported, encouraged, and executed largely—though not entirely—by a popular element oriented toward a devotional form of religion, it was bound to merge art and worship.

Preceding Asokan sculpture had established art in stone and on a monumental scale. This new medium and more imposing proportions were applied to subsequent Sunga art. At the same time, the stupa became a natural focus for a new Indian artistic tradition. The earliest stupas are noted for their simplicity and even at Bharhut and Sanchi adornment was confined to the rails and gates. It was not until later that it was considered appropriate to decorate the body of the stupa itself.

The complex symbolism embodied in the stupa as an evolved monument can be understood from texts. However, the origin of this form and its fundamental underlying symbolism is subject to discussion.[1] Here we are interested particularly in a relationship which may have originally existed between the stupa and West Asiatic monuments. Such a relationship has been suggested and has been traced especially well by Phyllis Ackerman.[2]

Ackerman considers the stupa dome as a representation of the cosmic mountain which, in opposition to water, may be seen to have dominated West Asiatic legends and art from earliest times. In ceramics, water has been consistently and naturally illustrated by a wavy line and the primeval mountain by a pyramidal motif. This interpretation of the universe is also manifest, according to Ackerman, for example in a 3rd millennium B. C. seal impression from Susa depicting the cosmic mountain as a heap of stones.[3] A comparable motif occurs on Minoan seal impressions.[4] In the architecture of Mesopotamia, Egypt,[5] and then India, a similar

[1] Longhurst, "The Evolution of the Stupa," *The Story of the Stupa*, 1936, Chap. 11; Havell. "Vedic Chandra Cult and Stupa," *Handbook of Indian Art*, 1920, Chap. II; Zimmer, *The Art of Indian Asia*, 1954, p. 232; Przyluski, "The Harmika and the Origin of the Buddhist Stupa," *Indian Historical Quarterly*, XI, 1935.

[2] Ackerman, "West Asiatic Ancestors of the Anda," *Marg*, 11, 1951-52, pp. 16-23.

[3] Ackerman, ibid., p. 21, fig. 4.

[4] Hutchinson, *Prehistoric Crete*, 1962, p. 206, fig. 39. The sealing depicts the Mountain Mother emerging from a mountain peak and flanked by guardian lions.

[5] Ackerman, op. cit., pp. 16-23, refers to the tholos at Nineveh, dated c. 3000 B.C., to the Egyptian pyramids, to the Tomb of Tantalus in Asia Minor which consists of a low cylinder on a high peaked cone, to the Sumerian temple towers at Khursag, and to the Babylonian Ziggurat

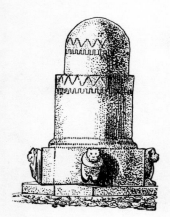

Fig. 255

Fig. 256

Fig. 257

cosmology can be visualized in a number of cylindrical or pyramidal monuments. Remarkably close to the Buddhist stupa in conception is a Phoenician monument attributed to the 6th or 7th century B.C. This structure, depicted in figure 255, consists of a square base, a cylindrical shaft decorated with a frieze, and a crowning hemispherical dome. Ackerman notes that the dome in its similarity to a phallus has been considered suggestive of generative power.[6]

In figure 255, attention may be drawn to the frieze which is comparable to the stepped pyramid or battlement motif in Sunga sculpture.[7] In our analysis of protohistoric ceramic motifs, we drew attention to the prevalence of the step design and its probable connection with the stepped pyramid as a motif in later sculpture. In the sculpture of Bharhut and Sanchi, architectural forms and symbols are transformed into repeated decorative elements. Thus, the stepped pyramid, as a symbolic representation, seen on a Phoenician monument and subsequently on Buddhist stupas, suggests the existence of an unbroken chain of symbolism which has pervaded the art of Western Asia and India from prehistory until the Christian Era.

Returning to P. Ackerman's identification of the stupa dome with the phallus and with generative powers, attention may be drawn to two terracotta stupas, discovered at Nasik in Period II, the Early Historic Period.[8] These stupas, seen in our figures 256 and 257, seem linked in conception with the forms of linga type objects found in the Indus Valley.[9] Both stupas were decorated with incised and dotted patterns.

Gisbert Combaz also refers to the Phoenician structure discussed above that he describes as a tumulus which visibly anticipates the stupa.[10]

Ackerman considers the Buddhist stupa to be a commemoration of the cosmic mountain, implying that the Sumerian myth migrated to India. She points out that the ancestors of the Aryans were in "cultural debt" to Sumer.[11] Ackerman's interpretation relates the Indian symbolism, evolved around the cosmic egg—designated as a solidified cosmogenic bubble—which was the first thing to emerge from a chaos of water, to Sumerian legends in which the mountain similarly emerged from water.

From another viewpoint, we may consider that essentially all architecture may be derived from simple dwellings constructed for the living, or alternatively from monuments or tombs constructed for the dead or for the worship of divine powers. As regards the stupa, this monument is shown by Longhurst[12] and by Mireille Benisti[13] to be an adaptation of a tumulus or funerary mound rather than a primitive domed hut. Smith also has stated: "The origin of the stupa lies in primitive burial ceremonies for they are primarily tombs like the iron age cairns of the

6 Ibid., p. 20.
7 Jairazbhoy, *Foreign Influence in Ancient India*, 1963, p. 35. Regarding this element, Jairazbhoy notes: "Stepped battlements in the representations of walls and square towers on the Northern Gateway at Sanchi are derived from Assyria or Persia, but it is impossible to decide which. A sandstone head with a crenellated crown upon it from Sarnath (cf. Bachhofer, *Early Indian Sculpture*, 1929, I, pl. 13) would seem to suggest that it was borrowed from that of Darius at Bisitun (cf. Dalton, *The Treasure of the Oxus*, 1926, fig. 40). At any rate tiered shrines are claimed to be based on ziggurats. . . ." Cf. also notes 36 and 37 *infra*.
8 Sankalia, and Deo, *Report on the Excavations at Nasik and Jorwe 1950-51*, 1955, pl. xxiii.
9 Marshall, *Mohenjo-daro and the Indus Valley Civilization*, 1931, pl. cxxx.
10 Combaz, *L'Évolution du Stupa en Asie*, 1933, v. II, p. 94.
11 Ackerman, op. cit., p. 17.
12 Longhurst, op. cit., p. 12.
13 Benisti, "Etude sur le stupa dans l'Inde Ancienne," *Bulletin de l'Ecole Francaise d'Extrême Orient*, LI, Paris, 1960.

South and such tumuli as excavated by Bloch near Nandangarh in the Champaran District."[14]

As essential detail shown by Benisti illustrates this. In a hut the domed roof overlaps the base as in figure 258, whereas in a stupa the dome is contained within the base as illustrated in figure 259.[15] Moreover the stupa's sacred and memorial intentions confirm its association with funerary monuments rather than with dwellings. This relationship between the stupa and funerary mounds or heaps, known as tumuli, further underlines the links which seem to have existed between Buddhist stupas and structures and symbolisms of Western Asia. In its dual role as a receptacle for remains or relics and as a venerable object of cosmic significance in itself, the Buddhist stupa appears to be an elaborate manifestation of a cult which had proto-historic roots throughout Western Asia.

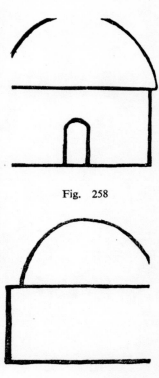

Fig. 258

Fig. 259

Although there is not much material evidence connecting the stupa with earlier mounds, its derivation from the simple tumulus is generally deduced by critics and may be tentatively accepted. Thus this monument appears as a manifestation parallel to the pyramid or the ziggurat rather than as an offspring of these forms. That the stupa as a permanent structure occurs rather belatedly is in accordance with a pattern of diffusion which we have observed from proto-historic times.

As a whole and in its component parts, the stupa embodies a complex symbolism of which many elements are in common with Mesopotamian traditions. Longhurst draws attention to the crowning umbrella which is seen as a symbol of religious sovereignty in ancient Egyptian murals, in Assyrian bas reliefs, and repeatedly at Persepolis.[16] Longhurst also notes that the umbrella was a mark of elevated rank in Greece and was an offering to the dead in China.

Rowland has summarized the elements constituting the intricate symbolism contained in the stupa.[17] He suggests that this symbolism was derived, at least partially, from the cosmography of Western Asia and that like the Mesopotamian ziggurat, the stupa was designed as an architectural representation of the cosmos. Rowland also believes that the Vedic altar, originally animated by a human sacrifice, a replica of the spirit of the cosmic man, may be in part the origin of the stupa. Thus according to him, Mesopotamian and Vedic concepts are the basis for the stupa's form and function and pre-Buddhistic solar cults are the basis for the surrounding railing and the ritual of veneration. The gateways at the four cardinal points form a swastika, the ancient sun symbol, and represent the four quarters of the world. Clockwise circumambulation described the course of the sun through the heavens. Havell also stresses the Vedic undercurrent in stupa symbolism.[18]

A. B. Govinda, considering the stupa derived from prehistoric tumuli containing relics and shaped like cones or pyramids as well as domes, relates its symbolism to the principle of circular form or the hemisphere.[19] This hemispherical form is associated with centralisation, lunar worship, mother earth, and Siva. It is opposed to, yet tends towards fusion with, the cone representing vertically solar-worship, father sky, and Vishnu. The Buddhist stupa, as an evolved form, may be

[14] Smith, *History of Fine Art in India and Ceylon*, third revised edition, p. 23.
[15] This interpretation is in accord with that of P. Mus in reference to his study on Borobudur, *Bulletin de L'Ecole Francaise d'Éxtrême Orient* 1932, and is supported by Coomaraswamy in "Symbolism of the Dome," *Indian Historical Quarterly*, XIV, March 1938.
[16] Longhurst, *The Story of the Stupa*, 1936, Chapter I, "The Umbrella as a Symbol of Religious Sovereignty."
[17] Rowland, *The Art and Architecture of India*, 1953, p. 52.
[18] Havell, op. cit., p. 19.
[19] Anagrika B. Govinda, *Some Aspects of Stupa Symbolism*, 1940, p. 2 and pp. 5 ff.

described as a heap of earth or stone enclosed by brick and plastered. This mound rests upon a base consisting of one or more terraces with space provided for the ritual of circumambulation. The structure is fenced in by a railing. This railing (*vedika*) and its gateways (*toranas*) are elaborately sculpted in the Bharhut and Sanchi stupas. The stupa itself is crowned by a terrace above which rises a symbolic umbrella.

The stupa of Bharhut is essentially the first known example of a decorated architectural construction in the history of Indian art and the date of this monument, c. 150 B.C., is based on inscriptions as well as style.[20] The major portion of the surviving remains of the Bharhut stupa were transported by Cunningham to the Indian Museum in Calcutta.

The sculptures of the Bharhut stupa were confined to the inner and outer faces of the railing and the gateways of which only one survives. Of the stupa itself only a fragment several feet long has been preserved. The original shape of this monument has been deduced from the pavement.[21] The surrounding railing or *vedika* was divided into four quadrants separated by four gateways at the cardinal points. Each quadrant was made up of sixteen pillars joined by three crossbars and covered by a coping. Remains of lions at either end of the coping have been found. The railing was extended at the left end of each entrance, forming a swastika. The *torana* or gateway arch was discovered in fragments and has been reconstructed.

The reappearance of the swastika in the fundamental plan of the stupa rail is significant. We may recall in this connection Father Heras' interpretation of the swastika as a Harappan symbol.[22] In the opinion of Father Heras the swastika is an outline of the plan of a fortified city whose gateways protruded for purposes of defence. This symbolic representation of a well defended and prospering community became equivalent with the concept of prosperity and the swastika thus in itself became a symbol of prosperity and therefore auspiciousness. Father Heras, in the same context, interprets the wheel, which occurs commonly in Harappan inscriptions and is a paramount Buddhist symbol, as the representation of the sun's path or the Zodiac.

The original specific meaning or meanings of the swastika which has been predominant in Indian as well as Occidental symbolism for at least five millennia remains elusive. In proto-historic art this sign often occurred as a radiating or turning motif suggestive of movement and probably therefore associated as much as the wheel with solar symbolism. Thus Father Heras' interpretation does not seem to consider the motion contained in this symbol. On the other hand, now this evidence of the swastika appearing in an architectural plan, specifically in accordance with Father Heras' intuitive description, is notable. Effectively, the rail enclosing a Buddhist stupa is a protective fence, the role of which is equivalent to that of fortifications in a secular context. It therefore seems as if the design of the railing surrounding Buddhist stupas may be correlated with Father Heras' analysis of the swastika and considered as suggestive that this enduring symbol retained its meaning over thousands of years. Yet the swastika as a symbolic motif probably antedates the existence or conception of fortifications and thus its real significance associated apparently with the sun, with movement, and with security and pros-

[20] Kramrisch, *Indian Sculpture*, 1933, p. 27, places Bharhut in the second half of the second century B.C.

[21] Details as to measurement, etc., of the Bharhut Stupa may be found in Cunningham's *The Stupa of Bharhut*, 1879, which is the original monograph dealing with this monument.

[22] Heras, *Studies in Proto Indo Mediterranean Culture*, I, 1953, p. 74; Heras, "India, the Empire of the Swastika," *Bombay Coronation Souvenir*, 1937.

perity, is not material or subject to analysis. We have attributed the migration and survival of symbols to their permanent yet fluid values. In this light a complex or multiple interpretation of any symbol is not inconsistent with the contention that it survived invested with its original meaning.[23]

The encircling rail at Bharhut is composed of slightly bevelled uprights which are joined by a triple row of crossbars and crowned by a coping. A central medallion and two half medallions at the top and bottom constitute the usual sculpted decoration on the uprights. Lotus flowers and other plants emerge from the rims of the medallions, sometimes bearing Yaksha or animal figures. Garlands and ornaments often issue from the lotus flowers. The crossbars are also decorated with medallions. The corner pillars are treated differently from the rest of the uprights bearing sculpted figures like those of Yakshas or Nagas on the inner corners and historical or else legendary scenes on the outer corners.

The coping is intricately sculpted. Both its inner and outer faces are covered with the undulations of a continuous creeper issuing from the mouth of a kneeling elephant. The panels marked by the vine's waves are filled on the inner face with Jataka scenes or with motifs of flowers, fruit, and jewelry. The outer face is covered with elaborated representations of full blown lotus flowers. The creeper is conceived as a wish fulfilling vine, yielding flowers, fruit, ornaments, and other objects of fulfilment, as well as legendary and historic scenes. Both faces of the coping are finished by a lower border of bells and an upper border of stepped merlons.

The *torana* as reconstructed by Cunningham rests on two pillars which are each composed of four adjoined octagonal pillars with campaniform capitals surmounted by one abacus. Addorsed winged lions and bulls rest on these abaci and in turn support the superstructure. The latter consists of three architraves ending in volutes conceived as the curled tail of a *makara*. These three architraves are separated on each side by two square blocks upon which lotus flowers and pilasters are sculpted. In the center, the architraves are separated by two rows of alternating figures and pillars. The entire *torana* is crowned in the center by a *dharmachakra* resting upon a honeysuckle. On either side a *triratna* rests upon a stepped pyramid or merlon. Two figures of mounted horses are placed at the extreme ends of the *torana*.

The dominant motif in the Bharhut repertoire is the lotus rosette, conceived either as a medallion, as a flowering creeper, or incorporated within other sculptures. The medallions which constitute the essential decoration of the uprights and crossbars of the Bharhut rail contain either floral patterns in a rich variety of combinations or else diverse Buddhist symbols, Jataka scenes, historic incidents or animal figures. The rosette, as a repeated symbolic and decorative motif, is an enduring and significant design in Indian art. As such it is supported by prominent roles in Hindu and Buddhist iconography. Underlying these roles however is a deeper and older value which seems to be the real meaning of this motif. This meaning may be interpreted as fructification or fruitfulness which is represented by the rosette and simultaneously is invoked by its repetitiveness.

It is this value—fruitfulness—which provides a link between the rosette as an integral part of the Indian Buddhist repertoire and its role in Achaemenian sculpture. It also relates the Bharhut rosette to its numerous counterparts—in Achaemenian metal work and in earlier Mesopotamian art. Finally, it relates this motif to prototypes which decorated proto-historic ceramics, or appeared on seals, or as we have seen among the ornaments and head-dresses of terracotta mother goddess

[23] Cf. Chapter IV *supra* for Zimmer's comments regarding the endurance of symbols.

figurines. A similar symbolism is expressed in the rosette mark upon the fore-head of a Bharhut Yakshi illustrated in plate 19.

In the preceding chapters we have referred to the rosette in the above mentioned contexts and have drawn attention to its prevalence in West Asiatic as well as Indian repertoires. We also indicated that its varied manifestations, however widespread in time or space, were fundamentally related and not coincidentally similar. Now its recurrence and prominence in Sunga, and even subsequent traditions, seems to underline the validity of this interpretation. We see that the rosette in all its forms was invested with a common value and that it retained this value throughout millennia. We may understand in the light of this basic symbolic connotation the distinctive and indigenous character of the Bharhut medallions. We may also understand the relationship prevailing between these medallions and their counterparts in Occidental traditions as well as their mutual indebtedness to proto-historic prototypes. The Bharhut rosettes are so unlike the uniform Iranian unelaborated forms that they can scarcely have been adaptations of the latter. Furthermore, a traditional symbolism is clearly embodied in the Buddhist examples. Yet these Bharhut examples cannot disavow some connection with the Persepolitan motif. Even their treatment as a continuous refrain reveals a similarity in conception between the Sunga and Achaemenian rosettes. Thus this motif, as it appears in both traditions, must be derived from an earlier common source. In other words, the Bharhut medallions and the rosettes of Persepolis are parallel expressions of a related repertoire. In each context they absorbed the style and additional implications of the tradition in which they are featured, but underlying these embellishments, an eternal value survives.

Because of its fluidity, it may not be really possible to pinpoint the value of an artistic symbol, yet it is suggested that the rosette is a representation of fruitfulness. This concept is in itself flexible but it appears to be in harmony with all the circumstances in which we have met this symbol. The idea of fruitfulness embraces fecundity and beauty. It includes flourishment as of kingdoms or religions and asks for blessings. Thus at Bharhut the rosette is depicted over and over again as a representation of magic beauty and as an expression of reverence.

The rosette depicted on the coping, like flowers of the wish-fulfilling creeper, are visualized most apparently as symbols of fruitfulness. On the inner face of the coping, the rosette is merged with other symbols of fulfilment—garlands, ornaments, fruit, or auspicious scenes and emblems.[24] On the outer face of the coping,[25] these symbolic representations are merged in a single symbol, with endless variations, which incorporates them all, the lotus in full bloom illustrating an idealized interpretation of fecundity that underlies all endeavours and determines their fruit or results. An associated concept is conveyed by the vase of plenty—the *purnaghata*—seen in several of the medallions.[26] The bowl from which issues a plant or a stream of water, often a libation, is a conventional motif in both Indian and Occidental repertoires.[27]

Within the rail medallions and even within the centers of the rosettes that occur throughout the Bharhut sculptures, are contained a wealth of minute details that are subordinated to the larger intentions of the sculptural unit. These diminutive patterns draw no attention to themselves, yet they appear to be fully intentional

[24] Cf. Cunningham, op. cit., pl. xlviii.
[25] Ibid., pl. xl, top.
[26] Cunningham, op. cit., pl. xxxviii, 1 and 3.
[27] Cf. Rosu, "Purnaghata et le symbolisme du lotus dans l'Inde," *Arts Asiatiques*, VIII, 1961, pp. 193-194. Rosu attributes the lotus and *purnaghata* to a vast pre-Aryan cultural complex and stresses the basic common origin of these elements within the Indo-Mediterranean sphere.

and meaningful, as meaningful as the identified Jataka or historic scenes. Their significance can be deduced from a remarkable similarity between a number of these patterns and those which occurred on proto-historic seals or amulets or in ceramics. These similarities appear to be referable equally to Indian or to Iranian and Mesopotamian elements suggesting that they lay at the very roots of artistic traditions.

Plates 20 to 23 illustrate a few designs contained within the Bharhut rosettes, comparable to proto-historic patterns (figs. 260 to 264). Plate 20, a railing medallion, displays an affinity with Mesopotamian and Indus Valley designs depicted on pottery or amulets as seen, for example, in figures 260 and 261. While the resemblance is not complete, it is suggestive. The undulations seen in the medallions depicted in plates 21 and 22, which condense and reiterate the creeper of the Bharhut coping, may be compared with waving motifs on cylinder seals as seen, for example, in figures 262 and 263. Herzfeld has interpreted these undulations as representations of landscape and has related them to similar patterns in ceramics.[28] The medallions are clearly conceived as vines or creepers. Yet their similarity, especially with figure 263, in which the spaces are also filled with rosettes is not negligible. As we have repeatedly seen, symbolism is a fluid thing and complimentary meanings are possible within related forms. The circles in figure 264 are of further interest in this context. The central portion of several Bharhut medallions are similarly conceived, as for example those depicted in plates 23 and 24 and figure 265. The hearts of these rosettes may be compared with a number of ancient button seals as seen, not only in figure 264 from Tepe Giyan but also in figures 101, 104 and 105 from Harappa, Tepe Hissar, and Northern Syria respectively. The Bharhut rosettes may be considered to cast some light upon the primitive button amulets which crop up at numerous prehistoric sites and which now appear to have perhaps embodied some symbolism related possibly to seeds or their centers or essence.

Examples like those given above show that even the minutest elements within the Bharhut medallions are intentional and may be derived from a tradition of incalculable antiquity. Figure 265 for instance illustrates a file of griffins. The elephant file also is depicted in one of the medallions, seen in plate 24. We have seen above that the animal file is a dominant motif in proto-historic ceramics both in West Asia and India. The circular medallion recreates the spacial properties of pottery in which the painted figures are invested with endless continuity. Thus, in our figures, the griffins or elephants are in a sense equivalent to bands of animals which encircled proto-historic pots in perpetual processions.

The Bharhut lotus medallions in their conception bear a tentative affinity to the tradition expressed in Achaemenian metal work illustrated in plates 25 and 26. The sculpted bowls and dishes, which in Iran succeeded painted pottery, had no counterparts in Indian traditions, but the symbolism they embodied, even if unknowingly, apparently diffused and emerged further East in ornamental medallions. Plates 25 and 26 may be compared with the Bharhut rosettes of plates 21, 22 and 23 and figure 265 and with additional examples illustrated by Cunningham.[29] A general similarity between the designs in the above examples is evident. Although the implications of this affinity are uncertain, it is of significance.

Closer in space and time to the Bharhut lotus medallions, and also in their resemblance as regards composition and content, are the ringstones discussed above. These discs have been attributed to the Maurya or Sunga periods.[30] As a group

[28] Herzfeld, *Iran in the Ancient East*, 1941, pp. 43-44.
[29] Cunningham, op. cit., pls. xxxv-xxxviii.
[30] Cf. *supra.*, Chapter 3, Sec. 4.

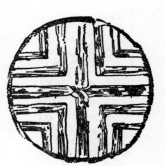

Fig. 260

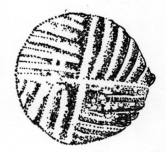

Fig. 261

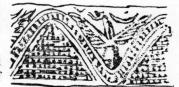

Fig. 262

Fig. 263

Fig. 264

Fig. 265

the discs share with the medallions a circular shape and radiating patterns as well as motifs like nude or almost nude female figures, conventional rosettes and palmettes, and files of elephants or griffins. More specifically, the ringstone depicted in plate 27 may be compared with figure 265 which it approximates.

The relationships which we have inferred from similarities between decorative symbolic motifs depicted in the Bharhut medallions and motifs antedating them by centuries or millennia cannot be conclusively demonstrated, any more than a connection could be categorically proven to exist between ceramic designs appearing far apart in space and time. Also difficult to affirm are relationships which we have tentatively traced between diverse objects (like ringstones, or metalwork dishes) which are similar in composition and content to the Bharhut medallions. Yet an unmistakable affinity exists between these widely separated designs and forms and there are some valid reasons for considering this affinity, on the whole, as significant rather than coincidental. The parallels to which we refer are specific, not general, and they occur over and over again in association with similar details. And as we have already suggested, basic meanings migrate with the designs or forms in which they are expressed from one culture to another, or from one age to the next. Furthermore, the motifs we have been discussing represent clearly and simply essential and thus eternal values—beauty and magic in a flower, fecundity in a woman, a seed or a yielding vine, reverence in the reiteration of beauty. Thus it is suggested that these values did not vanish to be reconceived again ages later, but rather were retained. Their later manifestations may be interpreted as expressions of an unforgotten tradition which nourished the artistic repertoires of both India and Western Asia.

Our knowledge points to the fact that there is some background for every artistic element which appears at Bharhut and that, however filled with detail these sculptures may be, none of these details is arbitrary. There is no known comprehensive prototype for Bharhut, but its repertoire is clearly drawn from the physical and social environment which produced this monument or from historic, legendary, or symbolic traditions.

The Bharhut medallions which we have been considering in particular are complete in themselves and condense the essence of Bharhut sculpture as a whole, repeating details which occur more prominently elsewhere. Some of these medallions depict in a sort of shorthand entire Jataka and historic incidents which in turn overflow with further symbolic representations. Others represent busts which have been identified as those of Yakshas, Nagas, etc., figures of real or mythical animals,[31] or most popularly, floral compositions. Within the above mentioned scenes or compositions we find absorbed many elements which have been met with before in Indus Valley traditions, in Maurya art, or in West Asiatic repertoires—elements, which are simultaneously illustrated in other contexts at Bharhut itself, and thus are intentional and significant. For example, plate 28 depicts a tree surrounded by a rail, a motif familiar from Harappan seals. This element is seen in the medallion which relates the building of the Jetavana Monastery. Plate 28 may be compared with figures 118 and 119 from Harappa. Other medallions illustrate modified Asokan pillars or else griffins and other mythical animals which are familiar as a genre from West Asian repertoires or from the Indus Valley seals. Conventional patterns like the bead and reel seen in plate 21 also are incorporated as borders.

That the above motifs are fully integrated in the Bharhut repertoire and not

[31] Cf. Cunningham, op. cit., pl. xxv-2 (elephant in scene identified as the Naga Jataka); pl. xxxvi-2 and 4; pl. xxxvii-3.

borrowed from foreign prototypes, is evident from their treatment and their affinity with the complete Bharhut tradition. Those elements which were met in Indian art for the first time in Maurya monuments appear at Bharhut to be, notwithstanding their later date, older in conception and execution than the earlier Asokan forms. They seem to be not learned from Asokan prototypes but rather derived directly from a still earlier tradition, bypassing their immediate more cosmopolitan antecedents. And in effect, the roots of many other motifs can be traced even to proto-historic sources. Thus our evaluation of the Bharhut tradition points to ancient origins and to probable wooden prototypes which do not survive but which have also been inferred from the Bharhut style. Motifs which have equivalents in Hellenistic, Achaemenian, or other West Asian traditions may be assumed, as proposed by Coomaraswamy and noted above, to have penetrated the Indian repertoire at different stages, but all much before they emerge at Bharhut fully assimilated and embodying Buddhist symbolism.

The single figures of Yakshinis and other superhuman personages sculpted on the corner stones of the Bharhut rail represent a formulated cult composed of ancient beliefs associated with trees and fecundity.[32] That the female divinities are in their essence mother-goddess figures is clear from their stressed femininity, and the manner in which they are depicted intertwined with trees. This association is reminiscent of the Harappan cult as suggested by several amulets depicting deities encompassed in an arch of branches.[33]

Other supernatural beings like Nagas, dwarfs, demons, or human-faced monsters, are similarly derived from popular traditions of great antiquity and as such are related to counterparts in Hellenistic and in Occidental traditions in general. In some instances prototypes for these forms may be visualized in Harappan terracotta statuettes. The roles of all these beings at Bharhut are distinctly determined and in harmony with the sculptures as a whole, thus precluding an alien origin.

At each of the four original entrances at Bharhut, the coping which crowned the railing ended in the figure of a lion sitting on its haunches. Broken remains of three of these lions were found, but only one head has survived. The treatment of these lions and to some extent of the lions which appear on the *torana* or elsewhere is evidently determined by the same traditions which produced Iranian lions and subsequently those crowning the Asokan *stambhas*. The shape of the head, the execution of the mane, the triangular eyes and open mouth are relatively stereotype and may imply an established convention. A collar composed of rosettes encircles the neck of the lion on the coping.[34] This collar may be compared with similar collars adorning Persepolitan bulls.[35] Yet, notwithstanding their affinity with Occidental forms, the mellowed Bharhut lions, as for example, the one in plate 29, are not ill adapted to their environment. They are as much integrated into the Sunga style and repertoires as their heraldic Persian counterparts are integrated in Persepolitan art.

We have already described the coping and referred briefly to the borders enclosing the designs which are encompassed within the waves of a continuous creeper. The lower border is composed of a series of bells, which incidentally bear no resemblance to the Asokan "campaniform" capitals. The upper border illustrated in figure 266, is composed of merlons

Fig. 266

[32] Cf. Chandra, "Some Aspects of the Yaksha Cult in Ancient India," *Bulletin of the Prince of Wales Museum of Western India*, 1952-53, p. 52.
[33] Vats, *Excavations at Harappa*, 1940, pl. xciii, 316 and 317.
[34] Cunningham, op. cit., pl. xxxix.
[35] Cf. Ghirshman, *Persia from the Origins to Alexander*, 1964, pls. 264 and 266.

separated by a floral pattern. We have discussed the origins of this motif in Chapter 1 in connection with the step design in ceramics with which it can be connected. In an interesting article G. Garbini has analysed this element as an architectural and symbolic feature in Near Eastern art.[36] He proposes that its relatively late appearance in Indian sculpture may be attributed to Achaemenian influence.

A similar view is expressed by Fabri:

"Nous pouvons donc affirmer avec sûreté qu'on trouve ici dans l'art de l'Inde un motif décoratif qui vent d'un dessin décoratif similaire de la Perse, et que ce denier, descendat sans doute en analyse dernière, d'une multiplication de zikkurrat. Une identification du point du vue indien ne semble pas possible. Des temples à degrés étaient complètement étrangers à l'art de l'Inde."[37]

However, this motif has a likely origin in an indigenous proto-historic tradition. Garbini notes the occurrence of the stepped pinnacle on Assyrian seals dated c. 13 century B.C., and attributes to Assyria the translation of this element into architecture, suggesting that it thence migrated to Iran and India. But Garbini draws attention to a recent discovery in Afghanistan of a similar motif on a building at Mundigak believed to be as ancient as 2500 B.C.[38]

As regards the significance of the stepped pinnacle or merlon, Garbini points out a dual meaning. He proposes that this pattern was originally conceived in the 4th millennium B.C. as a religious rather than as an architectural feature and refers to its occurrence as a symbol on seals. However, he also points out that the stepped pinnacle is "the representation of a pyramid as conceived in a country where architecture was conditioned by the exclusive use of clay bricks."[39] He concludes: "the great expansion of the pinnacle pattern favoured its decorative character to the detriment of its original importance as a religious symbol."[40]

Fig. 267

Fig. 268

We have put forth in the course of this work the view that the diffusion and survival of decorative motifs is not achieved without the diffusion and survival of their inherent values. In this light, it may be further proposed that the transformation of the stepped pinnacle from a design on seals or in ceramics into an architectural member is not incompatible with its retaining an original symbolism. We have already commented upon this transformation above and may further note in Indian art the merging of ornamental or symbolic and architectural forms. For example, the rail, the stupa, or the *stambha* are simultaneously symbols and architectural forms. Turning our attention once more to the rosette, we may refer to the suggestion of Combaz that the association between this motif and the stepped merlon as seen, for example, in figure 267 from Susa and in figure 268 is probably of symbolic significance.[41] Thus we have additional evidence pointing toward the fact that the stepped pinnacle as it appears in Assyrian, Iranian, and Indian architecture or sculpture has indeed a symbolic value. The presence of this element on the monument depicted in figure 255 as well as for example its occurrence along with the rosette on the

[36] Garbini, "The Stepped Pinnacle in the Ancient Near East," *East and West*, IX, 1958, pp. 86-88.
[37] Fabri, "Un Elément Mésopotamien dans l'art de l'Inde," *Journal Asiatique*, XXVII, Oct.-Dec. 1930, p. 302.
[38] Casal, Fouilles de Mundigak, 1961, V ii, fig. 22.
[39] Garbini, op. cit., p. 88.
[40] Ibid., p. 86.
[41] Combaz, op. cit., Chap. III.

crown of Darius depicted at Behistun[42] is suggestive of a symbolic connotation.

Bharhut's remaining *torana* or ornamental arch at the East gateway, illustrated in plate 30, was discovered in fragments and reconstructed by Cunningham. There is no surviving prototype to which this extraordinary monument can be referred, yet its developed form and established role at Bharhut and subsequently implies undiscovered or perished antecedents. The *torana* continues in use even at present in India as an auspicious and decorative arch which is set up at wedding and other celebrations.

Although the *torana* itself is a new element, its constituent parts, as we shall see, can be related to earlier expressions in Indian or Occidental artistic traditions. The two pillars which support the arch are, as mentioned above, composed of four adjoining octagonal pillars with campaniform, or lotus, capitals. They are crowned by a single abacus and addorsed winged animals. That these pillars are similar to the earlier Asokan and Achaemenian columns is evident. However, the nature and implications of this similarity are not entirely obvious and may be appraised.

It might be concluded from the chronological position of Bharhut that the *torana* pillars as well as variant forms which have been converted into sculpted motifs elsewhere in the monument were derived from Asokan *stambhas*. However, the Bharhut interpretation of this motif reveals notable differences. Unique is the clustering of four columns into a single unit. Also a departure from Asokan and Achaemenian precedent is the conversion of the round shaft into an octagonal member. The capitals retain the bulge seen in their Maurya counterparts. The crowning animals are disposed differently than in either Maurya or Achaemenian examples. Whereas the Persepolitan protomes are addorsed and in profile, and the Sanchi and Sarnath lions are concentric facing the four quarters, the Bharhut animals are posed in profile, one behind another. The front figure is fully visible but the rear one is only partially seen. The Bharhut winged bulls or lions are nearer the Iranian beasts than the Asokan ones in that they are mythical rather than real. But unique again is the fact that the Bharhut crowning animals are not sculpted in the round but are conceived as figures in relief.

The above features that distinguish the columns of the Bharhut *torana* are perhaps subject to more than one interpretation. One essential fact however seems significant. This is that in general these columns are not much closer in conception to their immediate Asokan predecessors than they are to the somewhat more remote—in time and space and style—Persepolitan examples. Thus it may be proposed that in effect the Bharhut forms were derived neither from Asokan nor from Achaemenian prototypes but represent a parallel development. The Sunga tradition appears to be as old or older than the preceding Maurya art, in that its roots or origins steeped in popular traditions, antedate the latter. Thus it may be described as having evolved independently of Maurya art, although Maurya art shared these roots. Specifically we may propose that the Bharhut sculptures did not borrow its forms from either Asokan or Western prototypes. In fact, for many Bharhut features there are no prototypes in Maurya art. Therefore it would seem that parallels between elements in the Bharhut tradition and in either Maurya or Occidental repertoires are attributable to an earlier common origin.

Attention may be drawn to the small pillars which alternating with statuettes filled the spaces between curving *torana* beams. These pillars, as depicted in plate 31, have a vase as a base and their different composition further suggests an evolution independent of Asokan or Persian influence.

[2] Ghirshman, op. cit., p. 236, pl. 284.

Of the three *torana* beams, two were reconstructed by Cunningham. The lower beam represents a scene by now familiar—a procession of elephants. The middle beam also depicts an animal file or procession of leonine animals. The two middle lions are realistic but the ones on the right and left had a human and a bird head respectively. These beams terminated in open mouthed *makaras* with voluted tails.

The six square ends of the three beams to the inside of the crocodiles depict stupas on the left side and shrines on the right, with rosettes filling the background. The blocks which supported the square ends of the beams have been reconstructed by Cunningham. They are shown to have depicted more pillars which are described as "Persepolitan half pillars standing on a Buddhist railing, with large lotus flowers in the spaces between the pillars."[43] Plate 32 illustrates these blocks which, notwithstanding Cunningham's nomenclature, will be seen to bear little affinity to the columns of Persepolis or to the Asoka *stambhas*.

The pinnacles which rested on the *torana's* uppermost beam dominated the Bharhut stupa and symbolize the Buddhism which it glorified. The central emblem is a nine-petalled honeysuckle palmette emerging from a demi-medallion or rosette and crowned by a garlanded *dharmachakra*. Flanking this emblem are two *triratna* symbols resting upon rosettes which in turn are supported by a stepped pyramid.

In view of the importance which unquestionably is attached to the *dharmachakra* and the *triratna* symbols, we may take for granted that the details associated with the above symbols are similarly meaningful. In this context then, the presence of the honeysuckle, the rosette, and the stepped merlon, may be interpreted as evidence that these motifs were of symbolic value in the Bharhut repertoire. Therefore, to assume that any of the above mentioned elements are not indigenous—that is to say that they were formally copied from foreign prototypes—is incongruous with the essential role they evidently play in the traditional and evolved symbolism manifest at Bharhut. We may recall in this connection, for example, the presence of the honeysuckle palmette on the abaci of the Maurya Sankissa elephant and Rampurva bull capitals. The recurrence of this motif in such a prominent position at Bharhut, whose symbolism goes back much further than the Maurya age, can be considered almost as proof that it existed in Indian traditions prior to its appearance in the Asokan repertoire. At the same time, the prevalence of these conventional elements in Mesopotamian, Iranian, and Greek art implied that in the West too they were invested with a symbolic value. Consequently, this value must have been a common one and it may be referred back to a fundamental source whence it diffused to Indian art, but the precise time at which this diffusion took place is difficult to determine. The diffusion of some elements like the rosette may be traced back to proto-history; other elements are perhaps comparatively less ancient. However, it appears that none of the equivalent motifs can be attributed to the age in which they are, as far as we know, formulated in stone for the first time.

Turning our attention now to the *dharmachakra* and the *triratna*, both of these emblems have been associated with elements present in the Harappan tradition.[44] The *dharmachakra*, essentially a wheel, is a simple and self explanatory and thus eternal symbol and as such can be related in a general way to prototypes both in Indian and foreign traditions. The wheel occurs with frequency in the Indus Valley script, but more broadly speaking this motif, conceived as a solar symbol or an illustration of circular movement, can also be related to other more or less similar forms. For example, the *dharmachakra* in its essence and presentation may be compared with figure 269 which depicts the symbol of the Sumerian sun-god.

Fig. 269

[43] Cunningham, op. cit., p. 7.
[44] Cf. Aravamuthan, *Some Survivals of the Harappan Culture*, 1942, f. 16.

The *triratna* is a more distinctive form. It bears a certain resemblance to the headdress worn by the well-known Harappan figure which anticipates the Lord Siva. The Bharhut *triratna* clearly seen in plate 30 may be compared with the head-dress or horned crown of figure 117; although the similarity is not entirely convincing, there remains some possibility that the Buddhist symbol is derived from this Indus Valley element. However, the *triratna* is on the whole singularly without parallels in non-Buddhist repertoires.[45]

In the foregoing review of Bharhut motifs and their antecedents, equivalents, and values, we have tried to show that on the whole the elements which were assembled in this monument had ancient origins. The Bharhut symbolism was evolved from older traditions which acquired new or transformed connotations as Buddhism itself became formulated and transformed.

However, though this symbolism was fluid, its nucleus remained constant, and thus the essential or underlying meaning of motifs like mythical beasts, the rosette, the palmette, the wheel, the stepped pyramid, the rail, or the undulating vine, survived through their endless elaborated manifestations. Profoundly connected with the significance of the decorative and symbolic elements which dominate the Bharhut repertoire, is the underlying symbolism determining the form of the stupa itself and of its constituent parts, like the umbrella, the encircling rail, the gates and their disposition as a swastika, or the ornamental medallions. These elements too are of ancient origin and their interchanging roles—as architectural and again as ornamental motifs—underline their importance.

The implications of the above, as regards the relationship of those elements in the Bharhut tradition which are equivalent to forms in West Asiatic art, seem clear. Briefly, it may be suggested that probably none of the Bharhut decorative motifs were superficial formulae adapted from alien repertoires for their aesthetic value; but rather that these motifs were established conventions with indigenous symbolic meaning in both Indian and Mesopotamian or Iranian contexts. Parallels between Bharhut and Occidental elements in this light may be interpreted as forms of ancient origin.

In the above evaluation of Buddhist motifs, we have confined our study to elements which could be equated to earlier expressions in Indian or Western art. A large portion of the Bharhut sculpture is narrative and concerns itself with historical or legendary events pertaining to Buddhist traditions. As these sculptures are not directly relevant to the intentions of our study and as their interpretation is linked with that of literary material, they have not been analysed. It must be pointed out however that these narrative sculptures constitute a distinctive and integral portion of the Bharhut art. Yet even these narrative panels and medallions incorporate the symbolic motifs which we have evaluated above. Thus the decorative symbols are seen to play a significant role in the tableaux and to completely permeate Bharhut sculpture.

The elaborate Buddhist symbolism with which the Bharhut repertoire is invested can be understood with the help of literary sources. As we are concerned only with artistic evidence, the more specific meaning which Buddhism has bestowed upon these symbols has not been dealt with. However, we hope to have shown that underneath their Buddhist garb, the Bharhut motifs express earlier and more encompassing values which can be related to ancient roots and to the values expressed by similar motifs in the repertoires of other religions or other cultures.

[45] Cunningham, *The Bhilsa Topes*, pp. 355-56, describes the monogram as well as the swastika as an emblem composed of Sanskrit letters.

3. SANCHI

The artistic tradition expressed in the Bharhut Stupa reached a peak at Sanchi and continued to flourish for some time until it gradually became transformed more or less in the early centuries A.D. New idioms—outgrowths of the Sunga school, of the new Mahayana Buddhism, of an artistic background inherited from Asiatic Greek colonies in the North-West, and of fresh contacts with the Roman Empire—succeeded the Bharhut school. These idioms once again reflect a kinship with Western traditions which was to an extent inherited from Bharhut and Sanchi but also drew upon these more recent contacts. However, these new schools of sculpture do not fall within the scope of this study, which terminates with an evaluation of the tradition that emerges at Bharhut and culminates at Sanchi. Specific interest in the Bharhut and Sanchi school lies in the fact that it represents the first resurgence of popular traditions which, as far as we know, had survived practically without artistic expression for millennia. Although most of the links in the chain that connect Bharhut to proto-historic or to earlier Occidental traditions are missing, this connection seems manifest in the motifs we have discussed above. Thus, in the foregoing analysis of the Bharhut repertoire we hope to have demonstrated that artistic traditions in India and Western Asia from proto-historic times until the Christian Era evolved and diffused from a common nucleus. In the remaining part of this work, in which we will consider the flourishing and expansion of the Bharhut idiom, it is hoped that these views will be further substantiated. If it seems remarkable that artistic motifs, as expressions of constant values, can supersede cultural, geographic, and historical barriers, and spread even in the absence of clear cut contacts, we may recall that linguistic formulae have done just that. In art, as in language, although certain superimposed features are attributable to foreign influence, equivalent expressions may similarly be parallel derivants of one original form.

Contemporary with Bharhut, or slightly later, is the rail of Sanchi Stupa II which is followed by the gates and rail of Stupas I and III.[46] Their precise chronology has been debated, but as a group they follow Bharhut and illustrate further development of the traditions expressed in the latter monument.

The sculptures of Stupa II are on the whole the earliest at Sanchi. Stupa II is encircled by a balustrade or railing but has no *torana*. Smaller railings belonging to the berm and the *harmika* are also sculpted. In style the sculpture of Stupa II approximates Bharhut though rounder lines, more developed perspective, and elaboration in the medallions may be noted as an advancement.

The sculptures of Stupa I, known as the Great Stupa, are subsequent to those of Stupa II and illustrate the culmination of the tradition to which they belong. That the Great Stupa was originally built in the Maurya period is deduced from the Maurya type bricks used in the core.[47] Later in the Sunga period it was encased in stone and enlarged to its present diameter of 120 feet. It is enclosed by a railing composed of the usual uprights, crossbars and coping, which in contrast with the Bharhut balustrade or that of Stupas II and III at Sanchi, are uncarved.[48] The Stupa itself is an almost hemispherical dome truncated near the top and surrounded by a terrace accessible by a stairway. The terrace berm and stairway balus-

[46] Kramrisch, *Indian Sculpture*, 1933, pp. 30-31, attributes the sculptures of Stupa II to the second century B.C. and those of Stupas I and III from the first century B.C. to about the Christian Era.

[47] Marshall, *A Guide to Sanchi*, 1936, p. 33.

[48] Ibid., p. 32.

trades are carved as well as the coping of the railing which encloses the *harmika*. The uprights and cross bars of the *harmika* rail are unornamented. Portions of the crowning umbrella were discovered in fragments. The four elaborate *toranas* at the southern, northern, eastern and western entrances are the focal points of the Great Stupa and their sculptures embrace an overflowing repertoire of Buddhist historical, legendary, and decorative subjects as well as semi-divine figures and real or mythical animals. In form the Sanchi *toranas* are similar to those of Bharhut.

The addorsed lions supporting the *torana* of the South gate[49] are appreciably similar in disposition and detail to the lions of the Maurya Sarnath column and are possibly an imitation of the Maurya prototype. These lions, resting on a round abacus, represent perhaps the closest parallel to Asokan monuments met with at Sanchi. As noted in the case of Bharhut, the art of Sanchi with this exception appears to be derived not from Maurya forms, but from an earlier heritage. Alternatively, both the Sanchi lions and their Asokan predecessors, may represent an artistic convention, further examples of which have perished. The four addorsed elephants on the North gate[50] are disposed similarly to the lions and thus suggest the possibility that this plan was an established one. We have discussed above the stereotype treatment of lions in Indian and Occidental contexts. These Sanchi lions represent a further example of this conventional treatment.

Stupa III is comparable with the Great Stupa. Not much of the ground balustrade has survived, but the remaining portion is carved with the usual medallions. The stair and berm balustrades are also sculpted. Stupa III has a single *torana* elaborately carved. Marshall attributes this gateway to the beginning of the Christian Era—a later period than that of the stairway, berm and *harmika* balustrades—and considers it the most recent of the five Sanchi *toranas*.[51]

The motifs illustrated in the Sanchi stupas described above can be considered as a group, since notwithstanding variety and stylistic differences, they are homogeneous in conception and intention. They may be described as an elaboration of Bharhut and together the Bharhut and Sanchi sculptures are in essence endless variations of determined and constant themes. These themes are composed of two merged but essentially different groups of elements—narrative and decorative or symbolic. The narrative sculptures are bound by historic and legendary material. The decorative and symbolic group of sculptures however, like Kramrisch's "ageless" terracottas, are permanent in their values or significance. They are conventionalized and bound by neither time nor place. Their Buddhist symbolism may be viewed as superficial and a phase, for these motifs antedate and outlive Buddhism and exist beyond its scope.

The relationships evident in the Bharhut repertoire are apparent again at Sanchi. In the latter sculptures most of the Bharhut forms are repeated in similar contexts and with the same basic significance. As at Bharhut, the medallion is a foremost decorative and symbolic element. As this and other motifs have been studied in detail already, they do not call for additional comment. However, in the fuller Sanchi repertoire our attention is further drawn to recurrent motifs which are specifically equivalent to motifs in Western Asiatic repertoires and which, at the same time, are suggestively similar to Harappan motifs. These forms may be considered as belonging to the constant decorative and symbolic group of elements.

The Tree of Life is a prominent Sanchi motif that can be derived from more than one source. These alternate origins are themselves expressions of affiliated

[49] Cf. Zimmer, *The Art of Indian Asia*, v. II, pl. 24.
[50] Ibid., pl. 13.
[51] Marshall, op. cit., p. 93.

concepts and thus can be understood as having contributed as a whole to the evolution of the Sanchi form. Therefore, we may refer the Sanchi Tree of Life to a Harappan prototype as well as to conventional Assyrian precedents which are clearly related to the later Indian forms of this motif.[52] The Sanchi Tree of Life retains the symmetry which is the essence of the Assyrian formula, but lacks the rigidity of the latter.

The flowing and full Sanchi trees partially merge in concept and form with the undulating wish-fulfilling creepers which issue from the bodies or mouths of real or fabulous creatures or from a symbolic jug.[53] The tree is distinguished from the creeper however by its specific dualistic symmetry which suggests a somewhat different underlying intention. Thus the flowering creeper may be interpreted as a fundamentally female and self-contained symbol of fulfilment, as apparent, for example, in plates 33 and 34 from Stupa II. In both examples the vine issues from the navel of a female figure. Plate 33 is comparable with a Bharhut medallion which we have depicted in plate 35. In conception, though not in form, these illustrations may all be compared with the Harappan amulet depicted above in figure 116. The Indus Valley tablet represents a scene centered around a female with a plant issuing from her womb.

A dualistic and relatively more developed concept of fertility seems manifest in the Tree of Life which similarly represents fertility and productivity, but is not purely feminine nor, like the lotus creeper, self-fulfilling. This dualistic conception suggested by the Tree of Life, was also present in proto-historic Indian traditions. Figure 136 from Mohenjodaro may be visualized as containing the nucleus of the later Tree of Life. In the unique Indus Valley sealing, attention may be drawn to the markings in the root or center of the plant which issues from adjoined unicorns. The attitude of the animals is closely paralleled in the center group of plate 38.[54]

Illustrations of the *Kalpavrksha* as represented at Sanchi are depicted in our plates 36 to 38. Plate 36 appears on the Western gate of Stupa I and plates 37 and 38 are from Stupa II. The Sanchi motif is comparable with the Assyrian Tree of Life as depicted in plates 39 and 40.

Numerous fabulous and composite creatures at Sanchi play a rather elusive role. Though as a generic group they are related simultaneously to Harappan and to Western Asiatic creatures, specifically many are without earlier counterparts and although a fundamental significance undoubtedly accounts for their presence amidst the ornamental and narrative sculptures, in particular many of the forms appear fanciful rather than conventional. The Bharhut mythological creatures provide a point of departure for the Sanchi figures where endless animated permutations and combinations have been fully formulated. The presence of mythological creatures in Buddhist or Vedic literature may explain the nature of many of these beings as they appear at Sanchi, but essentially the composite creatures pertain to the symbolic group of motifs that precede and supersede their Buddhist attributes. Thus, literary sources cannot totally account for their function. These animals often appear in a passive decorative state at Sanchi, rather than as participants in any action which may be related to legendary matter, and hence their classification as ornamental or symbolic motifs seems to be substantiated. At the

[52] Cf. fig. 136 and plates 37, 38 and 39.

[53] Cf. Cunningham, op. cit., pl. xl; pl. xxxix; Marshall and Foucher, *The Monuments of Sanchi*, v. II, pl. xxvi c; pl. xliv; pl. 1 c; v. III, pl. xci 88a; pl. c.

[54] This connection has been noted by Sharma in "The Unicorn in Indian Art," *Journal of the Bihar Research Society*, XXXXIII, 1957, p. 363.

same time, notwithstanding their inactivity, the Sanchi composite creatures are in total harmony with their environment and there is thus no basis for evaluating them as intrusive. Whatever features they share with Occidental counterparts, the Sanchi forms are totally assimilated and thus these creatures can be viewed as parallels of Assyrian or Iranian composites rather than as being directly inspired by the latter. In fact, their descent from Harappan prototypes is apparent.

The role of composite creatures in the Sanchi repertoire is a collective one. As a group these mythical beings, human faced or winged quadrupeds, scaled creatures or creatures terminating in a fish tail, etc., suggest that the world depicted in the sculptures is a superhuman one. It is a world in which reality comprehends mundane activities, legendary happenings, philosophical and symbolic formulae, and the collective imagination of the cultures represented by the Bharhut and Sanchi artists. This imagination is inspired in traditional cults and draws from far reaching and extensive roots; thus it encompasses forms encountered earlier in Harappan or West Asiatic contexts.

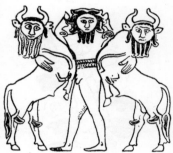

Fig. 270

Plates 41 to 46 illustrate several of the composite beings which appear among the Bharhut and Sanchi sculptures. These forms are equivalent to numerous West Asiatic examples of creatures more or less similarly conceived. Plates 47 to 49 and figures 270 and 271 from Occidental sources may be compared with the Indian creatures. It is notable that the degree of similarity varies. In some cases only a general affinity is perceptible whereas in others similarity approaches identity. It is of interest in this connection to observe that the human faced animals in Indian and Western repertoires are most similar to one another in conception and form. It is possibly significant that human faced animals, among the composite creatures, are also most clearly derived from Indus Valley and Mesopotamian prototypes respectively in Indian and in later West Asian art. The conclusion suggested by this circumstance is that a common proto-historic tradition appears to be the source of both the Bharhut-Sanchi and the Assyrian and the subsequent Western human faced creatures. Earlier Harappan and Mesopotamian composite beings illustrated in figures 122 to 131 and in figure 272 may be compared with plates 41 to 46 from Bharhut and Sanchi and with plates 47 to 49, and figures 270 and 271 from Assyrian and Iranian sources. A homogeneity all around is apparent and would seem to indicate a fundamental relationship beyond the realm of coincidence.

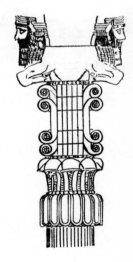

Fig. 271

F. C. Maisey draws attention to necklaces of symbols which adorn the votive pillars and which he notes are equivalent to similar necklaces depicted in Assyrian art. His illustrations, on which we have based our figures 273-275, reveal considerable similarity between the Sanchi and the Assyrian necklaces. The implications of these parallels are difficult to determine beyond the fact that some relationship is manifest. Figures 273 and 274 illustrate two such necklaces from Sanchi and figure 275 depicts the Assyrian one shown by Maisey. He draws attention further to an underlying common origin and significance in Indian, West Asiatic, and Greek art, but his further conclusions—for example, that Buddhism dates from only about the Christian Era—seem to have no foundation.[55]

The presence of atlantes or burden-bearers in the Bharhut-Sanchi tradition calls for some comment as regards their connection with earlier forms seen in the art of Western Asia from the Assyrian period. This particular motif cannot be related to proto-historic antecedents. However, its appearance in the second century B.C. may have been anticipated in impermanent material.

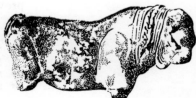

Fig. 272

[55] Maisey, *Sanchi and its Remains*, 1892, p. xii; cf. also p. 50.

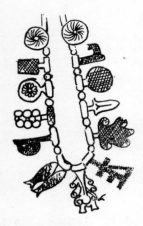

Figs. 273-275

Gairola has reviewed the subject of atlantes in early Indian art and has drawn attention to parallel forms in Western traditions.[56] He notes: "Like a number of other motifs, the atlantes in India seem to owe their origin to Western Asia. However they were soon incorporated and assimilated into Indian art."[57]

In the course of our survey of the Sanchi sculptures, we may note the absence of the swastika as a prominent symbolic element in this tradition, although, as we have seen, it occurs as a ground plan for the rail enclosing the stupa. This absence is not too surprising since we have already observed that many symbolic elements which are predominant for centuries or millennia are conspicuously rare, subordinated, or missing in certain contexts. For example, we have noted the absence of the true rosette in Harappan ceramics or of the mother goddess figurines in post-Harappan cultures. However, notwithstanding these lacunae, the elements in question eventually reappear in full force retaining their ancient basic significance.

Although among the Bharhut and Sanchi decorative motifs there appears to be little material which can be considered intrusive or alien, occasionally figures occur which seem to represent foreign personages. Attention may be drawn to an interesting scene in this category, which depicts a figure wearing boots and a kilt in combat with a lion. This scene, shown in plate 50, is a favourite subject at Persepolis. Plate 51 from Persepolis may be compared with the Sanchi sculpture. Of interest in connection with this motif is a possible relationship to the Sumerian Gilgamesh scenes, equivalents of which occurred in the Harappan repertoire. At the same time it is interesting to note that in this particular instance the fighting figure is apparently represented as an alien. Thus the context in which he appears may imply an association of the man versus beast theme with West Asiatic art or tradition.

In conclusion, it may be stated that the Bharhut and Sanchi artistic tradition in general, unlike preceding Maurya sculpture, is not subject to fundamentally controversial evaluation by art historians. On the whole, it is recognized as an indigenous popular tradition in which the role of Occidental influence is relatively insignificant. However, divergent opinions have been expressed on questions of chronology and iconography which are not directly relevant to our analysis and, more pertinently to this study, regarding the origins of motifs which are equivalent to motifs in West Asiatic and Greek art.

In the comprehensive work *The Monuments of Sanchi* by Sir John Marshall and A. Foucher, some comments are made regarding the question of foreign influence.[58] This influence, although acknowledged to have little bearing upon the essential "Indian" character of the monuments, is considered manifest in several motifs, specifically, fabulous creatures, Persepolitan columns, a "yavana" wreath worn by a figure participating in one of the narrative scenes,[59] or the grape vine as incorporated in the Tree of Life depicted on one of the pillars of the Western gateway.[60] The addorsed "Persepolitan" lions are postulated to be either a Maurya legacy or the product of later influence from stray "objets d'art" of Western provenance.

Marshall suggests that West Asiatic features present in Indian art were im-

[56] Gairola, "Atlantes in Early Indian Art," *Oriental Art*, 11, 1956.
[57] Ibid., p. 138.
[58] Marshall and Foucher, op. cit., p. 155ff.
[59] Ibid., cf. plate 29b. The wreath is worn by one of Mara's host in a Temptation scene on Northern gateway, Stupa I.
[60] Ibid., cf. plate 66c from the Western gateway, Stupa I.

ported in the Maurya period rather than earlier or during Achaemenian times, as there is little evidence of Iranian impact at Taxila except among the minor antiquities.[61] He adds:

"The most likely explanation as it seems to me is that in the second and first centuries B.C. the dissemination in India of Asiatic Greek art in the form of coins, gems, terracottas, small carvings and textiles, acted as a valuable stimulus to indigenous art, not only providing it with many new motifs but leading in many cases to the adoption of more developed methods of technique."[62]

The above interpretation is plausible in respect to the stimulus which is recognised to have been provided by trade and cultural contacts with the West and which was artistically recorded in minor "objets d'art". Beyond this, it may be noted that there is a conspicuous absence of major artistic objects of a distinctly Occidental character pertaining to the period between Achaemenian intrusion in India and the beginning of the Christian Era. Thus, considerable importance has been placed in Marshall's interpretation upon minor antiquities either of Western style or of Western origin.

However, although some stimulus toward a general diffusion of art and culture was possibly provided by these minor antiquities, in the Bharhut and Sanchi repertoires there are practically no specific recurrent motifs which may be directly attributed to current Western influence. We have analysed above many of those motifs which are equivalent to Western Asiatic or Hellenistic motifs and hope to have demonstrated their origins to antedate even the Achaemenian period and to be rooted in indigenous traditions and symbolism. For example, we have seen that the fabulous creatures which are considered in particular to be of Near Eastern provenance are anticipated in Harappan art and thus have been a part of Indian tradition for centuries. Marshall has proposed that the Sanchi themes were derived from a traditional heritage mingled with "foreign" themes from the Near East,[63] but for the most part these so called foreign themes remain elusive.

Apparent at Sanchi is the fundamental symbolism, absorbed and adapted by Buddhism, which is expressed by the ornamental elements. Marshall believes that although further knowledge may enlighten many of these elements, a purely decorative residue will remain.[64] We hope to have shown, however, that even if from the viewpoint of Buddhism such a residue may remain, an underlying symbolism is manifest in almost every recurrent decorative motif. Art is a language or a means of expression and it cannot endure without substance.

Vincent Smith feels that post-Asokan sculptures are "essentially Indian with nothing foreign except details" and that they "presuppose the existence of a long previous evolution of native art probably embodied in impermanent materials and consequently not represented by actual remains"[65] He adds, however, regarding the sudden appearance of stone sculpture that this "raises a reasonable presumption that the novelties thus introduced into the ancient framework of Indian civilization must have been suggested from outside.[66] Smith believes that prototypes for Indian stone relief may have been provided by Alexandrian reliefs rather than by Persian sculpture.[67]

[61] Ibid., p. 94.
[62] Ibid., p. 103.
[63] Ibid., p. 176.
[64] Ibid., p. 179.
[65] Smith, *History of Fine Arts in India and Ceylon*, third edition, edited by Khandalavala, p. 64.
[66] Ibid.
[67] Ibid.

As indicative of Alexandrian influence, Smith draws attention to a number of motifs, specifically to the "Woman and Tree motif," to the "Rider motif," to the "undulating roll" and to "weird creatures."[68] However, the woman and tree, undulating motifs, and fabulous beings, were all seen to be invested with an ancient and profound symbolism which can be related to motifs in Indus Valley and Mesopotamian contexts. The rider as a subject in the Sanchi sculptures would appear to be taken at face value and to represent current mundane or legendary incidents. There does not seem to be any basis for attributing this element to foreign inspiration.

The foregoing interpretation of the Bharhut and Sanchi sculptures represents a general critical tendency to acknowledge this tradition as an indigenous and popular one, but at the same time revealing some elements of Western influence either in decorative motifs or in certain stylistic details. A stronger view, which attributes considerable importance to a "subtle" Western influence within the Sanchi tradition, is expressed by Foucher. He writes regarding the sculptures on the Eastern gate of Stupa I:

"A quantity of decorative motifs have appeared to us so directly borrowed from Persia that their importation can scarcely be explained otherwise than by an immigration of Iranian artists. But this is not all; here and there, in bold fore-shortenings, in the skilful placing of three-quarter length figures, in the harmonious balancing of groups—in a word, in the detail of the working process, as also in the general arrangement of the composition—we detect growing traces of an influence more subtle and more difficult to disentangle but incomparably more artistic which in fact had by the vicissitudes of political history been brought much nearer, the influence of Hellenistic models.[69]

Zimmer has drawn attention to the Sanchi lions which he thinks reflect Iranian influence. He writes, "Iranian motifs are winged lions on the beams of the Northern gate (pl. 7) and squatting lions such as those of the lion capitals of the Southern gate (pl. 24), which in clear contrast to the lifelike elephants are stiff and heraldic."[70] In this connection it has been noted at the beginning of this section that the Sanchi lions reveal an affinity with Maurya prototypes.

Among the motifs which have been, perhaps undiscerningly, considered intrusive in the Bharhut and Sanchi repertoires, we have pointed out many which are in effect ancient elements containing basic Indian symbolic values. Therefore, they may be considered equivalent to motifs in West Asiatic or Greek art, but not directly inherited from Iranian or Greek prototypes. Rather, they seem to be parallel expressions derived from a common nucleus that diffused continually from proto-historic times onward.

Above, motifs as mythical creatures, stylized lions, floral themes like rosettes and conventional decorative elements like the honeysuckle, etc., have been traced from their earliest occurrence in Indian and Occidental contexts. Many of these elements have been met with from proto-historic times and have survived for millennia in both Indian and West Asiatic art. From this survival it can be inferred that their more recent renderings were traditional rather than super-imposed upon Buddhist art.

Several comments relevant to our views are made by Stella Kramrisch. She underlines three "configurations" which are recurrent in Indian art over 2000 years:

[68] Ibid., pp. 64-68.
[69] Foucher, *The Beginnings of Buddhist Art*, 1917, pp. 81-82.
[70] Zimmer, op. cit., p. 236.

the combined man and animal shape, the woman and tree configuration and the group of man and woman in union.[71] She notes that the first motif is known not only to Indian but also to paleolithic cave painting, to Mesopotamian, Egyptian and Greek art, and to the Renaissance. The *mithuna* theme or the man and woman in union, according to Kramrisch, is also manifest in entwined serpents. The above incidents illustrate the enduring vitality of artistic motifs and are in accord with our interpretation of the composite monster or the woman and tree themes as ancient and of indigenous origin.

In the same study Kramrisch writes regarding the wave which merges into the lotus rhizome:

"It rises and sinks in even repeated rhythm, carrying lotus flowers and the fruits of all trees, and not only these but also the fruit of all actions. These are exemplified in the scenes which illustrate the stories of the former births of the Buddha. These scenes are carved in the rising and falling of the wave. The wave in the shape of the lotus rhizome is a plastic equivalent of the theory of reincarnation."[72]

This passage is of great interest and importance in that it enlightens one of the foremost early Buddhist motifs, revealing it to be clearly symbolic rather than only decorative in intention. We have discussed the rhizome or creeper above and implied that like other ornamental elements it was invested with a symbolism that superseded its decorative function. Kramrisch gives us an insight into the nature of this symbolism. We may add that although the Bharhut and Sanchi artists may not have been fully aware of the underlying symbolic connotations of the motifs they sculpted, their work was nevertheless dominated by this symbolism. Moreover, the essential value of the creeper or other elements was not subject only to Buddhist interpretations, but anticipated and extended beyond the limits of any particular religion or cultural complex.

Stella Kramrisch's identification of the rhizome with the wave is also relevant to our association of this theme in the Bharhut-Sanchi repertoire with similar motifs depicted on early seals. It further suggests a relationship with wavy patterns in proto-historic ceramics in India as well as Western Asia. In early contexts there is evidence in the background scenes that wavy patterns were in fact representations of water. Thus the suggestion that the concept of the wave was retained in the lotus creeper of fulfilment has some bearing upon our reference of this motif to proto-historic prototypes.

Before concluding this commentary on Sanchi, attention may be drawn to one aspect of the Sanchi sculptures that in general has received little notice. It has already been pointed out that the Bharhut-Sanchi tradition, in contrast with the preceding Maurya school, is a popular one. However, this popularity does not imply a complete lack of sophistication or even of royal patronage. Rather, the Sanchi idiom represents a merging of popular trends with a certain degree of sophistication that may be attributed to more exalted sponsorship. We may refer to an inscription on the upper beam of the Southern gateway of Stupa I which bears the name of Ananda, foreman of the artisans of King Sri Satakarni. Kramrisch notes that the relief produced by the royal atelier, representing symbolically the seven Manushi Buddhas,[73] is well proportioned in comparison, for example, to the jammed relief produced by the ivory carvers of Vidisa, depicting the homage rendered

[71] Kramrisch, *Indian Sculpture in the Philadelphia Museum of Art*, 1960, p. iv.
[72] Ibid., p. 21.
[73] Represented by the symbolic stupa, sambodhi trees, etc.

to Buddha's severed topknot and its ascent to heaven.[74] As regards the heritage upon which even the king's sculptors drew, there is nothing to suggest that this tradition was not derived from indigenous sources.

Niharanjan Ray suggests that the Bharhut and Sanchi as well as the Bodhgaya reliefs are stone adaptations of scroll paintings which were produced by a popular tradition. He points out that the panels of the gates were carried by religious demonstrators.[75] Coomaraswamy also refers to exhibitions of scroll paintings in Magadha and to evidence pointing toward a similar custom in Persia.[76]

To recapitulate, it may be proposed that the Sanchi tradition is derived from an indigenous heritage, which according to Ray, unlike Maurya court art, "is born of India's own seed with deep and intimate ethnic and local roots."[77] Sanchi can in fact be viewed as the emergence of a tradition which had remained submerged or unformulated in stone for centuries. The Sanchi idiom is not specifically derived from the earlier Maurya school, though to an extent it must have been influenced by this sculpture. Rather, it is a parallel expression which drew its inspiration directly from predominantly, though not exclusively, popular sources. Bharhut or Sanchi motifs, which are similar to Asokan or to West Asiatic elements, occur not as adaptations of the former, but rather as equivalent expressions which may be related to a common origin. The fact that the Sanchi expression may be later in date is in accordance with a pattern of cultural diffusion which seems to have been consistent from proto-historic times until the present. We have shown that in general ceramic or glyptic elements appeared in Mesopotamian art earlier than in Indian traditions, without their implying that the Indian elements were in each instance borrowed from West Asiatic prototypes. Similarly, those motifs in the Sanchi repertoire which are similar in concept or in form to Occidental motifs cannot be interpreted as intrusive only because they occur for the first time earlier, as far as we know, in Occidental traditions.

We have indicated above that the symbolic value which is inherent in the Sanchi motifs lies deeper than the superimposed Buddhist symbolism with which these elements are also invested. From this viewpoint it is interesting to consider that the Bharhut and Sanchi sculptures are not entirely faithful to the austerity of the early Buddhism in whose service they were created. The sculptures are apparently inspired largely in lay folk traditions which incorporated old fertility cults and other ancient formulae. Coomaraswamy writes in this connection:

"The art of Sanchi is not, as art, created or inspired by Buddhism, but is early Indian art adapted to edifying ends, and therewith retaining its own intrinsic qualities. A pure Buddhist content is far more apparent in the early architecture and especially in the undecorated hemispherical stupa . . . and in the excavated caitya-halls"[78]

4. EXPANSION OF THE BHARHUT-SANCHI STYLE

a. Bodhgaya

The Bodhgaya railing which originally enclosed the Bodhi tree of Buddha's enlightenment is approximately contemporary, probably slightly posterior to

[74] Kramrisch in "Links between Early and Later Buddhist Art," *Marg*, IX, 1955-56, Section on Sanchi.
[75] Ray, *Maurya and Sunga Art*, 1945, p. 73.
[76] Coomaraswamy, "Picture Showmen," *Indian Historical Quarterly*, V, 1929, p. 182.
[77] Ray, op. cit., p. 94.
[78] Coomaraswamy, *History of Indian and Indonesian Art*, 1927. p. 36.

Bharhut. The Bodhgaya style is distinct from that of either Bharhut or Sanchi and its precise chronology has been disputed.

Dr. Ray evaluates the Bodhgaya style as a step forward from Bharhut, both "technically" and from the viewpoint of "visual perception."[79] Kramrisch describes Bodhgaya as an "elegant if superficial sequel to Bharhut."[80] Smith also considers Bodhgaya later than Bharhut though earlier than Sanchi.[81] However, Benisiti, based on a more limited analysis of the form of the lotus medallion, suggests that the Bodhgaya balustrade antedates Bharhut, attributing the former to c. 250 B.C. and the latter monument to c. 200 B.C.[82] The specific chronological position of Bodhgaya is not relevant to our evaluation of Occidental affinities.

Although the Bodhgaya reliefs are related to the Bharhut and Sanchi school, they reflect a somewhat different stylistic attitude. They lack the elaborate richness and refinement of their Bharhut or Sanchi counterparts, but at the same time are less congested—the spaces are better utilised. Bachhofer considers the Bodhgaya figures unsteady and lacking firmness.[83] At the same time, as pointed out by Ray, the sculptures are characterised by order, brevity, and clearness.[84] Kramrisch notes: "The figures now move with greater self assurance and their rhythmical ease is not confined to the surface only but extends into depth."[85]

The Bodhgaya railing, like those of Bharhut and Sanchi, is composed of uprights, crossbars, and a coping. The uprights are carved with the usual central medallion and demi-medallions at the top and bottom or with standing figures or relief panels depicting varied scenes. The crossbars are similarly decorated with medallions and the coping again depicts a band of rosettes. The inner faces of the medallions often enclose human busts or real or mythical animals. The mythical creatures appear in a great variety of forms and are elaborately conceived, though simply executed. The floral motifs, however, are limited and unimaginative in comparison to Bharhut or Sanchi.

As regards the relationship of the Bodhgaya rail with Western art, which is of particular interest in this work, divergent opinions have been put forth.

Rajendralal Mitra as early as 1878 was in opposition to the idea that the Bodhgaya sculptures could be considered of Western origin.[86] Coomaraswamy also has refuted this opinion, and sees in Bodhgaya, as in Bharhut and Sanchi, Vedic formulae.[87] The Bodhgaya repertoire is essentially related to that of Bharhut and Sanchi and thus may be viewed as having an equivalent position vis-à-vis Occidental traditions. However, attention may be drawn to a few of the Bodhgaya elements that have been subject to controversial interpretations. In particular the significance of one scene, depicting a figure in a chariot drawn by four horses,[88] has been debated. This panel has been described as a representation of the Indian Surya in his chariot and alternatively as a sun-god based upon a Greek prototype.[89] While

[79] Ray, *Maurya and Sunga Art*, 1945, p. 92.
[80] Kramrisch, *Indian Sculpture*, 1933, p. 29. Kramrisch places the Bodhgaya railing in the first half of the first century B.C.
[81] Smith, op. cit., p. 31.
[82] Benisiti, *Le Medaillon Lotiforme dans la Sculpture Indienne*, 1952, p. 31.
[83] Bachhofer, *Early Indian Sculpture*, 1929, p. 30. Bachhofer attributes the Bodhgaya railing to the first half of the first century B.C. on bases of style and inscriptions. Cf. p. 30 and p. 20.
[84] Ray, op. cit., p. 93.
[85] Kramrisch, op. cit., p. 29.
[86] Mitra, *Buddha Gaya*, 1878, p. 165.
[87] Coomaraswamy, *La Sculpture de Bodhgaya*, 1935, p. 2.
[88] Ibid., pl. xxxiii and p. 44.
[89] Ibid., p. 44.

this question is essentially a matter of iconography, it is not unconnected with the issue of Western or Greek influence or elements in the Bodhgaya tradition. In effect, the interpretation of the above scene is related to the further reaching matter of origins and possible Occidental sources. Coomaraswamy rejected the view that this or other motifs in the Bodhgaya, Sanchi, or Bharhut repertoires could be attributed to foreign prototypes. Mitra similarly rejects such a view and interprets the above scene as a representation of an Indian charioteer with Amazon ladies.[90] He accordingly interprets other Bodhgaya elements, in particular mythical creatures, as indigenous.

Rowland is in accordance with the identification of this panel as a representation of Surya. He writes:

"This representation of the sun-god in a quadriga is sometimes interpreted as an influence of Hellenistic art, although stylistically there is nothing beyond the iconography to remind us of the characteristic representation of Helios in Classical art in which the solar chariot is invariably represented in a foreshortened view. The concept of a sun-god traversing space in a horse-drawn chariot is of Babylonian and Iranian origin and spread from these regions to both India and Greece so that the representation is simply an interpretation of the iconography, and not the borrowing of a pre-existing stylistic motif.[91]

The above interpretation is of considerable interest in establishing an early origin for this motif.

As regards the fabulous beings which recur at Bodhgaya, Rowland states, "The medallions are filled with a repertory of fantastic beasts of West Asiatic origin, which in the heraldic simplicity of their presentation are prophetic of later Sassanian motifs."[92]

It may be added that the imaginary creatures at Bodhgaya are evidently assimilated in their Indian context.

Coomaraswamy also discusses in some detail the meaning and origins of the many imaginary monsters which appear among the sculptures at Bodhgaya. He relates the floral themes and aquatic creatures to an underlying symbolism which is suggestive of abundance and is derived from an ancient water symbolism. This symbolism underlines many ceramic and glyptic designs as well as sculptural motifs in West Asiatic or Indian art of all times. Under the relevant heading "La Cosmologie Aquatique," Coomaraswamy writes:

"L'idée fondamentale est que les eaux sont a l'origine de toute vie et demeurent la source de toute abondance. Le lotus, le makara, la conque (Sankha), et le vase plein (Purnaghata) sont symbols de l'eau." "... dans l'iconographie de la cosmologie aquatique nous les voyons pour ainsi dire presider aux origines aqueuses de la vie et de l'abondance à Bodhgaya; leur charactère phallique eat très accentué."[93]

In addition to aquatic creatures, the Bodhgaya repertoire is rich in other winged and composite beings, in some instances depicted in a file or frieze reminiscent of ceramic conventions. For example, plate 52 illustrates a procession of real and imaginary creatures from the Bodhgaya rail.

Although the Bodhgaya sculptures have a distinctive style there does not seem to be any evidence to suggest that this tradition was to a greater or less extent akin to Western traditions than Bharhut or Sanchi. Decorative motifs are conceived

[90] Mitra, op. cit., p. 161.
[91] Rowland, *The Art and Architecture of India*, 1953, p. 60; cf. pl. 19A.
[92] Ibid., p. 60.
[93] Coomaraswamy, op. cit., p. 52.

similarly to those of Bharhut and Sanchi, though their treatment and form varies somewhat. However, the symbolic intentions of the Bodhgaya ornamental motifs are in common with Bharhut and Sanchi, and historic or legendary scenes refer to the same Buddhist sources.

Coomaraswamy's evaluation of the Bodhgaya art is of interest. According to him, Bodhgaya is a natural stylistic development and does not reflect any Occidental influence. This interpretation is also valid for Bharhut and Sanchi. The Bodhgaya mythical composite or winged creatures are also related to Bharhut or Sanchi counterparts and may be similarly interpreted. As a genre they are not copied from West Asiatic or Greek forms, but are assimilated and descended from ancient, often proto-historic, prototypes. A conceptual relationship between semi-human monsters from Mohenjo-daro, Mesopotamia, and Bodhgaya, can be seen in figures 276 to 278.

Coomaraswamy summarizes in connection with the Bodhgaya art as follows:

"A mon sens cette evolution du style était normale et inevitable; les éléments animaliers, les thèmes de cosmologie aquatique ne sont pas des innovations de l'epoque, mais, bien l'hertage d'une très haute antiquité, la phase indienne de l'art asiatique primitif, en un mot des motifs cousins de ceus de l'Occident, mais non derivé d'eux . . ."[94]

Thus, Bodhgaya may be considered vis-à-vis Occidental traditions in the same light as Bharhut and Sanchi. Essentially, as proposed by Coomaraswamy and seen in figures 276 to 278, its repertoire can be interpreted as related to rather than descended from Occidental themes.

b. Amaravati and Jaggayapeta

The tradition of Bharhut and Sanchi extended to Andhradesa, where at the Buddhist sites of Amaravati and Jaggayapeta an early phase of sculpture is closely related to the Bharhut school. However, the sculptures which adorn the Amaravati and Jaggayapeta stupas reveal distinctive characteristics that ultimately result in the transformation of the original Bharhut style into something quite new and different. This school is chronologically beyond the limits of this work.

Figs. 276-278

Our chief interest lies in the fewer early Andhra or Satavahana sculptures which reiterate those elements that in the Bharhut, Sanchi, or Bodhgaya repertoires were noted for their similarity to Occidental motifs. There is no evidence to suggest that the mythical creatures which recur in the Amaravati and Jaggayapeta repertoire at the early stage can be attributed directly to influence from or contact with Western art. Rather, such forms along with other elements of style or content can be considered to have been, to some extent though not completely, derived from the Bharhut school itself. The presence in Andhra art of motifs like mythical beasts, campaniform capitals, addorsed animals, or undulating creepers indicates that these are fundamental motifs in Indian art. They occur continually and prominently throughout early Buddhist sculpture invested with an ancient and evolved symbolism.

Although perhaps it can be said that the Bharhut style migrated or diffused to Amaravati and Jaggayapeta, the latter tradition could similarly be viewed as an additional manifestation of the same artistic heritage which culminated once at Sanchi. But, however the early phase of Andhra sculptures is interpreted, it seems clear that the themes it expressed were deeply ingrained in Indian art at this stage.

[94] Ibid., p. 52.

Of the early phase at Amaravati only a few fragmentary sculptures have survived. The precise dating of these sculptures has been subject to some discussion. but they are approximately contemporary with Sanchi.[95] In style the Amaravati sculptures are close to Jaggayapeta and in many respects equivalent to Bharhut. On the other hand, subjects like that of a boy chasing animals and especially a tendency towards elongation are distinctive. As regards the Amaravati style, Kramrisch notes: "In last two centuries B.C. the delicacy of the modelling, the slimness of the over-elongated limbs, the powerful characters of the bodies, and with it all a sensibility and keenness of movement were distinctly of local origin."[96]

The Amaravati stupa was erected about 200 B.C. and was enlarged and embellished through a period of several centuries. The so-called mature stage at which building and sculptural activity reached a peak is attributed to the second or third century A.D.[97] and thus is not within the scope of this study.

The Great Stupa was encased by sculpted slabs and surrounded by a large and richly sculpted railing composed of the usual uprights, crossbars, and coping. The rail had four gateways which were simple openings. The gates were faced by four projecting platforms known as "ayaka" platforms.[98] These platforms are absent in representations of stupas of the early phase but are conspicuous in the later phase. Unfortunately, the Amaravati stupa was carelessly handled subsequent to its discovery in 1797 by Col. Mackenzie, and has not survived in situ.[99] Thus its form can be deduced only tentatively from the surviving marble slabs and from the plans of early archaeologists. A major portion of the Amaravati remains are at present in the London and Madras Museums.[100]

At Jaggayapeta, about thirty miles from Amaravati, a complex of Buddhist structures was erected over a period of about seven centuries from the second century B.C. to the fifth century A.D. The Great Jaggayapeta Stupa was surrounded by a processional path formed of carved slabs and encircled by a railing. The body of the stupa was covered at the base with carved marble slabs and at the dome by a brick casing plastered in lime and probably originally painted. The remaining sculpted pilasters which rose above the slabs at the base are comparable in style with the earliest Amaravati sculptures and with Bharhut. Maurya type characters in inscriptions found on some unsculpted slabs seem to confirm an early date for the original structure.[101] Thus, the Jaggayapeta sculptures may be contemporary with or just slightly posterior to Bharhut.[102]

[95] Barett, *Sculptures from Amaravati in the British Museum*, 1954, p. 56: "It is not too much to say that the early phase at Amaravati, so far as we can judge it from the relatively few surviving fragments, derives all the elements of its style from Sanchi"; Kramrisch, op. cit., p. 34, attributes the early Amaravati sculpture to the first century B.C.; Sivaramamurti, "Amaravati Sculptures in the Madras Government Museum," *Bulletin of the Madras Government Museum*, IV, 1942, p. 29, dates Period I at Amaravati between c. 200-100 B.C. and describes the style as Bharhut; Bachhofer, op. cit., p. 45, states: "A few fragments unearthed there undoubtedly belong to the period featured here (i.e. 50 B.C.—A.D. 75). In addition to the fact that the dress of the worshippers closely resembles the garments worn on the reliefs of Sanchi, a minute examination of the means of representation warrants the conclusion that these works must have been executed in the same period."

[96] Kramrisch, op. cit., p. 46.

[97] Cf. Barrett, op. cit., p. 40; Rowland, op. cit., p. 124; Archaeological Survey of India, *Archaeological Remains, Monuments and Museums*, 1964, p. 105.

[98] Cf. Rowland, ibid., p. 116; Agrawala, *Indian Art*, 1965, p. 288.

[99] Agrawala, ibid., pp. 283-284.

[100] Cf. Barrett, op. cit.; Sivaramamurti, op. cit.

[101] Burgess, *Buddhist Stupas of Amaravati and Jaggayapeta*, 1887, p. 108; Smith, op. cit., p. 44. However, Khandalavala questions the exactitude of this evidence (cf. Smith, op. cit., p. 44, note 1).

[102] Kramrisch, op. cit., p. 34, dates Jaggayapeta in the 2nd century B.C.

Bachhofer places Jaggayapeta in the mid-second century B.C. and draws attention to similarity between these reliefs and a few pillars of the Sanchi Stupa III, attributed to the same period.[103] He further notes the distinctive local style of the Jaggayapeta sculptures:

"They are of special interest because, as we are here in Southern India we can speak of a local character already evident in the first productions. In the works from Jaggayapeta one notices the same preference for very slim figures, a preference which is manifested three centuries later at Amaravati where the artists never seem to have had enough of the tall and narrow figures."[104]

The form of the Jaggayapeta pilasters is of interest. They consist of a pot-shaped base lavishly decorated with lotus petals and surmounted by a mythical creature, preferably fish-tailed. A Yaksha or Yakshi, similar to the figures on the uprights of the Bharhut rail, rests upon this creature. The pilaster's capital resembles the base.[105] Similar pillar forms occur at Amaravati.

On the whole, the Amaravati and Jaggayapeta sculptures in the earliest stage are encompassed by the scope of the Bharhut-Sanchi tradition,[106] though they represented the beginning of a new school. As has already been stated, the Andhra sculptures retained most of those themes which in Maurya and Sunga art were shown to be equivalent to but not borrowed from elements in West Asiatic art. The implications of this recurrence are not conclusive, but it very much seems that in this context forms such as winged, fish-tailed, or other mythical beasts, campaniform members, or undulating motifs cannot be attributed to foreign sources. As suggested above, they may to some extent be considered derived from Sunga art. More specifically, such forms seem to have been evolved locally as an extention of the Bharhut tradition rather than as a dependent school. This view is perhaps supported by the distinctive style of the Amaravati and Jaggayapeta reliefs, by the future independence of Andhra art, and by the fact that its beginnings were contemporary with Bharhut or at the latest Sanchi.[107] Thus the fact that the early Amaravati-Jaggayapeta motifs are of local origin rather than totally borrowed directly from Bharhut and Sanchi, may be considered significant and of importance in substantiating the view that such motifs thoughout early Indian art were not imitations of foreign prototypes.

A few of the mythical creatures appearing in the Amaravati repertoire are illustrated in plates 53 to 56. Plates 57 and 58 represent garlands and wavy creepers from the same site. An illustration of a person holding a winged lion by the ear can be seen in plate 59. This theme is not familiar at Bharhut or Sanchi. Nor is it noted in Occidental art. However, an early relief depicting winged animals led by men[108] is noted by Zimmer as testifying to influence of the archaic Mesopotamian style.[109] This is of special interest as it upholds our view that Asiatic influence diffused to India at a very early period.

Finally, attention may be drawn to plate 60 which depicts entwined snakes.

[103] Bachhofer, op. cit., p. 28.
[104] Ibid., p. 28.
[105] Burgess, op. cit., pl. liv, 2-3.
[106] Regarding the common elements among Bharhut, Sanchi, Mathura and Amaravati, which are stronger than differences, Bachhofer writes: "This is not surprising as both the social arrangement and the intellctual and spiritual foundations of India were at that time everywhere similar. . . ."
[107] Barrett, op. cit., p. 56.
[108] Zimmer, The Art of Indain Asia, 1954, II, pl. 38.
[109] Ibid., p. 349.

This motif is unquestionably of great antiquity as well as widespread in West Asiatic art. This figure may be equated with any number of twisting serpent motifs in Occidental art.[110] The symbolism with which serpents and entwined figures is invested cannot but be deep and far reaching. Although the artistic formulae illustrating this symbolism occur far apart in time and space, they are fundamentally related and express a constant concept.

c. Cave Temples

Maurya caves in the Barabar hills mark the beginning of rock-cut architecture and sculpture, which ultimately achieve a perfection unsurpassed outside Indian art. Cave temples were excavated in India over a period of nearly 1000 years, and the early examples of this movement in Orissa and in Western India incorporate many elements of the Sunga tradition as well as distinctive features.[111] As regards the position of rock-cut sculpture and architecture vis-à-vis West Asiatic art, the recurrence of many forms which have been discussed above may again be noted. We shall also draw attention to some additional material which, it is hoped, may provide further insight into the question of the relationship between similar artistic formulae in Indian and Occidental art.

In the Udayagiri and Khandagiri hills in Orissa, a number of Jaina caves were carved approximately at the same time as the sculpture of Bharhut-Sanchi.[112] More specific dating of these caves hinges upon the controversial date of Kharavela and his Hatigumpha inscription which have been attributed to different periods between the 2nd century B.C. to the 1st century A.D.[113] Based upon stylistic comparisons, the Udayagiri and Khandagiri caves may be attributed to a period between Sanchi II and Sanchi I or later.

Architecturally these caves vary from small dens to elaborate two-storeyed excavations like the Rani Gumpha, with verandahs, terraces, and many chambers. The sculptures occur as wall friezes in relief, depicting a variety of scenes, or as decorative elements, for example, as carved on the arches. The verandah pillars have square shafts and vase capitals or else the familiar addorsed animal capitals.

Both in subject and style the Orissan cave sculptures reveal an affinity or contact with the Bharhut and Sanchi schools, with some Amaravati motifs and with the sculptures of the Western cave temples. Although common elements may be due to a political unity achieved by the Satavahanas, who controlled a large area extending from the West coast to the borders of Orissa, these elements are also the product of a common heritage, of a pre-existing style, examples of which have perished or remain undiscovered. This latter view is in harmony with the fact that many equivalent norms like campaniform members or animal crowned pillars antedate the Satavahana period and can be referred to examples in Sunga or even Maurya sculpture. In fact, if we consider that the Bharhut-Sanchi tradition diffused to Orissa, or was paralleled in the sculptures of the Khandagiri-Udayagiri hills,

[110] For example, see Frankfort, *Cylinder Seals*, 1939, p. 199, f. 33 and Frankfort, *Art and Architecture of the Ancient Orient*, 1954, p. 16, fig. 7.

[111] Kramrisch, op. cit., p. 34, notes that the first and second century B.C. sculptures have a provincial aspect and depend mainly on Madhyadesya but also to some extent on the South.

[112] In the second and first centuries B. C. Kramrisch, op. cit., p. 34, and Rowland, op. cit., p. 73.

[113] Buhler, in the *Cambridge History of India*, pp. 530-535, places Kharavela in 2nd century B.C.; Raychaudhari and Barua, see Barua's *Old Brahmi Inscriptions*, p. 293, on the other hand place Kharavela in the second quarter of the 1st century, A.D.; Sahu in "A Note on the Khandagiri and Udayagiri Caves," *Marg*, VIII, Sept. 1955, places the Kharavela inscription one century after Asoka.

artistic similarities can be understood even without postulating lost prototypes. The common heritage, from which most plausibly all of the early Indian schools drew inspiration, probably preceded even Maurya art and may have existed in perishable material or to some extent also in an artistically unformulated state, just as an unwritten language exists before it becomes recorded.

The sculptures in the Orissa caves do not seem to contain fresh elements significantly similar to elements in Western repertoires. There are however many echoes of forms which have been evaluated above in relationship with their Occidental counterparts. It may be suggested that the recurrence of such forms, as noted at Amaravati, implies that they can be accepted as indigenous, that is, totally assimilated in Indian repertoires. Specifically, in this category we may refer, for example, to a representation in the Ananta Gumpha of a figure identified as the Sun-god riding in a chariot drawn by four horses.[114]

This scene may be equated with a similar Bodhgaya relief.[115] Its reappearance has been noted by Kramrisch[116] and may be taken to support the view that this motif in effect is not derived from Greek prototypes but represents a traditional Indian concept. Attention may be drawn to the fact that although the Khandagiri-Udayagiri sculptures are apparently not Buddhist, their repertoire is in essence closely related to that of the contemporary Buddhist monuments. This circumstance is important in connection with our interpretation of early Indian motifs as invested with a basic symbolism that underlies their particular religious connotations.

The decorative elements utilized in the sculptures of the Orissa caves are familiar and ancient symbols which have been analyzed above. Winding creepers, figures issuing plants, the rail, the *triratna*, the battlement motif, the lotus, serpents, and real and mythical animals, are prominent. The swastika which is basically absent in early Buddhist contexts appears once again.

The caves of Western India are rock-cut Buddhist *chaityas* and *viharas* excavated in the hills along the coast. These caves are numerous (over one thousand), and were excavated over a long period of time. Of the early Hinayana phase (c. 22 B.C.-A.D. 200) the most interesting caves may be considered those at Bhaja, Pitalkhora, Kondane, Nasik, Bedsa, Karla, Kanheri, and Ajanta (Caves 9 and 10). These caves may be attributed very approximately to a period between 150 B.C. and the Christian Era,[117] with the exception of Kanheri which belongs to the late first or early second century A.D.[118]

The *chaitya* is a Buddhist temple which in design approximates a Christian church, consisting of a nave, apse and aisles. The object of worship, a stupa, is placed in the apse. This similarity does not necessarily suggest a connection and may be attributed to the similar intentions of both structures.[119]

The *vihara* is a monastery which provided accommodation for monks and consisted of a verandah and a central hall surrounded by cells. Certain details of the early rock-cut *chaityas* and *viharas* suggest that they were copied from structural prototypes in wood. For example, an inward stoop of pillars apparently was

[114] Cf. Fergusson, *History of Indian and Eastern Architecture*, 1919, v. II, p. 16.
[115] Coomaraswamy, op. cit., pl. xxxiii.
[116] Kramrisch op. cit., p. 34.
[117] Rowland, op. cit., p. 70, attributes the Bhaja *chaitya* to the early second century B.C.; Smith op. cit., p. 27, also specifies the second century B.C. for this cave.
[118] Smith, Ibid., p. 27, places Karla and Kanheri in the second century A.D.
[119] Rowland, op. cit., p. 70, comments in this connection: "Although this arrangement does suggest the plan of a typical Classic or Early Christian Basilica, the resemblance is no more than accidental. . . ."

imitated from timber constructions and joints and fastenings seem to be derived from carpentry rather than from masonry. In fact, in some instances, wooden constructions were added to the rock-cut caves.

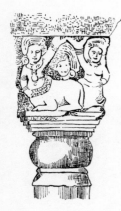

Fig. 279

Turning our attention to the sculptured elements in the various caves noted above, most of the interesting early material comes from the Bhaja *vihara* and from Pitalkhora. The Bhaja complex consisted of a large *vihara*, a large *chaitya*, and a group of fourteen monolithic stupas. Reliefs in the *vihara* are generally identified as Surya in his chariot and as Indra on an elephant.[120] The pillars and pilasters of the Bhaja *vihara* and in the cave temples in general are particularly interesting. The surmounting campaniform pot capitals or *amalaka* capitals and the crowning animal or composite figures are imaginative and supersede earlier Occidental forms in variety. Figure 279 from the Bhaja *vihara* depicts a pot capital surmounted by bovine bodies with human female busts.

Recent comprehensive archaeological clearing at the Pitalkhora caves[121] has yielded a number of outstanding early sculptures attributed to the period just around the Christian Era,[122] which makes a substantial general contribution to the history of art in Western India and are also relevant to the study of this art in relationship with Western traditions. The repertoire of the Pitalkhora sculptures comprehends influences from or some connection with Amaravati, as seen for example in the narrow wings of addorsed creatures. At the same time the Pitalkhora style and motifs are reminiscent of Bharhut and Sanchi. Thus it is not clear whether the Western caves were influenced by the contemporary Bharhut and Sanchi schools, or conversely were a source of inspiration to both Sanchi and Amaravati. In either case, these sculptures are a testimony to a general interrelationship between the various schools of early Indian sculpture, and the Pitalkhora motifs, on the whole, are familiar and similar to these encountered at other sites.

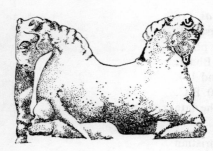

Fig. 280

Among the Pitalkhora sculptures, attention may be drawn to the treatment in one instance of addorsed horses appearing on a pilaster which was found in the debris in front of Cave 4 (the *vihara*). This pilaster, reproduced in figure 280, shows the animals joined back to back in a manner which approximates that of Persepolitan capitals. Indian capitals of addorsed creatures are usually shown with one animal in front of the other, as in plate 61, also from Pitalkhora. However, a Bodhgaya relief, illustrating a *dharmachakra* supported by a pair of addorsed creatures is, as can be seen in figure 281, similar to the Pitalkhora pilaster. Here, again the animals are depicted back to back and in profile in the Achaemenid fashion.

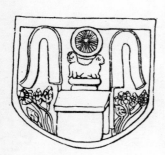

Fig. 281

Although the Pitalkhora repertoire perhaps reveals a closer affinity to Persian art than that of other cave temples, this affinity is only tentative. It may be manifest in the pilaster described above or in the questionably "foreign" appearance of the winged creatures. As in the other caves relatively little figural sculpture has come to light, less material offers itself for comparison with Occidental forms. But even at Pitalkhora, the overall tone is equivalent to that met with at Bharhut, Sanchi, or Amaravati and traditional motifs and symbols like elephants, yakshas, the lotus, pyramidal merlons, etc., are dominant. Even the pilaster depicting addorsed horses is, as just noted, comparable to the Bodhgaya plaque seen in figure 281 and there is no clear evidence relating it directly to Persian antecedents.

[120] In this connection cf. Das Gupta, "Early Terracottas from Chandraketugarh," *Lalit Kala*, VI, 1959, p. 46. Das Gupta draws attention to a terracotta of a Surya-like figure trampling on a giant, depicted on a toy cart, which recalls the Bhaja relief.

[121] Deshpande, "The Rock Cut Caves of Pitalkhora in the Deccan," *Ancient India*, XV, 1959.

[122] Ibid., p. 70.

The origin of addorsed animal forms and their probable connection with proto-historic prototypes have been considered above in the discussion of the Maurya *stambhas*. Similarly, the winged creatures at Pitalkhora do not suggest a closer connection with Western forms than their numerous counterparts at Sanchi and elsewhere, analyzed in the preceding sections. More specifically, there is no unmistakable evidence of Occidental influence at Pitalkhora. The absence of evidence of any original Westernized artistic activity on the part of the early Yavana communities in North-West India makes it difficult to propose that these communities in the pre-Christian centuries provided prototypes for Indian sculptures. Even at Taxila, which has been extensively excavated, there is no real evidence of Hellenistic impact upon the development of Indian art before the Christian Era. Rather, as suggested by the Besnagar pillar, the Yavana community adopted Indian traditions. This pillar, originally crowned by a Garuda, was erected c. 100-90 B.C. at the command of Heliodorus,[123] a Greek devotee of Vishnu.

Thus the early Pitalkhora sculptures cannot be said to reveal any new connection with Persian or Hellenistic traditions.

Fig. 282

The remaining Western caves offer still less specific evidence of a direct relationship with Occidental art in the pre-Christian period. However, the pillar capitals in the rock-cut *chaityas* and *viharas* in general, for example, as illustrated in plates 61 to 64 and figure 279 from Bhaja, Karla, Pitalkhora, Nasik, and Bedsa, are of interest and show a great deal of imagination. On the whole these pillars, progressively more and more removed from Persian forms, suggest an independence of Western traditions except possibly in the common concept of an animal-crowned or campaniform capital. This has been discussed above in detail when dealing with Asokan *stambhas*. Campaniform or lotus capitals as well as pot shaped capitals are common in the cave temples and do not seem to be influenced by Western prototypes. Rather, they apparently are the product of indigenous conventions which were originally shared with Western Asia.

In this connection, attention may be drawn to a third form of capital, the *amalaka*, as seen for example in our plate 62 from Nasik, and figures 282 and 283 from Bhaja and Kanheri respectively. Percy Brown discusses this form. He suggests that the *amalaka* shape is derived not from the melon-shaped fruit as popularly believed, but is of remote origin and associated with the ringstone.[124] He adds that this form is usually represented enshrined in a casket. Our figure 284 reproduces Brown's plate IX which shows the development of this form. Plates 63 and 64 illustrate further examples of the encased *amalaka* as an architectural member

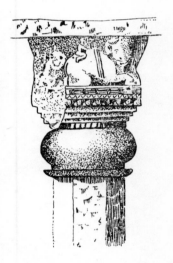

Fig. 283

in the Western caves. It is very interesting to note that a somewhat similarly shaped capital, as illustrated in plate 65, was used at Knossos. Although there is no evidence to suggest a connection between the Minoan capitals and those of India, their similarity is notable. It is also possible that the *amalaka* shape incorporated some baetylic significance, as it recurs in other contexts. For example, it is seen in the thrones in Persepolitan reliefs, as depicted in plate 66.

On the whole, it may be concluded that Indian rock-cut caves do not appear to show a greater affinity with West Asiatic or Hellenistic forms than the art of the Bharhut and Sanchi stupas. There does not seem to be

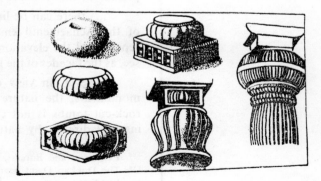

Fig. 284

[123] Cf. Jairazbhoy, *Foreign Influence in Ancient India*, 1963, pp. 56-57.
[124] Brown, *Indian Architecture*, 1942, I, pp. 13-14.

sufficient evidence to support the view expressed by Fergusson and Burgess that whereas Bharhut arose and developed without foreign influence, as regards the Bhaja sculptures, "it seems difficult to refuse to believe that it is not due to some Bactrian or foreign influence that they owe their most striking peculiarities."[125] Reference is made to the figure of a spear bearer of a foreign type and to bell shaped "quasi Persepolitan" capitals. The fact that representations of foreigners occur in Indian sculpture has already been mentioned. Foreigners were part of the Indian scene. As regards the campaniform or lotus capital and its probable origins, a detailed discussion has been given in Chapter IV, pages 82 to 87.

The rock-cut caves of Orissa and Western India, though expressive of distinctive styles, are broadly speaking the product of the same heritage as the stupas of Bharhut and Sanchi. In addition to a common background, cultural intercourse further contributed toward bringing these schools closer together. As in the Bharhut-Sanchi tradition, in the cave sculpture elements occur which are comparable to forms in West Asian art. Most outstanding are the mythical creatures and pillar capitals. However, there is no evidence which might indicate a special connection between these sculptures and Persian or Hellenistic art. Rather, the material in the cave temples seem to supplement the views expressed earlier. In short, it appears as if the sources of both Indian and Occidental traditions were originally shared or diffused before the Maurya period, but that no further foreign influence materially affected the course of early Indian forms. The diversified pillar capitals in the Western caves seem even more remote from Persepolitan prototypes than those of Bharhut and Sanchi.

Before concluding this survey of the cave temples, it remains to consider the question of the origin of rock-cut architecture and sculpture. Indian excavations in rock were preceded in Iran by Median rock-cut tombs[126] and by the tombs of the Achaemenian kings at Naqsh-i-Rustam. The Indian cave temples, however, apart from the fact that they were also carved in living rock, are dissimilar from the simpler Iranian tombs in style and in function.[127] Although the Asokan edicts captured something of the personal air of heraldry expressed in Darius' inscriptions as at Naqsh-i-Rustam,[128] and although the imposing character of the Asokan monoliths may have been inspired in Achaemenian precedent, no real parallels are evident between the Iranian rock-cut tombs, and the later Indian excavations. At the same time, there is no basis for denying that the Persian tombs may have exerted some influence upon Indian architecture and sculpture, particularly since the earliest excavations in the Barabar hills are attributed to the Maurya period. In this connection, Rowland writes:

"... there can be little doubt of the influence of such prototypes as the tombs of the Achaemenid emperors at Naqsh-i-Rustam, in which the carved façade represented the elevation of a palace at Persepolis in much the same way, we shall see, as the façades of the Indian *chaitya*-halls reproduced those of actual buildings."[129]

However, in view of the dissimilarity between Indian and Iranian rock-cut monuments, the nature of the debt of the early Indian cave temples to Persian rock-cut tombs is not clear, and it remains probable that the Indian caves were inspired directly by natural caverns. A relevant comparison is made by Zimmer

[125] Fergusson and Burgess, *Cave Temples of India*, 1880, p. 522.
[126] The Dukkan Daud near Sar-i-pul in the Western foothills of the Zagros and other tombs in Kurdistan.
[127] Cf. Herzfeld, *Iran in the Ancient East*, 1941, pls. xxxvii and xxxviii.
[128] Ghrishman, *Iran*, 1954, pp. 152-53.
[129] Rowland, op. cit., p. 69.

between a Toda hut and the *chaitya.* Zimmer writes: "Text plate A 3 shows a Toda hut which was the ultimate primitive source of the multifariously echoed motif of the *chaitya* entrance."[130]

In an article dealing with this question, Muriel Neff has attributed the origin and development of cave temples to indigenous psychological, philosophical, and physical factors. She writes: "However for all the reasons above, it seems unnecessary to trace the origin of the rock-cut temple to Persia, where in any case, not temples but tombs and monuments were hewn out for the Achaemenids."[131]

The monuments which have been evaluated in this chapter are seen to belong to a coherent tradition with diverse manifestations. This tradition also embraced a number of smaller works of art. The evaluation of these works and questions of their chronology is outside the sphere of this study. However, it may be indicated that this material, on the whole, is absorbed in the main stream of the Bharhut-Sanchi tradition. At the same time, many of these minor works reveal a notable affinity with still earlier Indian (or Occidental) art. For example, we have commented above upon the permanent characteristics like jewellery or nudity of terracotta figurines. Even terracottas which have been discovered in Indo-Greek contexts—described as the Sar Dheri type—are strikingly ancient in conception.[132] Figure 285 illustrates a female figurine from the Indo-Greek stratum at Sar Dheri which has a plant issuing from its womb. This symbolism has been seen in a Mohenjo-daro seal (figure 115) and is comparable with the Bharhut and Sanchi reliefs depicting vegetation issuing from the navel as seen, for example, in plates 33 to 35. The nudity and rosette headdress of the Sar Dheri types may also be compared with proto-historic Indian examples illustrated in figures 144 and 145. On the other hand, an interesting comparison may be made between figure 285 and an idol from Turang Tepe attributed to the third or early second millennium B.C. and shown in figure 286.

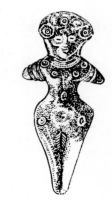

Fig. 285

Terracottas in general and mother goddess types in particular are essentially popular in spirit and thus may be considered representative of cults and traditions which remained uninfluenced by the impact of Hellenistic culture. Nevertheless, now and again terracotta figurines reveal a familiarity with a foreign form or style. For example, Das Gupta draws attention to figures which suggest contact with Hellenistic works as seen in their garments or headdresses.[133]

A unique link with Harappan art and symbolism is provided by the Gudimallam Sivalinga illustrated in plate 67. This *linga* has been attributed to about the second century B.C. by Sivaramamurti.[134] Our interest in this image of Siva emerging in relief from a naturalistic linga lies in its obvious relationship to Indus Valley phallic symbols.

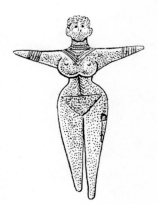

Fig. 286

There is no clear break between Indian artistic achievement towards the close of the pre-Christian Era and later movements. However, in a sense, this period represents the end of the first epoch of historic Indian art.

[130] Zimmer, op. cit., p. 247.
[131] Muriel Neff, "The Origins of Indian Cave Temples," *Oriental Art*, IV, 1958, p. 26.
[132] Cf. Gordon, "Early Indian Terracottas," *Journal of the Indian Society of Oriental Art*, XI, 1943, p. 147. Gordon states that the Sar Dheri type figurines discovered in North-Western India are not earlier than 200 B.C.
[133] Das Gupta, "Early Terracottas from Chandraketugarh," *Lalit Kala*, VI, 1959, pl. xiii, fig. 1 and fig. 4, p. 46.
[134] Sivaramamurti, *Indian Sculpture*, p. 96, fig. 6.

Conclusion

In this work we have traced prominent and enduring art motifs and symbols in Indian and West Asian repertoires from proto-historic times until the close of the pre-Christian Era. Among these recurrent and enduring forms, elements like the swastika, rosette, mother goddess figures, and composite animals are outstanding. We have also evaluated the implications which might be derived from the recurrence of these motifs, bearing in mind that art is a penetrating representation of a culture's pulse. The contacts or isolation of a community may be recorded in artistic traditions. Similarly, through art a culture is revealed to be young, or mature, or on the decline. Cultural decline may be related to decadence in art which is well analysed by Coomaraswamy as apathy independent of technical achievement. He suggests that primitive art shows an awkward underdeveloped consciousness and progress is the development of consciousness. When this development ceases, indifference and decadence set in.[1]

The foregoing chapters have shown, through art, what India's relationship with civilizations of Iran and Western Asia has been over the centuries. More specifically, repeated examples have illustrated that India and the West inherited a common ancient artistic tradition manifest in ceramics, seals, terracottas, and sculpture. This ancient tradtion or substratum is ultimately referrable to proto-historic times and has been built up by a process of continuing cultural diffusion achieved by contact from community to community, by infiltrations and migrations, by trade, and perhaps through still other means. In any given period, elements with foreign affinities, which do not revert directly to a preceding or contemporary influence, but are of more ancient provenance, can be considered products of cultural diffusion. And, in effect, it has been seen that a majority of those motifs in Indian art which are comparable with motifs in Occidental traditions are not direct borrowings but are rather of an ancient and common origin. In Harappan traditions and even earlier, such forms have been seen in most cases to be assimilated rather than superimposed. Thus, themes like the rosette have been traditional in Indian as well as in Western art for thousands of years and have endured and are vital even in modern times.

[1] Coomaraswamy, *Introduction to Indian and Indonesian Art*, 1923, p. 2.

This study concludes approximately with the close of the pre-Christian Era. In Indian art, we have seen that, notwithstanding an inevitable overlap, some demarcation can be made between the traditions which flourished in the last centuries B.C. and the subsequent schools. Similarly, in the West, Christianity and the rise of the Roman Empire may be viewed as initiating a new era. However, as regards the survival of art symbols and traditions, there is no real hiatus between the pre-Christian and post-Christian centuries, or for that matter, even between Western and Eastern cultures.

Thus, it would be an extremely interesting and valuable, although perhaps difficult and prolonged task, to follow the course of the motifs and symbols studied here upto the present time. Further study might reveal, as yet unappreciated links between different traditions of the world. At present, we may only note that even today the cult of the mother goddess or symbols like the rosette, the swastika, or even conventions in abstraction and stylization, pervade both Eastern and Western traditions at sophisticated as well as at elemental levels. These artistic symbols are some of the most ancient and yet most enduring and widespread expressions of man's esthetic and spiritual heritage.

Appendices

APPENDIX A

Chronological Notes—India

1. AMRI

No absolute chronology has been established for Amri-Nal sites. Carbon remains at Amri were mixed with roots and thus could not be reliably dated by radio-carbon.[1] A relative chronology has been established by comparison of the Amri ceramics with those of other complexes. Casal has suggested the following dates and correlations for Amri:[2]

Period I: A—D

The beginning of Period I is tentatively considered contemporary with Jamdat Nasr and attributed to the early 3rd Millennium B.C.

Period I-D perhaps corresponds with the foundation of Mohenjo-daro.

Period II:

 A. Abandon
 B. Infiltration of Harappan elements

Period III:

 A. Harappan
 B. Transition
 C. Late Mohenjo-daro
 D. Jhukar

Period IV:

 Jhangar

[1] Casal, *Fouiles d'Amri*, 1964, p. 53.
[2] Ibid., p. 21, fig. A.

Periods I and II at Amri are approximately contemporary with Kot Diji[3] for which the following Carbon 14 dates have been given:[4]

Early Level	—	2605	±	145	B.C.
Middle Level	—	2335	±	155	B.C. and
		2255	±	140	B.C.
Late Level	—	2090	±	140	B.C.

2. QUETTA SITES

The following Carbon 14 dates have been given for samples from the site of Damb Sadaat:[5]

Damb Sadaat I	2400	±	1900	B.C.
Damb Sadaat II	2250	±	1850	B.C.
Damb Sadaat III	2450	±	1650	B.C.

Fairservis correlates Damb Sadaat I with Amri and Damb Sadaat II with the Harappan Civilization. B. B. Lal notes the following Carbon 14 dates for the same site:[6]

Damb Sadaat I	2325	±	360	B.C.

This period features Kechi Beg Ware prevalent at Kili Ghul Mohammad:

Damb Sadaat II:	Four samples dated:			
	2220	±	410	B.C.
	2220	±	360	B.C.
	2560	±	200	B.C.
This Period features Quetta Ware.	2220	±	75	B.C.

In the same article the following Carbon 14 dates are mentioned for Kili Ghul Mohammad:

Period I	pre-pottery	3690	±	85	B.C.
	and	3510	±	515	B.C.
Period II	handmade ware				
Period III	wheel-made black or red ware and copper				
Period IV	ceramic industries—especially Kechi Beg Ware				

Lal suggests that the transition from Period II to Period III might imply foreign infiltration.

Beatrice de Cardi[7] notes a Carbon 14 date of 3500-3100 B.C. for the earliest pre-pottery period at Kili Ghul Mohammad.

3. KULLI SITES

B. B. Lal[8] notes the following Carbon 14 date for a sample from Niai Buthi in West Pakistan associated with Kulli pottery: 1900 ± 65 B.C.

[3] Ibid., p. 55.

[4] Lal, "A picture emerges—an assessment of the Carbon-14 datings of the protohistoric cultures of the Indo-Pakistan Subcontinent," *Ancient India*, XVIII-XIX, 1962-63, p. 211.

[5] Fairservis, *Excavations in the Quetta Valley, West Pakistan*, 1956, p. 356.

[6] Lal, op. cit., p. 211.

[7] de Cardi, "British Expeditions to Kalat, 1948 and 1957." *Pakistan Archaeology*, No. 1, 1964, p. 22.

[8] Lal, op. cit., p. 212.

4. ZHOB SITES

The chronology for the Zhob cultures can be approximately estimated from the following table adapted from Fairservis[9] which correlated the stratigraphy of Damb Sadaat and Kili Ghul Mohammad in the Quetta Valley with Zhob sites.

Quetta Valley	Rana Ghundai	Sur Jangal	Dabar-Kot	Periano Ghundai
	Rana Ghundai IV		Ghul ? Jhukar ? Harappan Occupation	Incinerary Pot
Damb Sadaat III* (c. 2450-1650 B.C.)	Rana Ghundai IIIc Rana Ghundai IIIb		Zhob Cult	Zhob Cult
Damb Sadaat II (c. 2250-1850 B.C.)	Rana Ghundai IIIa	Sur Jangal III		
Damb Sadaat I (c. 2400-1900 B.C.)	Rana Ghundai II	Sur Jangal II	Prehistoric cultures of Group I	Prehistoric cultures
Kili Ghul Mohammad IV Kili Ghul Mohammad III	Rana Ghundai Ib	Sur Jangal I Virgin soil		
Kili Ghul Mohammad II Kili Ghul Mohammad I (c. 3690-3000 B. C.) ± 515	Rana Ghundai Ia ?			

*These dates are noted above in the sections on the sites mentioned.

CHAPTER II

THE INDUS VALLEY CIVILIZATION IN THE PUNJAB AND SIND

The approximate dates of Harappa and Mohenjo-daro have been calculated from a number of seals of Harappan style or Harappan provenance which were discovered at various dated Mesopotamian sites. Wheeler,[10] assessing the seals reported by Gadd and others[11] from Ur, Kish, Susa, Lagash, Umma, and Tell Asmar, notes that only twelve of about thirty examples were found in chronological contexts. Of these twelve, Wheeler states that seven may be Sargonid, one may be pre-Sargonid, and four Larsa or later. Thus these seals can be attributed to a period between 2500 and 1500 B.C. with a focus on 2350 B.C.

The levels recorded by Marshall, Vats and Mackay in their excavation reports do not follow a scientific system of stratigraphy. However, following are the levels and proposed dates for Mohenjo-daro and Harappa.

A. MOHENJO-DARO[12]

Late (Uppermost) Period c. 2500 B.C.

Phase Ia 3.2 feet below datum level (i.e. door sills and pavement)
Phase IIb 5 feet ,, ,, ,,
Phase II 7 feet ,, ,, ,,
Phase III 9.9 feet ,, ,, ,, Second flood

[9] Fairservis, *Archaeological Surveys in the Zhob and Loralai Districts, West Pakistan*, 1959, Table 7, p. 363.
[10] Wheeler, *The Indus Civilization*, 1960, pp. 90-93.
[11] Gadd, "Seals of Ancient Indian Style Found at Ur," *Proceedings of the British Academy*, XVIII, 1932; Frankfort, *Cylinder Seals*, 1939, p. 305.
[12] Mackay, *Further Excavations at Mohenjo-daro*, 1938, Introduction, p. xiv.

Intermediate Period

Phase I	13 feet	below datum level
Phase II	15.9 feet	,, ,, ,,
Phase III	20.4 feet	,, ,, ,, First flood

Early Period c. 2800 B.C.

Phase I	Average probably 24 feet below datum level
Phase II	Not ascertained
Phase III	Not ascertained

B. HARAPPA[13]

Location	Period		Strata	Date
Mound F	Late	I	III	c. 2750-3050 B.C.
	,,	II		
	,,	III		
	Intermediate	I		
	,,	II		
	,,	III	IV-VII*	c. 3050-3500 B.C.
	,,	IV		
	Early	I	VIII	First half of fourth millennium B.C.
Mound A, B	Late	I ⎫		
	,,	II ⎬	I-IV	Contemporary with Late Period Mound F (i.e. 2750-3050 B.C.)
	,,	III ⎭		
	,,	IV		
	Intermediate	I	V-VI	Before c. 3050 B.C.
	,,	II		
Area J	Late	I	I-II	c. 2850-3050 B.C.
	,,	II		
	Intermediate	I	III-IV	Before c. 3050 B.C.
	,,	II		
Area G	Late	I ⎫	I-II	c. 2700-2800 B.C.
	,,	II ⎬		
	Intermediate	I	III	c. 3250 B.C.
Cemetery H	Late	I ⎫	I-II	c. 2000-2500 B.C.
	,,	II ⎬		

*At mound F from the fourth stratum down tiny seals and sealings were found.

Fairservis notes that recent Carbon 14 dates suggest that the beginnings of Harappan Civilization are nearer to 2200 B.C. than 2500 B.C. and that its survival, estimated to be until 150 B.C., perhaps was until 1300 B.C.[14] He writes:

[13] Vats, *Excavations at Harappa*, 1940, pp. 9-10.
[14] Fairservis, *Excavations in the Quetta Valley, West Pakistan*, 1956, p. 357.

"If these dates are reliable the long existence of the Harappan civilization as indicated by the archaeological evidence may force us to consider a later date than the middle of the second millennium for the collapse of this civilization."

B. B. Lal reports a Carbon 14 date of 1760 ± 115 B.C. for a sample from a late level at Mohenjo-daro.[15] He also notes the following Carbon 14 dates for samples from the pre-Harappan site of Kalibangan:[16]

Late Level of Harappan Culture: 2095 ± 115 B.C.
Late Level of Harappan Culture: 2045 ± 75 B.C.

The Carbon 14 datings have been subject however to diverse interpretations, suggestive of both long and shorter durations for the Indus Valley Civilization. Reference may be made to the following:

D. P. Agrawal, "Harappa. New Evidence for a Shorter Chronology," *Science*, 143, Jan.-March, 1964, pp. 950-951.

(Agrawal suggests a total span from 2300 to 1750 B.C. for the Harappan Civilization).

R. E. M. Wheeler, *Civilizations of the Indus Valley and Beyond*, 1966, pp. 68-72.

(Wheeler refers to evidence pointing toward a very early date for the foundation of Mohenjo-daro, the earliest levels of which are unaccessible).

CHAPTER III

1. CEMETERY H AND JHUKAR

The chronology for the above cultures hinges upon the terminal date of the preceding Harappan settlements. There are no precise dates established as yet for Cemetery H and Jhukar settlements, but as they are post-Harappan[17] they may be approximately referred to the mid-second millennium B.C.

2. SHAHI TUMP

The Shahi Tump Cemetery post-dates the Kulli settlement at the same site. As there is evidence that the Kulli and Harappan cultures were in contact and hence coeval at some stage, the Shahi Tump Cemetery is also later than some phase of Harappa.[18]

3. LOTHAL AND RANGPUR

Chronological information on Lothal and Rangpur may be summed up as follows:

A. LOTHAL[19]

Cultural Period	Structural Phase	Carbon 14 *Dates of Samples*[20]
A—2400-1850 B.C.	I	
	II	
	III c. 2000 B.C.	2000 ± 115 B.C.
		1995 ± 125 B.C.
	Flood	2010 ± 115 B.C.

[15] Lal, op. cit., p. 214; cf. "The Chronology of the Harappan Civilization and the Aryan Invasion," *Man*, 1956.

[16] Ibid., p. 212.

[17] Cf. Chapter III, Part 2.

[18] Piggott, *Prehistoric India*, 1952, p. 215.

[19] Rao, "Further Excavations at Lothal," *Lalit Kala*, XI, 1962, pp. 14-17.

[20] Lal, op. cit., p. 213.

B—1850-1700 B.C. IV c. 1900 B.C. 1900 ± 115 B.C.

Flood

V 1865 ± 110 B.C.
 1810 ± 140 B.C.

B. RANGPUR[21]

Period	Date	Culture
I	3000 B.C.	Pre-Pottery Microlithic
II A	2000-1500 B.C.	Harappa Culture
II B	1500-1100 B.C.	Late Harappa Culture
II C	1100-1000 B.C.	Transitional Phase
III	1000- 800 B.C.	Lustrous Red Ware and Black and Red Ware

4. COPPER HOARDS

There are no Carbon 14 dates as yet available for the Copper Hoards. A fragmentary figure, possibly anthropomorphic, has been found in the late levels of Phase IV at Lothal and tentatively suggests that the Copper Hoard Culture was in existence in the 19th century B.C.[22]

5. PAINTED GREY WARE SITES

The following table given by B. B. Lal[23] contains chronological data on Painted Grey Ware and Northern Black Polished Ware sites:

Dates		Hastinapura	Ahichhatra	Kausambi	Taxila	Kotla-Nihang
A.D.	1600					
	1400					
	1200	Period V				
	1000		Str. I			
	800					
	600	Break	Str. II			
	400		Str. III	Gupta	Sirsukh	
	200		Str. IV	Kushana		
	0	Period IV	Str. V			
B.C.	200		Str. VI	Mitra	Sirkap	
		Break	Str. VII			
	400	Period III	Str. VIII	N.B.P.	Bhir Mound	
		N.B.P.	Str. IX			
	600	Break	?	Pre N.B.P.		?
	800	?				
	1000	Period II	P.G.			
		P.G.	?	Natural Soil		P.G.
	1200	Break				?
			Natural Soil			Break
	1400	Period I				?
	1600	Natural Soil				Harappa

[21] Rao, S. R. and Others. "Excavations at Rangpur and other Explorations in Gujarat," *Ancient India*, XVIII-XIX, 1962-63.
[22] Lal, "A Picture emerges. An assessment of the Carbon-14 datings of the protohistoric cultures of the Indo-Pakistan Subcontinent," *Ancient India*, XVIII-XIX, 1962-63, p. 220.
[23] Lal, "Excavations at Hastinapura and Other Explorations in the Upper Ganga and Sutlej Basins, 1950-52," *Ancient India*, X-XI, 1954-55, p. 24, fig. 3.

B. B. Lal[24] notes the following Carbon 14 dates from the Upper Painted Grey Ware levels at Hastinapura: 505 to 130 B.C. to 325 to 115 B.C.

This date lowers by several centuries the dates suggested in the above table and upholds Wheeler's proposed chronology. Wheeler dates Painted Grey Ware from the 8th to the 5th century B.C. and the Northern Black Polished Ware to about the 5th century B.C.[25] However, Lal notes that the Hastinapura samples dated above were mixed with rootlets.

Y. D. Sharma notes the following sequence for the site of Rupar where occupations have been traced from Harappan to recent times:[26]

I	c. 2000-1400 B.C.	Harappan—also late Harappan and degenerate Harappan.
	—Gap—	
II	c. 1000-700 B.C.	Painted Grey Ware
	c. 700 B.C. Site abandoned	
III	c. 600-200 B.C.	Northern Black Polished Ware, coarse grey pottery and plain red ware.
IV	c. 200 B.C.-600 A.D.	Sunga, Kushana, Gupta, etc.
V	c. 800-1000 A.D.	
VI	c. 1300-1700 A.D.	

6. CENTRAL INDIAN CHALOLITHIC CULTURES

AHAR: The following Carbon 14 dates have been published for Ahar:[27]

Middle level of Sub Period I A	1725 ± 140 B.C.
	1310 ± 115 B.C.
Middle level of Sub Period IC	1550 ± 110 B.C.
	1275 ± 110 B.C.

MAHESHWAR AND NAVDATOLI: The following chronological sequence has been given by the excavators of Maheshwar and Navdatoli.[28]

Period	I	Prehistoric	Early Stone Age
Period	II	Pre-historic	Middle Stone Age
Period	III	Proto-historic	1st half of 1st millennium B.C.
Period	IV	Early Historic I	400-100 B.C.
Period	V	Early Historic II	100 B.C.-A.D. 100
Period	VI	Early Historic III	100 A.D.-500 A.D.
Period	VII	Muslim Maratha	

The pottery types noted in the above periods are as follows:

In Period III: A. Painted Red Ware—the so-called Malwa or NVT Painted Red Ware and the Jorwe-Nevasa Painted Red Ware
B. Painted Black and Red Ware
C. White Slipped Painted Ware
D. Greyish Black Ware } in small numbers
E. Very Coarse Red and Black Ware
F. Incised Ware
G. Tan Ware—2 sherds

[24] Lal, "A picture emerges—An assessment of the Carbon-14 datings of the protohistoric cultures of the Indo-Pakistan Subcontinent," *Ancient India*, XIX, 1962-63, p. 221.

[25] Wheeler, *Early India and Pakistan*, 1959, p. 28.

[26] Sharma, "Exploration of Historical Sites," *Ancient India*, IX, 1953, p. 124.

[27] Lal, "A picture emerges—An assessment of the Carbon-14 datings of the protohistoric cultures of the Indo-Pakistan Subcontinent," *Ancient India*, XIX, 1962-63, p. 214.

[28] Sankalia, Subbarao and Deo, *The Excavations at Maheshwar and Navdatoli, 1952-53*, 1958, pp. 19-23.

In Period IV:

A Coarse Red Ware—abundant
B Slipped Burnished Red Ware
C Black and Red Ware
D Northern Black Polish Ware—rare

B. B. Lal lists Carbon 14 dates for the following phases of the Chalcolithic Period at Navdatoli:[29]

Early Level of Phase	I	1645 ± 130 B C.
,, ,, ,,	I	1610 ± 70 B.C.
,, ,, ,,	I	1610 ± 130 B.C.
Late ,, ,, ,,	I	1530 ± 110 B.C.
Middle ,, ,, ,,	II	2300 ± 70 B.C.
Late ,, ,, ,,	II	1660 ± 130 B.C.
,, ,, ,,	III	1600 ± 130 B.C.
,, ,, ,,	IV	1440 ± 130 B.C.

NASIK AND JORWE: H. D. Sankalia and S. B. Deo give the following sequence for Nasik.[30] Jorwe is contemporary at least with Nasik I. In other words it has been provisionally attributed to the Copper or Early Bronze Age and antedates the early Historic Period.

Date	Period	Finds
—	Early Stone Age	—
500 B.C.-1000 or 1500 B.C.	I Chalcolithic or Early Bronze Age	Microliths & Orange Coloured Pottery
200 B.C.-300 or 400 B.C.	II A. Early Historic overlap	Red Ware—main utilitarian ware
50 A.D.-200 B.C.	II B. Early Historic—later phase overlap	Same as period II A—cast coins, etc.
50 A.D.-200 A.D.	III Roman contact	Samian Ware. Red Polished Ware
1400 A.D.-1875 A.D.	IV A. Early Muslim	
	IV B. Mughal	
	IV C. Maratha	

NEVASA: The Nevasa excavations have revealed the following sequence:[31]

Date	Period	Pottery
150,000 B.C.	I Early Paleolithic	
25,000 B.C.	II Middle Paleolithic	
1,500-1,000 B.C.	III Chalcolithic	65% of the pottery was painted Black on Red or Jorwe Ware. The remaining wares were grey ware, coarse red ware, and orange ware.
150-50 B.C.	IV Early Historic	A few Northern Black Polished Ware sherds, crisscross painted Andhra and others.
50 B.C.-200 A.D.	V Late Early Historic (Indo-Roman)	Red Polished Ware, Amphoras and Rouletted Ware.
	VI Medieval	

[29] Lal, op. cit., p. 216.
[30] Sankalia and Deo, *Report on the Excavations at Nasik and Jorwe, 1950-51*, 1955, pp. 27-29.
[31] Sankalia, Deo, Ansari, and Erhardt, *From History to Prehistory at Nevasa, 1954-56*, 1960, pp. 64-70.

B. B. Lal notes the following Carbon 14 dates for samples from the late Chalcolithic level at Nevasa:[32]

1225 ± 115 B.C.
1250 ± 125 B.C.

7. THE EARLY HISTORIC PERIOD

Indian history can be reconstructed with some continuity from about the end of the 7th century B.C. (note 33 infra).

It is known that at this time the country was divided into a number of independent states.

Magadha rose to supremacy under Ajatasatru following a victory over Kosala in the 5th century B.C. About 475 B.C., Magdha's traditional capital at Rajagriha was shifted to Pataliputra. The death of the Buddha may be noted as having occurred c. 486 B.C., though there is some doubt about the accuracy of this date. Ceylonese tradition places the Buddha's death in 544 B.C.

The Achaemenid Empire was contemporary with the period of Magadhan supremacy. Cyrus (558-530 B.C.) possibly subjected several tribes south of the Hindu Kush and Darius I who reigned between 522 and 486 B.C. is known to have annexed Indian territory.

Alexander's brief expedition into India between 327 and 325 B.C., as is known, had many repercussions. At his death, c. 323 B.C., Western Asia came under the yoke of Seleucus and his successors.

Chandragupta ascended the Magadhan throne about 322 B.C. initiating the Maurya Dynasty.

CHAPTER IV

THE MAURYA EMPIRE[33]

Highlights

c. 322 B.C. Chandragupta Maurya, guided by his Prime Minister Kautilya, uprooted the Nanda Dynasty and ascended the Magadha throne. Chandragupta previously distinguished himself by repulsing Greek attacks and gaining control of three provinces in Punjab and Sindh.

Subsequently, Chandragupta is known to have contended with Seleucus and reached a settlement favourable to Magadha.

Megasthenes, Seleucus' ambassador, lived at Chandragupta's court.

Bindusara succeeded Chandragupta and maintained diplomatic contacts with Antiochus—Seleucus' successor.

c. 273 B.C. Asoka succeeded Bindusara. He achieved the conquest of Kalinga in the ninth year of his reign after which he turned his attention to the propagation of Buddhism at home and abroad. The Asokan Empire apparently embraced most of India proper—with the exclusion of the extreme south and Assam but inclusive of Baluchistan and Afghanistan. Asoka's rule was highly centralized and his administration personal. Asoka's personality and power are reflected in the monuments he erected.

c. 250 B.C. Bactria and Parthia revolted against the Seleucids declaring independence. Unable to reassert their authority, the Seleucids were compelled to acknowledge the independence of both provinces toward the end of the 3rd century B.C.

c. 232 B.C. Asoka died and was followed by seven kings who reigned a total of about fifty years. Within several years after Asoka's death, the Maurya Empire suffered a decline. The Andhras,

[32] Lal, op. cit., p. 216.
[33] The notes for the Early Historic Period (supra), for Chapter IV, and for Chapter V are based on Majumdar's *Ancient India* and historical works noted in the Bibliography. These brief notes are very general and bypass many controversial questions which have no direct bearing upon the problems dealt with in our text. They are intended only to provide some point of departure for our evaluation of artistic traditions.

a powerful tribe who seem to have enjoyed internal autonomy under Asoka, rose and wrested the region south of the Vindhyas from Magadha. Artistic activity flourished under Andhra rule at Buddhist sites.

c. 190 B.C. The Maurya Emperor Brihadratha apparently lost a portion of his empire to the Greco-Bactrian King Demetrius.

c. 185 B.C. The weakened Maurya Empire succumbed under the stress of internal strife and pressure from the Greco-Bactrian kings. In the wake of the Mauryas, a number of minor independent states arose and flourished, though details of their history are uncertain.

CHAPTER V

POST-MAURYA KINGDOMS AND CONFLICTS

Highlights

c. 185 B.C. Pushyamitra Sunga, Brihadratha's commander-in-chief, murdered the last Maurya king and assumed the throne, initiating the Sunga dynasty which ruled for about 112 years.

Although Pushyamitra was a Hindu and is described as a persecutor of Buddhism by Buddhist tradition, Buddhist art flourished under the Sungas.

c. 120 B.C. The Scythians or Sakas invaded Bactria, which was weakened by internal dissension, and drove the Greeks into Afghanistan and Western Punjab. These rival Hellenistic dynasties held sway for about 200 years more.

from the mid 2nd century B.C. Parthians began to attack Indian territory. Later Maues established a principality in Western Punjab and another line of Parthian rulers established themselves in the Kandahar region. By the close of the first century A.D., Parthian chiefs were contesting for power in lower Sindh.

about the 2nd century B.C. Kalinga (Orissa) which had been conquered by Asoka achieved significant power following the collapse of the Maurya Empire. Under Kharavela, a devout Jaina and a great ruler, Kalinga scored victories in Magadha and Andhra. The Hatigumpha inscription records Kharavela's deeds. Some of the Jaina caves in the Khandagiri hills were excavated by this ruler, but it is not certain which ones. Kharavela's date is controversial. He has been placed as early as the second century B.C. and as late as the first century A.D. by different scholars.

c. 73 B.C. The tenth Sunga King was assassinated and was succeeded by his minister Vasudeva, founder of the Kanva dynasty. The Kanvas reigned for only forty-five years.

c. 65 B.C. The Kushanas—members of a Turkish nomadic tribe called the Yueh-chi were driven from Kan-su in North-West China by another nomadic tribe, the Hiung-nu or Huns. Forced westwards, the Kushanas fell upon the Sakas who had displaced the Bactrian Greeks. The Sakas in turn moved on to India in waves and established several principalities in the north and in Kathiawar. The Kushanas remained in Bactria, gathered strength and ultimately extended their rule into India about the Christian Era. The Kushana Empire flourished for several centuries until overthrown by the Sassanians in the third century A.D.

c. 27 B.C. ? Simuka Satavahana put an end to Kanva power. Although Simuka's date is controversial (some authorities believe him to have lived c. 220 B.C.), the Andhra empire is known to have exerted its influence over South India after the collapse of Maurya power and over Magadha and Central India as well in the first century B.C. The Satavahanas conflicted with the Saka satraps who advanced into Andhra dominions until Satakarni who ascended the Andhra throne in A.D. 106 crushed the Saka chieftains. Andhra rule came to an end in the mid-third century A.D.

APPENDIX B

Chronological Chart for Iran

(Adapted from E. Porada, *Ancient Iran*)

B.C.	South		VARIOUS SITES	North
	SUSIANA			*SOLDUZ*
	Agricultural villages, Neolithic stage			
	ALI KOSH		TEPE SARAB, HOTU CAVE	HAJJI FIRUZ TEPE (near Hasanlu)
6000				
5000	a b c d	Four phases painted pottery	TEPE SIAHBID	DALMA TEPE (near Hasanlu)
4000				
	SUSA A Painted pottery (Style I) Copper tools, stamp seals			PISDELI TEPE (near Hasanlu)
3500	**SUSA B** Potter's wheel		SIALK III, HISSAR I Painted pottery, potter's wheel, copper tools, stamp seals	
3000	**SUSA C** Urbanization, cylinder seals		SIALK IV Influence from Susa, decline of painted pottery	
	SUSA D, GIYAN IV Polychrome pottery (Style II). Elaborate tombs with chariot burials		BRONZE AGE HISSAR II Appearance of burnished grey pottery	BRONZE AGE
2500	First Dynasty of Awan			HASANLU VII Painted Orange ware

157

B.C.	South		North
	SUSIANA	*VARIOUS SITES*	*SOLDUZ*
	Akkadian suzerainty in Susa. Fall of Susa probably at hands of Guti		
		HISSAR III, TURENG TEPE Metal-work; spread of grey pottery	
2000	Third Dynasty of Ur dominates Susa. Destruction of Ur by Elamites		
	OLD ELAMITE PERIOD Elamite kings of Simash alternately warring and allied with rulers of Isin, Larsa, Eshnunna dynasties		**HASANLU VI** Painted buff pottery comparable to Chabur ware
1500	**MIDDLE ELAMITE PERIOD** Occasional Kassite incursions, Elamite expansion, Untashgal, c. 20 years ± 1265 B.C. Tchoga Zanbil	**IRON AGE**	**IRON AGE** **HASANLU V** (Button base period) contemporary with Sialk V (A); Giyan I
	Kidin-Khutran ± 1230 B.C. Shutruk-Nahunte ± 1170 B.C. Shilhak-Inshushinak ± 1160 B.C.		
1000	**NEO-ELAMITE PERIOD**		**HASANLU IV** Contemporary with Sialk VI (B); Giyan I
900			Grey ware period
800			Urartian incursions
700	Susa sacked by		Treasure of
600	Ashurbanipal, c. 640 B.C.	Scythians in Iran	**ZIWIYE** Median
500			**HASANLU III** art

APPENDIX C

Chronological Chart for Mesopotamia

(Adapted from E. Porada, *Ancient Iran*)

B.C.	South		North
6000	UBAID 1		HASSUNA PERIOD
5000	UBAID 2	Fine painted pottery, spread of villages	HALAF PERIOD
	UBAID 3		Halaf Ubaid
4000			NORTHERN UBAID
	UBAID 4		PERIOD
		Stamp seals, painted pottery, beginnings of irrigation systems, temple architecture	
	URUK PERIOD		GAWRA PERIOD
3500	Early: potter's wheel: grey, red and buff pottery Late: urbanization, writing, cylinder seals		
3000	JEMDET NASR PERIOD	Painted pottery; widespread use of cylinder and stamp seals	NINEVITE PERIOD
	FIRST EARLY DYNASTIC PERIOD, SECOND EARLY DYNASTIC PERIOD, City States, chariot burials at Kish		
	THIRD EARLY DYNASTIC PERIOD, "Royal Cemetery" of Ur		
2500	SARGONID PERIOD (c. 2370-2230). Sargon establishes empire with capital at Agade (Akkad)		

B.C.	South	North
2250	**GUTI INVASION AND GUTI RULE** (c. 2230-2120) **THIRD DYNASTY OF UR** (c. 2113-2006) Neo-Sumerian period	
2000	**DYNASTIES OF ISIN AND LARSA** (c. 2020-1794; 2025-1768) **FIRST-DYNASTY OF BABYLON** (c. 1894-1595) Hammurabi (c. 1792-1750) **KASSITE DYNASTY** (c. 1590-1150)	
1500	Interval of Elamite rule under Kidin-Khutran Second interval of Elamite rule **SECOND DYNASTY OF ISIN** Marduk-kabit-ahheshu after 1160	**MITANNIAN EMPIRE** (c. 1600-1350) **MIDDLE ASSYRIAN PERIOD** (c. 1350-800) Tukulti-Ninurta I (1244-1208)
1000		
900	Marduk-shapik-zeri (c. 1080-1068)	**NEO-ASSYRIAN PERIOD**
860		Ashurnasirpal (883-859) Tiglathpileser III (744-727) Sargon II (721-705) Sennacherib (704-681) Ashurbanipal (668-627) Fall of Assyria 612
700		
600	**NEO-BABYLON EMPIRE** (625-530)	
500		

APPENDIX D

Chronological Chart for Crete and Greece

(Adapted from R. W. Hutchinson, Prehistoric Crete and G. M. A. Richter, A Handbook of Greek Art)

B.C.	Crete	Mainland of Greece
5000	Neolithic	
3000	Post-Neolithic	Neolithic
2800		
2700		
2600		
2500	————————————	————————————
	Early Minoan I	Early Helladic I
2400	————————————	————————————
2350		
2300		
	Early Minoan II	Early Helladic II
2250		
2200		————————————
2150		
2100	————————————	Early Helladic III
2050	Early Minoan III	
2000		
1950	————————————	
1900	Middle Minoan I	————————————
1850		Middle Helladic I
	Middle Minoan II	————————————
1800		Middle Helladic II
1750	————————————	————————————

161

B.C.	*Crete*		*Mainland of Greece*
1700			
	Middle Minoan III		Middle Helladic III
1650			
1600			————————————
1550	————————————		Late Helladic I
1500	Late Minoan I		————————————
1450	————————————		
	Late Minoan II		Late Helladic II
1400	————————————		————————————
1350			
1300			
1250			
	Late Minoan III		Late Helladic III
1200			Trojan War
1100			————————————
			Sub-Mycenaean
1050	————————————		
1020			
1000	Sub-Minoan		Proto-geometric Pottery
970	————————————		
950	Early Proto-geometric		
920	————————————		
900	Middle Proto-geometric		
870	————————————		————————————
	Late Proto-geometric		
850	————————————		Geometric pottery in Attica
835	Proto-geometric 'B'		Homeric poems written ?
820	————————————		
800	Early Geometric		
	————————————		
770	Mature Geometric		First Olympiad
	————————————		
750	Late Geometric		————————————
735	————————————		Proto-Corinthian pottery
700	Early Orientalizing		Orientalizing and Archaic Periods
680	————————————	Early dedalic sculpture	

B.C.	Crete		Mainland of Greece
650	Late Orientalizing pottery	Middle Dedalic	
640			
635			
630	Archaic	Late Dedalic	
620			
600		Post-Dedalic	
500			Early Classic
400			Classic
300			Hellenistic
200			
100			

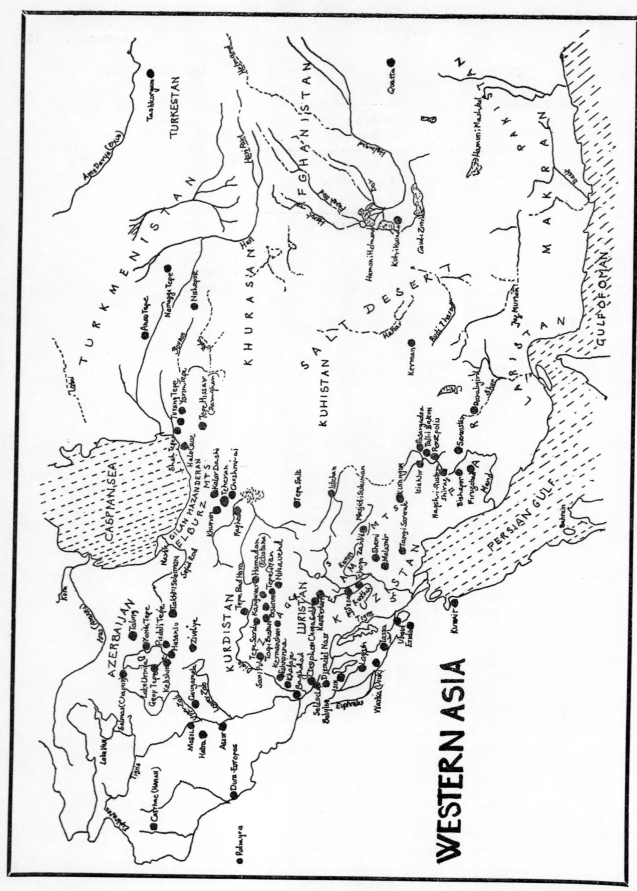

Map of Ancient Cultural Sites in Western Asia

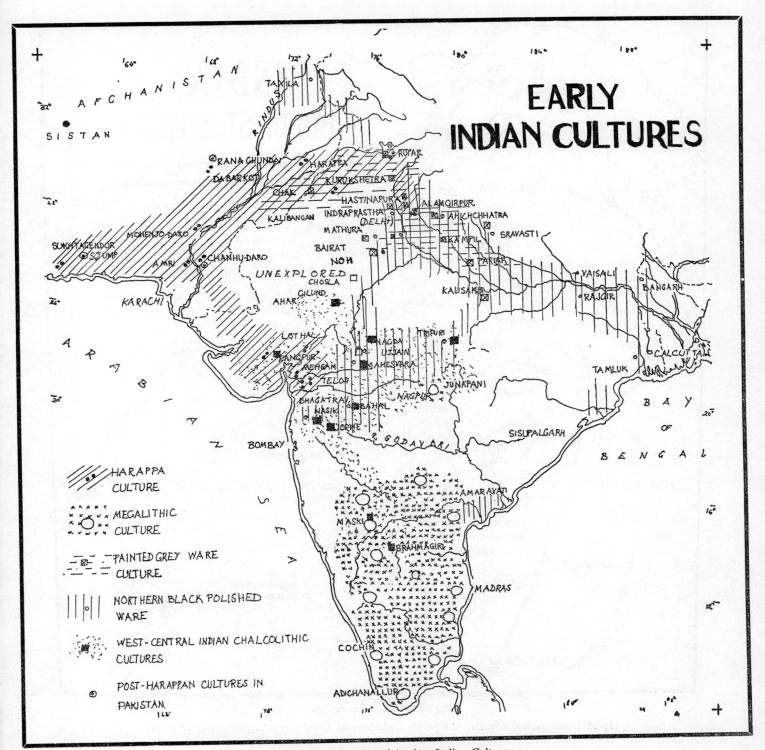

Map Showing the Sites of Ancient Indian Cultures

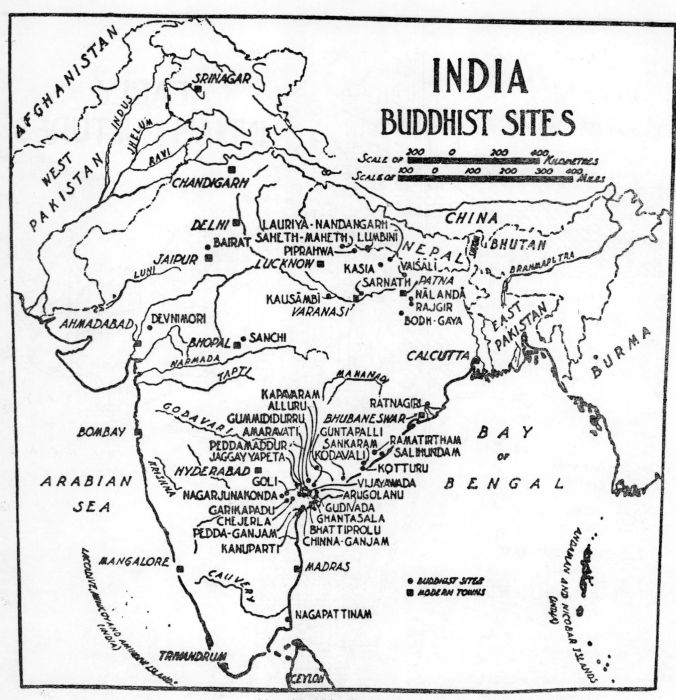

Map of Buddhist Sites in India

(From *Archaeological Remains, Monuments, and Museums,* 1964, Archaeological Survey of India)

Bibliography

A. BOOKS

AGRAWALA, V. S., *Indian Art*, Banaras, 1965.

AKURGAL, EKREM, *The Art of the Hittites*, London, 1962.

ALTEKAR, A. S. AND MISHRA VIJAYAKANTA, *Report on Kumrahar Excavations, 1951-55*, Patna, 1959.

ARCHAEOLOGICAL SURVEY OF INDIA, *Archaeological Remains, Monuments and Museums*, Delhi, 1964.

ARVAMUTHAN, T. G., *Some Survivals of the Harappa Culture*, 1942.

ASHTON, LEIGH (ed.) *Art of India and Pakistan*, London, 1948.

AUBOYER, J., *Arts et Styles de L'Inde*, Paris 1951.

———— *Le Trône et son Symbolism dans L'Inde Ancienne*, Paris, 1949.

BACHHOFER, L. *Early Indian Sculpture*, Paris, 1929.

BANERJEA, J., *Development of Hindu Iconography*, Calcutta, 1956.

BANERJEE, G. J., *Hellenism in Ancient India*, Delhi, 1961.

BANERJEE, R. D., *Prehistoric, Ancient and Hindu India*, Bombay, 1934.

BARRETT, DOUGLAS, *A Guide to the Karla Caves*, Bombay, 1957.

———— *Sculptures from Amaravati in The British Museum*, London, 1954.

BARUA, B. M., *Bharhut*, Calcutta, 1934-47.

———— *Gaya and Buddha Gaya*, Calcutta, 1934.

BASAK, RADHAGOVINDA, *Asokan Inscriptions*, Calcutta, 1959.

BASHAM, A. L., *The Wonder that was India*, London, 1954.

BEAL, S., *Buddhist Records of the Western World* (Trs. from the Chinese of Hiuen Tsiang), 1906.

BENISTI, MIREILLE, *Le Medaillon Lotiforme dans la Sculpture Indienne*, Paris, 1952.

BHANDARKAR, D. R., *Asoka*, Calcutta, 1925.

BHATTACHARYA, B., *Indian Buddhist Iconography*, Calcutta, 1958.

BIEBER, M., *The Sculpture of the Hellenistic Age*, New York, 1961.

BOARDMAN, JOHN, *The Greeks Overseas*, Harmondsworth, 1964.

BOSCH, F. D. K., *The Golden Germ*, The Hague, 1960.

BROWN, PERCY, *Indian Architecture*, Bombay, 1942.

BURGESS, J., *Buddhist Cave Temples and Their Inscriptions*, London, 1883.

———— *The Buddhist Stupas of Amaravati and Jaggayyapeta*, London, 1887.

BURGESS, J. AND FERGUSSON, J., *Cave Temples of India*, London, 1880.

BURY, J. B., *History of Greece*, London, 1952.

BURY, J. B., *The Hellenistic Age*, Cambridge, 1923.

CAPART, J., *Egyptian Art*, London, 1923.

CASAL, J. M., *Fouilles D'Amri*, Paris, 1964.

———— *Fouilles de Mundigak*, Paris, 1961 (*Mémoirs de la Délégation Archéologique Francaise en Afghanistan*, Vol. 17).

CHAKRAVARTY, S. K., *Study of Ancient Indian Numismatics*, 1931.

CHATTOPADHYAYA, SUDHAKAR, *The Sakas in India*, 1955.

CHILDE, V. G., *New Light on the Most Ancient East*, London, 1952.

CLARK, G. AND PIGGOTT, S., *Prehistoric Society*, New York, 1965.

CODRINGTON, K. B., *Ancient India*, London, 1926.

COMBAZ, GISBERT, *L'évolution du Stupa en Asie*, Brussels, 1933.

———— *L'Inde et l'Orient Classique*, Paris, 1935.

COOMARASWAMY, A. K., *Elements of Buddhist Iconography*, Cambridge, Mass., 1935.

———— *History of Indian and Indonesian Art*, London, 1927.

———— *Introduction to Indian Art*, Madras, 1923.

———— *La Sculpture de Bodhgaya*, Paris, 1935.

CUNNINGHAM, ALEXANDER, *Ancient Geography of India*, Calcutta, 1871.

———— *Bhilsa Topes or Buddhist Monuments of Central India*, London, 1854.

———— *Mahabodhi or Great Buddhist Temple at Bodhgaya*, London, 1892.

———— *Stupa of Bharhut*, London, 1879.

DALTON, C. M., *Treasure of the Oxus*, 1926.

D'ALVIELLA, COUNT G., *Ce que l'Inde doit à la Grece*, 1926.

———— *Migration of Symbols*, 1894.

DAS GUPTA, C. C., *Origin and Evolution of Indian Clay Sculpture*, Calcutta, 1961.

DICKINS, G., *Hellenistic Sculpture*, Oxford, 1920.

EDMONDS, C. D., *Greek History for Schools*, Cambridge, 1914.

EGGERMONT, P. H. L., *The Chronology of the Reign of Asoka Moriya*, Leiden, 1956.

———— *Relative Chronologies in Old World Archaeology*, Chicago, 1954 (edited by R. W. Ehrich).

EVANS, SIR ARTHUR, *The Mycenean Tree and Pillar Cults*, London, 1901.

———— *The Palace of Minos at Knossos*, London, 1921-1936.

FAIRSERVIS, W. A., *Archaeological Survey in the Zhob and Lorelai District, West Pakistan*, New York, 1959.

———— *Excavations in the Quetta Valley, West Pakistan*, New York, 1956.

———— *The Origins of Oriental Civilization*, New York, 1959.

FAUSBOLL, V. (ed.), *Jatakas* (Trs. by Rhys Davids), London, 1877-97.

FERGUSSON, JAMES, *A History of Indian and Eastern Architecture* (Revised by J. Burgess), London, 1910.

———— *Illustrations of the Rock Cut Temples of India*, London, 1845.

———— *Tree and Serpent Worship*, London, 1873.

FOUCHER, A., *The Beginnings of Buddhist Art*, Paris, 1917.

———— *On the Iconography of the Buddha's Nativity*, Delhi, 1934.

———— *La Vielle Boute de l'Inde de Bactres à Taxila*, Paris, 1942.

FRANKFORT, HENRI, *The Art and Architecture of the Ancient Orient*, Harmondsworth, 1954.

———— *The Birth of Civilization in the Near East*, London, 1951.

———— *Cylinder Seals*, London, 1939.

———— *Studies in Early Pottery of the Near East*, I, 1924; II, 1927.

FREDERIC, LOUIS, *Indian Temples and Sculpture*, London, 1959.

GARDIN, J. C., *Céramiques de Bactres*, Paris, 1957 (*Mémoirs de la Délégation Archéologique Francaise en Afghanistan*, XLV).

GANGOLY, O. C., *Indian Terracotta Art*, Calcutta, 1959.

———— *Indian Architecture*, Bombay, 1946.

GHIRSHMAN, R., *Iran*, Harmondsworth, 1954.

———— *Persia from the Origins to Alexander*, London, 1964.

GODARD, ANDRE, *The Art of Iran*, London, 1965.

GOETZ, H., *India—Five Thousand Years of Art*, London, 1959.

GORDON, D. H., *Prehistoric Background of Indian Culture*, Bombay, 1958.

GOVINDA, A. B., *Some Aspects of Stupa Symbolism*, Allahabad, 1940.

GRIFFITH, G. T., *Mercenaries of the Hellenistic World*, Cambridge, 1935.

GROUSSET, RENE, *The Civilizations of the East—India*, London, 1932.

GRUNWEDEL, A., *Buddhist Art in India*, London, 1901.

HACKIN, J., *La Sculpture Indienne et Tibetaine au Musée Guimet*, Paris, 1931.

——— *L'art Bouddhique de la Bactriane*, Kabul, 1937.

HACKIN, J. AND HACKIN, MADAME J. R., *Recherches Archeologiques à Begram*, Paris, 1939 and 1959. (*Mémoirs de la Délégation Archeologique Francaise en Afghanistan*, IX and XI.)

HALL, H. R., *Ancient History of the Near East*, London, 1947.

HALLADE, MADELEINE, *Arts de L'Asie Ancienne. Thèmes et Motifs de L'Inde*, Paris, 1954.

HAMID, M. M., KAF, R.C., AND CHANDA, R. P., *Catalogue of the Museum of Archaeology at Sanchi*, 1946.

HARGREAVES, H., *The Buddha Story in Stone* (Handbook to Sculptures in the Peshawar Museum), Lahore, 1939.

HAVELL, E. B., *Handbook of Indian Art*, London, 1920.

——— *The Ideals of Indian Art*, revised ed., Bombay, 1964.

HERAS, H., *Studies in Proto-Indo Mediterranean Culture*, I, Bombay, 1953.

HERZFELD, E. E., *Iran in the Ancient East*, Oxford, 1941.

HRONZNY, BEDRICH, *Ancient History of Western Asia, India, Crete*, Prague, n.d.

HUNTER, G. R., *The Script of Harappa and Mohenjo-daro*, London, 1954.

HUTCHINSON, R. W., *Prehistoric Crete*, Middlesex, 1962.

IYER, BHARATHA K., *Indian Art*, Bombay, 1958.

JAIRAZBHOY, R. A., *Foreign Influence in Ancient India*, Bombay, 1963.

——— *Oriental Influence in Western Art*, Bombay, 1965.

JAMES, E. O., *The Cult of the Mother Goddess*, London, 1959.

——— *Prehistoric Religion*, London, 1957.

JOUGUET, P., *Arthashastra*, Bombay, 1960 (edited by R. P. Kangle).

——— *Macedonian Imperialism and Hellenization of the East*, London, 1928.

KHANDALAVALA, K., *Indian Sculpture and Painting*, Bombay, 1938.

KING, L. W. AND THOMPSON, R. S., *The Sculpture and Inscriptions of Darius the Great on the Rock of Behistun*, London, 1907.

KOSAMBI, D. D., *The Culture and Civilization of Ancient India*, London, 1963.

KRAMRISCH, STELLA, *The Art of India*, London, 1954.

——— *Indian Sculpture*, Calcutta, 1933.

——— *Indian Sculpture in the Philadelphia Museum of Art*, Philadelphia, 1960.

KRISHNA DEVA AND MISHRA, VIJAYAKANTA, *Vaisali Excavations, 1950*, Vaisali, 1961.

KUIRAISHI, M. H. AND GHOSH, A., *A Guide to Rajgir*, Delhi, 1951.

LA VALLE POUSSIN, LOUIS DE, *L'Inde an temps de Mauryas et de Barbares, Grecs, Scythes, Parthes, et Yue-tchi*, Paris, 1930.

——— *Indo Européens at Indo Iraniens, L'Inde jusque vers 300 av. J. C.*, Paris, 1936.

LEEMANS, W. F., *Foreign Trade in the Old Babylonian Period*, Leiden, 1960.

LEGGE, JAMES (trs.), *A Record of Buddhistic Kingdoms* (by Fa-Hien), Oxford, 1886.

LOHUIZEN DE LEEUW, J. E. VAN., *The Scythian Period*, Leiden, 1949.

LONGHURST, A.H., *The Story of the Stupa*, Colombo, 1936.

——— *History of Sanskrit Literature*, Delhi, 1958.

MACDONNEL, A. A., *India's Past*, Oxford, 1927.

MACDONNEL, A. A. AND KEITH, A. B., *Vedic Index of Names and Subjects*, Varanasi, 1958.

MACGOVERN, W. M., *The Early Empires of Central Asia*, Chapel Hill, 1939.

MACKAY, E., *Chanhu-daro Excavations*, New Haven, 1943.

——— *The Early Indus Civilization*, London, 1948.

——— *Further Excavations at Mohenjo-daro*, Delhi, 1938.

——— *Indus Civilizations*, London, 1935.

MACKENZIE, D. A., *Indian Myths and Legends*, London, 1913.

———— *Myths of Babylonia and Assyria*, London, n. d.

———— *Myths of Crete and Pre-Hellenic Europe*, n. d.

MACPHAIL, J. M., *Asoka*, Calcutta, 1928.

MAISEY, F. C., *Sanchi and its Remains*, London, 1892.

MAJUMDAR, B., *Guide to Sarnath*, Delhi, 1947.

———— *Guide to Sculpture in the Indian Museum*, Delhi, 1937.

MAJUMDAR, R. C., *Ancient India*, Delhi, 1960.

———— *Classical Accounts of India*, Calcutta, 1960.

MAJUMDAR, R. C. AND OTHERS, *Age of Imperial Unity*, Bombay, 1953 (Vol. 2 of *History and Culture of the Indian People*).

MANSOURI, S. M., *Art and Culture of India and Egypt*, Calcutta, 1959.

MARSHALL, SIR JOHN H., *A Guide to Sanchi*, Delhi, 1955.

———— *A Guide Taxila*, Calcutta, 1936.

———— *Taxila*, Cambridge, 1960.

MARSHALL, J. H. AND OTHERS, *Mohenjo-daro and The Indus Valley Civilization*, London, 1931.

MARSHALL, J. H. AND FOUCHER, *The Monuments of Sanchi*, Calcutta, n. d.

MATZ, FREDERICH, *Crete and Early Greece*, London, 1962.

MCCRINDLE, J. W., *Ancient India*, Westminster, 1901.

———— *Commerce and Navigation of the Erythrean Sea*, Calcutta, 1879.

———— *Invasion of India by Alexander the Great*, Westminster, 1896.

MCNEILL, W. H., *The Rise of the West*, Chicago, 1963.

MEHTA, R. R., *Pre-Buddhist India*, Bombay, 1939.

MITRA, RAJENDRALAL, *Buddha Gaya*, Calcutta, 1878.

———— *The Antiquities of Orissa*, Calcutta, 1880.

MODE, HEINZ, *The Harappa Culture and the West*, Calcutta, 1961.

MOOKERJI, R. K., *Asoka*, Delhi, 1954.

———— *Chandragupta Maurya and his Times*, Madras, 1943.

———— *Indian Shipping*, Bombay, 1957.

MUKERJEE, R., *Culture and Art of India*, London, 1959.

MURRAY, M. A., *The Splendour that Was Egypt*, London, 1949.

NARAIN, A. K., *The Indo Greeks*, Oxford, 1957.

OLMSTEAD, A. T., *History of the Persian Empire*, Chicago, 1948.

PERKINS, A. L., *Comparative Archaeology of Early Mesopotamia*, Chicago, 1957.

PERROT E. AND CHIPIEZ, C., *History of Art in Persia*, London, 1892.

PIGGOTT, S. (ed.), *Prehistoric India*, Harmondsworth, 1952.

———— *The Dawn of Civilization*, London 1961.

POPE, A. U. (ed.), *A Survey of Persian Art*, London, 1938.

PORADA, E., *Ancient Iran*, London, 1965.

PRAKASH, A., *The Foundation of Indian Art and Archaeology*, Lucknow, 1942.

PURI, B. N., *India in Classical Greek Writings*, Allahabad, 1963.

RAMCHANDRAN, T. N. AND JAIN, CHHOTELAL, *Khandagiri and Udayagiri Caves*, Calcutta, 1951.

RAMSAY, W., *Asiatic Elements in Greek Civilization*, London, 1927.

RANDHAWA, M. S., *The Cult of Trees and Tree Worship in Buddhist-Hindu Sculpture*, New Delhi, 1964.

RAPSON, E. J. (ed.), *Cambridge History of India*, I, Cambridge, 1922.

RAWLINSON, H. G., *India. A Short Cultural History*, London, 1968.

———— *Intercourse between India and the Western World*, Cambridge, 1926.

RAY, NIHAR-RANJAN, *Maurya and Sunga Art*, Calcutta, 1945.

RAYCHAUDHRI, H., *Political History of Ancient India*, Calcutta, 1950.

RHYS DAVIDS, T. W., *Buddhist India*, London, 1903.

RHYS DAVIDS, MRS. C. A. F., *Stories of the Buddha from the Jatakas*, London, 1929.

RICHTER, G. M. A., *The Art of Egypt through the Ages*, London, 1931.

RICHTER, G. M. A., *A Handbook of Greek Art*, London, 1960.

ROSTOVTZEFF, M., *Social and Economic History of the Hellenistic World*, Oxford, 1941.

ROWLAND, BENJAMIN, *The Art and Architecture of India*, London, 1953.

SAHNI, D. R., *Catalogue of the Museum of Archaeology at Sarnath*, Calcutta, 1914.

———— *Guide to the Buddhist Ruins of Sarnath*, Delhi, 1933.

SANKALIA, H. D., *Indian Archaeology Today*, Bombay, 1962.

———— *Prehistory and Protohistory in India and Pakistan*, Bombay, 1962.

SANKALIA, H. D., SUBBARAO, B. AND DEO, S. B., *The Excavations at Maheshwar and Navdatoli 1952-53*, Poona-Baroda, 1958.

SANKALIA, H. D., DEO, S. B., ANSARI, Z. D., SOPHIE ERHARDT, *From History to Prehistory at Nevasa 1954-56*, Poona, 1960.

SANKALIA, H. D., AND DEO, S. B., *Report on the Excavations at Nasik and Jorwe 1950-51*, Poona, 1955.

SARASWATI, S. K., *Survey of Indian Sculpture*, Calcutta, 1957.

SASTRI, K. A. NILKANTA, *Age of the Nandas and Mauryas*, Benaras, 1952.

———— *Mauryas and Satavahanas*, Bombay, 1957 (Vol. 11 of *A Comprehensive History of India*).

SASTRI, K. N., *New Light on the Indus Civilization*, Delhi, 1957.

SATYA, SHRAVA, *The Sakas in India*, Lahore, 1947.

SCHMIDT, E. F., *Persepolis I*: (Structures, Reliefs Inscriptions), Chicago, 1953.

SECKEL, D., *The Art of Buddhism*, London, 1964.

SHARMA, G. R., *Excavations at Kausambi (1957-59)*, Allahabad, 1960.

SIVARAMAMURTI, C., *A Guide to the Archaeological Gallery of the Indian Art Museum*, Calcutta, 1956.

———— *Indian Sculpture*, Bombay, 1961.

SMITH, V. A., *Asoka*, Oxford, 1909.

———— *Early History of India*, Oxford, 1928.

———— *History of Fine Arts in India, and Ceylon* (K. Khandalavala, ed.), Bombay, 1969.

———— *Oxford History of India*, Oxford, 1924.

STARR, R. F. S., *Indus Valley Painted Pottery*, Princeton, 1941.

STEIN, SIR AUREL, *On Alexander's Track to the Indus*, London, 1929.

———— *Archaeological Reconnaissances in North-West India and South-East Iran*, London, 1937.

STOBART, J. C., *The Glory that was Greece*, London, 1951.

SUBBARAO, B., *Personality of India*, Baroda, 1958.

TARN, W. W., *Alexander the Great*, Cambridge, 1942.

———— *The Greeks in Bactria and India*, Cambridge, 1938.

———— *Hellenistic Civilization*, London, 1927.

THARPAR, ROMILA, *Asoka and the Decline of the Mauryas*, Oxford, 1961.

THOMAS, P., *Epics, Myths and Legends of India*, Bombay, n. d.

TILAK, B. G., *Orion or the Antiquity of the Vedas*, Poona, 1916.

TOYNBEE, A., *Hellenism, History of a Civilization*, London, 1959.

UPPJOHN, E. M. AND OTHERS, *History of World Art*, New York-Oxford, 1958.

VAN BUREN, E. D., *Clay Figurines of Babylonia and Assyria*, New Haven, 1930.

VATS, M. S., *Excavations at Harappa*, Delhi, 1940.

VOGEL, J., *Buddhist Art in India, Ceylon and Java*, Oxford, 1936.

WADDELL, L. A., *Indo-Sumerian Seals Deciphered*, London, 1925.

———— *Report on Excavations at Pataliputra*, Calcutta, 1903.

WARMINGTON, E. H., *Commerce between the Roman Empire and India*, Cambridge, 1928.

WAUCHOPE, R. S., *Buddhist Cave Temples of India*, Calcutta, 1933.

WEBSTER, T. B. L., *Greek Terracottas*, Harmondsworth, 1950.

WHEELER, R. E. M., *Charsada*, London, 1962.

———— *Civilizations of the Indus Valley and Beyond*, London, 1966.

———— *Early India and Pakistan*, New York, 1959 (Supplementary volume to the *Cambridge History of India*).

———— *Five Thousand Years of Pakistan*, London, 1950.

WHEELER, R. E. M., *Rome beyond the Imperial Frontiers*, London, 1959.

WINTERNITZ, M., *A History of Indian Literature*, Calcutta, 1959.

WOOLLEY, L., *Excavations at Ur*, London, 1954.

———— *Mesopotamia and the Middle East*, London, 1961.

———— *The Sumerians*, Oxford, 1928.

ZIMMER, HEINRICH, *The Art of Indian Asia*, New York, 1954.

———— *Myths and Symbols in Indian Art and Civilization*, New York, 1946.

B. ARTICLES

ACHARYA, P. K., "Indo Persian Architecture," *Calcutta Review*, February-April, 1930.

ACKERMAN, PHYLLIS, "West Asiatic Ancestors of the Anda," *Marg*, V, 1951-52.

AGRAWAL, D. P., "Harappa Culture. New Evidence for a Shorter Chronology," *Science*, V, 143, No. 3609, January-March, 1964.

AGRAWALA, V. S., "Pre Kushana Art of Mathura," *JUPHS*, 1933.

———— "Terracotta Figurines of Ahichhatra, District Bareilly, U. P.," *Ancient India*, IV, July, 1947 to January 1948.

ALLCHIN, F. R., "The Culture Sequence of Bactria," *Antiquity*, XXX, 1957.

ANSARI, Z. D., "Evolution of Pottery Forms in India," *Marg*, V, 1951-52.

———— "Spiral Horned Antelope Motif in the Chalcolithic Pottery of Nevasa and Western Asia," *Bulletin of the Deccan College*, XVIII, 1957.

ASAWA, S. K., "Lotus and Indian Art," *Modern Review*, Calcutta, CI-5, 1957.

AUBOYER, JEANNINE, "Ancient Ivories from Begram, Afghanistan," *JISOA*, XVI, 1948.

BAKSHI, K. G., "A New Pre-Maurya Statue Discovered at Bhilsa," *PIHC*, VIII, 1945.

BANERJEA, A. N., "A Bharhut Railing Sculpture," *PIHC*, X, 1947.

———— "Indian Votive and Memorial Columns," *JISOA*, V, 1937.

———— "The Phallic Emblem in Ancient and Medieval India," *JISOA*, III, 1935.

———— "The Webbed Fingers of Buddha," *IHQ*, XXVII, 1951.

BANERJI, ADRIS, "Mauryan Sculptures in Banaras," *Roopa Lekha*, XXIV, 1953.

———— "Origin of the Imperial Pataliputra School," *Journal of Indian Museums*, VIII, 1952.

———— "The Lomasa Risi Cave Façade," *JBORS*, XII, 1926.

BANERJI SASTRI, A., "Remains of a Prehistoric Civilization in the Gangetic Valley," *JBHS*, III, 1930.

———— "The Nati of Pataliputra," *IHQ*, IX, 1933.

BAREAU, A., "Le Construction et le Culte de Stupa Après les Vinaya Pitakas," L, facs. 2, *BEFEO*, 1962.

BARNETT, L. D., "A Review of de la Valle Poussin's *Indo-Européens et Indo-Iraniens*," *JRAS*, 1925.

BARUA, B. M., "Bharhut Sculptures in the Allahabad Museum," *JUPHS*, XIX, 1946.

———— "Bodhgaya," *Marg*, IX, 1946.

———— "Bodh Gaya Sculptures," *Indian Culture*, IV, 1937-38.

BENISTI, MIREILLE, "A propos de la Sculpture de Bharhut," *Arts Asiatiques*, V, facs. 2, 1958.

———— "Etude sur le Stupa de l'Inde," *BEFEO*, L, 1960.

BHANDARKAR, D. R., "Siva of Prehistoric India," *JISOA*, VIII, 1937.

BIBBY, GEOFFREY, "The Ancient Indian Style Seals from Bahrein," *Antiquity*, XXXII, 1958.

BUCHTHAL, H., "The Common Classical Sources of Buddhist and Christian Narrative Art," *JRAS*, 1943.

BURN, R. A., "A Review of Tarn's, *The Greeks in Bactria and India*," *JRAS*, 1941.

BUSSAGLI, MARIO, "Aspects of the Ancient Art of India and the Mediterranean," *East and West*, I, 1950-51.

CASAL, J. M., "L'Afghanistan et les Problèmes d'Archéologie indienne," *Artibus Asiae*, XXVI, 1963-64.

———— "Archeologie Pakistainaise: les fouilles de Kot Diji," *Arts Asiatiques*, VII, facs. 2, 1958.

———— "Rapport provisoire sur les fouilles executées à Amri (Pakistan) en 1959-60," *Arts Asiatiques*, VIII, facs. I, 1961.

CHHABRA, B. CH., "Antiquities from Jhusi and Other Sites," *Lalit Kala*, IX, 1961.

CHAKRAVARTI, N. P., "The Minor Rock Edicts of Asoka and some Connected Problems," *Ancient India*, IV, 1947-48.

CHAKROBORTTY, S. K., "Persian and Greek Coins and Their Imitations in Ancient India," *IHQ*, X, 1934.

CHANDA, RAM PRASAD, "Beginnings of Art in Eastern India," *MASI*, XXX, 1927.

———— "The Indus Valley in the Vedic Period," *MASI*, XXXI, 1928.

———— "Survival of the Prehistoric Civilization of the Indus Valley," *MASI*, XXXI, 1929.

CHANDRA, G. C., "Excavations at Pataliputra," *ASIAR*, 1935-36.

CHANDRA, MOTI, "Indian Costume from Earliest Times to the 1st Century B. C.," *Bharatiya Vidya*, 1939.

———— "Some Aspects of the Yaksha Cult in Ancient India," *Bulletin of the Prince of Wales Museum*, III, 1952-53.

CHARPENTIER, J., "A Review of Wadell's *Indo Sumerian Seals Deciphered*," *JRAS*, 1925.

———— "Remarks on the Fourth Edict of Asoka," *IHQ*, IX, 1933.

CHATTOPADHYAYA, S., "The Achaemenids and India," *IHQ*, XXVI, 1950.

CHILDE, V. G., "India and the West before Darius," *Antiquity*, XIII, 1939.

COOMARASWAMY, A. K., "Archaic Indian Terracottas," *Marg*, VI, 1952-53.

———— "The Gudimallam Lingam," *IHQ*, VII, 1931.

———— "Origin of the Lotus Capital," *IHQ*, VII, 1931.

———— "Origin of the Lotus so-called Bell Capital," *IHQ*, VI, 1930.

———— "Picture Showmen," *IHQ*, V, 1929.

———— "Some Early Buddhist Reliefs Identified," *JRAS*, 1928.

———— "Symbolism of the Dome," *IHQ*, XIV, 1938.

———— "Two Reliefs from Bharhut in the Freer Gallery," *JISOA*, VI, 1938.

———— "The Webbed Fingers of the Buddha," *IHQ*, VII, 1921.

CORBIAU, S., "Indian and Babylonian Figurines," *Man*, XXXV, 1935.

DALES, G. F., "Harappan Outposts on the Makran Coast," *Antiquity*, XXXVI, 1962.

DANDEKAR, R. N., "East-West," *Journal of the University of Poona*, XVII, 1963.

DAS GUPTA, P. C., "Early Terracottas from Chandrake-Tugar," *Lalit Kala*, VI, October, 1959.

———— "On the affinity between one Mohenjo-daro and one Kish Terracotta figurine," *Indian Culture*, III, 1936.

DE CARDI, BEATRICE, "A new Prehistoric Ware from Baluchistan," *Iraq*, XIII, 1951.

———— "New Wares and Fresh Problems from Baluchistan," *Antiquity*, XXXIII, 1959.

———— "On the Borders of Pakistan, Recent Exploration," *Arts and Letters* (The Journal of the Royal India, Pakistan and Ceylon Society, London), XXIV.

DESHPANDE, M. N., "The Rock Cut Caves of Pitalkhora in the Deccan," *Ancient India*, XV, 1959.

DEVA KRISHNA AND MCCOWN, DONALD E., "Further Explorations in Sindh," *Ancient India*, V, 1949.

FABRI, C. L., "The Cretan Bull Grappling Sports and the Bull Sacrifice in the Indus Valley Civilization," *ASIAR*, 1934-35.

———— "Un Elêment Mesopotamien dans l'Art de l'Inde," *Journal Asiatique*, XXVII, 1930.

FAIRSERVIS, W. A., "The Chronology of the Harappan Civilization and the Aryan Invasion," *Man*, LVI, November, 1956.

FRANKFORT, HENRI, "Achaemenian Sculpture," *American Journal of Archaeology* L, 1946.

———— "The Indus Civilization and the Near East," *Annual Bibliography of Indian Archaeology*, 1932-34.

———— "Tel Asmar, Khafaje, Khorsabad," *Oriental Institute of Chicago Communications*, XVI, 1933.

GADD, C. J., "Seals of Ancient Indian Style found at Ur," *Proceedings of the British Academy*, XVIII, 1932.

———— "A Review of Frankfort's *Cylinder Seals*," *JRAS*, 1941.

GAIROLA, C. KRISHNA, "Atlantes in Early Indian Art," *Oriental Art*, XI, 1956.

———— "Evolution of Buddhist Architecture and Sculpture in the Times of the Satavahanas," *Marg*, IX, 1955.

GANGOLY, O. C., "The So-called Bell Capital," *IHQ*, VI, 1930.

GARBINI, G., "The Stepped Pinnacle in the Ancient Near East," *East and West*, IX, 1958.

GHOSAL, U. N., "A Review of Tarn's *The Greeks in Bactria and India*," *IHQ*, XIV, 1938.

GHOSH, A., "Rajgir: 1950," *Ancient India*, VII, 1951.

GHOSH, A. AND PANIGRAHI, K. C., "Pottery of Ahichhatra (U. P.)," *Ancient India*, II, 1946.

GHOSH, DEVAPRASAD, "The Development of Buddhist Art in South India," *IHQ*, III, 1927.

GLOB, P. V., "Bahrein—Island of the Hundred Thousand Burial Mounds," *Kuml*, 1954.
———— "The Danish Archaeological Bahrein Expeditions Second Excavation Campaign," *Kuml*, 1955.
———— "Snake Sacrifices in Bahrein's Ancient Capital," *Kuml*, 1957.
GOETZ, H., "Imperial Rome and the Genesis of Classic Indian Art, " *East and West*, X, 1959.
GORDON, D. H., "Early Indian Terracottas," *JISOA*, XI, 1947.
———— "The Pottery Industries of the Indo-Iranian Border," *Ancient India*, X-XI, 1954-55.
———— "The Problem of Early Indian Terracottas," *Man*, XXXV, 1935.
———— "Sialk, Giyan, Hissar and Indo-Iranian Connections," *Man in India*, XXVII, 1947.
GOVINDA, LAMA ANAGARIKA, "Solar and Lunar Symbolism in the Development of Stupa Architecture," *Marg*, XVI, 1963.
HARGREAVES, H., "Excavations in Baluchistan," *MASI*, XXXV, 1929.
HEINE, GELDERN R., "Archaeological Traces of the Vedic Aryans, *JISOA*, IV, 1936.
———— "The Coming of Aryans and the End of Harappan Civilization," *Man*, LVI, 1956.
HERAS, HENRY, "The Easter Island Script and the Script of Mohenjo-daro," *Annals of the Bhandarkar Oriental Research Institute*, XIX, Part II, 1938.
———— "India, the Empire of the Swastika," *Coronation Souvenir*, Bombay, April, 1957.
———— "The Origin of Sumerian Writing," *The Journal of the University of Bombay*, VII, Part I, July, 1938.
———— "Two Proto-Indian Inscriptions from Chanhu-daro," *JBORS*, XXII.
———— "The Religion of the Mohenjo-daro People according to the Inscriptions," *Journal of the University of Bombay*, V, July, 1936.
———— "The Trefoil Decoration in Indo-Mediterranean Art," *Rajah Sir Annamalai Chettiar. Commemoration Volume*.
HERZFELD, E. E., "A New Inscription of Darius from Hamadan," *MASI*, XXXIV, 1928.
IRWIN, JOHN, "Masterpieces of Oriental Art, Mauryan or Early Sunga Ringstones," *JRAS*, 1951.
JAYASWAL, K. P., "Brahmi Seals Newly discovered at Patna," *JBORS*, 1924.
———— "Jaina Image of the Maurya Period," *JBORS*, XXIII.
———— "Terracottas Dug out at Patna," *JISOA*, III, 1935.
JOHNSTON, E. A., "Reflections on Two Reliefs in Bhaja," *Marg*, IX, 1955-56.
———— "Two Buddhist Scenes at Bhaja," *JISOA*, VIII, 1939.
KALA, S. C., "Bharhut Sculptures in the Allahabad Museum," *JUPHS*, XVIII, 1945.
KALAPRIYA, "Bharhut," *Marg*, IX, 1955-56.
KENNEDY, J., "The Early Commerce of India with Babylon, 700-300 B. C.," *JRAS*, 1898.
KHAN, F. A., "Fresh Sidelight on the Indus Valley and the Bronze Age Orient," *Pakistan*, 1955 (Pamphlet).
———— "Preliminary Report on Kot Diji Excavations," *Annual Report of the Institute of Archaeology, Pakistan*, 1957-58.
KHOZAD, AHMAD ALI, "Begram in the Light of a Recent Work Entitled 'New Archaeological Enquiries at Begram,' " *East and West*, VII, No. 3, 1956.
KRAMER, S. N., "Dilmun: Quest for Paradise," *Antiquity*, XXXVII, 1963.
KRAMRISCH, STELLA, "Contact of Indian Art with Art of Other Countries," *JDLCUS*, 1923.
———— "Indian Terracottas," *JISOA*, VIII, 1939.
———— "Sanchi," *Marg*, IX, 1956.
LAL, B. B., "Excavations at Hastinapura and Other Explorations in the Upper Ganges and Sutlej Basin 1950-51," *Ancient India*, X-XI, 1954-55.
———— "Further Hoards from the Gangetic Basin and a Review of the Problem," *Ancient India*, VII, 1951.
———— "A Picture Emerges—an Assessment of the Carbon—14 Datings of the Protohistoric Cultures of the Indo-Pakistan Subcontinent," *Ancient India*, XVIII-XIX, 1962-63.
———— "Protohistoric Investigation," *Ancient India*, IX, 1953.
———— "Sisupalgarh: 1948. An Early Historical Fort in Eastern India," *Ancient India*, V, 1949.
LALLANJI, GOPAL, "Antiquity of Iron in India," *Journal of the Andhra Historical Research Society*, 1962-63.
LANGDON, S., "A New Factor in the Problem of Sumerian Origin," *JRAS*, 1931.
MACKAY, E., "East Sumerian Connections with Ancient India," *JRAS*, 1925.
———— "Further Links between Sind, Sumer and Elsewhere," *Antiquity*, V, 1931.

MAIURI, AMADEO, "The Ivory Statuette of Indian Art at Pompeii," *JUPHS*, XIX, 1946.

MAJUMDAR, N. G., "Explorations in Sind," *MASI*, XLVIII, 1934.

MARSHALL, J., "Recherches Archeologiques à Begram," *JRAS*, 1941.

MITRA, A. K., "A Bell Capital from Buvanesvara," *IHQ*, V, 1929.

———— "A Further Note on the Origin of the Bell Capital," *IHQ*, X, 1934.

———— "Mauryan Art," *IHQ*, III, 1927.

———— "Origin of the Bell Capital," *IHQ*, VII, 1931.

MOOKERJI, R. K., "Notes on Early Indian Art," *JUPHS*, XII, 1939.

MULK RAJ, ANAND, "The Continuity of Tradition," *Marg*, IX, 1956.

OPPENHEIM, A. L., "The Sea Faring Merchants of Ur," *Journal of the American Oriental Society*, LXXIV, 1954.

NATH, PRAN, "The Script on the Indus Valley Seals," *IHQ*, VII, 1931 (Supplement).

NEFF, MURIEL, "The Origins of the Indian Cave Temples," *Oriental Art*, IV, 1958.

NIGAM, J. S., "Northern Black Polished Ware," *Marg*, XIV, 1961.

———— "Decorated Pottery of North India," *Marg*, XIV, 1961.

NYLANDER, CARL, "British Expeditions to Kalat 1948 and 1957," *Pakistan Archaeology*, I, 1964, under Beatrice de Cardi.

———— "The Fall of Troy," *Antiquity*, XXXVIII, 1963.

———— "French Digging at Amri," *Pakistan Archaeology*, I, 1964, by J. M. Casal of the French Archaeological Mission.

PEPPE, W. CLAXTON, "Pipprahwa Stupa," *JRAS*, 1898.

PIGGOTT, S., "A New Prehistoric Ceramic from Baluchistan," *Ancient India*, III, 1947.

———— "Notes on Certain Pins and a Mace Head from Harappa," *Ancient India*, IV, 1947-48.

———— "Throne Fragments from Pataliputra," *Ancient India*, IV, 1947-48.

———— "Sassanian Motifs on Painted Pottery from North-West India," *Ancient India*, V, 1949.

PRZYLUSKI, J., "The Great Goddess in India and Iran," *IHQ*, X, 1934.

———— "The Harmika and the Origin of Buddhist Stupas," *IHQ*, XI, 1935.

———— "On the Origin of the Aryan Word Istaka," *IHQ*, VII, 1931.

———— "Pre-Dravidian and Proto-Dravidian," *IHQ*, VI, 1930.

———— "The Solar Wheel at Sarnath and in Buddhist Monuments," *JISOA*, IV, 1936.

RAIKES, R. L., "The Mohenjo-daro Floods," *Antiquity*, XXXIX, September, 1965.

———— "A New Prehistoric Bichrome Ware from the Plains of Baluchistan (West Pakistan)," *East and West*, XIV, 1965.

———— "A Supplementary Note on Pirak Bichrome Ware," *East and West*, 1964-65.

RAO, S. R., "Ceramic of the Indus Valley in Gujarat," *Marg*, XIV, 1960.

———— "Excavations at Lothal," *Lalit Kala*, III, 1956.

———— "Further Excavations at Lothal," *Lalit Kala*, XI, 1962.

———— "A Persian Gulf Seal from Lothal," *Antiquity*, XXXVII, 1963.

RAO, S. R. AND OTHERS, "Excavations at Rangpur and other Exploration in Gujarat," *Ancient India*, XVIII-XIX, 1962-63.

RICHTER, GISELA A., "Greeks in Persia," *American Journal of Archaeology*, L, 1946.

ROES, ANNE, "The Trefoil as a Sacred Emblem," *Artibus Asiae*, XVII, 1954.

ROSS, E. J. AND MCCOWN, D. E., "A Chalcolithic Site in Northern Baluchistan," *Journal of Near Eastern Studies*, V, 1946.

ROSU, ARION, "Purnaghate et le Symbolisme du Lotus dans l'Inde," *Arts Asiatiques*, VIII, Facs. 3, 1961.

SAHU, N. K., "A Note on the Khandagiri and Udayagiri Caves," *Marg*, VIII, 1955.

SANKALIA, H. D., "The Copper Stone Age Pottery of Maheshwar-Navdatoli," *Marg*, XIV, 1960-61.

———— "Navdatoli Dancers," *Antiquity*, XXIV, 1955.

———— "New Light on Indo-Iranian or Western Asiatic Relations between 1700 B. C. and 1200 B. C.," *Artibus Asiae*, XXVI, 1963-64.

SARKAR, HARIBISHNU, "Artifacts of Fishing and Navigation from the Indus Valley," *Man in India*, XXXIV, 1954.

SARUP, LAKSHMAN, "The Rigveda and Mohenjo-daro," *Indian Culture*, IV, July 1937-April 1938.

SHANKARANARAYANAN, S., "Ahraura Inscription of Ashoka," *IHQ*, XXXVII, 1961.

SHARMA, O. P., "Unicorn in Indian Art," *Journal of the Bihar Research Society*, XLIII, 1957.
SHARMA, Y. P., "Exploration of Historical Sites," *Ancient India*, IX, 1953.
———— "Past Patterns of Living as Unfolded by the Excavations at Rupar," *Lalit Kala*, I-II, 1955-56.
SHERE, S. A., "Stone Discs Found at Murtaziganj." *Journal of the Bihar Research Society*, XXXVII, 1951.
SIVARAMAMURTI, C., "Amaravati Sculptures in the Madras Government Museum," *Bulletin of the Madras Government Museum*, IV, 1942.
SOUNDARAN, RAJAN K. V., "Sarnath Lion Capital and the Animal Capitals of the Early Period," *Journal of Oriental Research*, XIX, 1949-50.
STEIN, SIR A., "An Archaeological Tour in Gedrosia," *MASI*, XLIII, 1931.
———— "An Archaeological Tour in Waziristan and Northern Baluchistan," *MASI*, XXXVII, 1929.
———— "Indo Iranian Borderlands," *Journal of the Royal Anthropological Institute*, July-December, 1934.
STRZYGOWSKI, JOSEF, "The Orient and the North," *Eastern Art*, I, 1929.
SUBRAHMANYAM, B. R., "Appearance and Spread of Iron in India," *Journal of the Oriental Institute*, XIII, 1963-64.
SUR, ATUL K., "Origin of the Indus Valley Script," *IHQ*, IX, 1933.
THAPAR, B. K., "Maski 1934. A Chalcolithic Site of the Southern Deccan," *Ancient India*, XIII, 1957.
THOMAS, E. G., "The So-called Indo Aryan Invasion," *IHQ*, V, 1929.
THORVILDSEN, KNUD, "Burial Cairns on Um en-Nar," *Kuml*, 1962.
TRAFALDAR, N. K., "Artistic Interest in Post-Asokan Sculpture," *IHQ*, II, 1926.
UNVALA, J. M., "Political and Cultural Relations between Iran and India," *Annals of the Bhandarkar Research Institute*, XXVIII, 1947.
UPASAK, C. S., "Some Salient Features of Asokan Brahmi Script," *Journal of the University of Bihar*, V, 1962.
WALSH, E. H. C., "Punch Marked Coins from Taxila," *MASI*, LIX, 1939.
WHEELER, R. E. M., "Archaeology and Transmission of Ideas," *Antiquity*, XXVI, 1952.
———— "Brahmagiri and Chandravalli 1947, Megalithic and Other Cultures in the Chitaldrug District, Mysore State," *Ancient India*, IV, 1948.
———— "The Defences of Cemetery R. 37 Harappa," *Ancient India*, III, 1947.
———— "Iran and India in Pre-Islamic Times," *Ancient India*, IV, 1947-48.
WILLETS, WILLIAM, "Excavations at Pitalkhora in the Aurangabad District of Maharashtra," *Oriental Art*, VIII, 1961.

C. SELECT LIST OF PUBLICATIONS AND ABBREVIATIONS

Ancient India
Annual Bibliography of Indian Archaeology
Archaeological Survey of India—Annual Reports : *ASIAR*
Archaeological Survey of India—Memoirs : *MASI*
Arts Asiatiques
Bulletin de L'Ecole Francaise d'Extrême Orient : *BEFEO*
East and West
Indian Archaeology—A Review
Indian Historical Quarterly : *IHQ*
Journal of the American Oriental Society
Journal of the Bihar and Orissa Research Society : *JBORS*
Journal of the Department of Letters, Calcutta University : *JDLCUS*
Journal of the Indian Society of Oriental Art : *JISOA*
Journal of the Royal Asiatic Society : *JRAS*
Journal of the U. P. Historical Society : *JUPHS*
Lalit Kala
Man
Man in India
Marg
Praci-Jyoti—Digest of Indological Studies
Proceedings of the Indian History Congress : *PIHC*

Index

Achaemenid, Achaemenian, 32, 34, 43, 74, 75, 78, 79, 81ff., 97, 99, 100, 101, 102, 103, 105, 106, 107, 109, 110, 115, 116, 117, 119, 120, 121, 129, 140, 142, 155.
Aegean, 10, 32.
Afghanistan, 8, 12, 27, 70, 76, 80, 93, 120.
Ahar, 63, 69, 70.
Ahichhatra, 65, 87.
Ajanta, 139.
Ajatasatru, king, 80.
Akkad, 28, 159.
Alexander, Alexandrian, 75, 76, 103, 129, 130.
Ali Kosh, 157.
Alizai, 65.
Al Ubaid, 6, 12, 159.
Amaravati, 93, 135ff., 138, 140.
Amri, 1, 2, 3, 4, 6, 7, 9, 10, 15, 19, 20, 23, 24, 26, 42, 56, 58, 147ff.
Anau, 5.
Andhra, 101, 135.
Arpachiya, 44, 62.
Arretine, Roman, 73.
Aryan, 13, 51, 54, 60, 63, 65, 66, 67, 68, 69, 106, 112.
Ashurnasirpal, 86.
Asoka, Asokan, 53, 72, 75, 77, 78, 79, 80, 81, 82ff., 94, 99, 101, 102, 103, 104, 105, 106, 107, 109, 110, 111, 118, 119, 121, 122, 125, 132, 142, 155.
Assurbanipal, 76.
Assyria, Assyrian, 4, 6, 20, 28, 34, 55, 56, 86, 101, 106, 107, 110, 113, 120, 126, 127, 160.

Babylon, 28, 75, 86.
Bactria, Bactrian, 88, 103, 155.
Bahrein, 62, 63.
Bairat, 80.
Baluchistan, 2, 4, 7, 8, 10, 12, 13, 15, 18, 19, 23, 25, 26, 27, 28, 39, 40, 42, 56, 57, 58, 60, 64, 65, 69, 70, 71, 74, 76.
Bampur, 8, 59.
Barabar, 80, 138, 142.
Baroque ladies, 98.
Basarh Bakhira, 83, 104.
Bedsa, 139.
Behistun, 121.
Besnagar, 141.
Bhabru edict, 83.
Bhaja, 139, 140, 141.
Bharut, 4, 79, 80, 84, 94, 95, 102, 109, 111ff., 124ff.
Bhir, 103.

Bodhgaya, 132ff., 139, 140.
Brahuis, 49.
Buddhist art, 6, 29, 43, 48, 55, 72, 75, 76, 77, 80, 103, 106, 130, 131
Buff ware, 7.
Bull pottery, 10.
Button seals, 28, 35, 39, 57.

Caucasus, 50.
Cave temples, 138ff.
Ceramics, 54, 55, 57, 59, 60, 68, 70, 73, 117, 147, See also Pottery.
Ceramics, Amri-Nal, 1ff., 75.
 Harappan, 16ff. 39, 48, 61ff., 71, 109, 128
 Indus Valley, 16ff.
 Kulli, 8ff.
 Lothal, 62ff.
 Post-Harappan, 59ff.
Cemeteries, 37, 50, 55, 59, 64, 68.
Cemetery H. 54, 55, 56, 60, 62, 63, 68, 71, 151.
Central India, 61, 63, 68ff., 73.
Chagar Bazar, 57.
Chalcolithic period, 1ff., 39, 44, 45, 49, 50, 53ff., 68ff., 73, 77, 153ff.
Chandragupta Maurya, 79, 155.
Chanhu-daro, 2, 24, 50, 56, 57, 58, 63, 103.
Charsada, 96, 97, 98.
China, 5, 12, 13, 113.
Cities, Indus Valley, 49.
Coins, 74.
Crete, Cretan, 3, 5, 10, 13, 14, 17, 18, 20, 21, 22, 23, 30, 34, 44, 47, 56, 60, 70, 101.
Crete, chronological chart, 161ff.
Cyrus, 76.

Dabar Kot, 10, 59
Daimabad, 71.
Dalma Tepe, 157.
Damb Sadaat, 4, 7, 12, 148, 149.
Darius, 76, 121, 142.
Dasaratha, 80.
Deccan, 68ff.
Dedalic period, 162.
Dharmachakra, 122.
Dhavaja, 106
Dhauli, 91, 93, 94.
Didarganj, 93.
Diyala, 61.

Dravidian, 49.
Durbhanga, 73.

Early historic period, 155.
Ecbatana, 79.
Edith Shahr, 9.
Egypt, Egyptian, 31, 33, 69, 70, 83, 106, 111, 113, 131.
Elamite, 8, 21, 28, 158.
Enkidu, 32, 33.
Eran, 63.
Erech, king of, 32.
Euphrates, 106.

Ganges valley, 60, 65, 67, 68, 73, 74, 79, 104.
Gawra, see Tepe Gawra.
Ghul painted pottery, 59.
Gilgamesh, 30, 32, 33.
Giyan, see Tepe Giyan.
Goddess, see Mother goddess.
Graeco-Roman sculpture, 75.
Greece, 76, 89, 95, 104, 113, 134.
Greece, chronological chart, 161ff.
Greek (Hellenism), 75, 81, 82, 88, 89, 90, 95, 100, 101, 102, 103, 104, 106, 108, 109, 110, 119, 122, 124, 127, 128, 130, 131, 134, 141, 142.
Greek coins, 74.
Gudimallam Sivalinga, 143.
Gujarat, 61, 63, 72.
Guti period, 160.

Hajji Firuz Tepe, 157.
Halaf, see Tell Halaf.
Hammurabi, 75.
Harappa, Harappan, 2, 3, 4, 5, 6, 7, 8, 9, 11, 13, 15, 16, 17, 18, 19, 20, 21, 22, 26, 27, 29, 30, 31, 32, 33, 34, 36, 37, 38, 39, 40, 41, 42, 43, 44, 45, 46, 47, 48, 49, 50, 51, 52, 53ff., 58, 60, 61ff., 66, 69, 71, 73, 74, 75, 76, 77, 85, 86, 87, 94, 95, 96, 97, 98, 100, 103, 104, 105, 107, 110, 114, 118, 119, 122, 123, 125, 126, 127, 128, 129, 143, 144, 147, 149ff., 153.
Harappan outposts, 61ff.
Harappan script, 49.
Hasanlu, 157, 158.
Hastinapur, 53, 65, 66, 67, 68, 73, 153.
Hassuna period, 159.
Helladic period, 161ff.
Hellenism, see Greek.
Hellenistic black glazed ware, 73.
Hissar, 10, 38, 39, 57, 70, 157, 158.
Historic age, 73ff.
Hittite, 57, 58, 101.
Hiuen Tsang, 80.

India, chronological notes, 147ff.
Indus Valley Civilization, 3, 4, 6, 8, 9, 10, 15ff., 41ff., 48, 49, 50, 52, 53, 54, 56, 58, 60ff., 68, 69, 71, 72, 75, 76, 80, 84, 86, 87, 90, 91, 94, 95, 96, 97, 98, 99, 104, 110, 112, 117, 118, 122, 126, 127, 130, 149ff.
Iran, Iranian, 4, 7, 8, 9, 11, 12, 13, 16, 19, 20, 23, 24, 28, 32, 34, 38, 39, 40, 41, 48, 55, 57, 59, 60, 61, 64, 65, 66, 68, 69, 70, 71, 73, 75, 77, 79, 81, 82, 83, 85, 86, 87, 88, 89, 90, 93, 95, 98, 99, 100, 103, 104, 106, 107, 110, 117, 120, 122, 123, 124, 136, 142.
Iran, chronological chart, 157ff.
Isin, 160

Jaggayapeta, 135ff.
Jaimangalgarh, 73.
Jamdat Nasr, 2, 5, 21, 24, 37, 38, 159.
Jhangar, 2, 58, 148.
Jhukar, 2, 27, 54ff., 56, 57, 58, 60, 63, 68, 147, 151.
Jhusi, 95.
Jorwe, 69, 70, 153.
Jorwe ware, 70, 154.

Kalat, 4, 7, 9, 10, 65.
Kalibangan, 44, 46, 151.
Kanheri, 139, 141.
Karez, 4.
Karla, 139.

Kathiawar, 63.
Kausambi, 66, 67, 73.
Kechi Beg, 4, 148.
Khandagiri, 138ff.
Khandahar, 2, 7.
Khurab cemetery, 18, 59.
Kili Ghul Mohammad, 4, 148, 149.
Kish, 149.
Knossos, 147.
Kosam, 95.
Kot Diji, 2, 3, 19, 20, 148.
Kulli, 7ff., 12, 13, 18, 19, 22, 24, 36, 42, 45, 55, 56, 59, 60, 62, 97, 148ff., 151.
Kulli Mehi, 7.
Kumrahar, 79, 80, 93.
Kurdish mountains, 32.
Kurdisthan, 82.
Kurukshetra, 65.

Lagash, 31, 149.
Lakhyopir, 66.
Larsa, 75, 149, 160.
Lauriya Nandangarh, 73, 75, 83, 89, 98.
Lohanipur, 92, 93.
Lohumjo-daro, 56.
Lomas Rishi cave, 80, 81.
Londo ware, 64ff., 68.
Loralai, 59.
Lothal, 2, 38, 47, 61ff., 151ff.
Luristan, 32, 65, 86.
Lustrous red ware, 61.
Lycean, 101.

Magadha, 132, 155.
Mahabharata, 65, 66,
Maheshwar, 69, 70, 73, 153.
Makran, 18, 57, 59, 64, 65.
Malwa ware, 70.
Masarh, 92.
Mashkai-Kolwa region, 8.
Mathura, 93, 95.
Maurya, Mauryan, 32, 72, 73, 75, 77, 78ff., 91ff., 109ff., 117, 119, 121, 124, 125, 129, 130, 131, 132, 138, 140, 142, 155ff.
Maurya sculpture, 78ff., 91ff., 122, 125.
Median tombs, 142.
Mehi, 7, 36, 59.
Mesopotamia, Mesopotamian, 4, 5, 7, 9, 10, 12, 13, 16, 19, 20, 21, 22, 23, 24, 29, 32, 33, 35, 37, 38, 39, 40, 41, 43, 44, 45, 46, 48, 49, 50, 51, 52, 56, 57, 61, 62, 72, 75, 78, 82, 88, 90, 96, 100, 106, 107, 110, 111, 113, 115, 117, 122, 123, 127, 130, 131, 132, 135, 149.
Mesopotamia, chronological chart, 159ff.
Mian Ghundai, 4.
Minoan, 17, 20, 21, 23, 28, 43, 54, 56, 111, 141, 161ff.
Mitannian empire, 160.
Mohenjo-daro, 2, 11, 15, 21, 23, 24, 25, 27, 33, 34, 35, 36, 42, 44, 45, 46, 47, 49, 50, 53, 58, 62, 63, 95, 97, 98, 103, 126, 135, 143, 147, 149ff.
Mother goddess, 10, 42, 44, 45, 46, 51, 63, 70, 75, 95, 115, 128, 143.
Mundigak, 8.9, 12, 16, 22, 120.
Murtaziganj, 95.
Musyan, 2, 5.
Mycenean, 101.

Nagarjuni caves, 80.
Nagda, 71.
Nal, 1, 2, 3, 4, 6, 8, 9, 10, 20, 22, 23, 25, 40, 42, 147.
Nandangarh, 113.
Naqsh-i-Rustam, 93, 142.
Narmada river, 69.
Nasik, 69, 70, 73, 112, 141.
Navdatoli, 63, 66, 69, 70, 71, 73, 153, 154.
Nebuchadnezzar, palace of, 76.
Nevasa, 69, 70, 73, 153.
Niai Buthi, 148.
Nihawand, 65.
Ninevite period, 159.
Northern black polished ware, 65, 66, 67, 73, 153, 154.

Orissa, 188ff.

Painted grey ware, 13, 60, 63, 65ff., 73, 74, 79, 152ff.
Painted red ware, 70, 153.
Parthia, 155.
Pataliputra, 79ff., 93, 100, 104.
Patna, 92, 93, 95, 104.
Pillars, Asokan, 82ff.
Periano Ghundai, 10.
Persepolis, Persepolitan, 4, 11, 43, 55, 56, 57, 59, 79, 82, 83, 85, 87, 106, 113, 116, 119, 121, 122, 123, 140, 141, 142.
Persia, Persian, 4, 6, 10, 32, 39, 60, 64, 65, 72, 73, 74, 76, 82, 85, 86, 87, 101, 102, 103, 104, 105, 106, 119, 121, 129, 130, 132, 140, 142, 143.
Persian Gulf, 62, 70.
Phoenician, 101, 112.
Piprahwa, 73, 75, 98.
Pisdelli Tepe, 157.
Pirak, pirak ware, 12, 18.
Pithalkhora, 140ff.
Post-Harappan culture, 53ff., 68, 72, 75.
Post-Maurya art, 129ff.
Post-Maurya period, 156.
Pottery, 4, 8, 12, 16, 27, 28, 42, 54, 55, 56, 57, 59, 60, 63, 64, 65, 67, 68, 69, 70, 73. See also Ceramics.
Pottery, Harappan, 16ff., 21, 22.

Quetta, 4ff., 8, 9, 12, 13, 29, 40, 42, 47, 59, 148, 149.

Rajagriha, 80.
Rajasthan, 69.
Rajghat, 95.
Rajgir, 73, 92.
Rampurva, 83, 88, 89, 104, 122.
Rana Ghundai, 10, 11, 13, 58, 59, 149.
Rangpur, 61, 63, 151ff.
Rock-cut caves, 79ff.
Rupar, 63, 95, 153.

Salempur, 92.
Samarra, 3, 11, 24, 71.
Sanchi, 77, 79, 80, 83, 89, 92, 94, 95, 109, 112, 114, 121, 124ff.
Sankissa, 83, 89, 95, 122.
Sar Dheri terracottas, 143.
Sargon, 32, 33, 149, 159.
Sarnath, 79, 83, 87, 88, 90, 93, 94, 102, 106, 107, 121, 125.
Sassanian, 93, 134.
Satavahana, 135, 138.
Saterh, 73.
Saurashtra, 53, 63, 69, 70, 75.
Scarlet ware, 8, 24.
Sculpture, 41ff., 48.
Sculpture, Mauryan, 78ff.
Scythian, 101, 103, 156, 158.
Seals, 8, 21, 27ff., 42, 48, 49, 54, 56, 57, 58, 62, 63, 74, 77, 88, 103, 118, 126.
Shah Tepe, 66.
Shahi Tump, 7, 54ff., 58, 60, 65, 67, 68, 151.
Sialk, 3, 5, 10, 11, 19, 39, 57, 58, 64, 65, 66, 70, 157.
Sind, 2, 4, 7, 12, 15, 27, 54, 56, 57, 58, 70, 90, 149.

Sistan, 7, 59.
Siva, 31, 34, 45, 46, 47, 63, 113.
Sotka-koh, 64.
Southern megalithic culture, 71.
Stambhas, 83ff., 103, 104, 105, 106, 107, 109, 120, 122.
Stone axe culture, 71.
Stupa, 111ff., 124ff.
Sumeria, Sumerian, 28, 31, 33, 34, 36, 37, 38, 39, 41, 43, 46, 47, 49, 50, 55, 75, 81, 101, 112, 122, 128.
Sunga, 80, 84, 94, 95, 96ff., 101, 107, 109ff., 112, 116, 117, 121, 124, 138.
Sur Jangal, 10, 11, 59, 149.
Susa, 2, 3, 5, 9, 24, 32, 62, 71, 79, 90, 111, 120, 149, 157.
Sut Kagen Dor, 64.
Syria, Syrian, 20, 39, 61, 117.

Taxila, 43, 74, 95, 103, 129, 140.
Tekwada, 71.
Tal-i-Bakun, 3, 5, 39.
Tell Agrab, 37.
Tell Asmar, 37, 58, 149.
Tell Halaf, 11, 19, 20, 21, 26, 39, 57, 159.
Tello, 43, 44.
Tepe Gawra, 19, 159.
Tepe Giyan, 5, 18, 19, 39, 55, 58, 62, 117, 157.
Tepe Hissar, 55, 117.
Tepe Sarab, 157.
Tepe Siahbid, 157.
Tepe Turang, see Turang Tepe.
Terracottas, 9, 41ff., 48, 70, 74ff., 96ff., 107, 125, 129, 143.
Thessaly, 66.
Togau, 10, 11.
Tree of Life, 55, 56, 125, 126, 128.
Triratna, 115, 122, 123.
Trojan, 101.
Tukulti-Ninurta, 160.
Turang Tepe, 143, 158.
Turkestan, 50.

Ubaid, See Al Ubaid.
Udayagiri, 138ff.
Ugarit, 62.
Ujjain, 71.
Umma, 149.
Ur, 3, 12, 28, 37, 50, 64, 149, 160.
Uruk, 159.
Usnisa, 44.

Vaisali, 79, 83, 95, 104.
Vedic age, 53, 88, 89, 106, 113.
Vedic texts, 53, 126.
Vidisa, 131.
Vishnu, 113.

Yaksha, Yaksha figures, 7, 47, 93, 94, 115, 116, 118, 119, 137.
Yavana, 139, 140.

Zhob, 10ff., 13, 42, 58, 59, 97, 149.
Ziggurat, 113.
Ziwiye, 158.